100 New Artists

LAURENCE KING

Published in 2011 by
Laurence King Publishing Ltd
361–373 City Road
London EC1V 1LR
United Kingdom

T 020 7841 6900
F 020 7841 6910
E enquiries@laurenceking.com
www.laurenceking.com

A catalogue for this book is available
from the British Library.

ISBN: 978 1 85669 734 7

Designed by John Morgan Studio

Printed and bound in China

100 New Artists. Francesca Gavin

Capturing the breadth of a new generation of international artists can be a bit like sticking pins in a horse's arse. Art, like life, is always out of reach and in movement. Once you think you've got a hold on it, it is entirely transformed. The one hundred international artists in this book are my attempt to highlight that breadth.

The art world can get rather preoccupied with its own etiquette, language and theoretical hang-ups. The aim of this book is to include and inspire, not intimidate and confuse. Rather than provide a critical text about every artist, I conducted an interview with each individual. The aim is to give them a chance to explain their work in their own words and provide routes to discover more about their approaches.

The result is a reference book for art fanatics and novices that points towards new directions in contemporary art: a class yearbook of the graduating generation. The artists were found over months of searching art biennials, international fairs, gallery websites and exhibitions. All the artists in the book were thirty-five or under at the time of writing – an age which seems to be the watershed between emerging and established.

Despite their disparate locations, there are some ideas that emerge from this varied selection of artists. There is a wave of people interested in the Internet and technology, who exploit it as a medium and a means of disseminating works. There are many who respond to their art historical heritage by twisting and reworking the past. A number of artists are pushing and prodding the heritage of modernism in particular, from abstraction to formal construction. Some are fascinated by architectural disintegration, and are making work that explores the fragility of the space around us. There are those who play with ideas of archival research and modes of display, or play with the representation of politics and the manipulation of truth. Each artist and each artwork can touch on themes as diverse as pop, language, humour, truth, sound, politics, optics, physicality or instinct.

Despite moments of clarity, there is no 'ism' in this book. No YBA or Neo Rauch or new minimalism. No easy-fit mood holds these artists together. Perhaps that is the defining approach of these one hundred artists: an emphasis on individual expression on a global scale.

The British documentarian, journalist and filmmaker Adam Curtis made a series of films for the BBC entitled 'The Century of the Self' in 2002. The first episode of the four-part series, *Happiness Machines*, examined how Sigmund Freud's American nephew Edward Bernays promoted ideas about psychology, desire and irrational emotions in the creation of advertising. Curtis persuasively argued that Western media is driven by the resulting 'cult of the individual', something exploited by advertising and governments, mutated by the 1960s counter-culture focus on self-discovery and transformed into the greed and consumerism that have fed the past two decades.

The selection of artists in this book emerged as that 'selfish capitalism' spread across the globe. The artworks featured here were made in the self-promoting era of the blog and the Facebook page. That cultural environment does not denigrate their work, but it is an important influencing factor of how and what they create. These artists are also emerging after the art bubble burst, when the monetary excesses and supersized art of the last decade started to transform into something else. The result is artwork that points to something more inventive and ultimately more interesting.

Francesca Gavin

100 New Artists

Futo Akiyoshi 1977, Japan, www.futoakiyoshi.com, www.taronasugallery.com

Explain your 'Polaroid' series.
I took 100 Polaroid photographs of painted wooden shapes, changing each composition one at a time. The wooden shapes were painted with oil paints. I checked the finished prints one by one, before moving on to the next composition. That improvised approach was interesting. I was also interested in the format of Polaroid film. Its unique form makes me feel it is more like a three-dimensional medium. Making the series was like painting on three-dimensional objects in different colours. This is why I installed these Polaroid works on white shelves, making each work lean against the wall to emphasize its form.

What do you find interesting about abstract shapes?
Abstract forms make me relieved. They suggest that there is nothing that is clearly identified. It is also interesting how viewers recognize those abstract forms. I always start my creation from things nearby – parts of my body or things that come out of my studio.

How do the ideas of childhood and play influence your work?
The 'Children's Room' series is my studio itself: very messy, with the walls covered with colours made by brushstrokes; rusty oil paints, shaky stools, loose lights; the floor filled with brushes and cigarette butts; white canvases ready for painting. It's like kids playing inside their room, messing up their toys and doing whatever they want. It's not my childhood memories that inspire my creation; it's always now. It is kind of a stage, for me to do something inside. I imagined it was my studio.

Do you want to push the boundary between media, such as sculpture and painting or video and painting?
To be accurate, my aim is to push all the boundaries surrounding painting. My challenge is to transform various media, such as photography, video and sculpture, into the medium of painting. My works are always related and share the aesthetics of painting.

What do you find interesting about drips of paint?
What interests me is the material of oil paint itself. Even the wooden bricks inside the 'Polaroid' series are painted with oil paint. I find oil paint more difficult to control at will than other materials, such as acrylics.

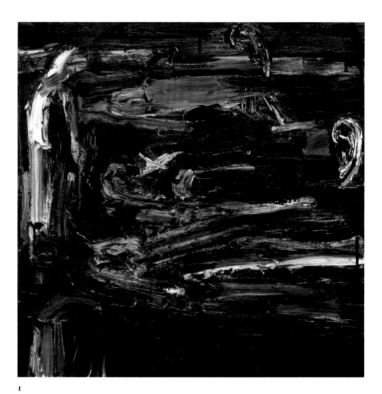

1

1. *Black 1*, 2003. Oil on canvas. 60.6 × 60.6 cm (23⅝ × 23⅝ in).

2. *Untitled*, 2008 (detail). Series of 100 Polaroids. Each 10.7 × 8.9 cm (4⅕ × 3½ in).

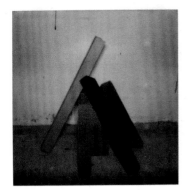 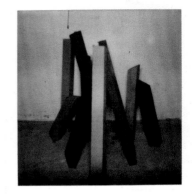 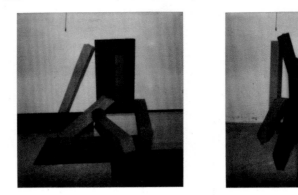

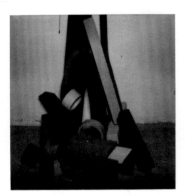 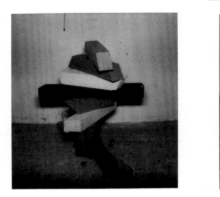 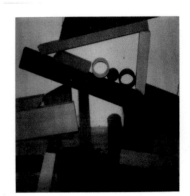

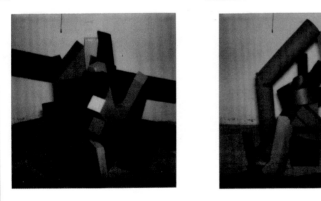 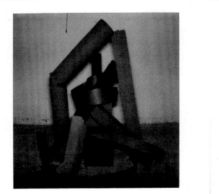 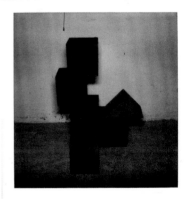

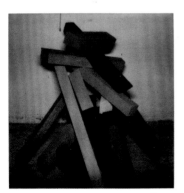 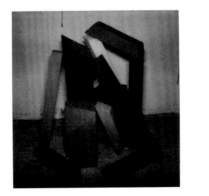

Alterazioni Video

Italy, www.alterazionivideo.com, www.prometeogallery.com

How does the wider idea of the collective, informed by the Internet, influence the ideas behind your work?

The idea behind collective work is that we're all attempting to perform individual tasks, and the ways in which we accomplish our objectives interact. Sometimes this is because we're all part of a larger project, and sometimes it's just because what we do can affect other people's plans if they know about what we've done. Sometimes, what we're attempting to do generates conflict with other people's objectives and at other times it generates opportunities. It would be great if we knew of these conflicts and opportunities – and if the Internet could tell us.

What attracts you to the aesthetic of found imagery?

What was important was literally to enact the image culture that we are in, and to project it back on itself with the agency of the imagination, to be creative about it and not just be recipients… I also have a joy in found material, a McLuhanesque sense of the proliferation of meanings, gestures and images, and an obsessive collector's sensibility. I'm not a rarefied minimalist, but a maximalist…

Describe your artist serial killer film.

The killer is on the train but we cannot see him. While looking out of the window he falls asleep. His oneiric journey starts in a deep forest. The killer is walking alone until he finds a small village dominated by a huge country house. You can feel him breathing but you cannot see his face. Entering the house, which looks more like a private mental health clinic, the killer starts killing everyone he encounters in a frenzy of violence and splatter images. Among others, he kills Joseph Beuys, Marina Abramovic, Bill Viola, Paul McCarthy and Pipilotti Rist. In the last scene he wakes up, the day is over, sunset is colouring the countryside and the train is still rolling fast. Nothing really happened. The point of view of the killer is the same as that of the viewer – as if all video experimental artists have been killed by the public itself. As in *Incertain Verification* by Barucchello and Grifi, no image has been shot, no audio has been created. The whole project is based on editing and post-production of videos from a massive archive of video art.

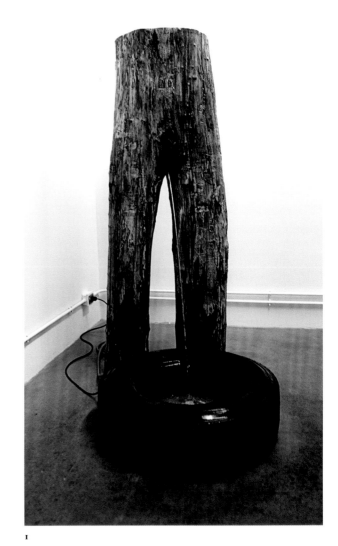

1

2. *All my friends are dead*, 2010. Album cover. 30.4 × 30.4 cm (12 × 12 in).

3. *Untitled* (*Google paintings*), 2009. Digital print and silkscreen on canvas. 100 × 70 cm (39⅖ × 27½ in).

1. *Susanna*, 2009. Chestnut wood, rubber, water pump and water. 240 × 90 × 120 cm (94½ × 35⅖ × 47¼ in).

4. *Untitled* (*Google paintings*), 2009. Digital print and silkscreen on canvas. 100 × 70 cm (39⅖ × 27½ in).

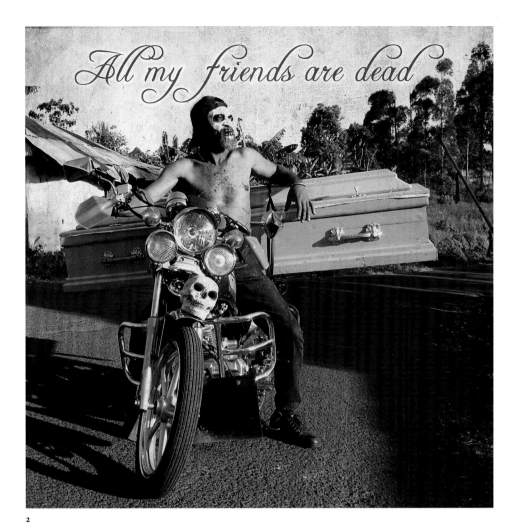

2

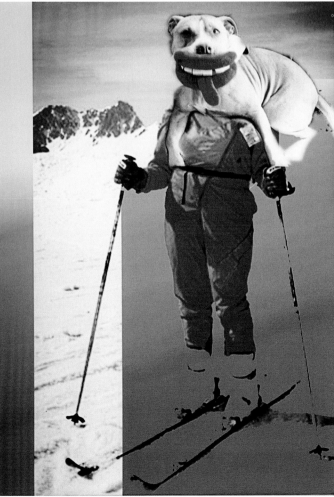

3

4

Özlem Altin 1977, Germany, www.circusberlin.de

What is the thought process behind your compositions?
I like to uncover the hidden potential of found material. It may at first convey an unambiguous denotation, but, by modifying or combining it, it reveals new layers of meaning and an associative power that might have been inherent but invisible. My way of arranging is intuitive. My work is all about opening up images for interpretation and meaning through new contexts.

How and why do you use the human body as a material?
My interest lies in the perception of the human body – the moment when a shift in appearance occurs through misrecognition or incomprehension; when we no longer see a person, but a type, an object; when a person appears without expression or character, almost flat in appearance. When the face is blanked out, covered or turned away, identification is made impossible. When does an individual turn into a shadow, a trace, a thing? At what point does subjectivity dissolve? The human body, depicted in the images and photographs I use, seems motionless, paralyzed (especially in comparison to the objects and sculptures in my installations, which seem quite animated). The bodies appear without wills of their own.

What is your interest in masks?
The mask makes very clear the distinction between the inside and the outside; what we see, clearly becomes surface. One is not oneself while wearing a mask, but something or someone else. I am interested in that alienation and detachment of the outer form from the inner, a shift in representation.

Is your work, to some extent, about museum display?
In order to present single collages or groups of images I make use of different modes of display, such as wooden walls, boards, tables, vitrines, plinths – typical designs from archives and museums. Besides the fact that they transmit a certain aesthetic language, they also imply a didactic authority.

What attracts you to making artist-books?
In 2007 I founded 'Orient Press', through which I am publishing artist-books on a regular basis. Working with the format of a book has always been an important framework for me to express my work and ideas. A publication implies a different structure, especially compared to spatial installations. The narrative follows its own rhythm and unfolds in its own time, but is basically determined by the confrontation of two single pages, where a specific dialogue takes place. I would call a book more concluded than an installation.

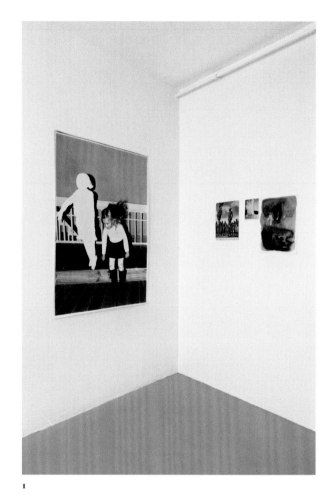

1

1. View of *Each movement appears like hesitation*, Galerie Circus, Berlin, 2009.

2. *Lying plinth*, 2009. Prints, photocopies and publications. 90 × 160 × 35 cm (35⅖ × 63 × 13¾ in).

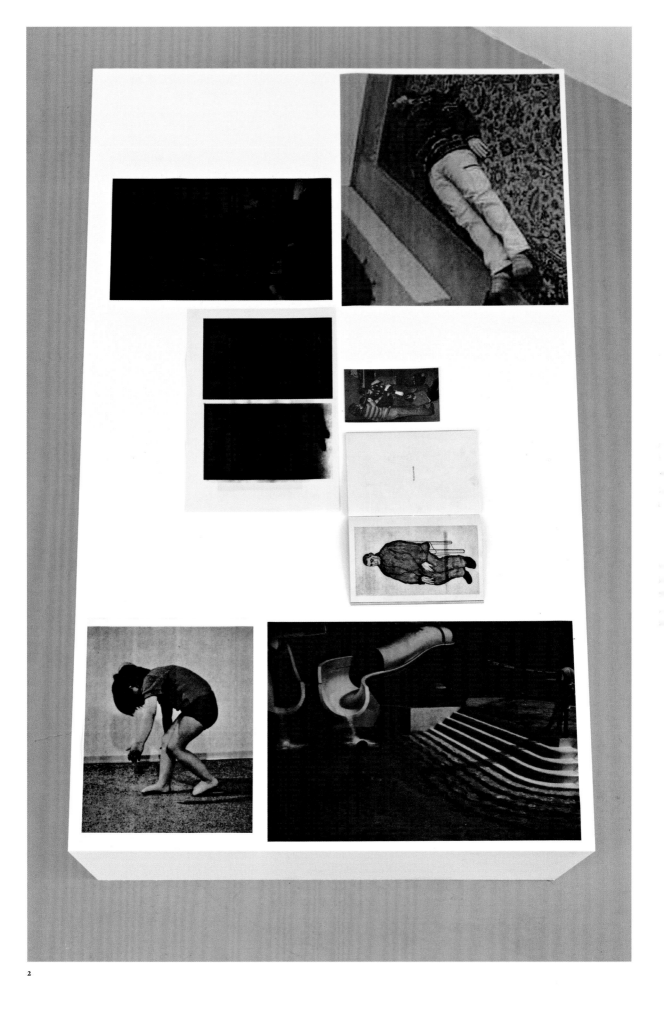

3

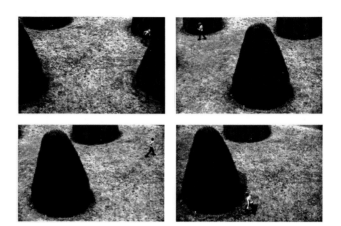

4

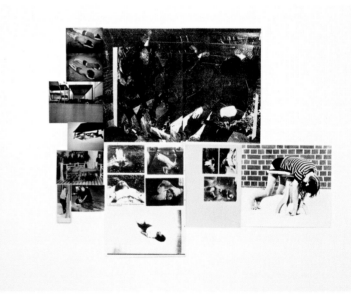

5

3. *Untitled (jongen met mandje)*, 2005.
Photo-print. 110 × 74 cm
(43⅓ × 29 in).

4. *Junge*, 2009. Prints. 55.5 × 85 cm
(22 × 33½ in).

5. *Lying*, 2009. Black-and-white pho-
tocopy and photographs. 81 × 102 cm
(32 × 40 in).

6. *Springen*, 2002/2006. Photo-print.
134.5 × 90 cm (53 × 35⅖ in).

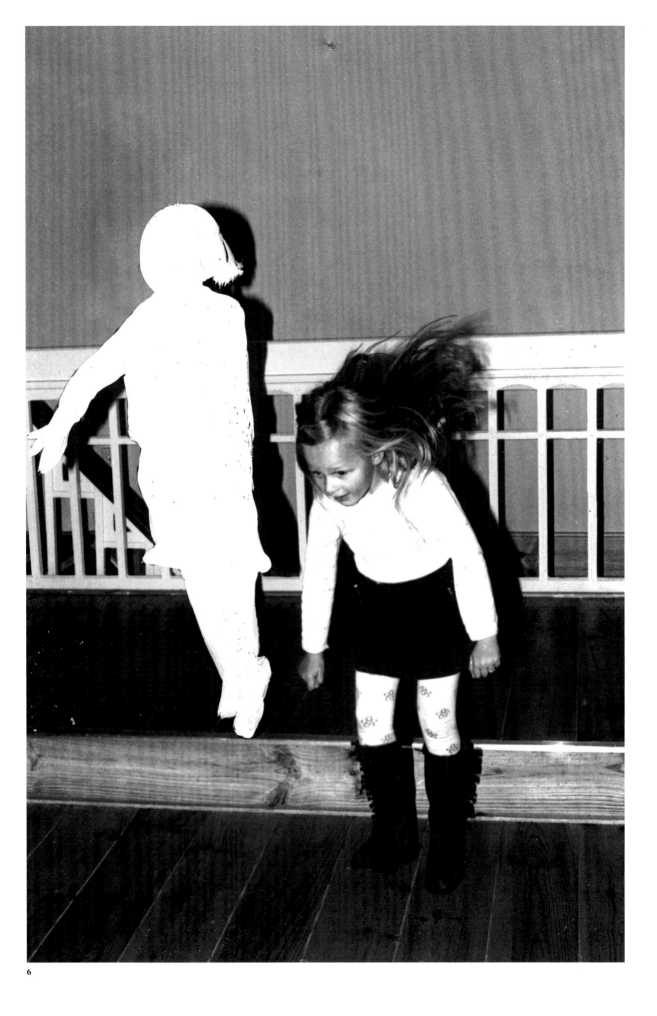

Dan Arps 1976, New Zealand, www.neonparc.com.au, www.michaellett.com

Why work with collage?
I like the idea that the subject matter is the source material. There is no leap of logic where the work has to be about something else. It's very direct.

What do you find interesting about magazines as a source?
I am really taken with magazine covers and how they try to evoke the ideal psychological space, like *OK!* or *Hello*. Generally my sources are common things that are there for the taking. I wouldn't say magazines were my only source or even my predominant source. Some things I use are found on the Internet, on the street or in the rubbish.

What interests you about the idea of defacing images?
It is a way of activating and working with my own ambivalence. It is not always about defacing something; it may be just disturbing a smooth surface or inserting something new into a space.

How do you comment and reflect on pop culture in your work?
Everything in my work has floated around long enough to be, at best, just out of fashion. So maybe there is something there about how pop culture generates newness. My work mimics this. I'll try not to repeat myself. Looking back though, there is a definite consistency in an apparent shallowness and transience. As things date they become like universal archetypes of themselves.

What interests you about posters?
The poster is a standard format. Posters answer a lot of questions about scale, material and the logic of display. They fail to represent an ideal because of their particularity – period styles, images of bodies and gestures, the appeal to the aspirational, the bad marketing, the leaps of logic that go nowhere. When posters fail they turn into the worst kind of surrealism.

Why do you focus on texture and mess in your sculptures?
There is something interesting in the use of pottery in art therapy and how there is a dialogue with the material. The things that result are like the material remains of an attempt at self-improvement. A lot of my favourite sculptures are things that have had several different lives and purposes over a long time. They get crusts of different materials and go through different processes.

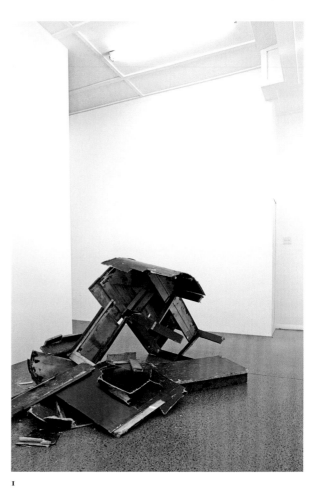

1

2. *Promotional Marketing Strategies*, 2008. Framed poster, found drawing and Blu-tac. 76 × 53 cm (30 × 21 in).

3. *Gift Horse*, 2009. Plasma ball, ornament, epoxy putty, polystyrene, plastic coated wire, plastic and eraser. 55 × 50 × 22 cm (21²⁄₃ × 19²⁄₃ × 8²⁄₃ in).

1. *Fractal Tears*, 2008. Installation at Michael Lett, Auckland. Dimensions variable.

4. *A Centre for Ants*, 2006. Installation at Mount Street Studio, Auckland. Dimensions variable.

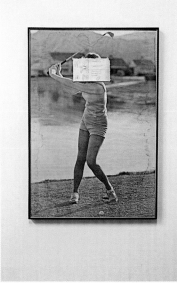

2

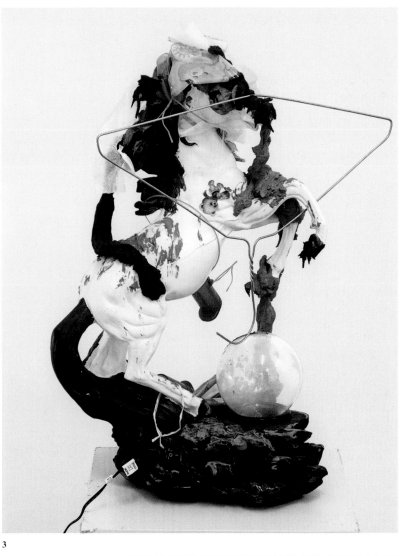

3

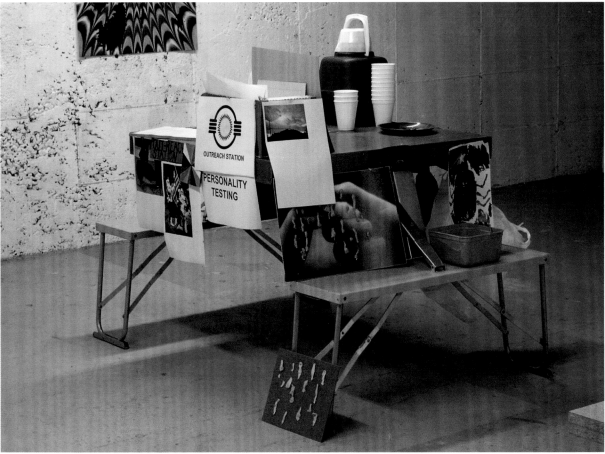

4

Lea Asja Pagenkemper 1976, Germany, www.jette-rudolph.de

What interests you visually about the street?
The street was my first playground, as a kid
as well as a teenager. I often found myself in
strange empty corners hanging around with
people, discussing life and teenage stuff. I was
fascinated by forgotten places (the Berlin Wall
had just come down) and the traces of human-
ity that were left there (rude graffiti). It was
fantastic to see straight architectural geometry
caked over and over again by wild colourful
spray paint, like the crazed psyche of a city.
I was always fascinated by the urge people
have to write a message on a wall or to express
their love on a toilet wall. For me, that is some-
thing very powerful, the underground life
of humanity.

Do you depict urban space?
I think that by using walls, staircases, elevators
and playgrounds, and transforming them into
a composition on canvas, I make them mine.
I use the spaces to fill them with my own
thoughts. I create, with the help of so-called
urban space, a field where I can deal with all
I had inside – even contradicting ideas.

How do poetry or words influence your work?
I start a painting with a sentence in my head,
or a word. I don't write the word itself onto the
canvas anymore, because I want to translate
it directly. Maybe I want to create a poem with
brush and paint. I am inspired by 'dark' writ-
ers like Baudelaire, Poe, Artaud, Lautréamont
and de Sade, all writers who wanted to cross
social or artistic borders.

*Your recent work has become much more
abstract and graphic. Why?*
I am not 'illustrating' space, psychic, emo-
tional or spiritual; I create that space. I work
with very sensitive shadows and contrasts.
It's the work of reducing. Painting is an em-
brace with death, or ghosts. The new works
are dealing with the unconscious, love, death,
transience, spirituality and sex.

What influences your colour palette?
I have developed a special liking for dark
colours – black gradients with painted high-
lights and close contrasts. It's a conscious
decision to use black, to create an uncertain
infinite space. I often take time to search
and find the right colour. I am dealing
with nuances.

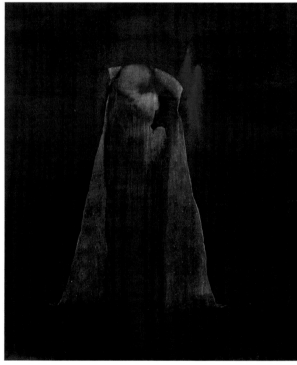

1

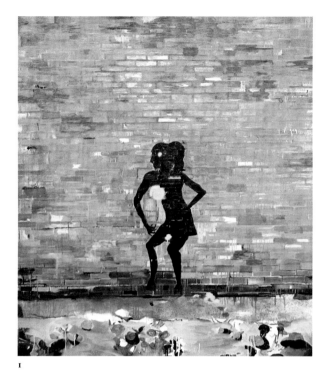

2

1. *Schattenmädchen*, 2010. Oil,
spray and chrome colour on canvas.
180 × 155 cm (71 × 61 in).

2. *Notturno*, 2009. Oil on canvas.
200 × 170 cm (78¾ × 67 in).

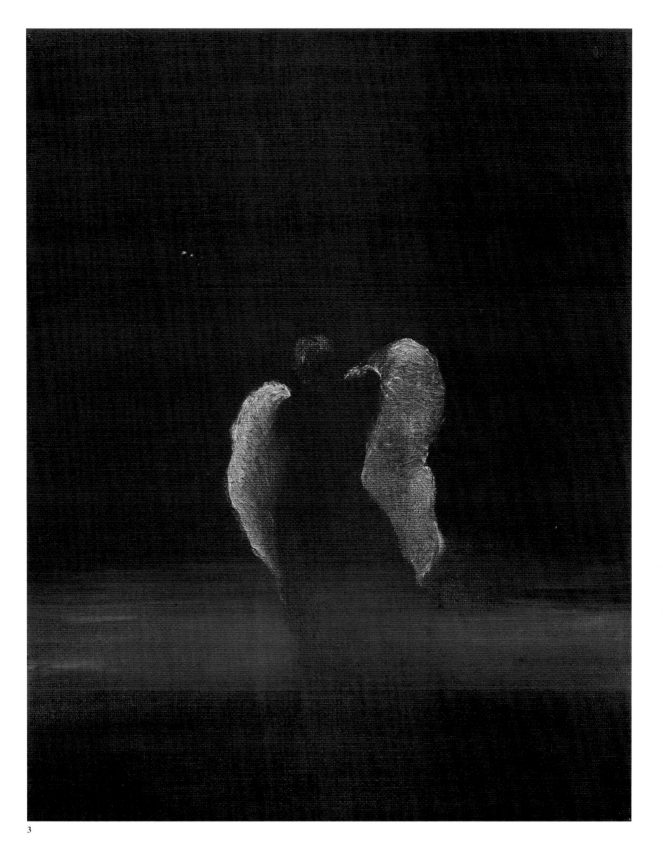

3

3. *L'ange Lautréamont*, 2009.
Oil on canvas. 30 × 24 cm
(11⅘ × 9⅖ in).

Mahmoud Bakhshi 1977, Iran, www.ropac.net

*How does history emerge in your visual
iconography?*
History is everything. Nothing is new, it's just
repeating. When you compare repetitive be-
haviours, you can discover plenty of sadness
as well as humour. In each movement towards
democracy in Iran, you can witness a losing
process that eventually wears on the psyche.
Almost every Iranian looks at the past with
a great sense of regret.

Why do you use flowers in your work?
Flowers are a symbol of beauty. They're also
symbolic of love, solitude, tombstones and
cemeteries; but the first impulse is beauty. I
had heard that most of my work was not beau-
tiful and that's why nobody was interested in
it. So one day, I went straight for that, for the
beautiful. I was interested in exposing the idea
of something beautiful, like the postcard. The
postcard is meant to capture the beauty of the
area visited, but it is a representation, a re-
moval from the reality. In my work, flowers
are the representation of Iran's splendour, but
they are just a façade for the harsher truths
of the existential reality. Iranian literature and
poetry are full of floral references. We always
say Iran is a country of 'flowers and nightin-
gales', or a 'rose garden'. Persian carpets are
full of flowers, as is architectural ornament.

*What role do violence, war and death play in
your work?*
When you live in an unstable environment,
these circumstances become like everyday life.
Employing violence, war and death is recog-
nizable and familiar. That is also why I some-
times conjoin the subjects with icons of the
quotidian, like graphics of driving lessons or
kitchen appliances. It also shows how deep
and universal the effects of our insecurity are.

How does interaction influence your pieces?
I like it when a work challenges the audience,
not just in a visual manner but also physically.
In one installation I placed mirrors on the
floor that cracked and broke as people entered
the space. In another piece, a wind tunnel
between a series of flags literally attacked the
audience as they passed through.

*What interests you about textiles, rugs
and costume?*
They are interesting objects, with value and
character that come from deep within the
culture. Rugs in particular offer a pictorial
history of Iran. I use them for this tradition,
which contrasts with the modernity of daily
life today.

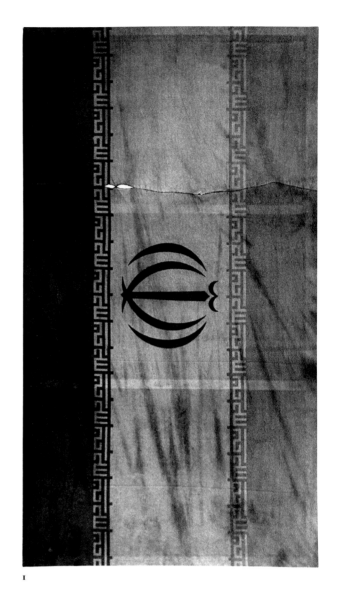

1

2. *Untitled*, 2010. From 'Persian
Rug' series, installation of 8 hand-
woven wool rugs. Each rug:
54 × 129.5 cm (21⅓ × 51 in).

3. *Tulips rise from the Blood of the
Nation's Youth*, 2008. From the
'Industrial Revolution' series,
installation of 8 tulips: neon,
tin plate, wood, plastic and electric
engine. Each tulip: 135 × 35 × 30 cm
(53 × 13¾ × 11⅘ in).

1. *Air Pollution of Iran*, 2004–2006
(detail). From 'Air Pollution of Iran'
series, installation of 8 framed flags.
Each flag: 253 × 139 cm
(99⅗ x 54¾ in).

2

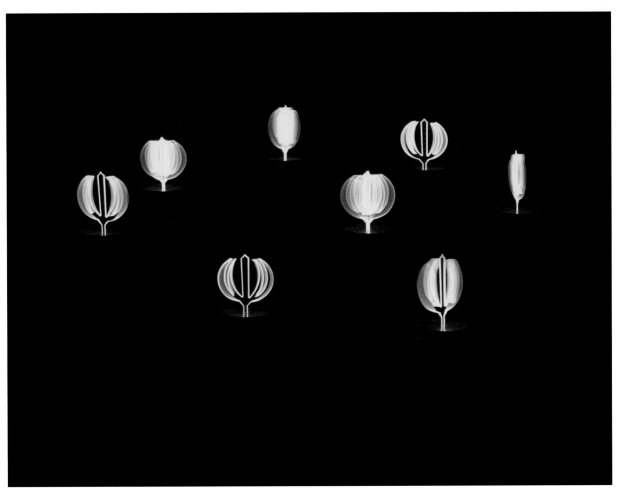

3

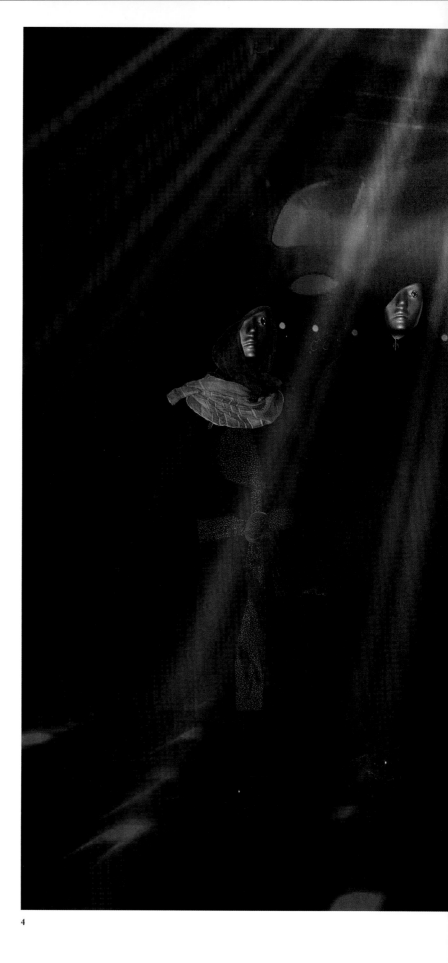

4

4. *Verdicts of Looking*, 2008.
5 single-channel videos, 5 man-
nequins. Each mannequin: 200 cm
(78¾ in) approx.

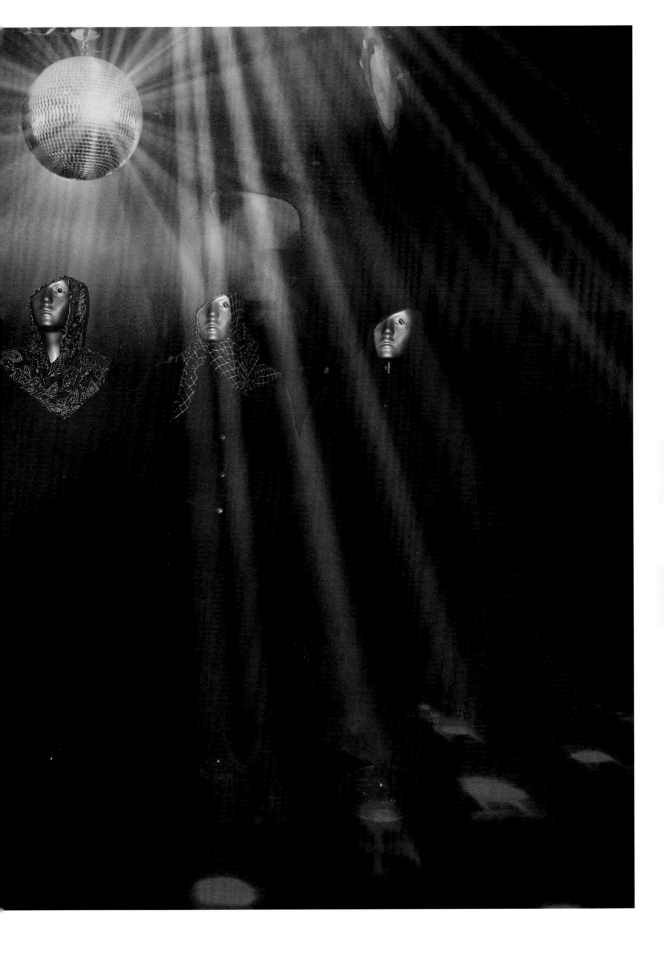

Charlotte Becket 1978, United Kingdom, www.charlottebecket.com

Why do you incorporate movement and animatronics in your work?

The kinetic pieces are machines that move very slowly, working to perform, and then undo, the same task. Because the machines are each driven by a simple motor, they loop and cycle through their work endlessly. They work both in a state of futility and in an unconscious celebration of themselves. Some of the work explores the idea of a double or split persona embroiled in an internal dialogue that fluctuates between a state of dissonance and collaboration. These forms stretch themselves apart and then mash back together again in an ambivalent tug of war.

Why have you used junk or garbage?

I was working on some pieces that were going nowhere and for months the only physical evidence of my work in the studio was piles of empty water bottles, sandwich bags and packaging from tools and supplies. Eventually those garbage piles became my materials; they seemed the most real. The rubble allowed me to insert something of myself into the landscapes that I was building and the figures that inhabited them. *The Wishing Well* is a single massive heap of junk and garbage, sandwiched between layers of plywood. The mechanism hoists loose trash up from the mechanically swallowing mouth and dumps it back out, mindlessly and gleefully gulping and regurgitating. The garbage functions in opposition to the purposeful optimism of the gestures. The disparity between the spirited actions and bleak conditions gives the work a humorous and absurd quality.

Do your pieces intentionally replicate or play with the idea of something human?

All of the pieces are abstractions of something figurative. The work deals with a human relationship to the world we have created. I am interested in making forms that initially appear alien and then reveal something very recognizable.

How does the idea of the grotesque emerge in your work?

The works address some of the ways in which we are inept and fallible. Often the figurative forms are truncated and incomplete, as a sign of their insufficiency. The notion of ourselves as only partially intact is unnerving and becomes grotesque.

What role do rhythm and speed play in your moving pieces?

The use of motion is central to my work. The movement is very slow and often takes a few seconds to notice. The rate of motion mimics a slow and strenuous inhalation and exhalation.

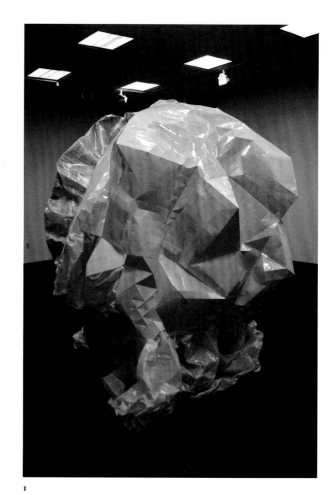

1

1. *Cyclops*, 2009. Monofilament tape, plastic, metal and a motor. 249 × 165 × 228 cm (98 × 65 × 89¾ in).

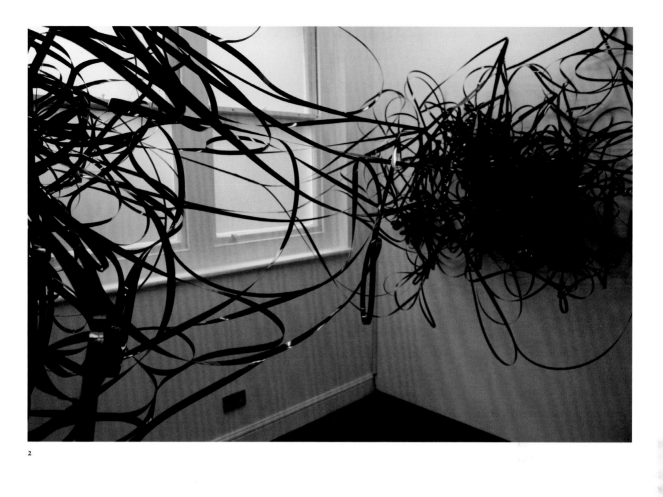

2

2. *Coil*, 2009. Strapping tape, steel
and motors. Dimensions variable.

3. *Untitled* (*White Blob*), 2005.
Vinyl, wood, aluminium and
a motor. 152 × 219 × 219 cm
(59⅞ × 86¼ × 86¼ in).

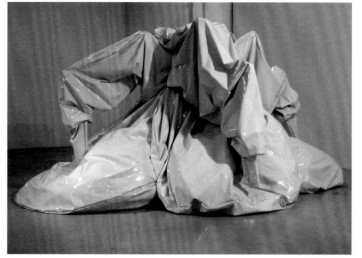

3

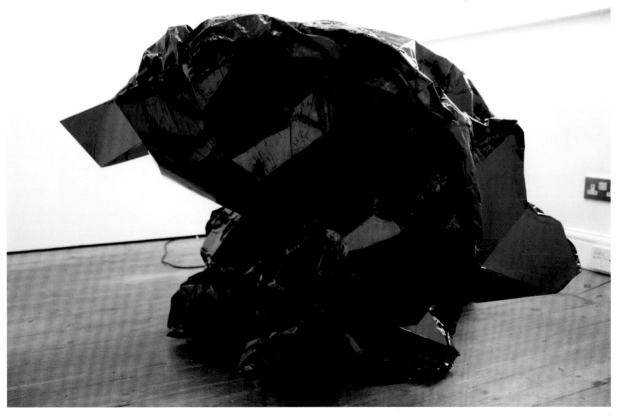

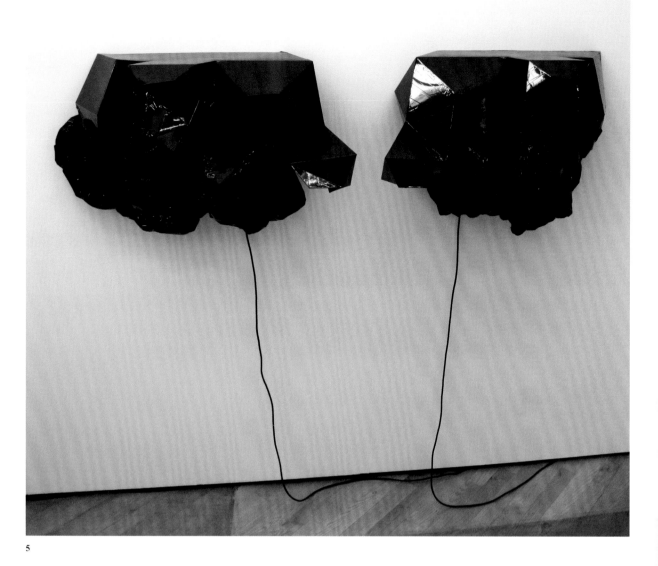

5

4. *Curdle*, 2009. Insulation tape, plastic, foam and motors. 80 × 120 × 130 cm (31½ × 47¼ × 51⅓ in).

5. *Inkblot VI*, 2009. Insulation tape, plastic, foam and motors. 55 × 140 × 27 cm (21⅝ × 55⅛ × 10⅝ in).

Andres Bedoya 1978, Bolivia, www.ohnosir.blogspot.com, www.andresbedoya.com

How do you approach the erotic in your work?
In life very little is erotic. What we actually
find sexually provocative tends to be what
challenges us morally rather than what we find
beautiful. Basic impulses, for example, are a
challenge to morals because they invalidate the
notion that there is a higher, even godly reason
for sex and desire. These cracks in learned sys-
tems like religion are where the erotic exists.

What is the process behind your drawings?
I usually produce several dozen drawings in
one sitting. Through quick repetition I try to
tease an evolution in the forms. If I succeed,
that becomes a new starting point. Often
there are radical changes in the subtleties
of the drawing.

Describe your work Ultra Madre.
Ultra Madre is an autobiographical abstrac-
tion. It is a contemplation of death, perma-
nence, protection and memory. In terms I can
understand, it recreates my mother's death
when I was young and what that meant to me.
It is an ephemeral performance-based instal-
lation in which fifty-six women participated.
Hair is used as a unifying symbol to create a
single collective body. This body fails to last as
a result of its very nature. Hair is the part of
our body where most ideological interventions
occur. As a result it becomes a container for
meaning. Within the National Museum of Art
in Bolivia, *Ultra Madre* draws parallels be-
tween itself and the architecture, which also
expresses desired permanence.

*What do you find interesting about hair and its
relationship to Bolivian society?*
What I find interesting about it is how specifi-
cally it affects people's perception of others
in relation to society at large. Male/female,
urban/rural, rich/poor are all things people
seem to believe are expressed clearly in hair.
I should say that this is true of most of the
world, but it is quite evident in Bolivia.

What attracts you to blurred images?
A lot of my work is about memories of
perception. If there is a concern in a blurred
aesthetic, it relates to the tentative nature
of recollections.

What interests you about the human body?
The body is not a good mask. At best it can
give the wrong impression about what one is
thinking but it could never hide the fact that
a thought has occurred. Intentions, desires,
memories and moods pull your muscles in
certain ways. The idea that the body can be
modified through thoughts and behaviours
is very intriguing.

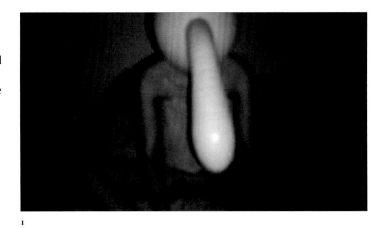

1

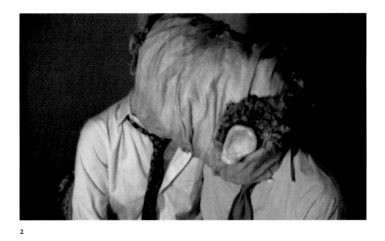

2

3

1. *Untitled* (*Study*), 2009.
HD digital video, 2:05 mins.

2. *Untitled*, 2009. HD digital video,
2:01 mins.

3, 4. *Ultra Madre*, 2009.
Performance/installation, 60 mins.
426.7 × 274.3 × 152.4 cm
(168 × 108 × 60 in) approx.

4

Steve Bishop 1983, Canada, www.stevebishop.org

How did you first start working with light?
I wanted to address its meaning as a material. Those pieces are really about the use of light in art today, and the baggage and the problems associated with it. In the context in which they are placed, next to the simple white frames, the strip lights can be seen as directly referencing minimalism, but they still perform in a pictorial sense, completing the form and structure of the clothes-horses.

Why do you use everyday objects in your work?
I just like the fact that these things had an intended use. By incorporating them into art, they get derailed. All material has associations outside a gallery. You can utilize this to construct levels of logic and meaning within a work. What I am careful not to do is to make them act out of character. I want to strike a natural and comfortable balance between something becoming transformed and something behaving naturally, like it would outside the gallery.

What interests you about using taxidermy and depicting animals?
I used taxidermy because of an interest in fur as a material and in the visceral impact gained from seeing it meet other surfaces, such as when it is embedded and matted in concrete or is pierced by strip lights. The use of clothes in general came out of thinking of fur and working with animals; from the idea of clothing as our modern fur and, when separated from the body, the fact that it represents simultaneously both absence and presence.

Your video pieces turn landscape cinema logos into something darker. Why?
I was interested in what these movie logos have come to represent. They haven't really changed since their incarnation. They occupy the same space and format as the films that follow them. They relate to myth and feelings of wonder. They were originally intended to dazzle the viewer into 'willingness for the moment', with images of cosmology, astronomy and winged horses. They show things that you won't or couldn't have experienced before – a view of Earth from outer space, a mythological horse or stars skating across the sky. In a couple of my video pieces, I subverted this with my own events edited in, derailing the expected outcome of the logos. They are so familiar that everyone knows how they go, and when they don't follow expectations, it is quite a jarring experience.

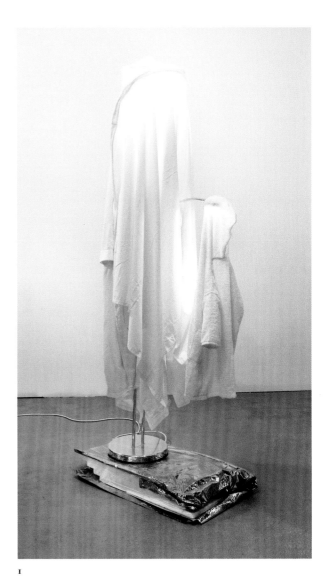

1

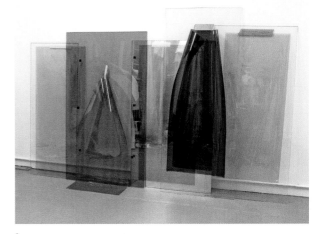

2

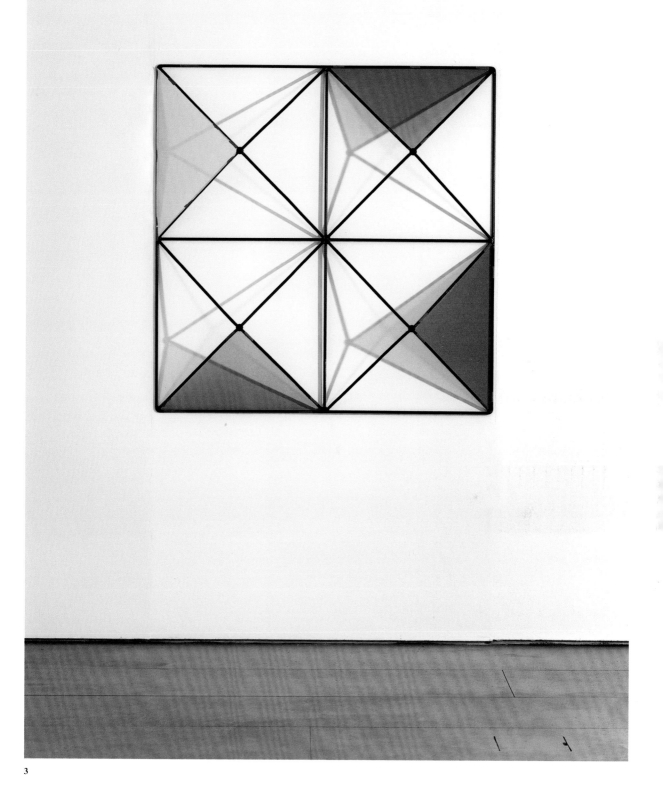

3

1. *A Few Too Many Nights Too Long*,
2009. Dressing gowns, bed sheet,
lamp, emergency blanket and poly-
styrene. 180 × 60 × 30 cm (71 × 23⅗ ×
11⅘ in).

2. *My Work Here is Done IX*, 2009.
Glass, lighting gels and various
tapes. 248 × 159 × 40 cm (97⅗ ×
62⅗ × 15¾ in).

3. *XXXX*, 2010. Steel, lighting gels
and mirrored film. 120 × 120 × 30 cm
(47¼ × 47¼ × 11⅘ in).

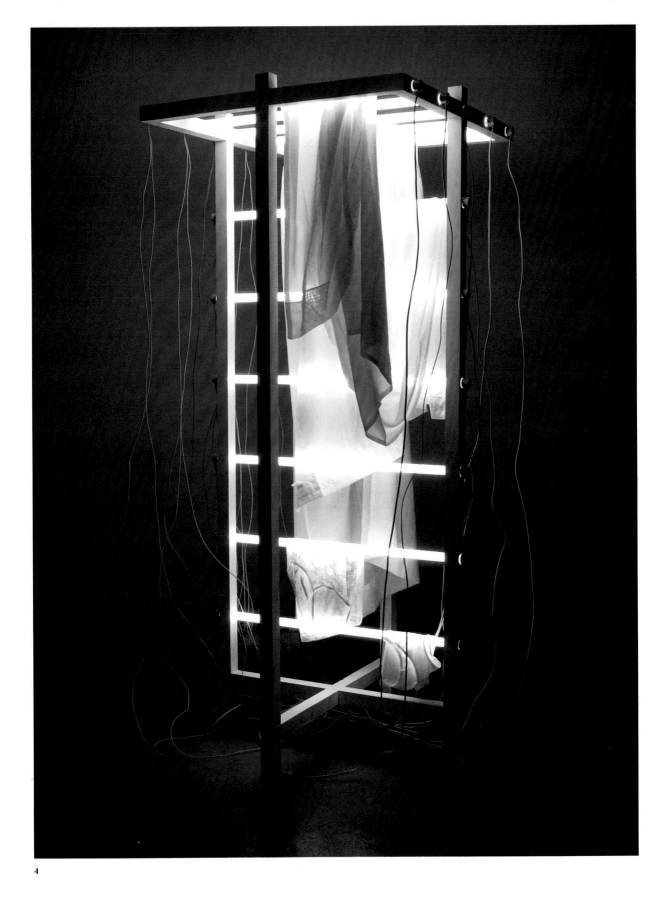

4

4. *Taking Me For All I'm Worth*, 2009.
Curtains, vest, underwear, sock,
wood, paint, fluorescent
tubes and electronic ballasts and
wires. 202 × 90 × 90 cm
(79½ × 35⅖ × 35⅖ in).

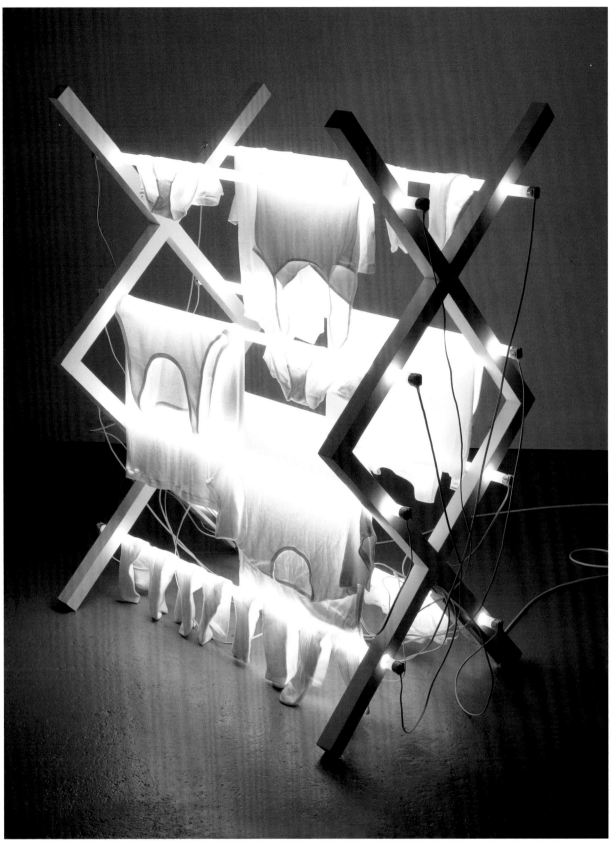

5. *Kicking Me When I'm Down*, 2008.
T-shirts, vest, underwear, socks,
wood, paint, fluorescent tubes and
electronic ballasts and wires. 100 ×
150 × 50 cm (39⅓ × 59 × 19⅔ in).

Melanie Bonajo 1978, The Netherlands, www.melaniebonajo.com

Explain your furniture bondage series.
When I was a child I was very restless. I never
wanted to sleep. My parents would tie me to
the bed with a rope. I often escaped and ran
around the house with the mattress strapped
to my back. I would also run away in shopping
malls. My parents kept me on a leash until
I was six. They told me later it was a trend in
the 1970s. I found all of this out on a gloomy
Sunday when I discovered a photograph of
myself with half a baby bed tied to my back.
I was already deeply immersed in the project
about the relationships between things and the
impossible need to create a perfect harmony
with the world around us. I am captivated by
the notion that the world consists of stuff that
humans think that they can impose their will
on to. The idea that material things need our
external intelligence and energy to bring them
to life. People cannot exist without clutter.
If we do not take care we will find ourselves
trapped in a world of things and leave no
room for observation.

What is bondage experience like?
It asks a lot of the models' perseverance.
The objects are random things that you find
in every household, hidden in a closet, under
the sink or in a barn. Sculpting them on to the
person makes it a representation of that per-
son's state of being at that particular moment.
Restraint can be liberating. Constraint gives
a sense of freedom, because it requires an un-
derstanding or trust. People litter the world
with rubbish. The images speak directly
about the weight that material has on life.

*What was your approach to animals in the
'Captive Lives Western Spectacle' images?*
The 'Captive Lives Western Spectacle' series
explores the inhuman relationships between
man and animal. It is about closeness and
distance and the inconsistency of power. It con-
sists of pictures of desolate and depressed ani-
mals in the Berlin Zoo. The idea that we move
animals around as lumps instead of living be-
ings, taken out of their own landscape, is an act
of violence. Through this action captured ani-
mals become more human than we think. It
illustrates the nature of oppression innate in
humans, in order to suppress some sort of
'Other'. To define an 'Other' is to define
ourselves. When evolution is accelerated by
greed and consumerism, it can only lead to
our own demise.

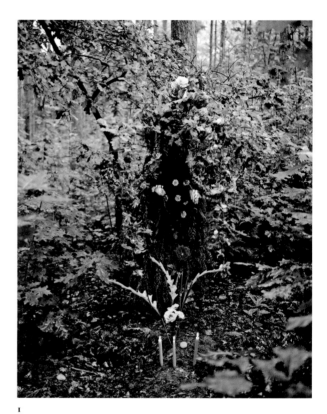

1

1. *Vision Quest 01*, 2007. In collabo-
ration with Kinga Kielscynska,
from the 'Modern Life of the Soul'
series, C-print. 150 × 120 cm
(59 × 47¼ in)

2. *Hanna*, 2007. From the 'Furniture
Bondage' series, C-print.
150 × 120 cm (59 × 47¼ in)

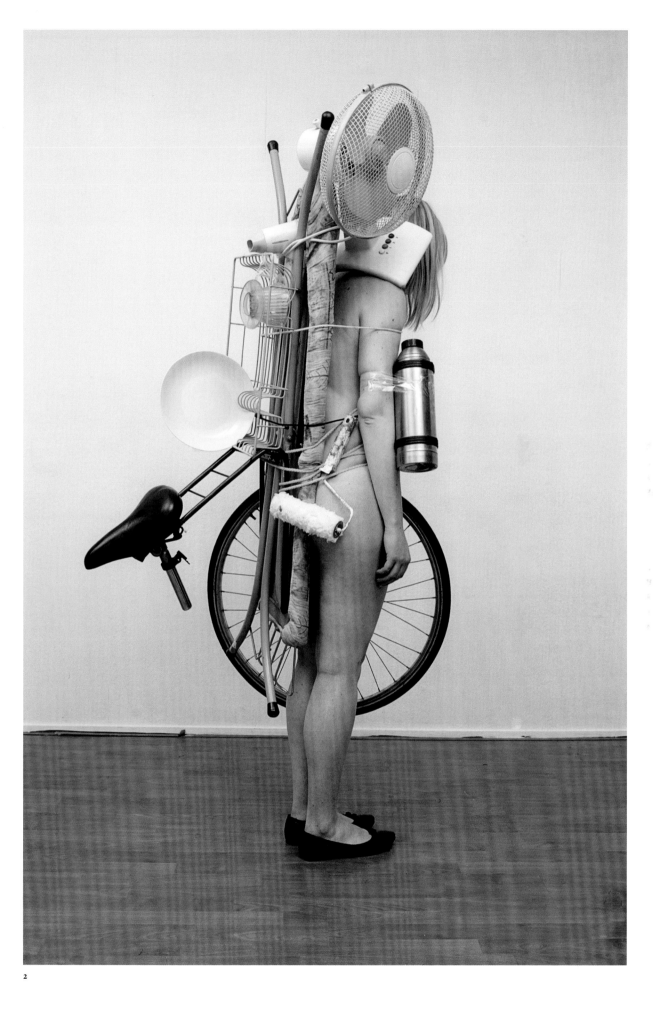

3

3. *What to Wear*, 2000. C-print.
90 × 110 cm (35²⁄₅ × 43¹⁄₃ in).

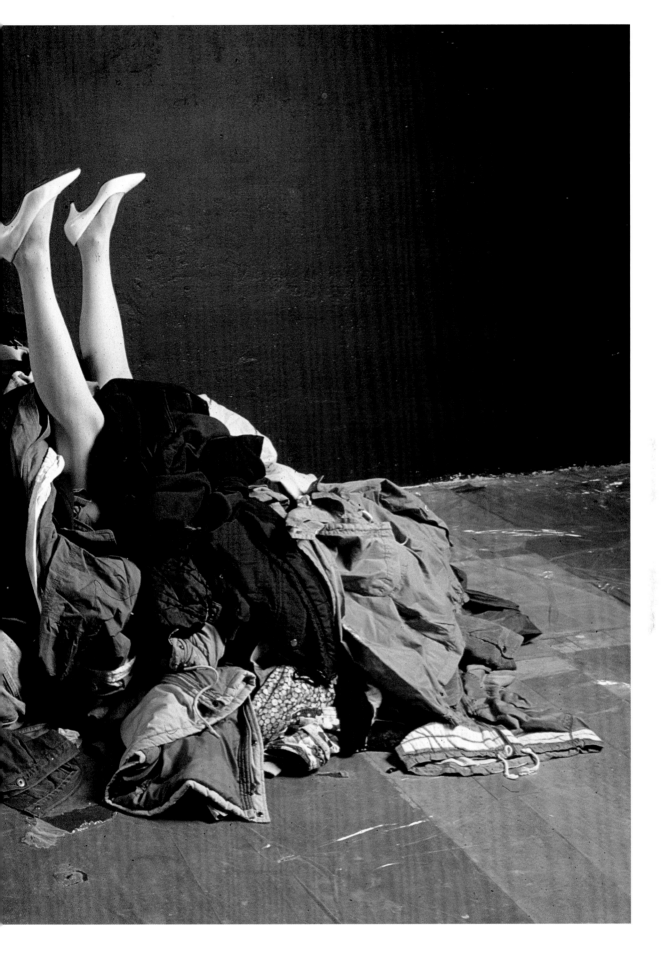

Harry Burden 1976, Australia, www.harryburden.com

What do you find interesting about working with imagery from the lexicon of art history?
It offers a chance for critique. I'm more interested in using imagery and subject matter from all areas of art. That includes the work of contemporary artists working today – a taboo – not just historical images. Rather than manipulating my personal history or cultural history, I started to take an interest in the history and mechanics of the current art world. I've been interested in technological and media manipulation for some time. I began to see how the contemporary art industry mimicked and aspired to these conventions.

What do you find interesting about the melting and disintegration in your sculptural heads?
These sculptures began as the purely conceptual idea of attacking a pre-existing artwork to create a new work. Something improved or added to by destruction. I had been reading a lot about Gustav Metzger and Auto-Destructive Art at the time. I started out with the intention of drilling holes in the face and head of stone-cast sculptural busts, but once they were hollowed out I was surrounded by dust. It occurred to me that another layer of insult to the act would be to remix the stone, and pour and sculpt it back into itself. The pouring mimicked the visceral bodily functions of vomit or a melting of the form. From the destruction – creation.

How does the Internet and found imagery inform your methods?
The Internet and digital technology have had a huge and rapid psychological effect on all our perceptions. It fits well with the areas of perceptual confusion and manipulation that I am interested in. The technology now exists to replicate any object as an image. I decided to play with painterly conventions through the digital printed medium.

I wanted to use random means to select my imagery, a kind of Dadaist approach to composition for the digital age, mixing images of high cultural significance with those of the highest banality, such as office furniture supplies, fluorescent lighting or artificially grown household plants. It mimics what I feel is a twenty-first-century experience amidst the speed and overwhelming information that saturates our lives. It becomes increasingly hard to navigate through the constructs of technological influence which separate us from any true sense of existence or personal freedom.

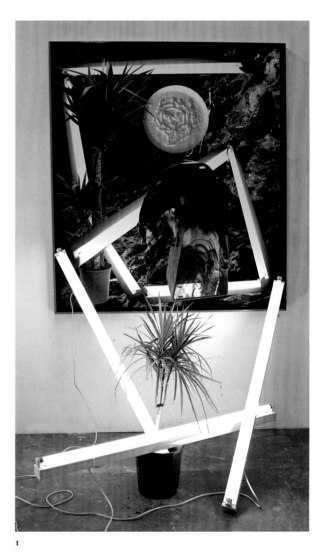

1

1. *Reflective Lighting*, 2009. Installation with Giclée print on somerset paper in hand-painted frame, fluorescent lights and house plants. Dimensions variable.

2. *Vomitoria*, 2009. Cast stone and herculite plaster with black-stained plywood plinth. 70 × 40 cm (27½ × 15¾ in).

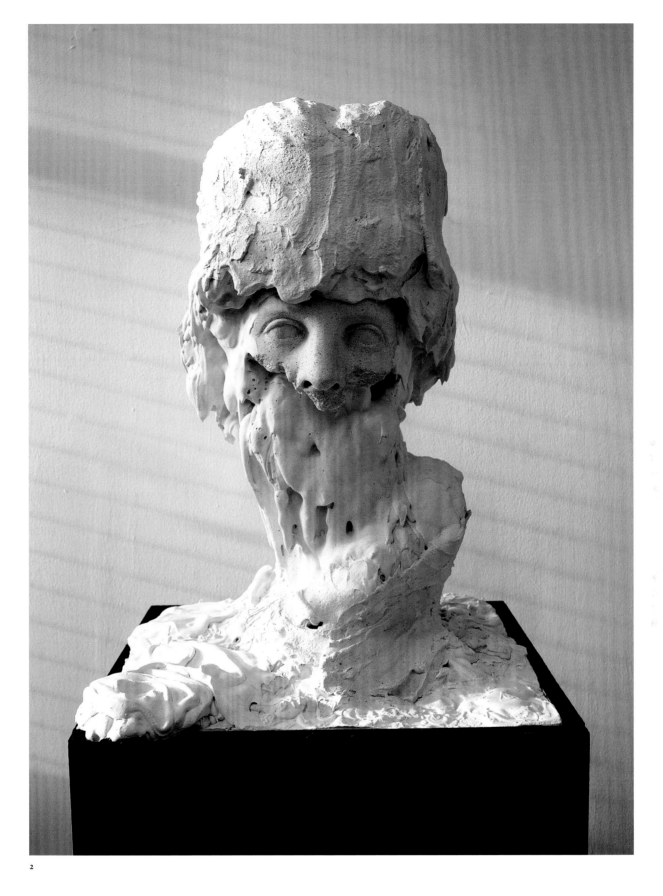

3. *Constellation (Sidney Nolan)*, 2009.
Installation with Giclée print and oil
paint on somerset paper and fluores-
cent lights. Dimensions variable.

4. *Lightmass,* 2009. Installation with
Giclée print on somerset paper in
hand-painted frame, fluorescent
lights and house plants. Dimensions
variable.

3

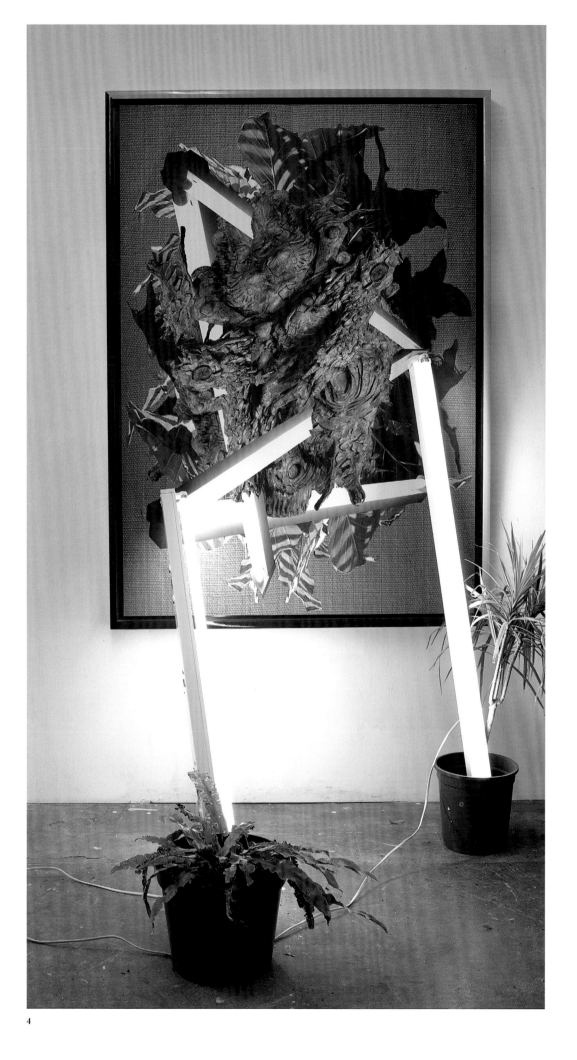

Nadine Byrne 1985, Sweden, www.nadinebyrne.com

How is your work influenced by mysticism and the occult?

Making work is in itself a mystic and occult process. Art is a tool with which you can expand reality. A work of art is a materialization of the thoughts of an artist. You could say viewing art is entering a parallel world. The occult functions in the same way. It opens you up to a world beyond the here and now and gives a depth to what sometimes feel a very flat reality. Art expands our notion of what the world and reality are. I use my artistic practice as a way of receiving knowledge about whatever interests me and as an outlet for whatever comes up while learning. I have this tremendous interest in the occult and can't help but use it in my work.

How did you first start working with costumes?

It started with the death of my mother. She worked a lot with textiles and when she passed away she left boxes of fabric. I saved all of them with the intention of making something out of them and in a way continue her work. I had not sewn much before, but it came very naturally. The first textile sculpture I made was *The Shaman Suit*. The aesthetics of it very much resemble the textile work my mother used to do. I do not remember if this was intentional or not. It felt like I had opened a gateway to my mother by sewing with her old fabrics. Making art was a way of making a connection with 'the other side'.

What do you like about how costumes interact with the human body?

I like the idea of a breathing sculpture. I think of the human body as a structure, onto which you can project so many things. Most of my textile sculptures conceal the face of the wearer. This is an easy way to evoke fear in the viewer.

Can you explain the symbolism in your work?

Symbols tell whole stories just by the simple pictorial crossing of lines. They can enclose or exclude you, depending on your knowledge. I have tried to make up my own symbols. I do not feel it is necessary always to know their meaning. I also use established symbols, like the Cross and the Star of David, as well as several geometrical shapes. I feel they are loaded with history and meaning.

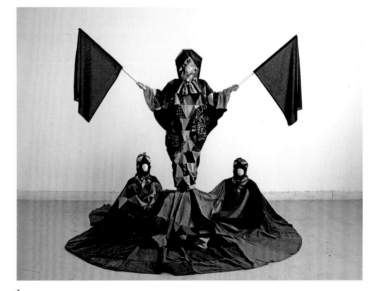

1

1. *The Shaman Suit*, 2008.
Textile sculpture. 250 × 200 cm (98⅖ × 78¾ in) approx.

2. *N.B. Emblem*, 2009. Paper collage. 25 × 38 cm (10 × 15 in).

3. *Demonhead Emblem*, 2009. Paper collage. 75 × 55 cm (29½ × 21⅔ in).

2

3

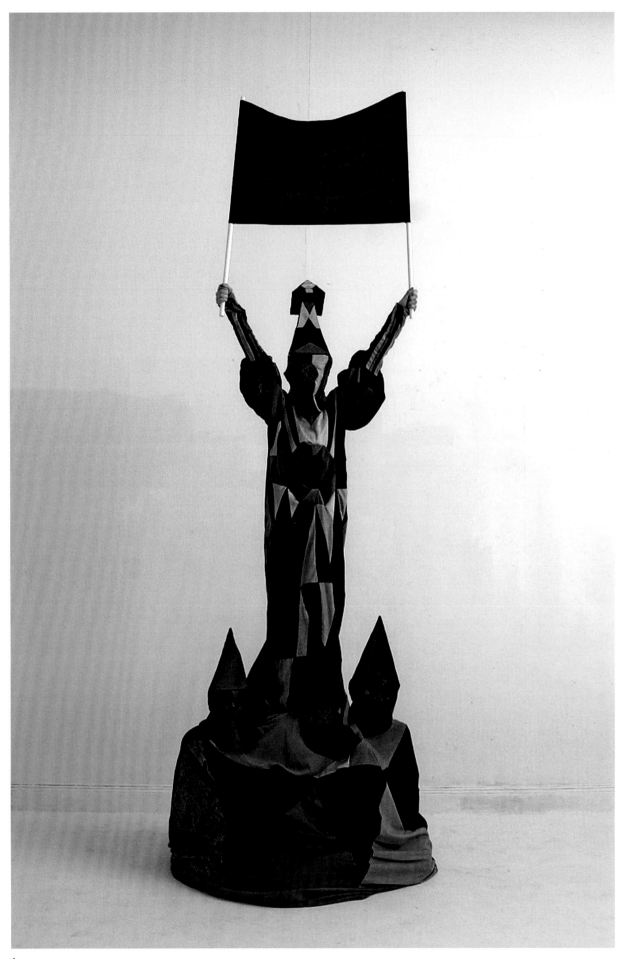

4

4. *The Shaman Suit Part 2* , 2009. Textile
sculpture. 300 × 200 cm
(118 × 78¾ in).

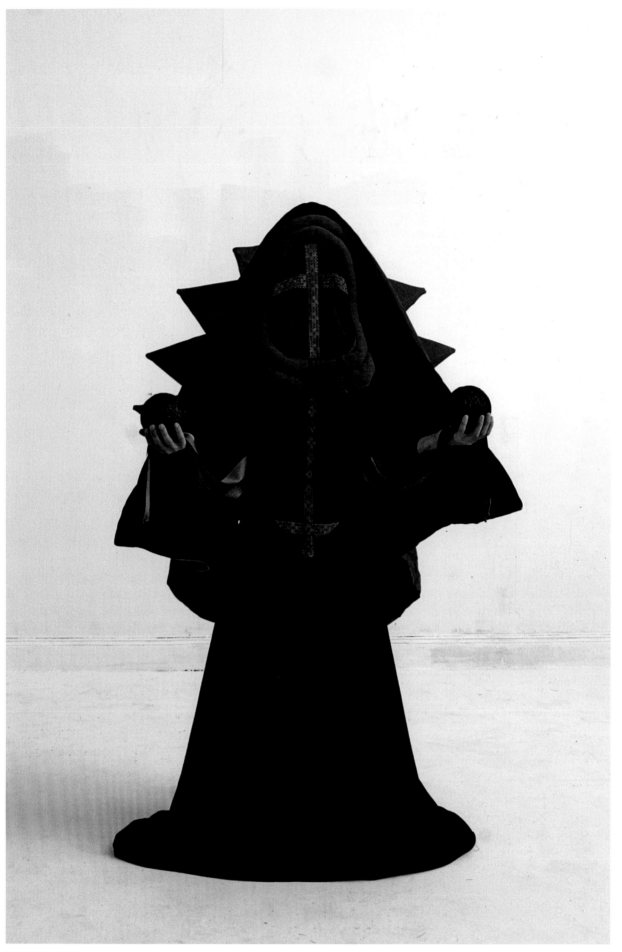

5

5. *The Nun*, 2009. Textile sculpture.
200 × 100 cm (78¾ × 39⅓ in) approx.

Guillermo Caivano 1977, Spain, www.ibidprojects.com

How does narrative emerge in your paintings?
To acknowledge the fact that the age of grand
narratives is gone for good should be the start-
ing point of any attempt to 'tell a story'.
Narrative has an aspect of artifice – it is a con-
struction from previous narrative ruins. I try
to use the images as hints of an untold story.
I use a cinematographic approach to allow the
viewer to construct a narrative out of a series
of stills, like a script or a photo novel. I am per-
sonally inclined to collect and obsessively hunt
for images that belong to the realm of belief –
be they ideological, religious or political.

*There is something intentionally unclear about
your work, a sense of mystery. Why?*
If I had to rationalize it I can only allude to the
fact that my images are always translations
of media-based documents (old lies). They are
borne out of a distance and edited, cropping,
zooming or deleting in order to make them
paintings. If painting is a matter of light, it
should be the light of things half remembered,
the veiled light of dreams.

*Does the heritage of Spanish painting
influence you?*
There are indeed some Spanish traits that I
think I have: a certain taste for mysticism; a
soberness and Goya-esque interest in witches,
disasters and corpses, as well as a Buñuel-like
dark sense of humour.

*What do you like about using such a dark
palette?*
The tonal spectrum I use depends on the sub-
ject I am depicting, but I do tend to use earthy
tones. A pessimist is an informed optimist, so
when I am working with tragic themes (like
torture and abduction in Argentina during
the 1970s) I naturally use a darker palette.

*What do you find interesting about the medium
of collage?*
Its spontaneity and playfulness. It's deeply
uncanny to create those series of hallucinatory
images. I see them as monsters that become
a strange breed of theatre sets and models for
sculptures. They are done on black leather, a
material that is in itself contradictory by being
distantly glossy like a screen yet also a skin.

*How did your degree in History of Art affect
your approach?*
The historical migration of symbols and
the diversity of artefacts have helped me in
my practice. The most banal of objects can
be, in my view, extremely revealing. Nothing
specific stays because I have the memory
of an epileptic snail.

1

2

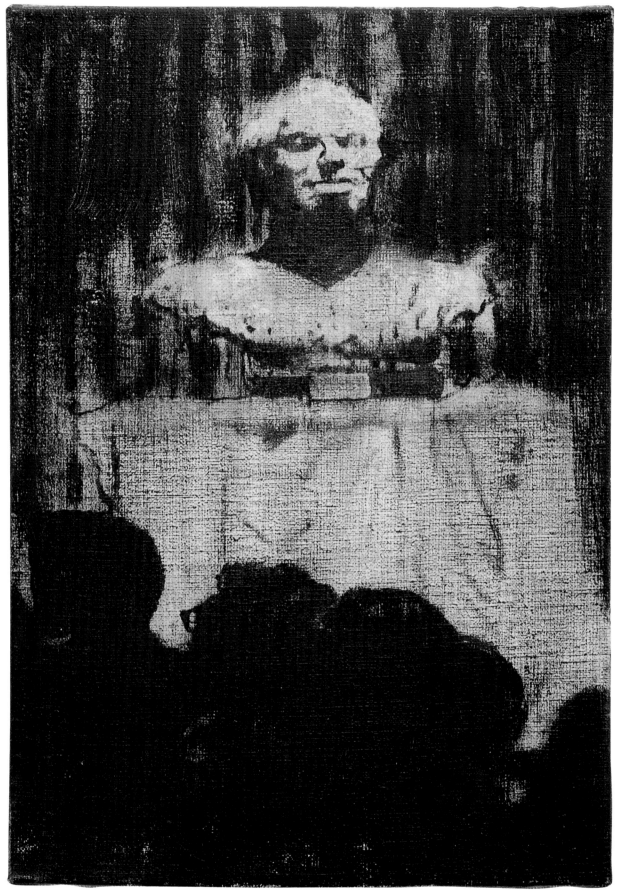

3

1. *The Errants*, 2008. Oil on canvas.
30 × 24 cm (11¾ × 9½ in).

2. *Ardent*, 2008. Oil on hessian.
44 × 34 cm (17⅜ × 13⅜ in).

3. *The interlocking of people's
needs*, 2008. Oil and mixed
media on canvas. 35 × 25 cm
(13¾ × 9⅞ in).

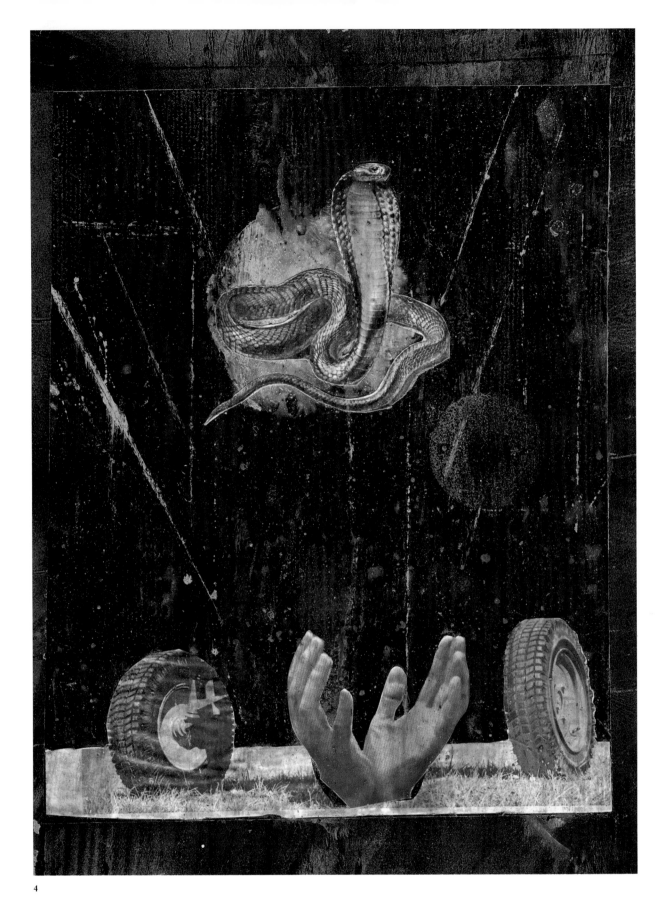

4

4. *The Muddy Consistency of Duration*, 2008. Collage and paint on leather. 28.5 × 22 cm (11¼ × 8⅝ in).

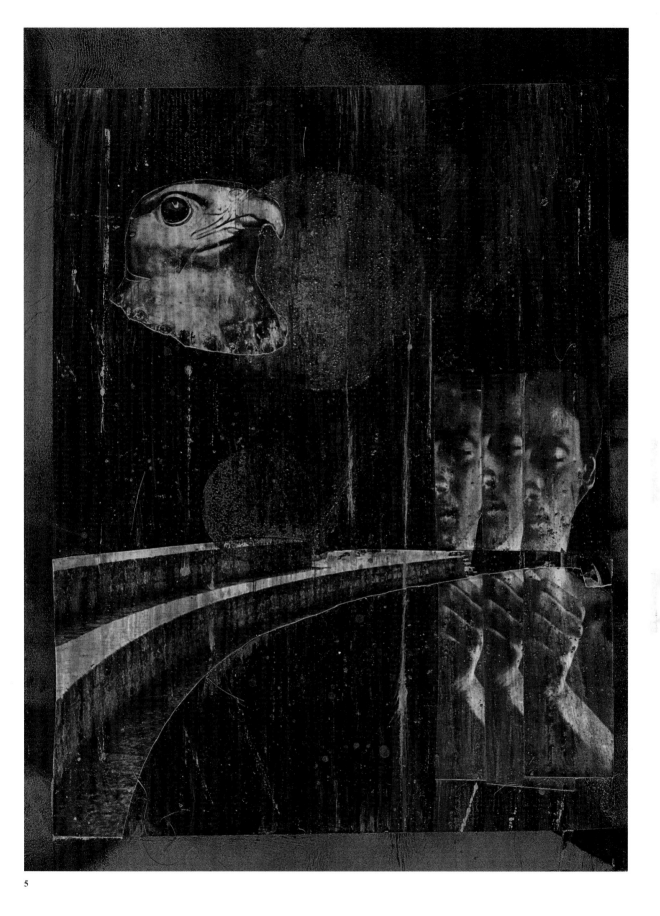

5. *The Solstices of Character*, 2008.
Collage and paint on leather.
28.5 × 22 cm (11¼ × 8⅝ in).

Jacobo Castellano 1976, Spain, www.fucares.com

What is it that attracts you in the relationship between physical structures and the emotional?
There is in my work a direct and indissoluble relationship. Most of my works narrate experiences I have lived, or refer to cultural or religious aspects of my native land, Andalusía. Here, religious devotion is very strong, and death and joy are lived in a very visceral way. The search for my own identity has also led me to explore the domestic spaces in which I used to live and narrate episodes that have to do with destruction or identity. The point is to re-elaborate reality using our capacity for recollection.

What interests you about architectural structures?
They are not peaceful structures. They are usually precarious, supported by ropes or slightly leaning on a wall. Everything seems to be on the verge of collapse. Their sheltering quality looks dubious. They pose a threat to anyone who approaches them. That precarious balance generates a disquieting feeling rather than calmness. This makes them unpleasant.

Tell me about your piece Desastre.
It consists of a white cardboard cabin with four windows, surrounded by a multitude of objects, photos, collages and drawings that refer to violent episodes. For instance, there is a collection of belts that Spanish military men used in different war exercises that I have turned into shackles. I found in the street some drawings by children that refer to their imaginings about war, which are really blood-curdling. All these are chaotically placed around the cardboard house, which seems to be falling to pieces under the very weight of all the things. The peace and quiet of the house dweller seems to be coming to an end. Everything conveys a worrying fragility. Disaster comes through our TV sets at home every day. The point is to disturb and to question the calmness and passivity with which we face war in the world.

Is narrative something important to you?
In baroque reredos (altar screens), a multitude of images are placed in determined places. Each is a separate, autonomous scene, but as a whole they tell us something much more complex. The process I use is similar. I have autonomous elements that, when placed beside each other, generate another, more complex reality. It is an ordered chaos.

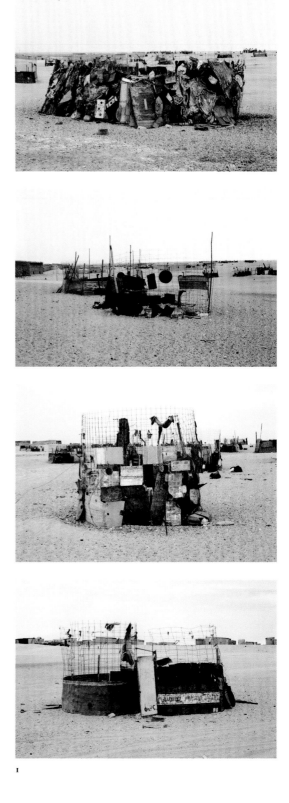

1

1. *Serie Corales*, 2004. Colour photographs. Each 55 × 75 cm (21⅝ × 29½ in).

2. *Desastre*, 2006. Wood, cardboard, paper, metal, blanket, leather, mirror, thread, wire, drawings, photographs and windows. 550 × 800 × 650 cm (216½ × 315 × 255⅞ in).

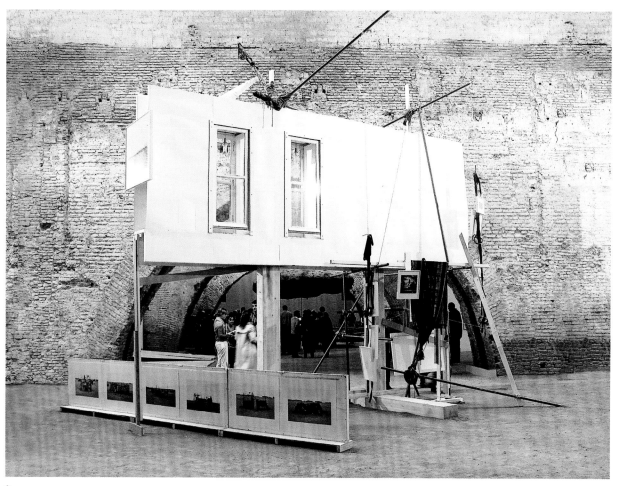

2

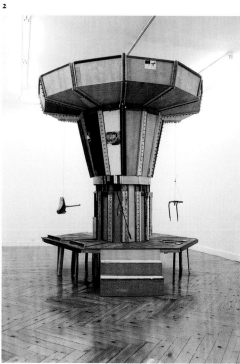

3

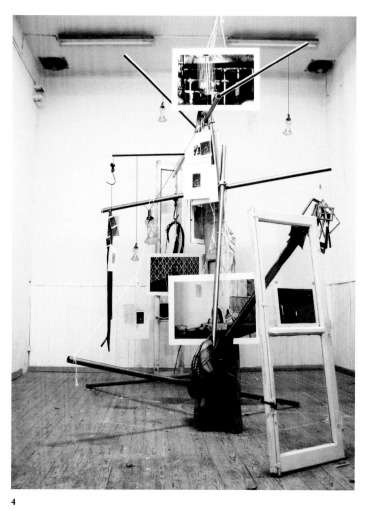

3. *Casa*, 2004/2005. Wood, iron and photographs. 274 × 281 × 341 cm (107⅞ × 110⅝ × 134¼ in).

4. *Casa I*, 2005/2006. Wood, metal, blanket, leather, thread, rope, wire, photographs and windows. 450 × 290 × 400 cm (177⅛ × 114⅛ × 157½ in).

4

Marcos Castro 1981, Mexico, www.luisadelantadomexico.com

How do you use narrative in your work?
It all starts from the creation of my own
mythology, which comes from my own experi-
ences and connection to nature. I am also
influenced by my cultural context and the
importance of rituals. Besides my personal
mythologies, all animals in the wild already
have their own universal roles, archetypes
and symbology. Everything is part of the
whole, every animal, landscape or natural
phenomenon.

What interests you about the idea of fragments?
All my work seems to be a story that is
never fully completed. It has no end and no
beginning. It is a story that keeps evolving.
Therefore every painting looks like a frag-
ment, as they are episodes within the
same world.

*Do animals have a symbolic meaning in your
work?*
I have a strong connection with nature and
animals. They somehow embody different
experiences, people and my interaction with
the world.

*What in particular do you like about the
contrast between nature and beauty, with
violence and blood?*
There is no contrast. Nature is all those things
together. It is beauty, violence and blood.
It is human sentimentalism that wants to see
human nature and conscience where there
are none. Violence is read as violence through
human eyes and intentions. Nature itself
is violent.

*What interests you in particular about the
medium of drawing?*
Drawing has been a human necessity since
the age of cave paintings. There are an ances-
tral connection and romanticism in the
medium. Paper, charcoal and pigments have
been used for hundreds of years. There is
something organic about drawing, which
makes you feel like part of the process. There
is a bridge from your mind to your arms
to the materials that enables you to create
something bigger than yourself. It is a way
of searching for the sublime.

*How does your own experience influence the
stories in your work?*
My own experiences are sometimes reflected
in the tone, atmosphere and mood of each
painting. My connection with nature and
interaction with landscape intermingle with
emotions, according to whatever is happening
within myself. The experience of a storm or
a sunset could be immense.

What are your animation pieces like?
They are all loops as they represent cycles of
creation and destruction, and they are in the
end drawings – drawings used in a different
way to complement the work.

1

1. *La oscuridad de la luz*, 2009.
Ink on paper. 120 × 70 cm
(47¼ × 27½ in).

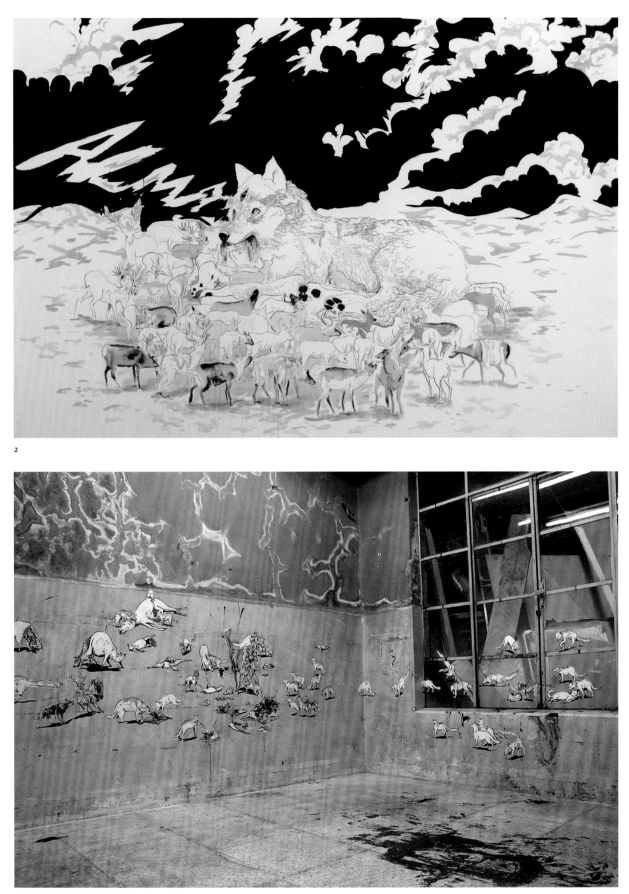

2

3

2. *A las barricadas!*, 2008.
Ink on paper. 70 × 120 cm
(27½ × 47¼ in).

3. *Familia*, 2006. Acrylic on wall.
250 × 900 cm (98⅖ × 354⅓ in).

4

4. *Bhagavat*, 2008. Acrylic on
canvas. 180 × 120 cm (71 × 47¼ in).

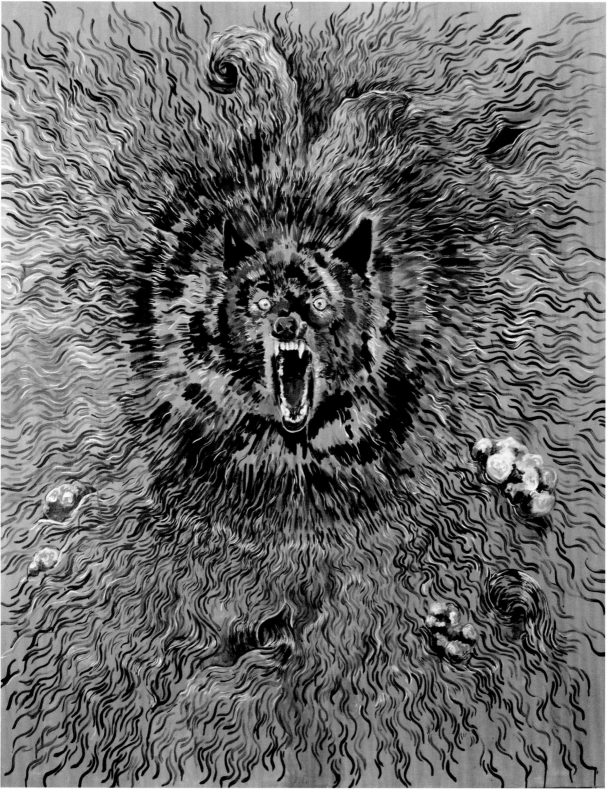

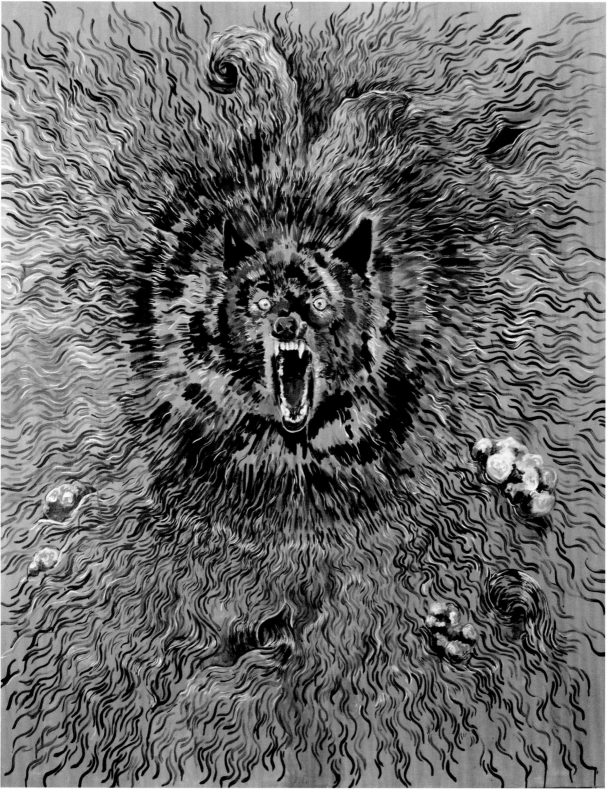

5

5. *El grito*, 2008. Acrylic on canvas.
180 × 120 cm (71 × 47¼ in).

Ajit Chauhan 1981, USA, www.jackhanley.com

How and why did you start making 'erased' images?
The impetus was to re-contextualize landscape imagery, say from classical records into faces. Rather than making an abstract into a face, I started with a face and moved back. I associate erasing with modesty. Maybe diffidence is a better word – 'hesitance in acting or speaking'. I see removing imagery as a lack of assertion, a reserved type of highlighting, a mild nihilistic cadence. I appreciate gestures that are quiet and can be missed. A group of people hacked into the parking meters of the city of San Francisco so they all read '$999.99' – the equivalent of infinity, or unlimited free parking. This seems like a very poignant and direct piece.

Do ideas around identity influence your work?
It interests me that a lip or a mole can distinguish one person from another. A mole or a gap in someone's teeth can contain an entire character. By erasing these iconic features and rendering someone anonymous, an icon becomes nothing.

What do you find interesting about record covers and music?
Pragmatically, how the cardboard holds up; how its thickness can retain a smooth finish after being worked over, unlike thinner formats like newspaper, which ripples or forms undulations. Also its uniformity; the size is consistent. Consistency can be forgiving. Record covers, apart from being infused with music or the author, are an enormous treasure trove of visual junk. The range of images to work with is wide. They're a marketing tool and a form of expression. It's fun to try to undermine that.

Tell me about your rickshaw drawings.
The drawings were a result of visual stimuli (bombardment is a better word) while riding them. Riding a rickshaw is like riding a pregnant animal. The animal is electric. It is pregnant with electricity. The drawings were an outgrowth rather than premeditated. I think of the drawings as something closer to a text. Psychedelic cannibalism and a hodgepodge fever dream.

How do your Pseudoscope *sculptures work?*
The *Pseudoscope*s are a grouping of mirrors that transfer your left eye information into your right eye, and your right eye information into your left. This creates illusions such as movement in static objects. Convex becomes concave. Things pointing towards you may look like they are pointing away. It subverts or undermines the existing state of things.

1

1. *Tago*, 2002. Pencil, ink and gouache. 20.6 × 13.9 cm (8⅛ × 5½ in).

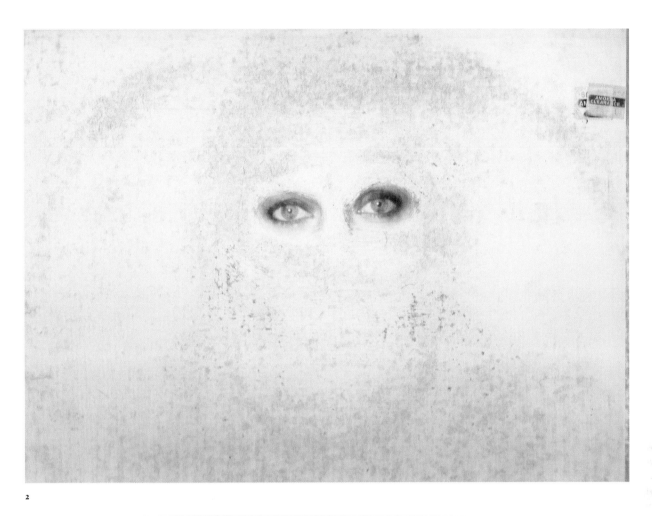

2

3

2. *I've Never Been To Me*, 2008.
Altered album cover.
30.4 × 30.4 cm (12 × 12 in).

3. *ReRecord*, 2009. 162 erased
album covers. 279.4 × 560 cm
(110 × 220½ in).

Paolo Chiasera 1978, Italy, www.paolochiasera.org, www.francescaminini.it

How do you look at the cinematic and film in your work?

I don't see myself as a cinematographer; I'm more of a painter, because in the end the image is always the most important result I'm searching for. I used video and film to show the process of creation. I use the media like a mirror of my cognitive experience. I try to build a shape that reflects the processes of meanings in contemporary culture. The process of signification is played out on different levels, such as construction, deconstruction and reconstruction. My work presents itself to viewers as a fragment, an erosion of my cognitive process.

What do you think about the heroic and how does that manifest itself in your work?

I don't relate my work to the figure of the hero. I'm mostly fascinated by the emblematic dimension that has been created by certain personalities. The focus is not on celebrating someone, just his or her ideas. By using icons, I can reach viewers directly.

Does youth culture influence what you create?

With art, we need to have a relationship based on trust, because we can never grasp the totality of just one project. Our approach to culture is always something critical, as is our relationship with the present, past and future. Georges Didi-Huberman noted that images often have a better memory and more of a future than the viewer does.

How does your work play with the idea of history?

It's like surfing between different eras. Google 'history of art' and you have the sensation that knowledge is something based on a horizontal line – Paolo Uccello has the same platform as the most recent artist. We lose the idea of time and the idea of the original. History is a starting point to create a process of deconstruction and construction of a shape. I'm interested in the possibility of investigating the aesthetic practices to reach a shape, canvas or sculpture.

You have burnt structures in a number of your works. Why?

When I was little in Bologna, every New Year's Eve a big scarecrow was burned in the central square of the city. I never took part in this ritual, but I've always dreamed about it. Burning something is a good technique to compress material, creating in the viewer the emotion of the disaster.

1

1. *Archivio Zarathustra*, 2009. Black-and-white photographs. 32 × 24 cm (12⅗ × 9½ in).

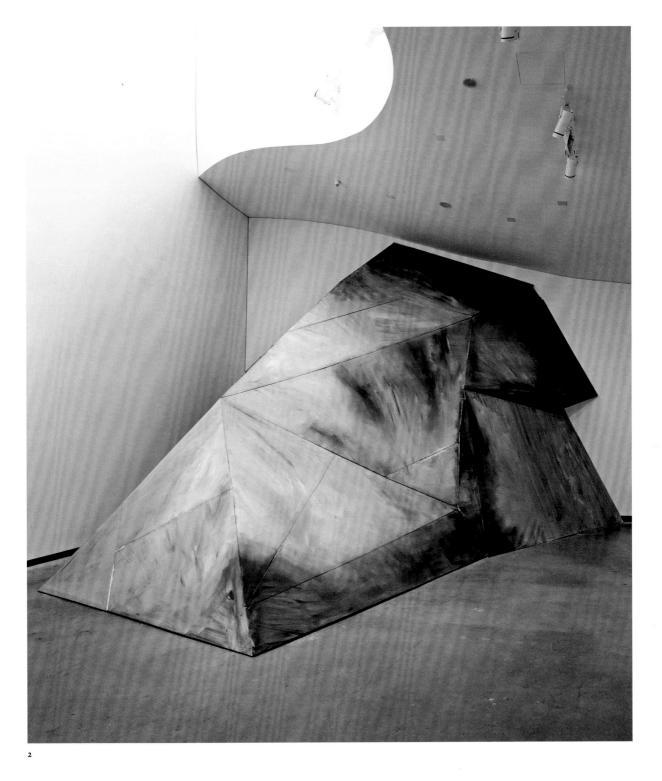

2

2. *Unter Freiem Himmel berg*,
2009. Wood and oil on canvas.
Dimensions variable.

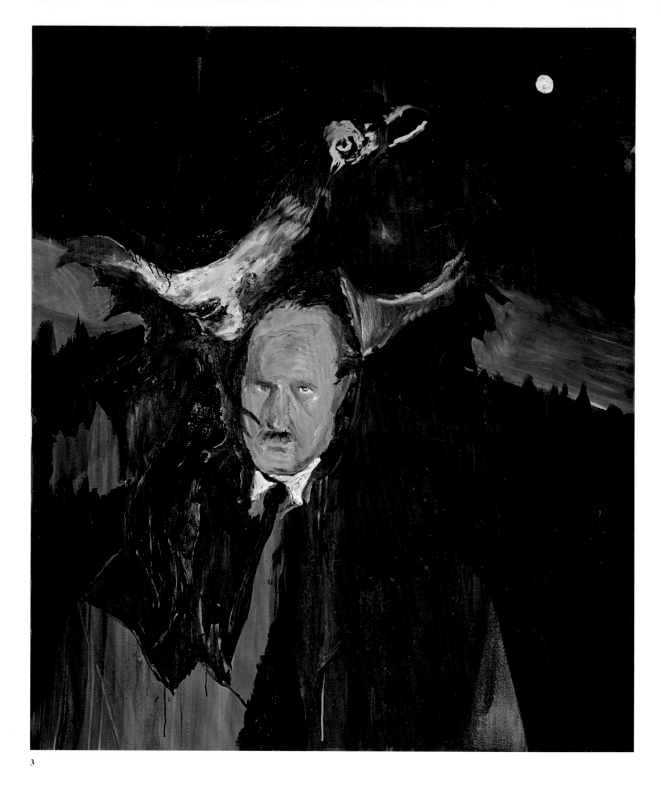

3

3, 4. *Black Gash 1*, 2009. Two panels
from a triptych, oil on canvas. Each
140 × 120 cm (55 × 47¼ in).

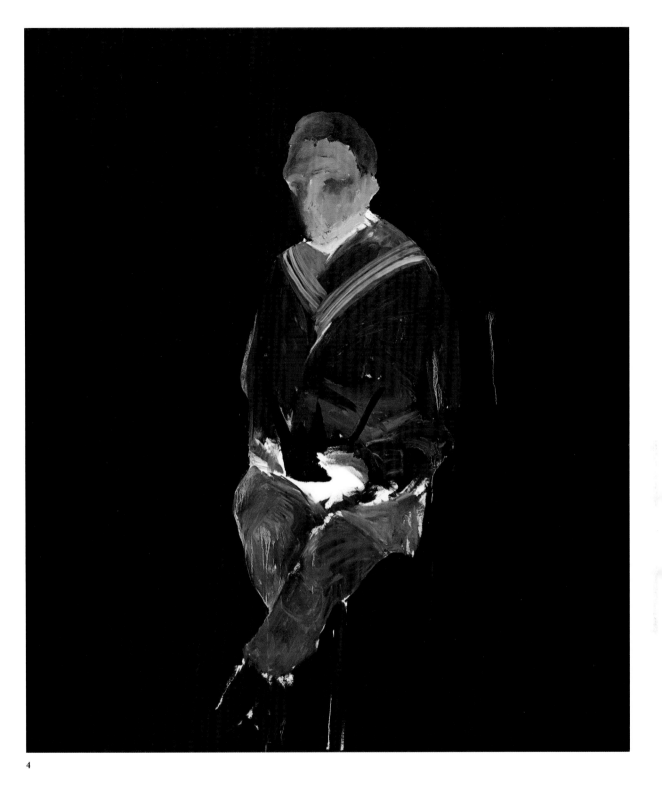

4

Louie Cordero

1978, Philippines, www.jonathanlevinegallery.com, www.osagegallery.com

What attracts you to blood and the grotesque?
I have been attracted to them since I was young, maybe because of my surroundings. In Manila I was saturated with bloody Christian imagery and too many Filipino B-movies, pulp horror Betamax tapes and weird Japanese TV show reruns. I was brought up in the strict Catholic tradition with lots of martyred saints. What people may call grotesque imagery and stories are normal for me. Sometimes it's funny how over-the-top and really kitsch it is.

Why display your paintings as crushing sculptural figures?
I was fascinated in art school by Paul Delaroche's declaration, 'From today, painting is dead', which keeps getting recycled. What if a painter is killed by painting? I am interested in the weird juxtapositions of different subcultures – such as the mixing of Jeepney folk art and Western heavy metal iconography.

What does the recurring image of a schoolchild with a face torn away mean to you?
It's one of those images that haunts me and needs to be released. The image is referenced from a photograph of myself at the age of six. I wanted to achieve the quality of St Dominic, the patron saint of schoolboys.

What do you like about the gloss and shine of your painted sculptures?
I want them to look really fake, like cheap yard-sale vases or the chrome steel enamel-painted Jeepneys that we have here. Jeepneys are our audacious, candy-coloured, high-gloss 'national' transport for the masses.

How do you integrate the conceptual with the pop comic in your work?
In college, I was trained in conceptual art. It was deeply rooted in my art school culture, but I can't leave behind painting and drawing, which I've done as far back as I can remember. Maybe that's the integration.

Tell me about your publication Nardong Tae?
Nardong Tae is a comic that I started in Manila around 2003 – a DIY Xerox publication. It was only released up to volume four. I haven't finished it yet. It's a sci-fi melodrama about a Filipino native boy who turned into a shit (literally) with superpowers combating all sorts of foes, from annoying neighbours, policemen and government officials to shit aliens. It's a me-against-the-world story that will make you cry.

1

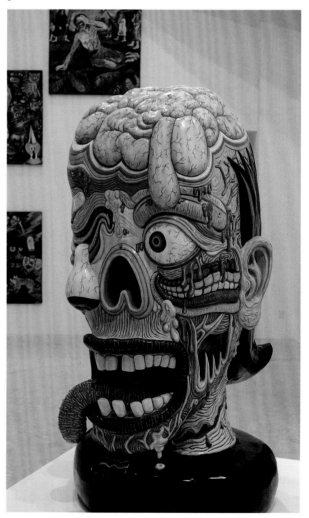

2

1. *Omnibus (soft death drawings)*, 2009. Ballpoint pen on paper. 35.5 × 43.1 cm (14 × 17 in).

2. *Having reached a climax at the age of 28...i'm a zombie*, 2006. Acrylic on cement. 182.8 × 106.6 cm (72 × 42 in).

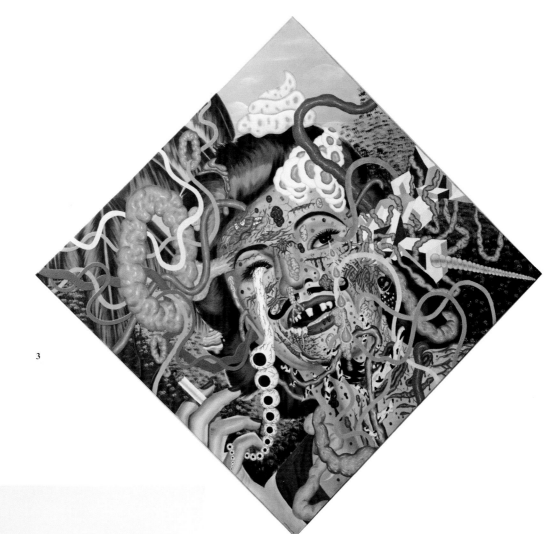

3

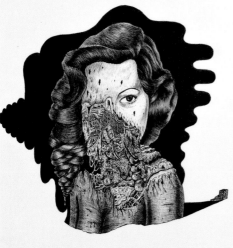

4

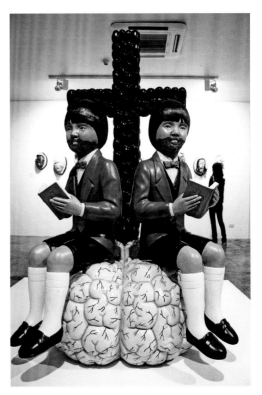

3. *Cactus temptress*, 2009. Acrylic
on canvas. 152.4 × 152.4 cm
(60 × 60 in).

4. *Mountain Delta* (*soft death
drawings*), 2009. Ballpoint pen on
paper. 43.1 × 35.5 cm (17 × 14 in).

5. The Lead Brothers, 2008. Acrylic
on fibreglass. 147.3 × 91.4 × 91.4 cm
(58 × 36 × 36 in).

Eli Cortiñas 1976, Spain, www.galerie-wiesehoefer.de, www.galeriewaldburger.com

How does your work differ from the cinematic?
I try to break the narrative and the expectations towards common film reception by composing mostly multi-channel videos that are projected on more than just one screen at a time. I'm keen on building up a time and space construction that is fundamentally different from the cinema experience, that usually provides a single mode of reception for the viewer – the linear one. The size of the screen projection, the technical devices that might appear within the installation – sometimes even clearly building a sculpture, all reveal the 'creation' of the illusion of 'film' by showing its materiality. Most of my works are loops, which means they have no beginning and no end. The possibility of getting in and out at any time is essential to me.

What draws you to female protagonists?
I'm interested in the definition of the female within certain constructions like family hierarchy, culture and society and even the art world. I'm also very interested in the idea of masculinity and the way it's meant to appeal to women. I'm interested in human characters and rules of behaviour in general.

What attracts you to melodrama?
I believe there is a certain amount of melodrama in everybody's life. I mainly work with found footage, but I also use autobiographical material that is already highly emotional and dramatic. I try to prolong and intensify these dramatic moments to bring the viewer to an uncertain, and sometimes uncomfortable, place.

What do you like about reworking narrative films?
I like the challenge of finding something else in every single shot or the idea of using what is already there but translating it into a completely new context. It is a simple tool that can have an extreme effect on the semantics of a scene, as well as slowing down the velocity of that scene. To extend the length of a clip by simply repeating the exact same image has an enormous effect on its impact. It's not just about using effects or getting seduced by the arbitrary repetition of beautiful images. It's about seeing between them, analyzing them closely and finding out what other choices they might offer. The same process happens while handling the sound and the music, which I largely cut and arrange to make new compositions.

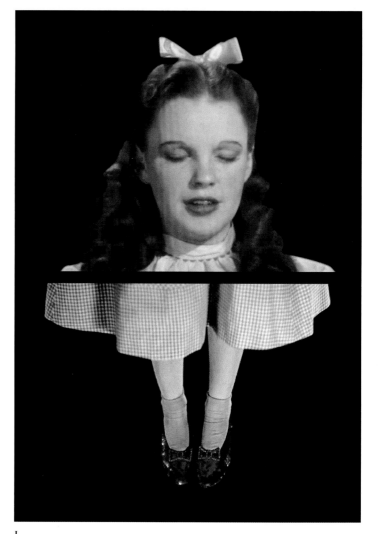

1

2. *Bird, Cherry, Lover*, 2010.
Video still from 2-channel video.

1. *No Place Like Home*, 2006. Video
still of 2-channel video, 3 mins. loop.

3. *FIN*, 2009. Video still from
1-channel video, 4 mins. loop.

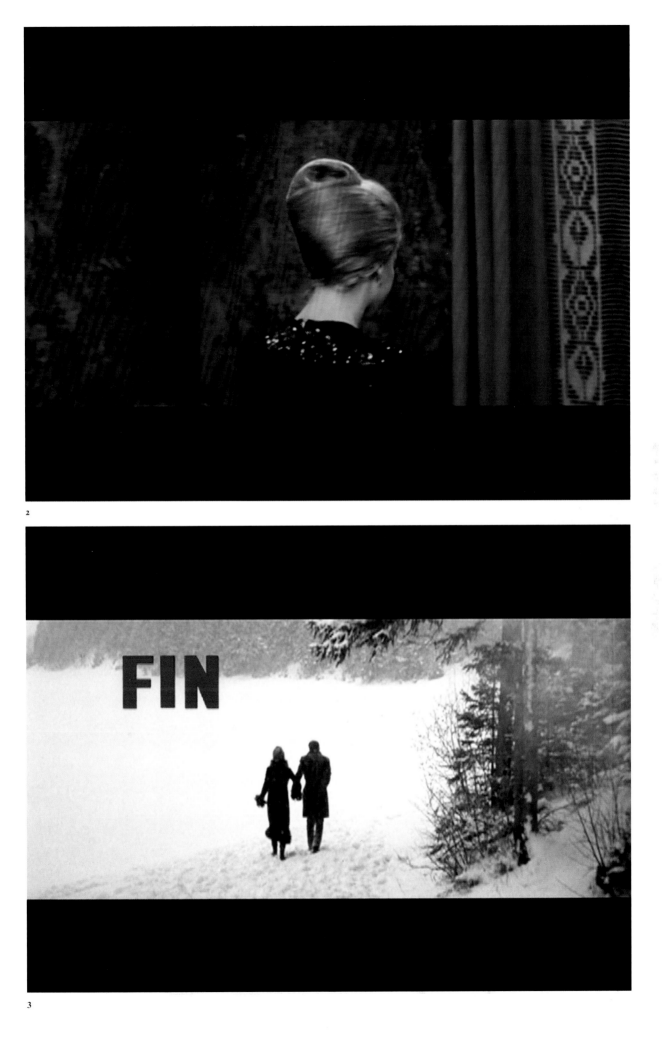

2

3

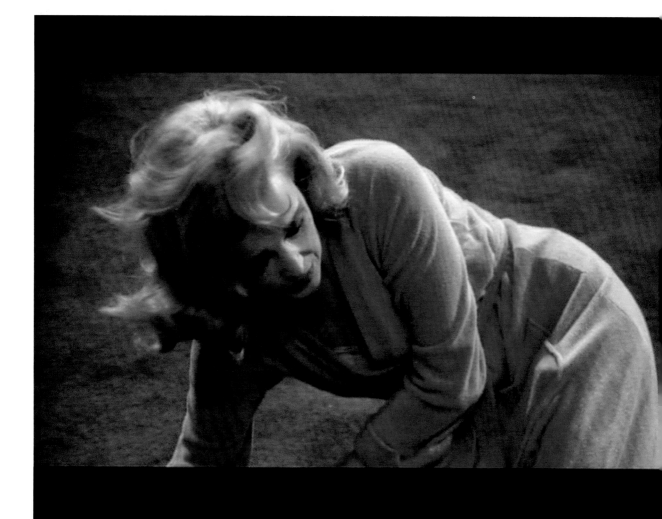

4

4. *Dial M for Mother*, 2009.
Video still of 2-channel video,
11 mins./ loop.

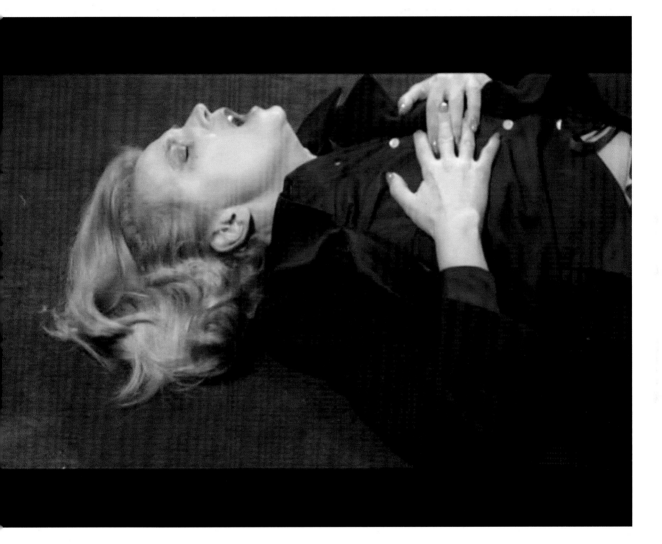

Rosson Crow 1982, USA, www.whitecube.com, www.honorfraser.com

*What draws you towards historical subjects
or spaces?*

I'm very interested in the idea of history, and
how it is misremembered and misconstrued.
I'm intrigued by nostalgia and how historical
places and events affect our psyche.

*What in particular interests you about
America's history?*

We are a nation that has known few historical
moments, but countless historical myths; a
nation nostalgic for a past. America's complex
relationship with myth has created a nation
seduced by special effects and scripted spaces
distorting the real into artificial, and vice
versa. We are consistently surrounded by
lavish, immersive fakery and ornate claptrap,
staged distractions and shrines to pleasure.
America is all about cheap utopias, pleasure
and the grotesque.

*What attracts you to painting on such a
large scale?*

I think it is linked to both the performative
aspect of the work, as well as my desire for the
paintings to adequately convey the spaces I'm
creating. They are grand spaces of spectacle
and decadence that function best as envelop-
ing environments. They are backdrops for
staged desires, the spectacle of spatial over-
abundance, the delirium of excess, the power,
the violence, the mindless indulgence.

*Why do you depict spaces that are abandoned
– when the party is over?*

I like the moment of frailty in the theatrical;
the moment the truth is both obscured and
brought to life; the sobering morning after an
orgy of myopic indulgence. Ours is a culture
built on indulgence, with little heed to tomor-
row, and I like playing with the fine line
between the celebration and the reality.

Why use bright, bloody colours?

I've always been drawn to the flashy and the
gaudy – the Las Vegas neon. I've never been
one for subtlety. I want the paintings to feel
aggressive and obscene, I don't want them
to sit back and play nice.

*What do you find interesting about interior
spaces?*

An interior can be a private world or a grand
stage. It can be intimate and cosy, or it can
threaten the *unheimlich* and uncanny. I'm
interested in the duality of these spaces and
how they function.

Why do you choose not to paint figures?

I've always been primarily interested in the
power of spaces and how they can make you
feel – overwhelmed, melancholy, anxious,
romantic, hopeful. The paintings are so large
that they really become theatrical backdrops
that the viewer can enter and experience and
in a sense become the figures in the work.

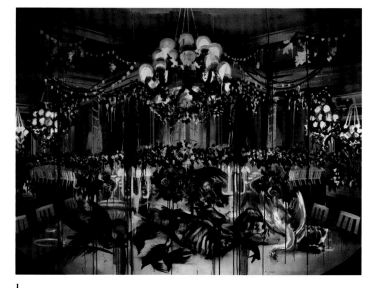

1

1. *Poverty Partye at the White House,*
2008. Oil and acrylic on canvas.
274.3 × 426.7 cm (108 × 168 in).

2. *I just can't stop loving you,* 2009.
Oil, acrylic and enamel on canvas.
213.3 × 289.5 cm (84 × 114 in).

4. *Five Minutes Late and Two Bucks
Short at the Cha Cha,* 2007. Acrylic,
enamel, spray paint and oil paint
on canvas. 228.6 × 335.2 cm
(90 × 132 in).

3. *Live in the Black Pussy,* 2007.
Oil, enamel, spray paint and
acrylic on canvas.
101.6 × 152.4 cm (48 × 60 in).

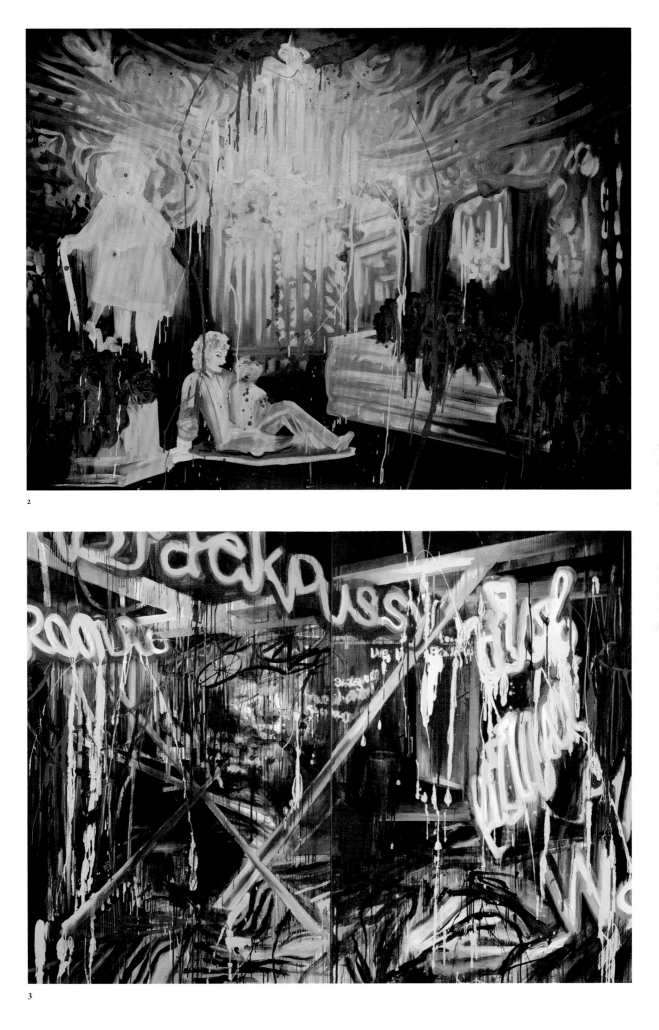

2

3

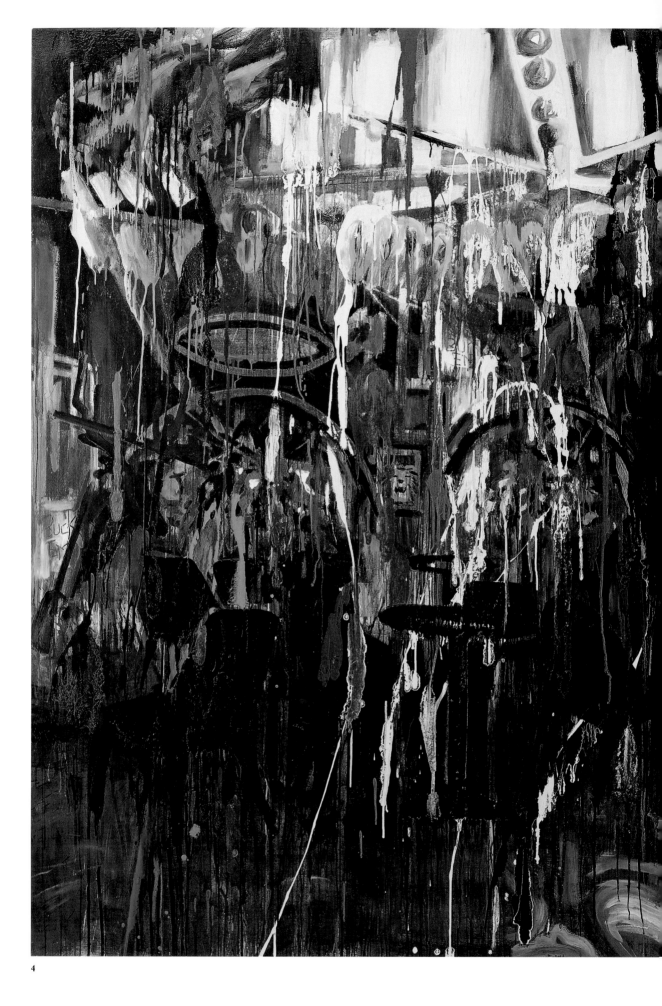

4

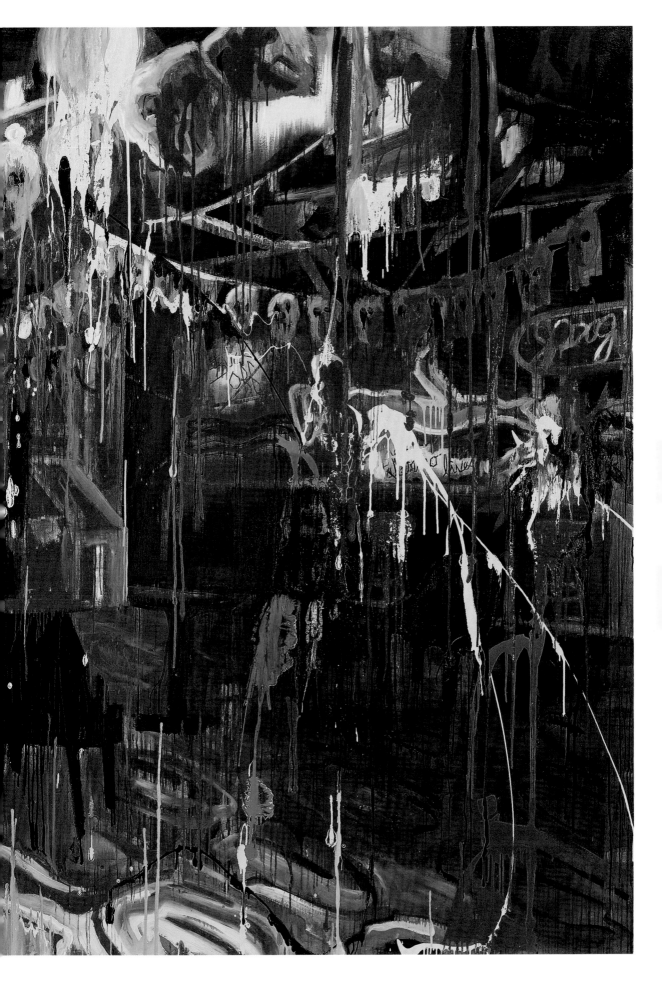

Regina de Miguel 1977, Spain, www.maisterravalbuena.com

*What attracts you to architectural models
and structures?*

My interest is in how spatial representation is
defined as a cultural form that mirrors a con-
temporary socio-political organization. In this
sense, my work has departed from plans and
architectural models, to an idea of rupture and
nomadism. I am interested in how space is
loaded by a vague familiarity, structured in the
attempt to conceal mechanisms of emotional
control. The interior spaces that I represent
are a product of this estrangement and alien-
ation, of the emptying of memories and crisis.

*How did you start incorporating video into your
sculptural models and why?*

This was a decision drawn from the formal
conception of the project *The air not yet
breathed*, as an installation device. I am inter-
ested in the light being the only source illumi-
nating the models, so they are observed in a
state of suspension produced exclusively by
the projection of the video.

What interests you about interior space?

My work can be understood as an assembly
of different pieces or a network of ideas. I am
interested in constructions or representations
that refer to the real and possess an illustrative
quality. I am interested in unveiling the mecha-
nisms that construct the images I produce.
I aim to make evident the artificial side of all
cultural constructs.

*What do you think about the relationship
between the emotional and physical spaces?*

The virtual animations depict neglected
spaces, uninhabited and in ruins. The images
of these spaces are found on websites and
online forums dedicated to urban exploration.
These online sites document and give them
visibility. The images are virtually recon-
structed using 3D animation software. The
work is a reflection of the status of the image
and how Internet sources generate new rules
that govern the collective imagination, chang-
ing notions of the archive and modes of
storing and distributing information.

*What do you find interesting about manipulat-
ing the way the viewer looks at your work?*

In my practice there is a desire to articulate
a constant mapping. The ideological content
is substituted for other content derived from
the everyday sphere. This results in an index
of experiences that attempt to give light to
the multiplicity of relationships and variables
that orientate a contemporary individual.

1

1, 2, 3. *The air not yet breathed*, 2008.
3D animation projected into a
wooden model. 130 × 70 × 40 cm
(51⅛ × 27½ × 15¾ in).

2

3

Gardar Eide Einarsson 1976, Norway, www.teamgal.com

Why are you drawn to monochrome?
All my work is based on found imagery and
reducing the image to monochrome, to a
graphic outline. It is intended to underline
that the image refers to another image,
making it a prop, a copy or a stand-in, a
shadow of that image. There are also certain
aesthetic references in this use of a reduced
palette, evocations of 1960s conceptualism,
for example, as well as a suggestion of fanzines
and photocopied DIY fliers.

Does the political inform what you do?
The work does operate with images and refer-
ences that suggest a sense of crisis, or at least
of conflict. In that way it definitely takes its
subject matter from a political field, a field
where different groups vie for power and
control (even if only over themselves). I also
think that all aesthetics are, to an extent,
political and express certain convictions.

*Does your work explore the power or impotence
of graphics?*
Graphics somehow exist as this lesser science
to the big 'art'. They are a vernacular that
exists in the service of something else (usually
selling a product) but draws heavily on 'fine'
art. That is why I take graphics that cannibal-
ize art back into art.

Are you questioning the idea of rebellion?
I certainly have been interested in the possibil-
ities and problems of rebellion and how rebel-
lion, especially within a field as tolerant as that
of contemporary art, is pretty close to impossi-
ble. I also want to question what drives and
motivates rebellious expression and to what
extent it is driven by a real urge for change.

Are you interested in ideas about masculinity?
There is definitely a critique of masculinity.
Not a negative dismissal but an exploration.
Much of the source imagery I work with
does come from male-dominated milieux
and I attempt to work with the vocabulary
of masculinity.

*What interests you about crime and prison
references in your art?*
I am interested in the language that is used
to establish identity and create a sense of be-
longing and a distance from the rest of society.
Historically, criminals around the world
have used sets of hermetic signs to signal
all these things.

Are you drawn to clichéd texts and phrases?
I am definitely drawn to language that em-
ploys cliché – the language of advertising,
the language of pop culture, the language of
totalitarianism and the language of populism.

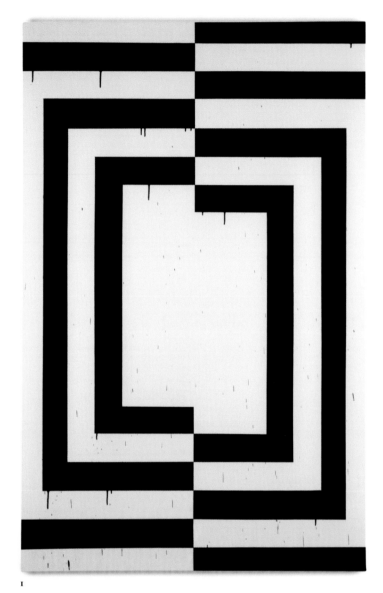

1

1. *Exile*, 2009. Acrylic and pencil
on canvas. 198.1 × 129.5 cm
(78 × 51 in).

2

2. *Untitled* (*Theft*), 2008. Acrylic on
canvas. 213.3 × 185.4 cm (84 × 73 in).

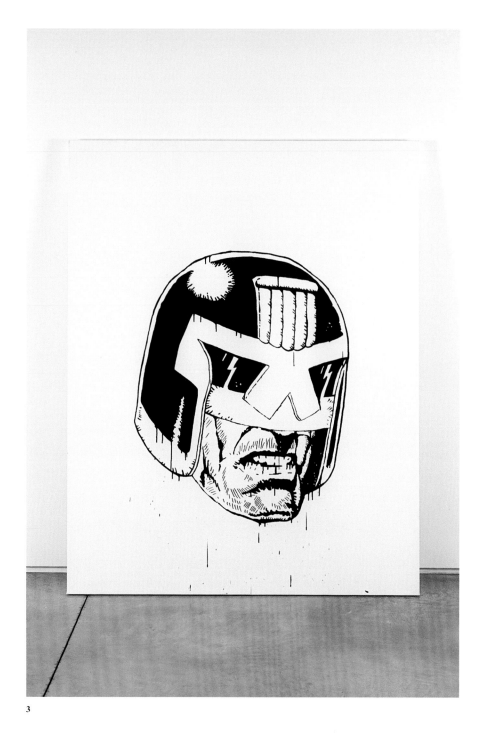

3

4. *...And I'll Give Em Hell,*
2007. Inkjet on wooden panel.
200 × 120 cm (78¾ × 47¼ in).

3. *Head (Dredd)*, 2007. Acrylic and
pencil on canvas. 152.4 × 121.9 cm
(60 × 48 in).

5. *Untitled*, 2007. Inkjet on
plywood panels. Each panel:
199.3 × 119.3 cm (78.5 × 47 in).

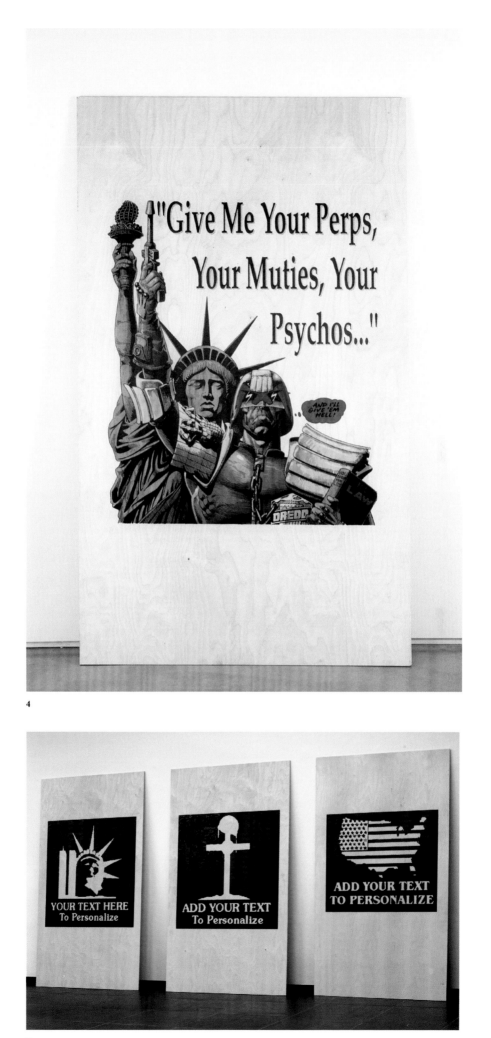

4

5

Lilah Fowler 1981, United Kingdom, www.lilahfowler.com

How do you explore ideas around geometry?
I am interested in how pattern, form and alternating perspectives can question our definition of reality. Illusions that present an alternative vision could indicate other layers of space and time. Using elements of geometric order allows me to engage directly with the viewer's experience of the work. I use basic primary shapes as a foundation, onto which I build simple forms. Layering these shapes allows me to create complex patterns that simulate some kind of parallax effect.

Is science fiction an influence on your work?
I am interested in both physical and psychological responses to form, space and surface. I am somewhat interested in the way that sci-fi tries to imagine future forms and the shapes of new technologies. I think that to create a focus towards the future is important to develop some sort of shared vision, where scenarios can be used to plan and map future occurrences.

What interests you about the idea of the frame or structures?
The way I install my sculptures enables me to layer the space that they establish around them. I see this as a kind of framing, which allows for new perspectives and relationships to evolve among the structural shapes and surfaces. My work invites the viewer to navigate around and among the structures and in doing so they are given fresh compositions and snapshots at different points.

Why do you work with colour-coated steel?
Using contrasting colours on the different faces of the sculptures creates a visual noise that triggers an optical shift. This use of opposing colour creates tension in the otherwise delicate pieces – a static tension, which is then activated when the sculptures are walked around. It enables the viewer to find a new composition, reflection or line of sight from every position. Using steel for this particular piece simply seemed like the most appropriate material to use in order to achieve the desired effect.

What do you find interesting about creating objects that grow out of the walls or ceiling?
I have found myself choreographing a dialogue between the various pieces and the space they inhabit. The way something touches the floor, leans on the wall or the way daylight plays on the surface and creates shadows, all affect the way the work is perceived. I don't wish to over-direct the installations but rather nurture a conversation between them and the architecture they find themselves in.

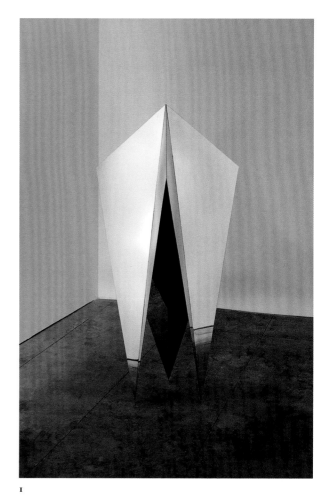

I

1. *Out of form*, 2009. Mirrored stainless steel. 72 × 72 × 140 cm (28⅜ × 28⅜ × 55⅛ in) variable.

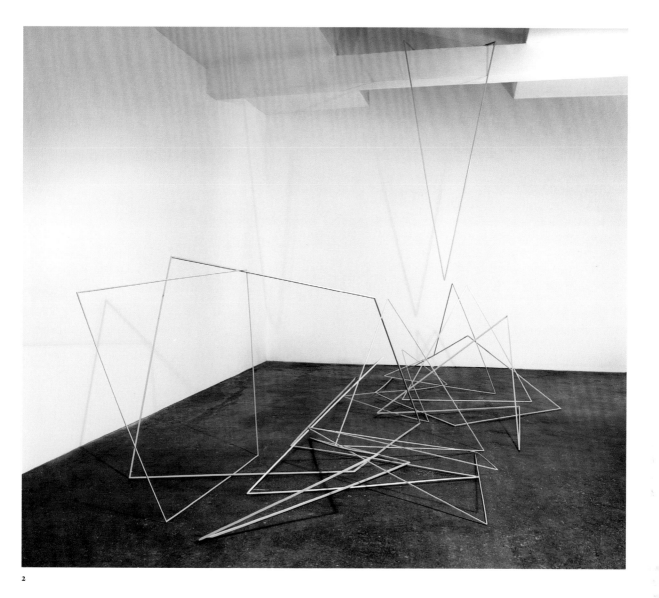

2

2. *Untitled (light pink and turquoise space frame)* with *Untitled (yellow and turquoise space frame)*, 2009. Steel. 600 × 300 × 310 cm (236⅛ × 118⅛ × 122 in) variable.

3

3. Detail of *Untitled (light pink and turquoise space frame)* with *Untitled (yellow and turquoise space frame)*, 2009.

What attracts you to nature?

I like nature because it is alive, beautiful and doesn't lose its liveliness when I take it into my work.

Your work is incredibly detailed. What do you like about precision?

It is not that I especially like detailed work, but I like to work within a size that I can be responsible for. It just becomes very precise as I put down what I think is necessary.

Why did you start working with etchings?

I use etching for most of my works. When I was a sophomore in college I had the chance to learn etching in class, and it was so much fun.

What interests you about pattern and decoration?

I don't pay too much attention to pattern and decoration when I am working. But because my work is in monochrome, I do consider them very important if used properly because they expand the depth of my work.

How are you influenced by Japanese art history?

I would say that I'm very influenced by Japanese art history. It is hard to say how but among all artworks I've seen so far, I would say that Japanese paintings touched me the most.

Why do you add a level of the fantastical or imaginary into your work, for example, playing with the size of animals, or depicting flying pigs and mythical animals?

To put it simply, it's just because I like them. The books I read when I am working on an etching influence me and give me ideas about these animals. I find the owl's silhouette very interesting. I like birds with faces that resemble people.

What do you like about creating on such an intimate scale?

I prefer working with a size that I can handle well.

Does femininity influence your work?

Not that I'm aware of, but femininity does attract me so it may have informed my work unconsciously.

What do you like about the density of imagery within your pieces?

I like the density because then you have a lot of things to look at without get bored too quickly.

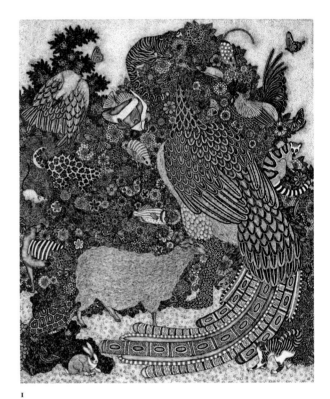

1

1. *Untitled (26)*, 2009. Etching (Ed.30/AP.3). 16.7 × 14 cm (6½ × 5½ in).

2. *Untitled (27)*, 2009. Etching (Ed.30/AP.3). 29.5 × 18.3 cm (11⅝ × 7⅕ in).

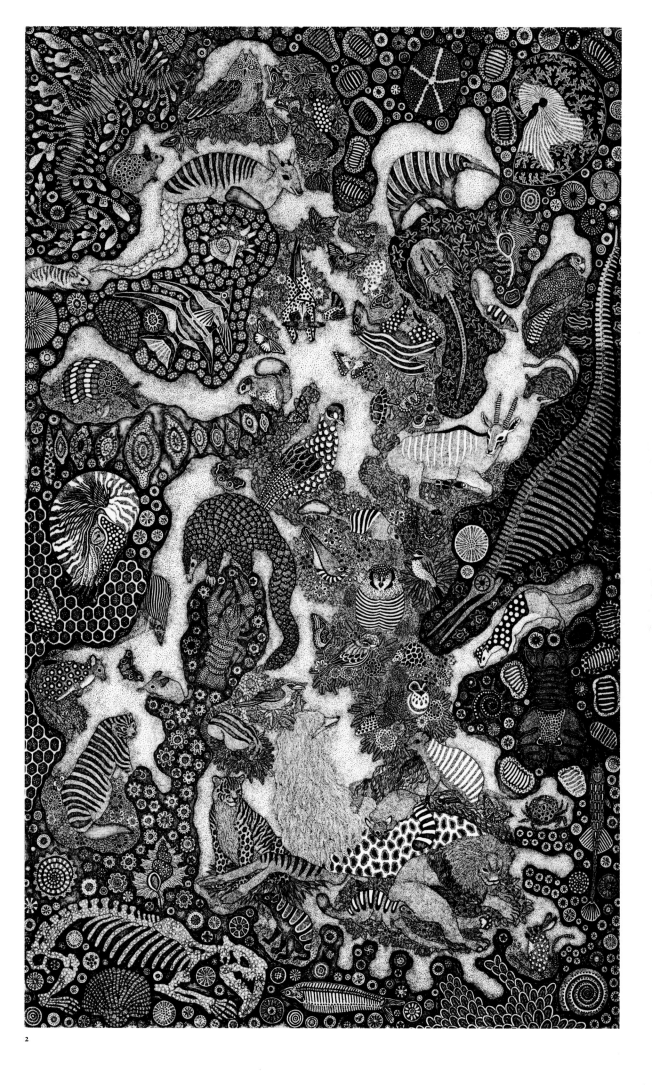

Nuria Fuster

1978, Spain, www.nuriafuster.com, www.galeriamartacervera.com

How do you source and choose the everyday objects you use?

It is an improvised process, something purely intuitive. I visit industrial places or look at containers in the street. The objects give me the keys for the pieces. My ideas do not emerge 'a priori'; it is the research process that configures an idea.

What is the importance of balance in your work?

The balance of Kubrick's films has always fascinated me; how he can combine in the same scene things seemingly opposite. I think the existence of balance between brutal and elegant is fundamental during the creative process, between chaos and order, madness and sensibleness. Art is generated in that small space between separate worlds.

Why explore domestic space?

I consider domestic space the place where we constantly leave residues and threads about who we are. Our domestic space, our utilities, work tools, habitat, etc. are constantly transforming. Every day we change the world in an imperceptible way.

What do you find interesting about producing compositions from disparate elements?

I like to generate new connections with different 'words'. It's like taking the significance of an object to its limits. I find it very exciting when I take an object from its environment and a new significance rises from its emptiness.

What do you like about playing with structure in your sculpture?

I guess reality, as we perceive it, begins with language. It is completely related to structures – macrostructures that contain microstructures. In that way I see a chair as talking about our bodies. The economic structure of a country is telling us about the psychology of that society. Each structure is always connected with another.

What do you find interesting about incorporating light into installations?

To me light is one of the most influential elements when we try to understand reality and perceive it. In my work light is used like an energetic engine. I use it like an accent that contrasts with slow elements. Fluorescent light is white, rational, artificial and very different to a bulb, which has a more romantic light. Fluorescent lights allow me make intense lines in the pieces – that creates an atmosphere. The fact that the work generates its own light makes it completely autonomous.

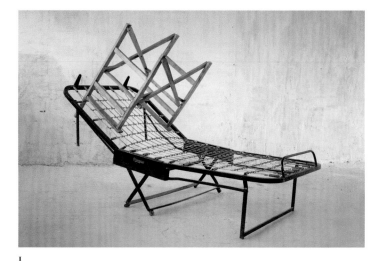

1

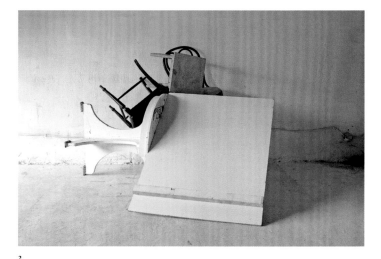

2

1. *Fuerza 8*, 2007.
Metal and wood.
175 × 120 × 85 cm
(69 × 47¼ × 33½ in).

2. *Tercer Salto*, 2007.
Wood. 145 × 210 × 250 cm
(57 × 82⅔ × 98⅔ in).

3. *Habitacion Blanca*, 2006.
Wood. 190 × 300 × 170 cm
(74⅘ × 118 × 67 in).

4. *El Mundo Como Estructura*,
2008. Metal and wood.
300 × 160 × 140 cm
(118 × 63 × 55 in).

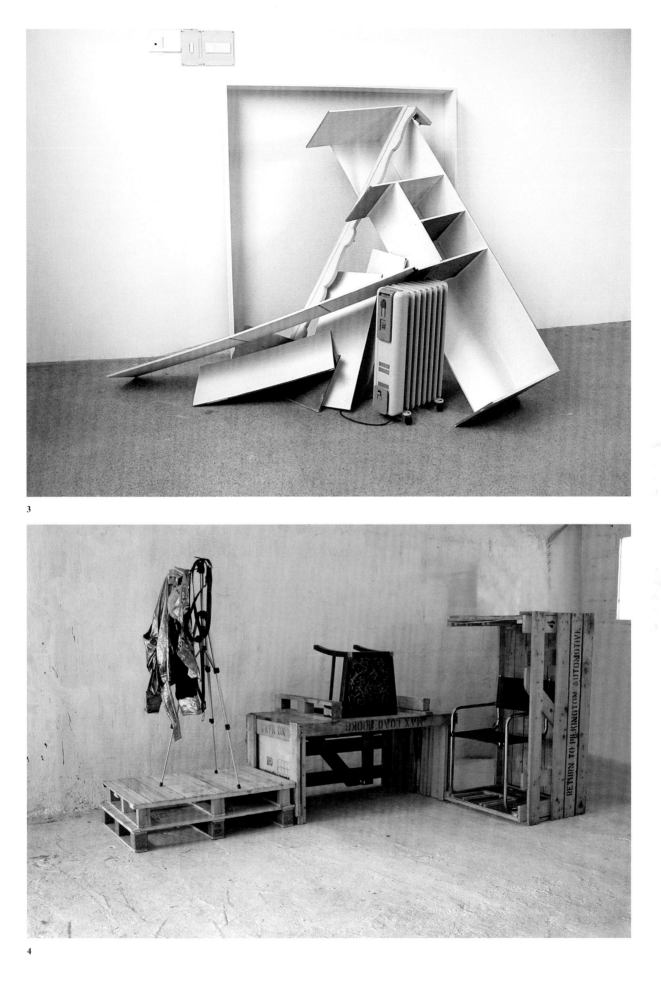

3

4

Geraldine Gliubislavich 1978, French/Swiss, www.vegasgallery.co.uk

How does working from photographs influence your approach?
It's an easily accessible, virtually unlimited source of images. It enables me to explore the friction between paint and photography – between the imaginary and the real. The one contaminates the other.

Why do you create a lack of clarity or opacity in your images?
For me, art is not about definition, but more about the opening of possibilities and significations. This is where the lack of clarity comes into play as a crucial component of my work process.

What draws you to your colour palette?
I limit my palette to white, black and red, focusing more on matter, paint, texture and thickness. I see my paintings as vectors. I try to build an ever-growing body of work enriched by the sparse addition of new colours and subjects.

What interests you about narrative in your work?
I am interested in those narratives that offer the spectator and the painter different levels of reading and interpretation. I am attracted to a certain degree of narrative blurriness. In that sense my work is closer to moods than stories. What interests me is that through these moods, new narratives unfold, enabling a variety of interpretations.

Tell me about the relationship between your paintings.
I like the idea of visual conversation. When my paintings are taken collectively, even though nothing is clearly articulated, one can sense that some kind of a common language is shared in what echoes from one painting to the next. I like that these works can address questions about the essence of painting, such as: What can painting say? What can it say in connection with its own condition and of that of the artist who uses it? How is it relevant today?

Are you interested in rituals?
I am very much interested in their depiction. A ritual is based on rules and obligations. Through paint all this seems to be broken down into a much more freewheeling thing. The ambiguous nature of the depiction of rituals enables me to work with the deconstruction of both image and sense, in a very spontaneous way.

It is often hard to tell if your paintings show violence or pleasure. What do you like about that boundary?
I guess it is a way for me to emphasize the sensuality of paint and what sets it apart from other media.

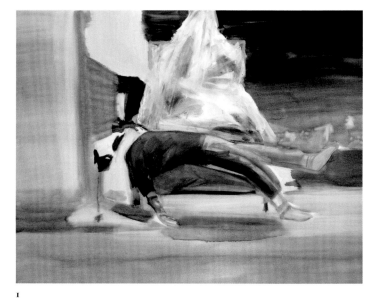

1

1. *Untitled*, 2008. Oil on canvas.
112 × 146 cm (44 × 57½ in).

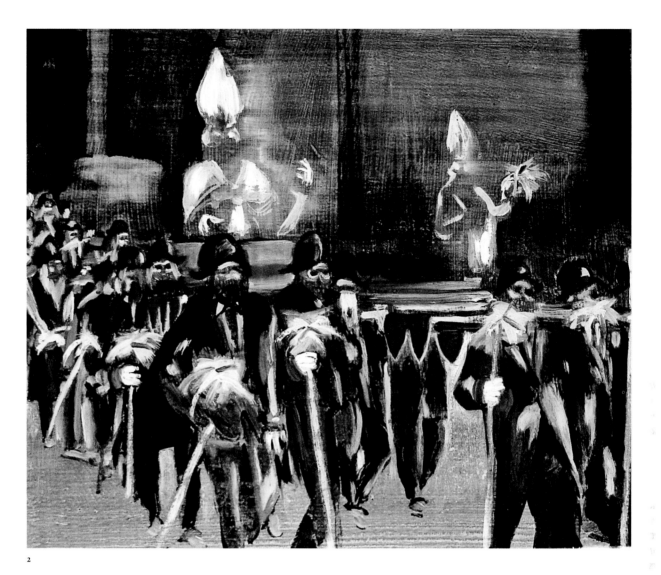

2

2. *Untitled*, 2008. Oil on canvas.
50 × 60 cm (19²⁄₃ × 23³⁄₅ in).

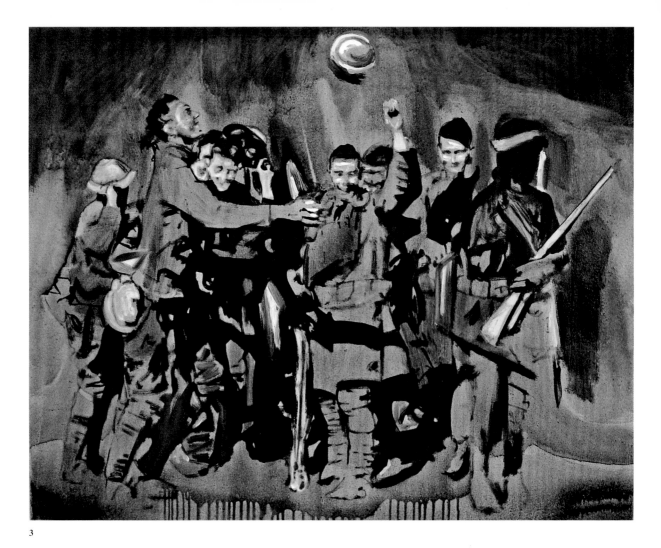

3

3. *Untitled*, 2009. Oil on canvas.
80 × 100 cm (31½ × 39⅓ in).

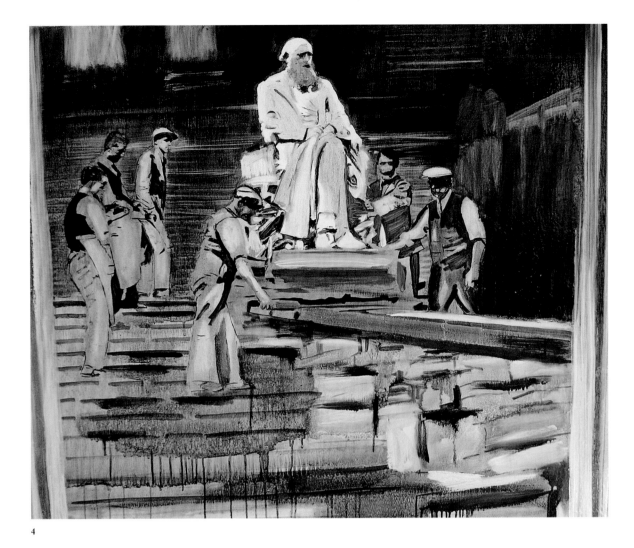

4

4. *Untitled*, 2009. Oil on canvas.
100 × 120 cm (39⅓ × 47¼ in).

Sayre Gomez 1982, USA, www.sayregomez.com, www.kavigupta.com

Why do you use colour gradations?
I began using gradients in my work because I was interested in the way that advertisements use them. I think originally advertisers would have a product photographed on a seamless background. The seamless seems to have been traded in advertising for the computer-generated gradient, which is essentially an abstraction that emulates space. It also possesses the ability to imbue the product or object placed within its boundaries with a certain sense of austerity and importance. This is a pretty intriguing mechanism to explore.

How does the idea of make and do inform your 'Formal Exercises' series?
The 'Formal Exercises' all cite their sources in the titling. So *Make and Do* was the first book I used to pull images from for the series. The book was interesting to me because it was a children's book on how to make art. Not only does this interest me because it suggests a kind of art free from pretence, in which the creative process is simply accepted as a positive force in one's life, it also offers a glance back at a very primary introduction to what art is and how ideas about art begin to be shaped. With these collages I thought it could be interesting not only to talk about an idea, but to illustrate it as well.

What do you like about the sense of something unfinished or handmade?
I would see these as choices or options. If something looks handmade it's because I am interested in what that might communicate about the subject matter and how it might affect the legibility of that work.

Is your work critical of the decorative object?
My work is more critical of a structure or system that allows an object to be considered decorative.

How do you approach collage?
I think of my whole practice in these terms. I make collages and assemblages in the traditional sense, but I can also think of my approach to making things as a kind of ahistorical collage, combining methods and practices.

What is the importance of the frame in your work?
I think at the end of the day it's what my work is really about – how we frame and contextualize, where and why we locate importance and how this affects us.

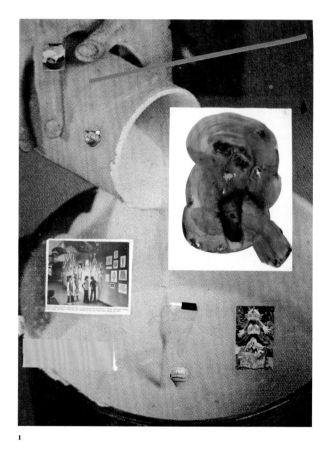

1

1. *Formal Exercise: Make and Do/ Art From Many Hands/Craft and Hobby*, 2008. Collage on archival digital print. 76.2 × 55.8 cm (30 × 22 in).

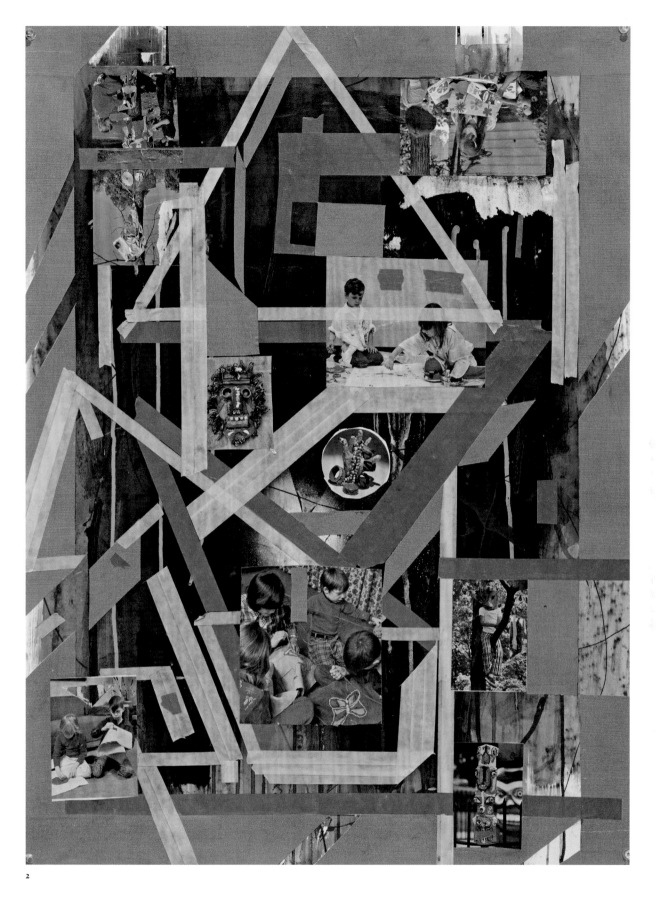

2. *Formal Exercise: Make and Do 2*,
2007. Collage and acrylic on paper.
76.2 × 55.8 cm (30 × 22 in).

3

3. *Untitled Drawing*, 2007. Graphite
and acrylic on paper. 76.2 × 55.8 cm
(30 × 22 in).

4

4. *Untitled Drawing*, 2007. Graphite
and acrylic on paper. 76.2 × 55.8 cm
(30 × 22 in).

Sam Griffin
1979, United Kingdom, www.galleryvela.com

What attracts you to the architectural projects?
I am interested in how we evaluate progress. Architecture is a useful indicator of the future we aspire to. Buildings provide a static testament to both our desire for a better future and our inability to achieve it.

Is there a meaning to the suspended symbols in your work?
They are lifted from a variety of sources, but all relate to the subject of each drawing. In the drawing *Zeitgeber*, for example, the central image is of the former Georgian Ministry of Highway Construction in Tbilisia building designed to mimic the habitat occupied by wildlife in trees and forests. It is flanked by symbols taken from 'Le Poeme de L'Angle Droit', the series of paintings and associated writings by Le Corbusier that describe our relationship with the natural and man-made environment. *Zeitgeber* literally means 'time giver', a term to describe the environmental systems that regulate our natural rhythms, such as the cycle of night and day.

What interests you about failed utopian projects?
I'm interested in the impossibility of the utopia and how this manifests itself in situations where plans to achieve are carried out. What is striking is how often the structures of these utopian scenarios are hierarchical and dogmatic. I am fascinated by the forces of recruitment and ideological governance at work within cult organizations, religious congregations, New Age communities and even corporations. I am particularly interested in how design is manipulated by these groups to galvanize a sense of faith.

What do you think about the connection between the scientific and the transcendental in your work?
The relationship between religion and science is interesting. Both are diametrically opposed modes of thought, yet the similarity of the fundamental questions they both seek to answer is striking: Who are we? Where did we come from? Where are we going? More vital is the ability of both these frameworks to rationalize not only a rapturous future but also the end of the world. Success and failure.

How do those sculpture and installation works relate to your works on paper?
I have become more focused on the physical and cognitive processes at work in various architectural environments. Sculptural and installation-based interventions have allowed me to engage directly with spaces and their characteristics. I am interested in the role of acoustics, particularly in congregational, architectural spaces – the church, concert hall, burial chamber and even the festival tent.

1. *Bring The Good News – Not Now But Soon*, 2009. Pencil on paper. 54 × 71 cm (21¼ × 28 in).

2. *Boondoggle Elysium*, 2009. Pencil on paper. 46 × 68 cm (18 × 26¾ in).

1

2

3

3. *Even If I Could Help You,*
I Couldn't/I Wouldn't, **2009.**
Aluminium composite panelling.
60 × 180 cm (23⅗ × 71 in).

4

4. *New Safe Confinement,* 2009.
Pencil on paper. 62 × 40 cm
(24²/₅ × 15¼ in).

Simon Gush 1981, South Africa, www.simongush.net, www.michaelstevenson.com

Why do you make interventions into public space?

I am not interested in the physical space generally denoted as public space, but in an abstract conceptual space in which matters of public interest are contested. I think that a work in a private space, such as a gallery, is capable of participating in a public debate. For me, the point at which a work begins to participate is really determined at a conceptual level rather than by its physical location. When I use public space in my work, I try to use it as a way of pointing to the public sphere.

What is the importance of politics in your work?

Politics is central to my work. Having grown up in a heavily politicized environment, I struggle to remove the political dimension in even everyday interactions. I believe that art can contribute in a very real way to the political. I think that it plays a part in the way we conceive of politics on an abstract level. I think what I really want to achieve in my work is to shift that understanding.

Why have you used cars in your work?

All sorts of transport have found their way into my work. I like cars and I really like driving. *Three Point Turn* (with Dorothee Kreutzfeldt) is something that started from driving in the centre of Johannesburg. We hired Sam Matentji to drive a car the wrong way down a one-way street. *Serenade* comes from a very different place. I noticed how the police in Europe would shout at pedestrians through their car's PA system. I thought it would be nice if they sung them love songs instead.

What was the idea behind your downloadable ringtone pieces?

The first ringtone piece started when I was driving with a friend and a car alarm went off somewhere near us, and my friend asked me if my phone was ringing. I didn't really think about it again until my phone was stolen. I think I just wanted my phone to sound like something that should not be stolen. I found six alarm sounds that I liked and started using them alternately as my ringtone, and put them online. What I enjoyed was the way that people reacted. I remember once being in an elevator on the 16th floor of a building and my phone rang. Everyone started getting their car keys out.

1

1. *The Wolf's Theme*, 2009. French Horns, music stands, scores of Sergei Prokofiev's *Peter and the Wolf* and rope. Dimensions variable.

2. *The Railway Maintenance Workers…*, 2008. Paint on wall. 240 × 48 cm (94 ½ × 19 in).

3. *In The Company Of*, 2008. Video still, single-channel HD video, ten-channel audio, 32 mins. 27 secs.

THE RAILWAY MAINTENANCE WORKERS OF A NORTHERN EUROPEAN COUNTRY HAVE BEEN EXPERIENCING A PROBLEM WITH THEIR PUBLIC IMAGE WHICH IS PROVING DIFFICULT TO SOLVE. THE DILEMMA IS SIMPLY THAT, WHILE WORKING, THEY ARE FORCED TO STOP AND WAIT FOR TRAINS TO PASS. WHEN VIEWED FROM THE PASSING TRAINS, THEY NEVER APPEAR TO BE BUSY.

2

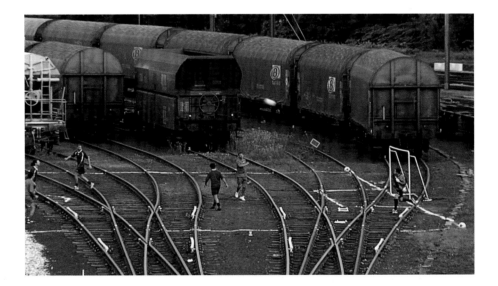

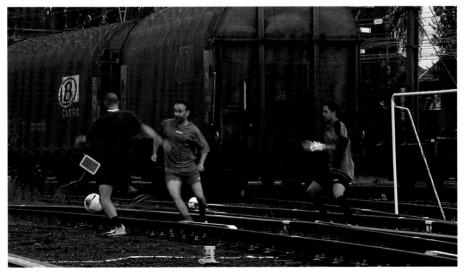

3

Hyon Gyon 1979, Korea, www.hyongyon.blogspot.com

What draws you to vibrant colours?
I used to work as a designer of *chima jeogori*,
Korean traditional clothes. I still
remember how excited I was when I first saw
the rich clothes. I was in charge of the arrange-
ment of the colours and embroideries there.
I would try to create a picture of the client in
my mind. The experience of having dealt with
limitless characters and the lure of the colours
made has been a strong influence on my
current work.

Why do you hide faces in your work?
I think the face is the most important part of
the human body, through which information
such as character, expression, race, age, beauty
and ugliness are all conveyed. Sometimes, you
even think you know someone just by looking
at his or her face. Hiding a figure's face makes
viewers puzzled and anxious.

*There is something out of control about your
paintings, like hairy whirlwinds. What draws
you to that chaos?*
Human beings cannot be described as any-
thing but chaotic. Some love beautiful order,
but others love chaos filled with energy. Deep
down, every one of us has something that
comes out of that chaotic reality, even though
we try to deny it. That something can be
changed into energy. Chaos filled with energy
is very human and attractive.

Is there a spiritual element to your work?
I'm interested in Korean shamanism. It has
been eliminated, because it is said to be super-
stitious and barbaric under the influence
of modern trends. Women tended to become
shamans. They become one by transcending
the pain of the body and spirit. Shamanism
healed Korean women. It works not only
for me, who paints, but also for the mind
of viewers.

What do swords mean for you symbolically?
Swords have many meanings. The swords that
appear in my paintings are all directed
inward. They are symbols of the pain caused
by reality, oppression and anger. They express
the scars from struggles and the feeling of
being cornered. Blades, swords and bells are
often used as magical tools in Korean
shamanic ritual. At first, those rituals seem
violent, but, in fact, they protect us and ward
off evil. The swords on the canvas have negative
meanings, such as unseen terror and feckless-
ness, but I change them positively by painting
those 'magical' elements in colourful and fash-
ionable ways.

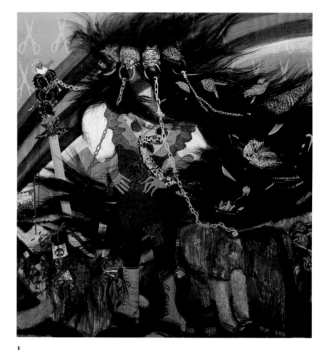

1

2

1. *Pyramid*, 2008. Acrylic paint
on panel. 180 × 168 cm (71 × 66 in).

2. *Zawazawa zudodon shupin shupin*,
2008. Acrylic paint and Japanese
paper on canvas. 235 × 240 cm
(92½ × 94½ in).

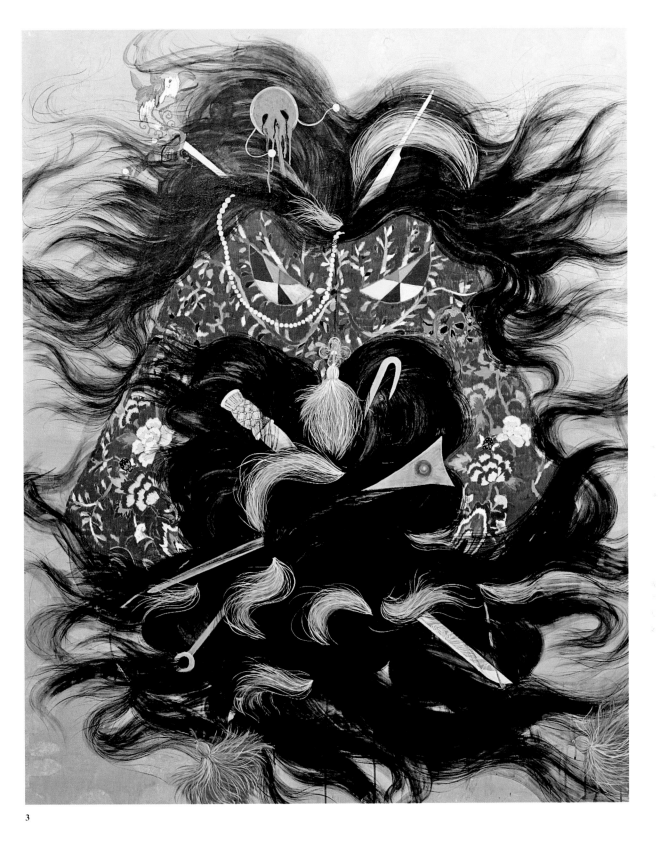

3

3. *Helmet red*, 2008. Acrylic paint
and Japanese paper on canvas.
162 × 130 cm (63¾ × 51 in).

Elín Hansdóttir 1980, Iceland, www.elinhansdottir.net

Why do you create work in public spaces?
Showing in unconventional spaces is important, because it not only gives you easier access to more people, with different backgrounds, it also enhances the element of surprise in people's daily life. I am very interested in challenging our prejudices about how things are or should be in our surroundings.

What interests you about the façades of buildings?
A façade is an image towards the outer world. It represents a mechanism of separation and unity at the same time. It is also a threshold that divides two different worlds. As soon as you step over the threshold, your mindset changes towards your surroundings.

What attracts you to creating pieces that involve physical interactions?
I am interested in people's imagination and thought through spatial experience. I would like to see my work as a starting point for other ideas that are beyond my control. I am interested in works where nothing is really on display or being exhibited, but rather where your movement and thoughts ignite a process in which the invisible comes to life. I like the idea that in all spaces there exist many parallel places that only come to life through people.

A number of your pieces seem to involve misty or smoked-filled interiors?
I like to explore disorientation as a means of focusing. In *Path*, I was interested in how a completely controlled space can actually bring with it the notion of the dissolution of space. Many people believed that the space was filled with smoke, but it was actually the combination of dim lighting and the shadows cast by the sharp corners that produced the sfumato effect, where the outlines of the space sometimes disappeared completely.

How would you describe your approach to making work?
My way of working is very process-oriented. I'm attracted to that because it gives room for creativity. It means that I am constantly faced with decisions that have to be taken, sometimes very late in the building process, depending on the situation. After that I am forced to trust the decisions I take, even though I don't know exactly what the outcome will be. Sometimes it can be a risky way of working, since the line between success and failure is very fine. But I like looking at the creative process as an adventurous journey that can surprise you and lead you in directions that you could never have foreseen.

1

2. *Peripheral*, 2006. 3–12 lightbulbs (red, green and blue). Dimensions variable.

1. *Untitled*, 2003. Site specific installation: plywood, mirrors, Plexiglass, pvc.

3. *Path*, 2008. Plasterboards, aluminium structure, sound system. Dimensions variable.

2

3

Graham Hudson
1977, United Kingdom, www.zingerpresents.net, www.monitoronline.org

Why do you create a feeling of the haphazard in your sculpture?

Buildings, stock markets and governments all fall – and are usually pushed. We fall just the same; a little bit every day in some way, emotionally more than physically. Permanence is an illusion.

What do you find interesting about structures and architecture?

Things half-made or torn down are more interesting than 'finished' structures. The collapse of any structure is inevitable and knocking it down is time on fast forward. As buildings go up and down they have the potential to be art, abstract and unusable. As floors, windows, handrails etc. are added – a building becomes 'safe' for human occupancy, and it loses that potential and becomes architecture.

What is it about scaffolding that appeals to you?

It's a skeleton, an echo and a reflection. Utilitarian and minimal, it's a highly efficient system that fits cathedrals, bridges and modernist blocks all the same – it doesn't care. The steel tubes and couplings carry the memory of previous incarnations in secret. It is constantly recycled and it is the true architecture of London, a crumbling old city that is at the same time a hyper-capitalist tornado. The scaffold forces the city upright and into the future.

Why did you decide to live inside your own DIY installation at the Chelsea Parade Ground?

It was a durational performance 24/7 for six months. It was my first residency, so I wanted it to be about exploring the idea of 'residence'. What is a home, a studio, an exhibition space? How are being and behaving in any place defined? Where are the edges? Who says that is a pile of rubbish? These are questions of social conditioning – like taste and value.

Why have you incorporated record-players and sound?

Music is the first art; it's primordial. We will always be a tribal species. Record-players are analogue and tactile. Their motion and sound can be used as materials. Both the soundtrack and structure of my works collapse, crash and change over time.

You once described your sculptures as sketches-in-materials. Can you explain that?

You can't fake a genuine moment: pretending you didn't know about the surprise birthday party, or trying to look pleased as you unwrap a present and realize it's something you dislike. I believe the first time is the best time. Keeping that freshness in an artwork is key. Simplicity is the hardest, most sublime, trick.

1

1. *2:1 Chair*, 2009. Timber, plastic, wicker and paint. 90 × 45 × 55 cm (35½ × 17¾ × 21⅝ in).

2. *The Ruins*, 2009. Scaffold, pallets, ladders, 5 × turntables, on/off timer and light chaser. 540 × 540 × 540 cm (212½ × 212½ × 212½ in).

3. *The look of the future (The 80's)*, 2009. Fruit machine and light box. 540 × 540 × 540 cm (212½ × 212½ × 212½ in).

4. *Sculpture IX 121109. A certain weight and location in space*, 2009. Steel and concrete. 80 × 80 × 20 cm (31½ × 31½ × 7⅞ in).

5. *Canal Street Commons*, 2009. Steel and concrete. 15 × 15 × 8 m (49 ft 2½ in × 49 ft 2½ in × 26 ft 3 in).

6. *Architecture or revolution*, 2009. Rubble. 65 × 40 × 20 cm (25½ × 15¾ × 7⅞ in).

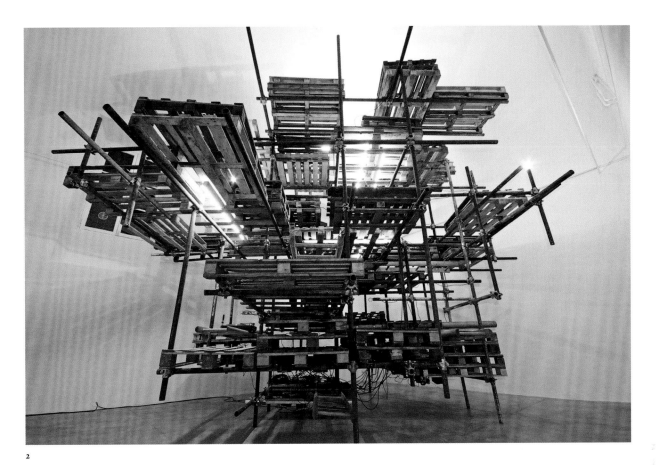

2

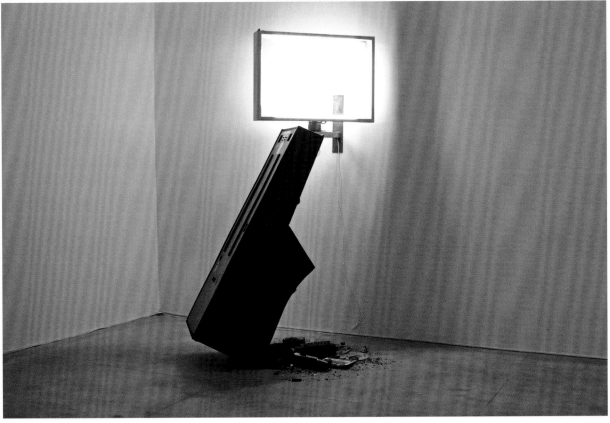

3

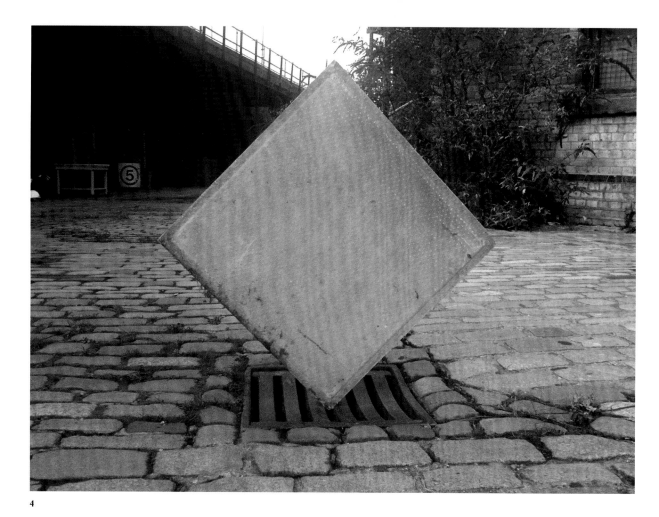

4

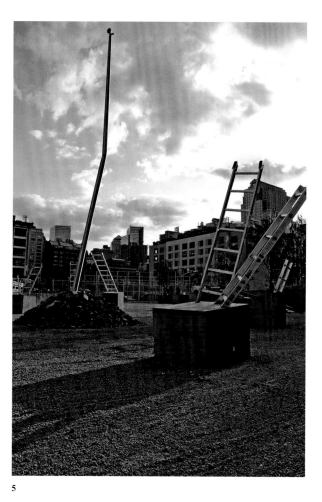

5

6

Carlos Huffmann 1981, Argentina, www.albertosendros.com

What do you find interesting about car imagery?
I am interested in how car imagery is used in the media. Cars seem to condense the human pretence, the desire for power over nature and fellow man; an exaltation of the ego. There is a very palpable pathos in cars being the ultimate unfulfilled promise of consumer culture. Car ads promise freedom, sex appeal, intelligence, respect, everything short of enlightenment if you buy the advertised product. I like to look at things that are so over-coded that it becomes difficult to see them for what they are. I feel like there are secrets hidden on billboards and the covers of magazines.

How do sex and the erotic emerge in your work?
I think they are very present. My interest in sex and the erotic in my work is intense and ambiguous. I sometimes say that I am a kind of post-Freudian surrealist – I don't fully agree with the belief that sexuality is the ultimate principle ruling human existence. At the same time I feel like I am the product of a sex-obsessed culture, so addressing this is an investigation of my own capacities of perception.

Are you interested in the representation of masculinity?
Yes, very much so. I grew up in a somewhat feminist environment, so in a way my idea of the masculine was defined. While I fully understand and support the historic demands made by feminism, I became dissatisfied by its definition of masculinity. Masculine and chauvinistic are sometimes interchangeable words. I believe it to be too simplistic.

What do you like about images of the monstrous?
I think art gives me the tool of exaggeration. Zombies feel like an exaggeration of the lifestyles imposed on people by most of the 'civilized' consumerist world.

Do you draw on the aesthetics of protest?
The aesthetic of protest and the aesthetic of the commercial slogan seem to be very similar. Both sell something, and both are almost always reductive by necessity. I try to generate a type of expectation that hijacks the spectator by not giving him what he's expecting of me and the object he is facing. The aesthetic of protest is also a by-product of what I think are dire times in terms of belief. Adolescence, with all of its immature rebellion and angst, seems to be the only time of life in which we are allowed to believe in something.

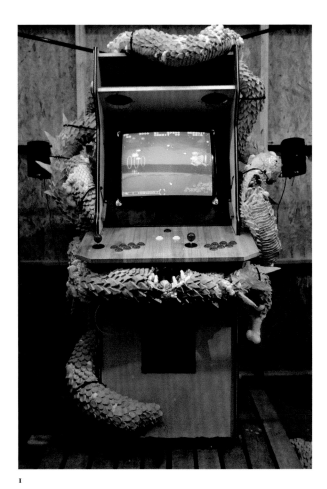

1

2. *Untitled* (*meaning machine*), 2007. Honda Civic front clip, wood, wire, epoxy clay, acrylics and garage lamp. 400 × 220 × 180 cm (157½ × 86⅗ × 70⅘ in).

1. *Zero Headed Hydra*, 2008 (detail). Wood, wire, electronics, epoxy clay, open source video games and 6,300 pirated games. Dimensions variable.

3. *Untitled* (*of me*), 2010. From the '12 Horsemen for 3 Endings' series, oil and inkjet print on canvas. 210 × 310 cm (82¾ × 122 in).

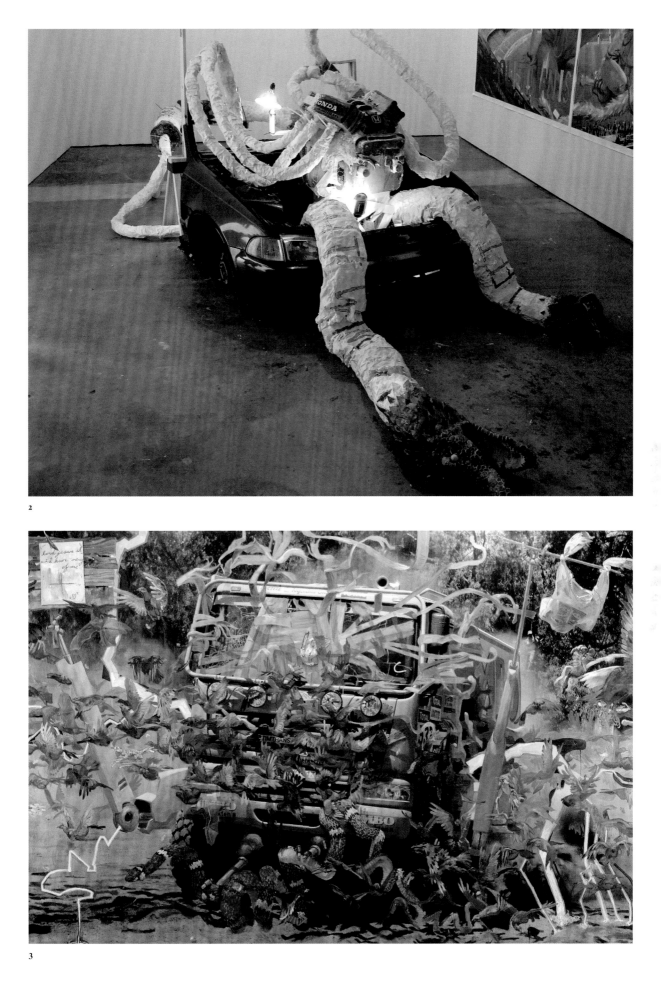

2

3

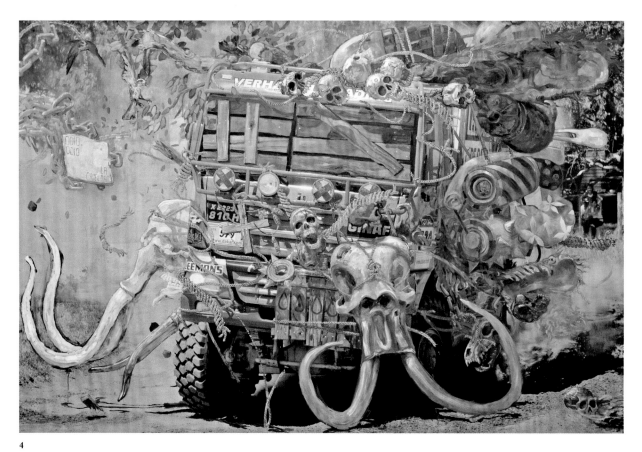

4

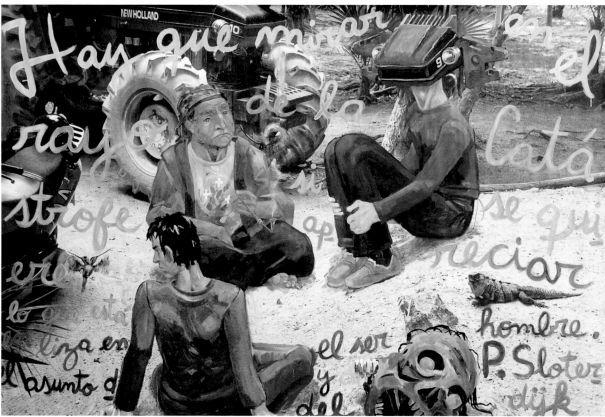

5

4. *Untitled (odio odio)*, 2009.
From the '12 Horsemen for 3
Endings' series, oil and inkjet
print on canvas. 210 × 310 cm
(82¾ × 122 in).

5. *Untitled (P.Sloterdijk)*, 2008.
Oil and inkjet print on canvas.
139 × 202 cm (54¾ × 79½ in).

6. *Untitled (your identity)*, 2008.
Oil and inkjet print on canvas.
160 × 107 cm (63 × 42 in).

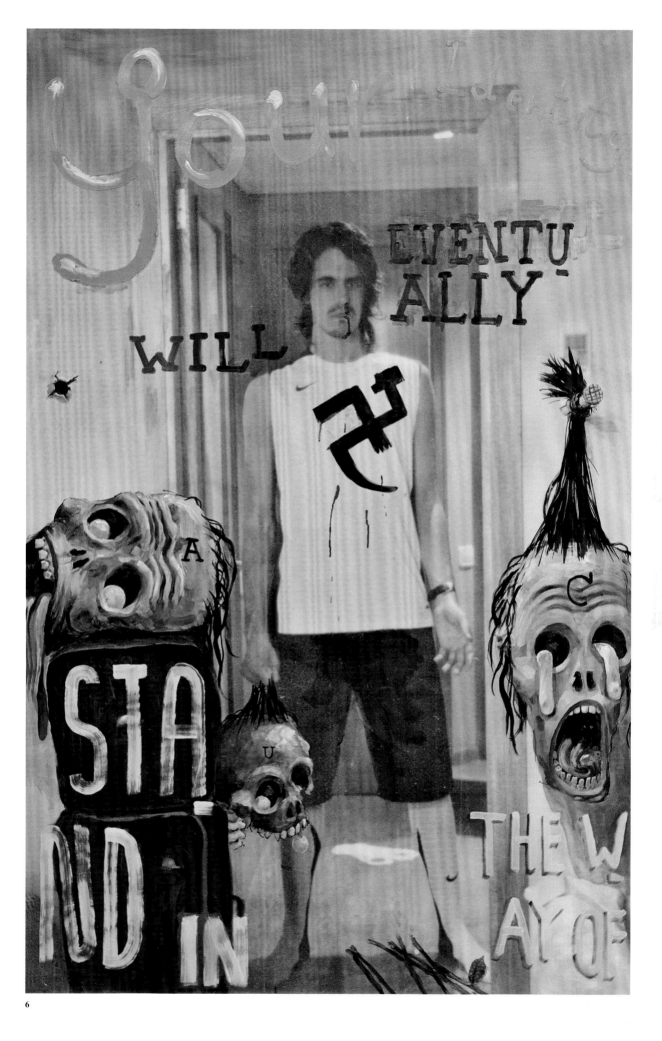

Pieter Hugo 1976, South Africa, www.pieterhugo.com, www.yossimilo.com

Is it part of your aim to explore African identity?
I'm not even sure I know what African identity means. I constantly get pigeon-holed, being an African photographer, in the debate about the politics of representation in Africa. I am a white South African, I have grown up here and I am surrounded by this landscape. I find it impossible to remove these images from the socio-political context in which they were taken; that is not my primary preoccupation but this element is inseparable from the images. Photography is an analytical medium.

What attracts you to the people who became the focus of The Hyena and Other Men*?*
I found out about them through a photograph that a cellphone company employee took while he was in Lagos. I came across it on the Internet and was able to have access to this community through a local journalist. It really bothers me that it gets read as hyper-exotic imagery. What attracted me to it was more the idea of people who live on the periphery; the absurd relationships between master and servant, between man and animal; the idea of taming the wild; the irony of a country that is the seventh biggest oil exporter. My pictures speak a lot about marginality; it is a part of me as well. There has to be a connection (positive or negative) with my subjects. They affirm my own 'outsider-ness'. The marginal becomes a mirror that amplifies my reality.

Are you drawn towards controversial images?
I want my images to be experienced as an active medium, not as pretty pictures that fulfil a purely aesthetic function. I want to make photographs that cause discomfort and confusion. I am interested in the hybridization of genres and media. My work sits in an uneasy, undefined space that it is difficult to classify. Photography has its roots in a faux representation of reality. People still look at it as the anchor of truthful representation. In my work, that anchor is dragging over the reef, the ship loose and moving across the surface of the ocean.

What interests you about the body and the landscape?
Frailty, vanity and how representing it can shift us out of our complacency; how it can reflect and amplify our situation back at us.

Are you interested in ideas about horror?
In as much as witnessing a car crash has a visceral pull: 'Why do we inquisitively look at it, even though we know it will repulse us?'

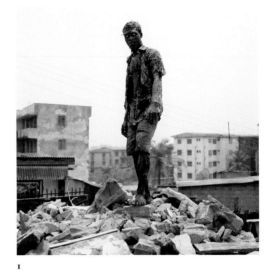

1

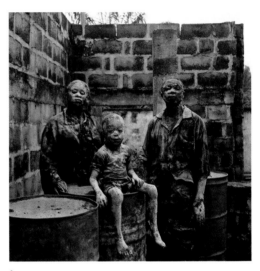

2

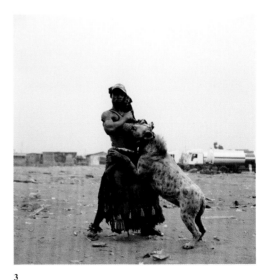

3

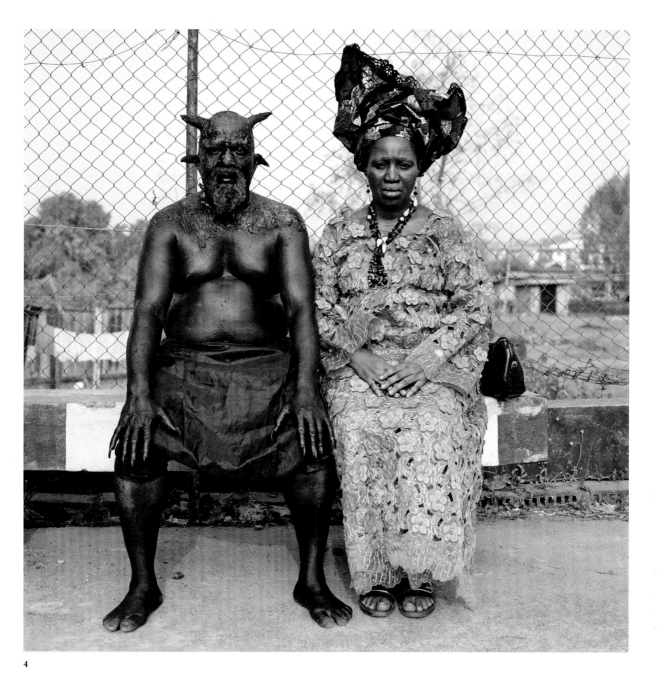

4

William Hunt 1977, United Kingdom, www.ibidprojects.co.uk

Why create physical barriers in your performances?

I use physical barriers in my performances literally to thwart, and then reveal, the attempt at communicating. By placing the body in extremis, the viewer is able to witness the struggle between the attempted performance and the situation it is performed in. The songs I write are songs of rapport, but this is frustrated or made difficult. This exposes the attempt, the trying in the face of difficulties. It's like the toddler in the supermarket who isn't getting what he wants.

Do you veer more towards comedy or pathos?

Comedy is the antidote to the romantic and immediately subverts mawkishness. There is something so horrific when the teenager pulls out an acoustic guitar and starts to emote, but also something brilliant. I am happy for the two meanings of 'romantic' to coexist in the work. Nervous laughter from the audience is also interesting. It enables a release at the start and brings everyone in the room into the same emotional place. It is then possible to relax, concentrate and really scrutinize what is going on.

What do you find interesting about ephemerality?

For me performance is inextricably linked to memory. Each successive action impacts on the ones that went before. Because performance is ephemeral it is always radical. There is a strong possibility that it might not work and by its nature has nothing to sell.

How do you draw on music culture?

Tied up together with writing the music and using the image of a musician or singer songwriter is a critique of popular music. A lot of it comes from what I call mainstream performative culture. Better than *X Factor* is watching karaoke, when a fan of a song is murdering what they cherish. Desire is written on their faces, their eyes closed as their mind projects to some imaginary perfect rendition.

What interests you about the idea of emotional authenticity?

I think I have spent a lot of time devising situations where I don't have to act. I really am upside down. I really am under water. I really am being squashed by a piano. I am willing to endure these situations so that I don't have to pretend anything and I am not aware that I am expressing anything.

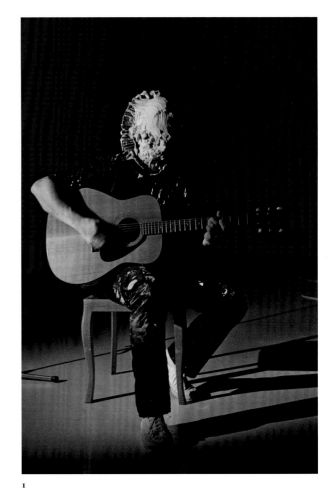

1

2. *Even As You See Me Now*, 2007. Performance.

1. *I Forgot Myself Looking At You*, 2008. Performance.

3. *Put Your Foot Down*, 2006. Performance.

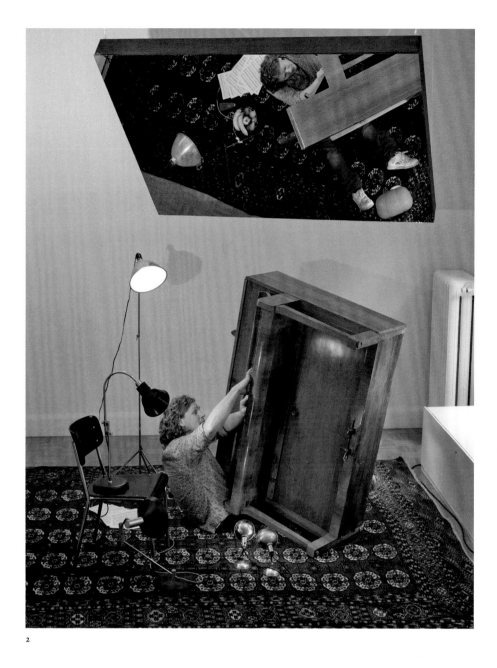

2

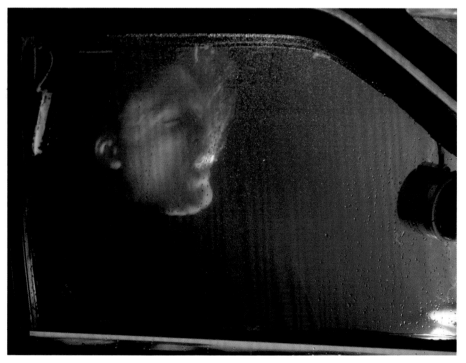

3

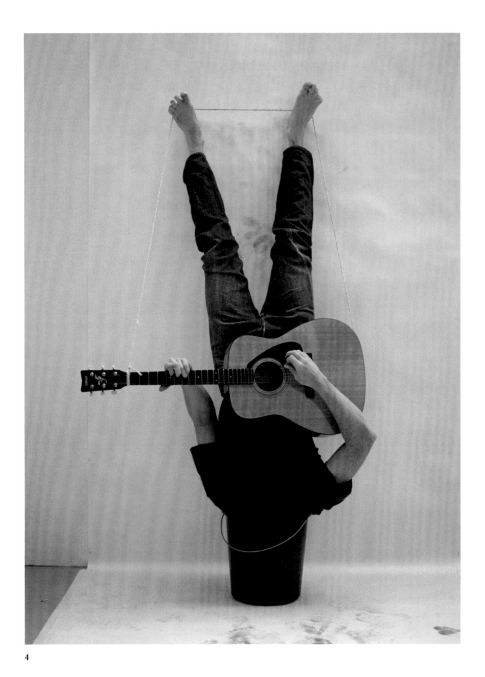

4

4. *Don't give me money, It's not
what I want, From you*, 2005.
Performance.

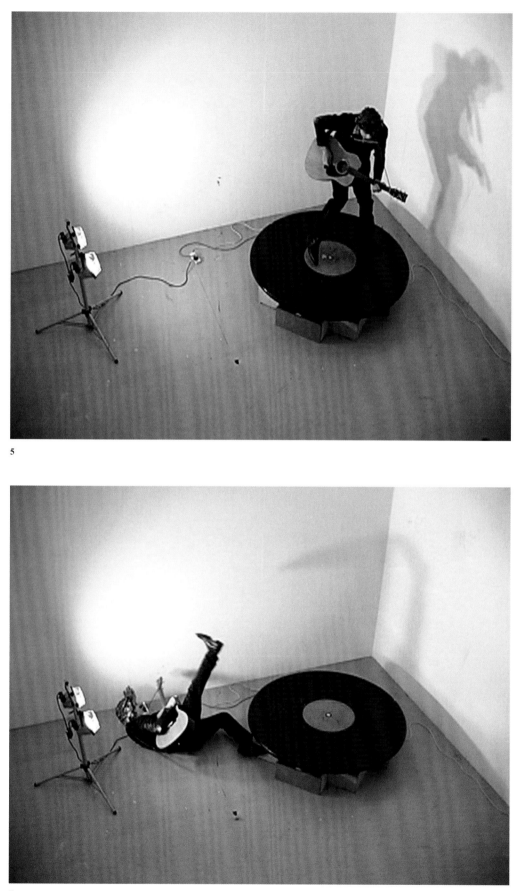

5

6

5, 6. *Rodeo Radio*, 2004.
Performance.

Sven Johne 1976, Germany, www.svenjohne.de, www.klemms-berlin.com

*What do you think about the boundaries
between truth and fiction?*

There are only versions of reality, different
perspectives on the same set of facts. What I do
is condense the facts, in the double sense of the
German word 'Verdichtung', meaning intensi-
fication and also fabrication/fiction. This
process of condensation or intensification
turns reality into fiction. But does this make it
any the less true?

Can you tell me about your processes?

They are not unlike the way a journalist works.
I hear about something, go there, talk to the
people and establish the facts. I often research
in archives. I then develop the story from this
large collection of material. Recently I have
been leaving out more and more details, reduc-
ing things. I boil it all down, distil the essence.
I am becoming more and more interested in
sparse, reduced methods to open up a larger
and larger space.

What draws you to stories?

It is the need to extract something exemplary
from an individual situation and tell people
about it. The narrative takes the viewer or the
reader and leads him by the hand. It is essen-
tial. As far as the text is concerned, it must be
completely unambiguous. I don't really allow
any other perspective than the one I have on a
certain reality. That is my message, a state-
ment. It is the beginning of an exchange of
communication.

*Are newspapers and the media the starting
points for your works?*

Press newsflashes are often the starting point.
What interests me is the space between these
meagre lines; I am interested in the informa-
tion hidden behind the reports. I am also influ-
enced by journalism in a technical sense –
images and short texts are used as teasers, as
an attraction, which allows me to follow on
with 'information' and 'opinions'.

*What do you find interesting about the idea
and representation of history?*

At the age of thirteen, I said goodbye to the
world of my childhood. The German
Democratic Republic (GDR) ceased to exist in
the autumn of 1989, with the fall of the Berlin
Wall. At school, our GDR history textbooks
had to be given in; they were no longer valid.
That was a shock. Becoming an adult was ac-
companied by a deep scepticism towards the
portrayal of history. My experience taught me
the history book is constantly being rewritten.
Can we believe historians simply because their
version of history sounds plausible? I dedicate
myself to taking a closer look at things that are
considered sidelines or footnotes in the great
picture of history.

1. *Ship Cancellation Maersk*, 2004.
From a series of 5 lambda prints
(edition 3+1 a.p.), silkscreen print
on glass. 110 × 150 cm (43⅓ × 59 in).

2. *24 abandoned and hidden spaces
beneath the city of New York*, 2008.
Silkscreen print (edition 3+1 a.p.),
text, object frame. 87.5 × 56.5 cm
(34½ × 22¼ in).

MAERSK SEALAND UTRECHT, Nordsee, 51 38 Nord, 2 31 Ost, Scheldemündung

1

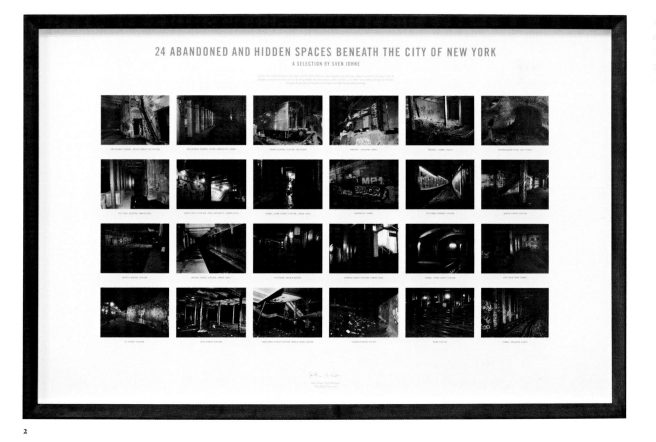

24 ABANDONED AND HIDDEN SPACES BENEATH THE CITY OF NEW YORK
A SELECTION BY SVEN JOHNE

2

3

3. *750 Jahre Kaliningrad*, 2007.
12 photographs of the city festival
in Kaliningrad, silkscreen print on
oil-gilded MDF plates, text on wall.
Each photograph: 11 × 16 cm
(4⅓ × 6⅓ in).

BLOCK WAR URSPRÜNGLICH GEBURTSTAGS-
GESCHENK AN MEINE GROSSELTERN,
BEIDE GEBOREN 1927 IN KÖNIGSBERG,
HABEN DANKEND ABGELEHNT. EU/30.04.2007

Rashid Johnson 1977, USA, www.moniquemeloche.com, www.jamesharrisgallery.com

How do you address the representation of African Americans in your work?

I have always had a difficult relationship with the representation of blacks in contemporary art. People tend to imagine that the black artist is a pained, angry character. When you don't fit that description it often causes a backlash. The characters in my work are privileged. For that reason, it is often difficult for people to enter what it is I'm doing, based on their own expectations. I then try to take advantage of that by continuing to defy expectations. I don't see blackness as a condition. My hope is that the work both confronts and rejects blackness as a monolithic experience.

What do you find interesting about experimenting with the process and methods of photography?

I'm interested in the history of the medium and how it can be manipulated. My interest in photography revolves around drawing with light and the way that light confronts the photographic surface. Photography is the language that I use to address representation. It is my chance to pull something from the world and re-contextualize it using my own vernacular.

What attracts you to the visceral textured nature of your sculptures?

For me it becomes about content, concept, material and process. I was always interested in the way that Joseph Beuys talked about substance. It's hard not to see the double meaning – the substance of our ideas and the substances in which we bring those ideas to life. Sculpture is a medium that gives so much meaning to utility and the semiotic. It provides, like no other medium, the opportunity to ask why. Sculpture changes our relationship with the familiar and provides the chance to question and manipulate those things we believe we know about objects.

What interests you about the altar as a structure?

When that work began, I was referring to them as shelves. Other people started calling them altars. I'm not naïve to their relationship to the spiritual, but I was thinking of them more as escapist vessels. They function as carriers for the iconography that I'm developing.

Why did you start using black soap as a material?

I wanted to make sculptures out of a material that you could cleanse yourself with. Black soap is often used by people with more sensitive skin and often by burn victims, etc. I wanted the work to reference the powers of healing.

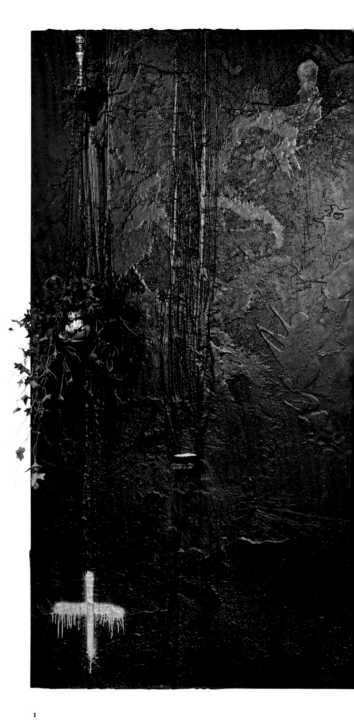

1

1. *Cosmic Topology*, 2009.
Black soap, wax, shea butter,
brass, silver gelatin print and
plants. 243.8 × 365.7 × 243.8 cm
(96 × 144 × 96 in).

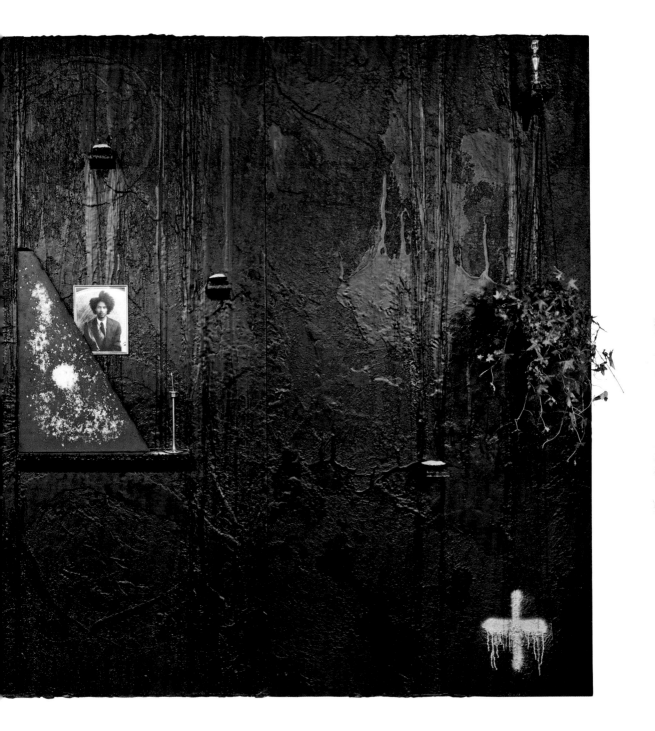

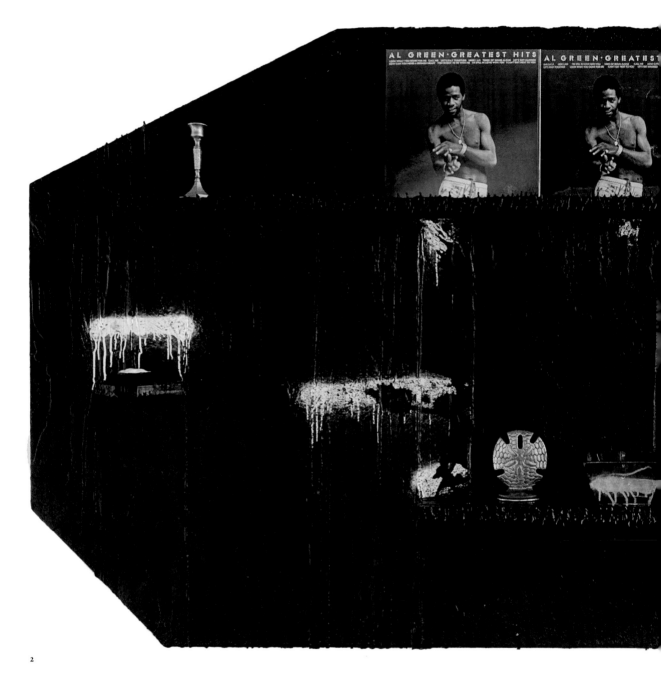

2

2. *Triple Consciousness*, 2009.
Black soap, wax, spray paint,
brass, vinyl and shea butter.
121.9 × 218.4 cm (48 × 86 in).

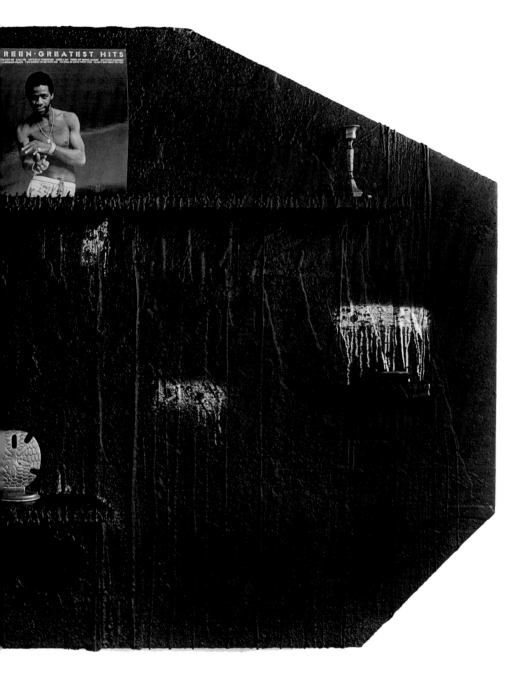

Ben Jones 1977, USA, www.galleriloyal.com

What do you find interesting about neon and acid colours?
Neon colours naturally emit light and vibration waves. They glow, like TV.

How do you approach making sculptures?
First I make a world. Next I inhabit this world with living and non-living objects. I start to write narratives, both linear and abstract, that exploit this constructed reality. Once I have the narratives, I reverse engineer and deconstruct all the elements and examine the fractured pieces with either formal executions or exercises. The de- or reconstructions become paintings and sculptures. During the whole creation cycle I am generating video, which serves as both a documentation and celebration of the constructed world and all its parts.

How do you use and explore the influence of the 1980s children's animations and computer culture?
Like someone who went through a war, though a very pampering and kind war, one that has scared [scarred?] my brain with its intense and deep visual attacks.

What is the importance of the Internet and computer references in your work?
I like the acting style of Bill Murray. He is almost winking at the camera the whole time, but is still an actor creating an illusion. I try to reference technology in the same way that Bill Murray tries to act. I want to use it and make fun of it at the same time.

What interests you about technology and digital imagery?
The timeless aspects of it. The abstraction of raw data or pixels is like excavating ancient things.

Are you interested in the ideas and aesthetics of psychedelia?
I think psychedelia is also an ancient thing. I think wanting to push our reality into complex weird spaces, visually or spiritually, is natural for the post-caveman. Going to a beach and swimming in bright blue water and seeing the sunset in the water is psychedelic to me.

How does your work with the collective project Paper Rad relate to your work as a solo artist?
I think in everything I do there is a constant impulse to act like an artist. Paper Rad was, and is, a great way to take my artistic vision and channel it into a complete and consistent artistic approach. Paper Rad was really about being an artist than about the zines, the music or the website. It is beyond an influence and more like a way of life.

1

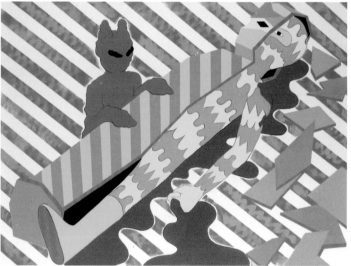

2

1. *Shapes 4*, 2009. Acrylic
and acryla-gouache on canvas.
90 × 120 cm (36 × 48 in).

2. *Shapes 3*, 2009. Acrylic
and acryla-gouache on canvas.
90 × 120 cm (36 × 48 in).

3. *The New Dark Age*, 2009.
Stills of video painting.

3

4

4. View of the exhibition 'Celebrate
the New Dark Age', Athens, 2008.

Hayv Kahraman 1981, Iraq, www.hayvkahraman.com, www.thethirdline.com

Why do you focus on female characters?
First and foremost is the immense empathy that I experience whenever I see, hear or read stories about women who have been through barbaric gender-related crimes, such as honour killings and rape, or even issues as simple as inequality in the mundane humdrum of their existence. It's a passion I am inescapably linked to in the most profound way, certainly because I am a woman. I feel a necessity, even a sense of duty, to be involved in these matters. Having fled Iraq during the war I'm constantly faced with the fact that I am not in the country of my origin. While I live a safe and pleasant life in the West, my fellow countrymen and women suffer from unspeakable wars and injustices. As a result I have inherited an appetite for rebellion that takes form in my work.

How do the traditions of Eastern and Middle Eastern painting inform your work?
It's fascinating how, when using simple yet meticulously calculated brush strokes, combined with a pristine sense of design and symmetry, you are capable of ardently conveying a massive burst of emotion. That effortless beauty in simplicity is what attracts me to Asian art and is something I am constantly striving for. I endeavour to merge anything from the Italian Renaissance and Japanese painting to Arabic calligraphy and Persian miniatures.

What do you find interesting about the contrast of politics, war and violence with beauty and decoration?
The world I paint is in a precarious state of contingency. The onlooker is hit with a sensation of duality, a battle of opposite forces. My themes are brutal, ruthless and very real.

What interested you about stylizing the figures you paint?
I think my background in design helped me form a cohesive and refined stylistic expression, where the combinations of ornate patterns are contrasted with the polished gentility of flesh tones.

Why rewrite historical and religious stories from a female perspective?
While references to the outer world are constantly present in my work, I do prefer to mix a cocktail of both reality and myth. I find it more interesting to tell a story that is conceptually based on reality, yet visually symbolic and timeless. Sometimes, when exploring difficult and brutal themes, it tends to be too overbearing. So the intuitive response is to translate the brutality into a more tolerable image. This is where myth and symbolism come in.

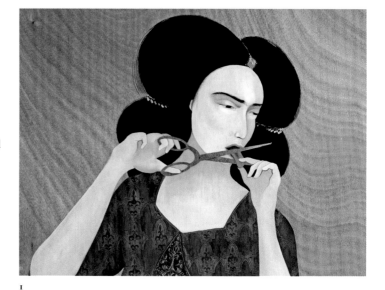

1

1. *Migrant 1*, 2010. Oil on panel.
114 × 178 cm (45 × 70 in).

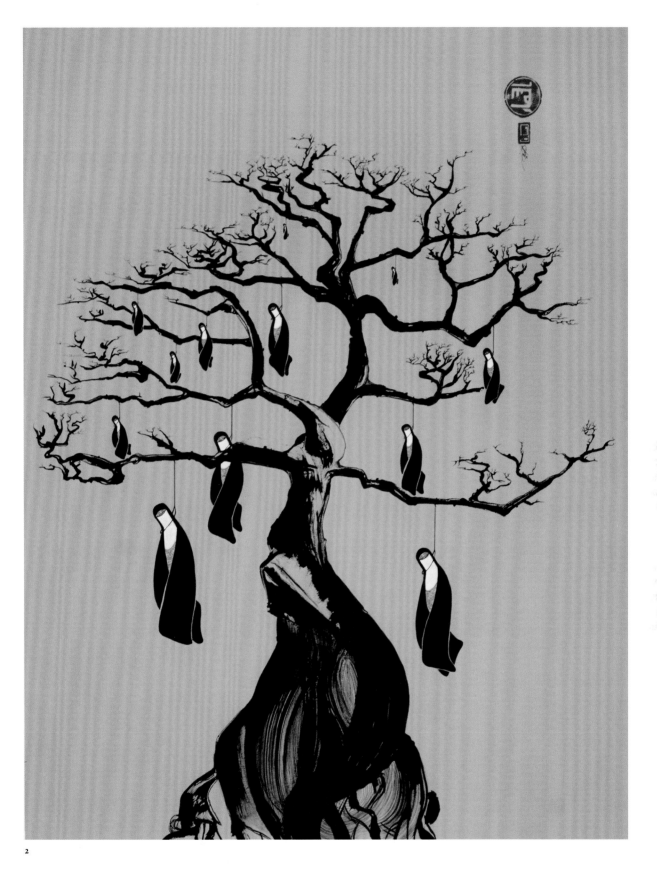

2

2. *Honour Killing*, 2006. Sumi ink
on paper. 76 × 60 cm (30 × 23 ⅗ in).

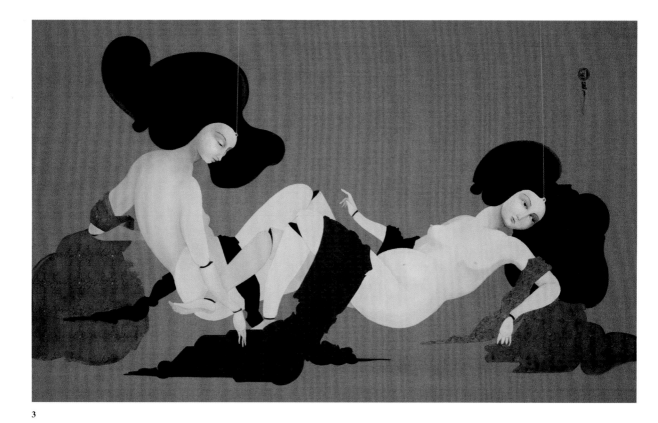

3

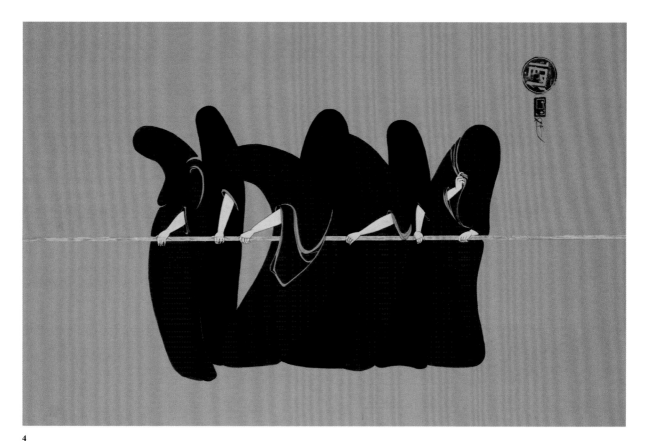

4

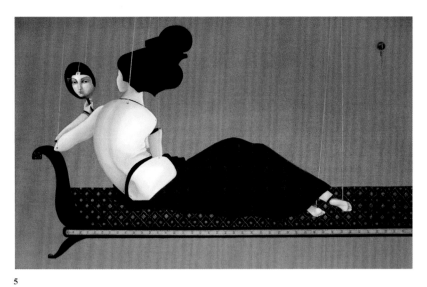

5

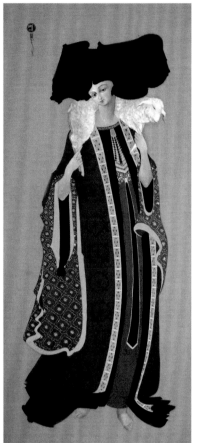

6

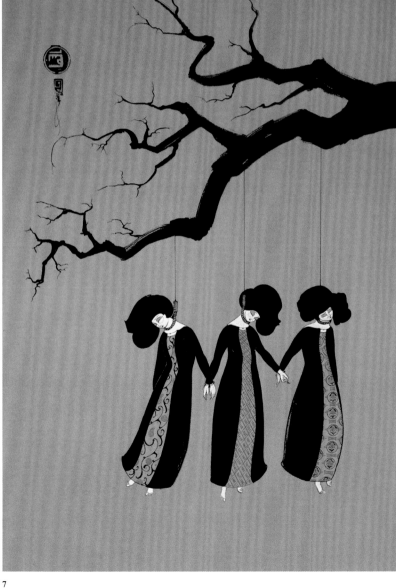

7

3. *Sexual*, 2009. Oil on linen canvas. 106 × 178 cm (41¾ × 70 in).

4. *In line*, 2007. Sumi ink on paper. 60 × 76 cm (23⅗ × 30 in).

5. *Toilette*, 2009. Oil on linen canvas. 106 × 173 cm (41¾ × 68 in).

6. *Carrying on shoulder 1*, 2008. Oil on linen canvas. 173 × 76 cm (68 × 30 in).

7. *Three women hanging*, 2008. Sumi ink on paper. 76 × 60 cm (30 × 23⅗ in).

Teppei Kaneuji 1978, Japan, www.teppeikaneuji.com, www.shugoarts.com

What draws you to the mass-produced objects you use in your work?

Most of them are not found but bought objects. I find it very fascinating to create a one-off phenomenon with materials that are replaceable and available to anyone. I like making things free from meanings, usages and names that are inherent in them, by bringing in new rules and restructuring things. I'm interested in creating works by leaving transformative or moulding materials untouched. I just let them flow freely.

Are you referencing childhood in some way?

I often get ideas and create works from my memories of a childhood of repetitive and meaningless play. I still cherish the feeling from childhood that I enjoyed creating my own imaginary place in a large enigmatic structure.

What do you find interesting about the relationship and contrast between the organic and the man-made in your work?

There are human beings and natural phenomena in the cities formed by organic movement, although they are constructed with large artificial structures. I feel a sense of reality in the repetition of clash and fusion. I move back and forth between the two extremes of organic and artificial things, and two and three dimensions – static and dynamic, light and shadow.

Your work can resemble miniature cities or temples.

It is important to shift the sense of scale in order to get rid of the meanings of ready-made objects. No matter how small the works are, I always try to represent large-scale things or phenomena. They are not miniature structures, but miniatures of large shapeless phenomena.

What do you like about the fragility of your work, with objects teetering in a delicate balance?

I feel a sense of reality with things that are not persistent, that form a structure or clump only for a moment and have a good chance of collapse or meltdown.

What interests you about pop culture and consumerism?

I treat such things as phenomena that construct our world, equal to natural phenomena, history and so on. I am interested in the fact that individuality or situation can be represented through things that people consume.

What do you like about drips?

I like them because they can make the fixed image fluid. They can add a sense of time. Sculptures with resin configure something similar to limestone caves or icicles, but at the same time appear to be a momentary shape of liquid; this is the gap that I like.

2. *White Discharge (Built-up Objects #4)*, 2009. Plastic, wood, steel and rubber found objects, pigment and resin. 201 × 87 × 87 cm (79⅛ × 34¼ × 34¼ in).

3. *Black puddle #4*, 2007. Collage with acrylic, gouache, ink, pencil, felt-tip pen and printed matter on paper. 188 × 236 cm (74 × 93 in).

4. *smoke&fog #3,#4, #5*, 2007. Plastic products and glassware. #3: 84 × 27.5 × 31.9 cm (33 × 10⅞ × 12½ in); #4: 61.4 × 19.5 × 25.9 cm (10⅛ × 7¾ × 24⅕ in); #5: 27.9 × 19.5 × 7.6 cm (11 × 7¾ × 2 in).

1. *Teenage Fan Club #20*, 2009. Plastic figures and hot melt glue. 44 × 33 × 28 cm (17⅓ × 13 × 11 in).

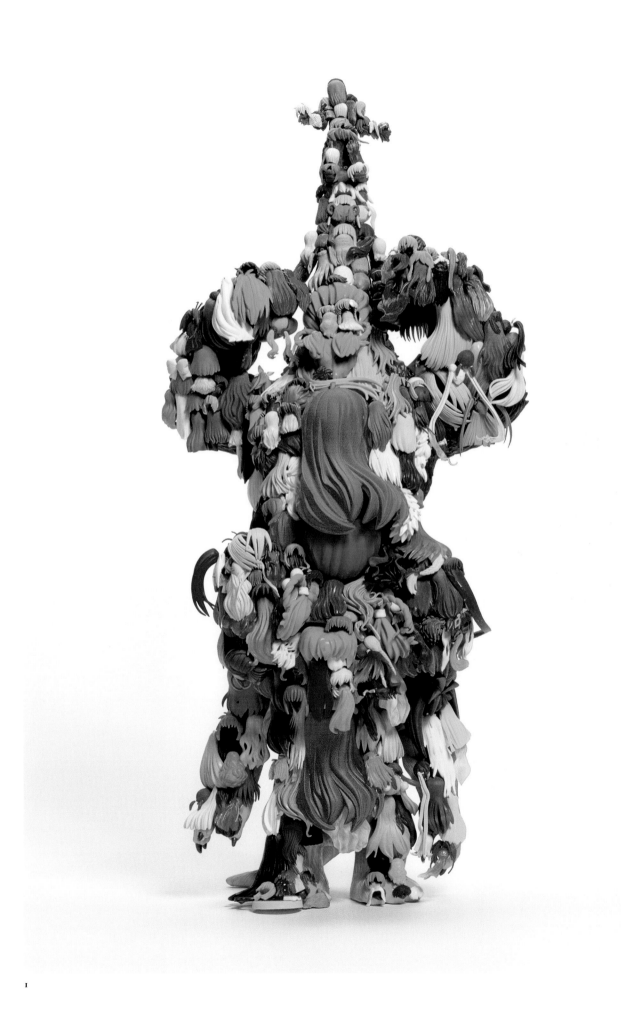

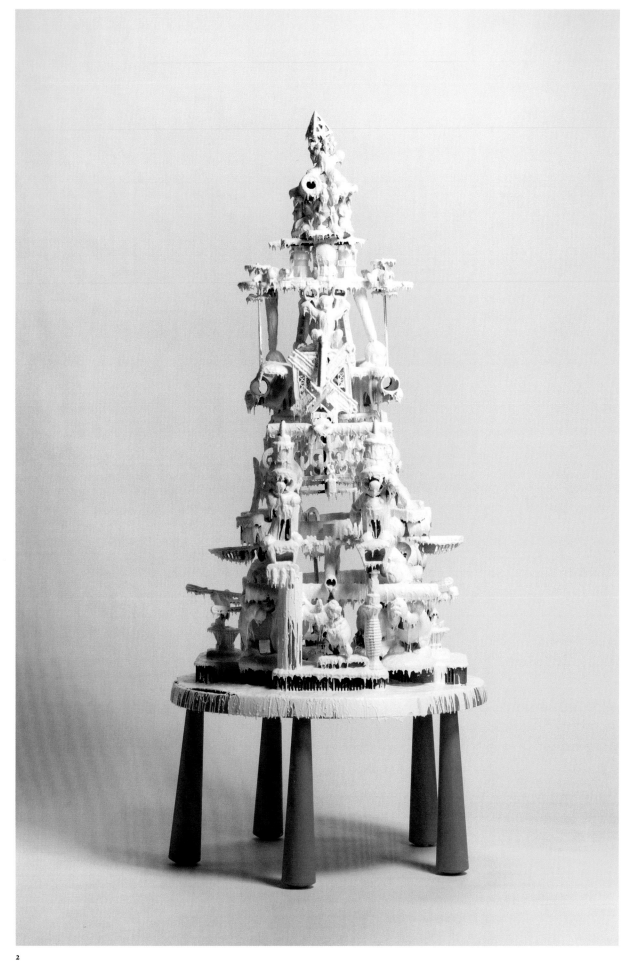

2

3

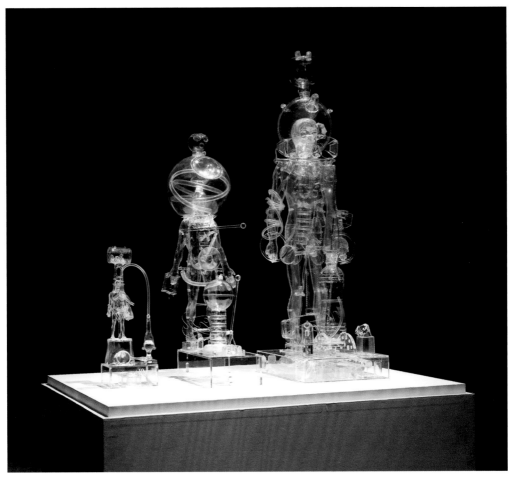

4

Dionisis Kavallieratos

1979, Greece, www.thebreedersystem.com, www.artnews.org/dionisiskavallieratos

Why are you attracted to using humour in your work?

Humour is a very serious thing. I see it as cruel, ridiculous, but beautiful. The world is surreal, so all I can do is laugh about it. Often jokes I tell to friends become artworks, although some are impossible to put into drawings or sculptures. Sometimes those works are satires of religion or politics; a fascist anarchist; a God-believing atheist; a Communist capitalist; an animal-loving carnivore.

What interests you about the imagery of pirates?

They were nasty and brutal but there is also something funny about them. The aura and the romance that surround them, the sea stories, the adventure, the fear, the freedom, the lack of ethics, the nice costumes, the smelly feet, the rum, the blood, the lust for gold, make them so exciting and their imagery so beautiful. But they are not my subjects. 'Pirrot the mighty' is obviously a caricature of power – you could say it was a conceptual piece. My aim was to make a political comment using the cliché of the pirate with the parrot on his shoulder. I play with male stereotypes. I'm a soft boy who wanted to be a macho man. So I just make fun of power, status, domination, authority…

What attracted you to Dante's Divine Comedy*?*

I opened the book with Gustav Doré's engravings of the *Divine Comedy* and found a very strong image of Dante and Virgil walking in Hell, Purgatory and Heaven. I put them in my world and replaced Virgil with Pellelo di Kavla (*kavla* in Greek means hard-on). He's a comic hero I created and have been using since 2005. He takes a lot of roles – the victim, the seducer, the evil guy, a symbol of purity and innocence, of earth's wealth, of hope.

What do you like about the absurd and exaggerated nature of comic faces?

I like dirty stuff, grotesque bad taste. It makes me feel good.

Are you interested in classical aesthetics?

The big burden of the past. I'm Greek and have grown up surrounded by ancient ruins and antiquities. It's a part of me naturally. I like dusty things. It's nostalgia. I often borrow stuff from history, literature, religion and mythology and I change or mix them together to make my own myths or 'immoral tales of morality'.

1

2

3. *The old bordello on the hill of sold souls #4*, 2009. Oil charcoal on paper. 170 × 220 cm (67 × 86⅗ in).

1. *Double nazi*, 2009. Oil charcoal on paper. 21 × 31 cm (8¼ × 12⅕ in).

2. *Not even a curly hair of Willem Tells balls*, 2009. Pencil on paper. 21 × 31 cm (8¼ × 12⅕ in).

4. *Seven dicks jesus offering a multi blowjob to Lernea Hydra, the nine-headed monster – the two remaining heads eat mana bread falling from the sky*, 2008. Pencil on paper. 21 × 31 cm (8¼ × 12⅕ in).

3

4

5

5. *What do you see?*, 2008.
Ceramic. 65 × 38 × 20 cm
(25⅗ × 15 × 7⅞ in).

6

6. *Pirrot the mighty*, 2008.
Ceramic, wood. 60 × 30 × 30 cm
(23⅗ × 11⅘ × 11⅘ in) approx.

Misaki Kawai 1978, Japan, www.misakikawai.com, www.takeninagawa.com

How are your style and content influenced by cartoons and comics?
I don't really read cartoons or comics, but when I was little, I read *Doraemon*, which was about a robot cat that lost his ears after they were eaten by a mouse. Japan is a cartoon and comic country. I think we always see cute and funny characters in everyday life – from medicine packaging to TV commercials.

What draws you to pastels or acid colours?
They are somehow home-made colours to me. I think fluorescent colours are very funny – unreal and cheesy.

What interests you about depicting sports and leisure activities as a subject?
When I am working on paintings or sculptures, I am usually indoors in the studio. So I wish I was doing something outdoors, like camping and swimming. One day I would like to have an outdoor studio, so I can paint indoor themes like reading a book on the couch or cooking a tomato, zucchini and eggplant omelette in the kitchen.

Why use papier mâché as a medium?
We use paper a lot in our daily life – in the kitchen, the toilet, newspapers. It's not a special material to use. Anyone can make art with it. The art is in our daily life.

Are you influenced by the Japanese idea of kawaii *(cuteness)?*
Kawaii stuff is easy to like – but I like to have a little punch with *kawaii*.

Do you think there is an innocence or naïvety in your work?
When I was a kid, I tried to draw realistic animals, but I always made something different. I grew to think it was more fun to draw in my own style. So I began to work in a home-made, perhaps innocent, way. That was the starting point of *heta-uma* – good sense, bad technique.

Is humour something important to you and the creation of your work?
I'm from Osaka, which is a comedy town. Even when some sad or bad thing happens, we make it into a funny story, so it doesn't seem so heavy.

What do you find interesting about flatness in your work?
Flatness gives the work some kind of unreal element. It makes it lighter.

Do you consider your work to be pop?
Pop is usually fun, light and colourful – so yes, I think my work is kind of pop.

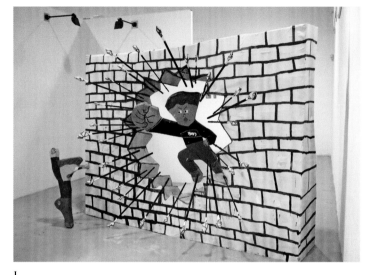

1

1. *Big Break*, 2007. Acrylic, cardboard, fabric and wood. Dimensions variable.

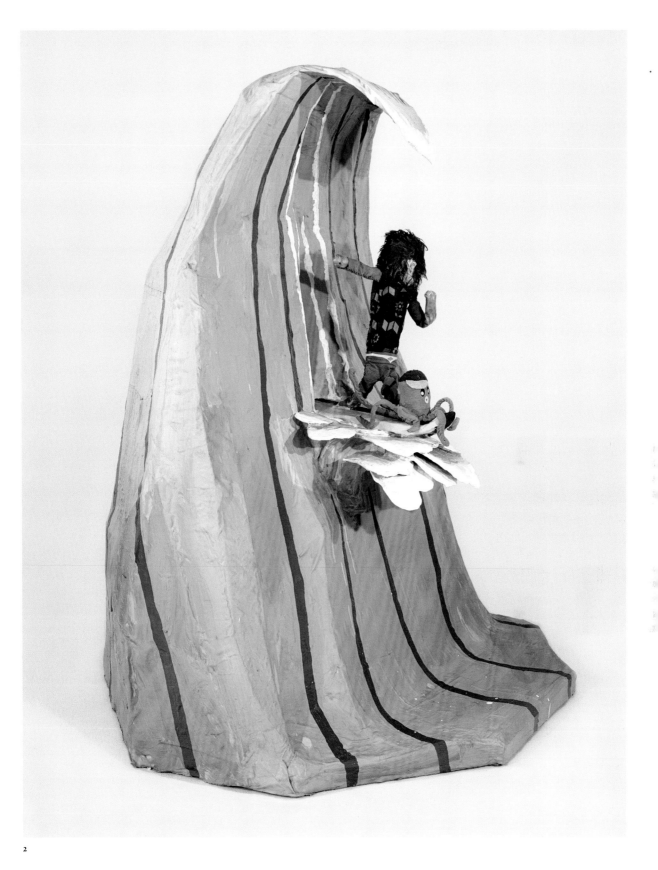

2. *Surfin George*, 2008. Acrylic,
cardboard, fabric, paper, wire
and wood. 91.4 × 94 × 116.8 cm
(36 × 37 × 46 in).

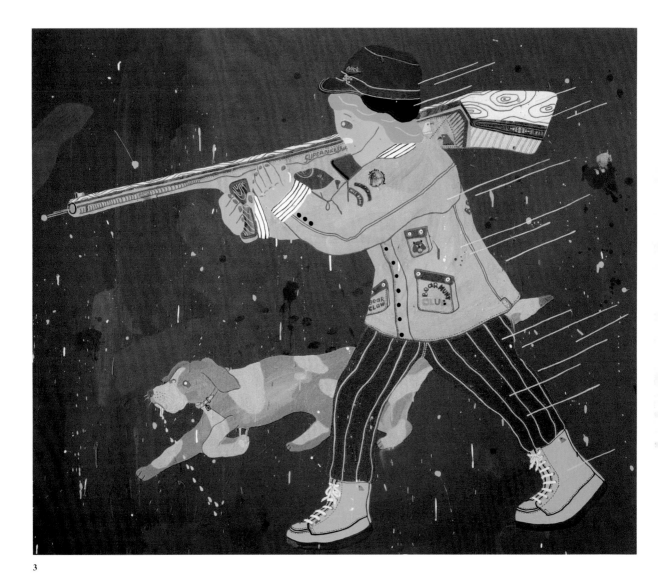

3

3. *Bear Hunt Club*, 2007. Acrylic,
fabric and paper on canvas.
152.4 × 182.9 cm (60 × 72 in).

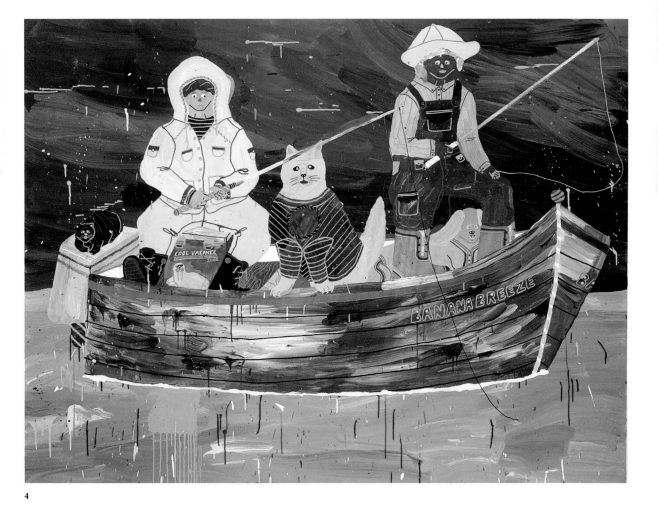

4. *Alaskan Vacance*, 2008.
Acrylic and paper on canvas.
152.4 × 203.2 cm (60 × 80 in).

Irina Korina 1977, Russia, www.xlgallery.ru

Is Russian history something that you want to address in your work?

The dramatic events of the late 1980s and early 1990s changed this country. These complex experiences are very important for me. Practically all my works are rooted in this history. Places and surfaces became different. We experienced the emergence of Euro-renovation, based on the empty white space instead of the typically wallpapered Soviet apartment. This Euro-renovation embodied the whole epoch of the 1990s. My first installation, *29 Transformations*, was connected to it: the white sterile room is distorted by swollen tumours that appear on the walls. The new sterile design conceals menace.

Why did you start working with disposable or discarded materials?

In 2005, when I designed the *Modules* sculpture for the 1st Moscow Biennale, I decided to use cheap decorative plastic panels with photo-printed textures. All the building suppliers were full of this inexpensive stuff. For me the material is significant: it is obviously fake; the low-price disposable coating mimics very expensive decorative materials like marble, malachite or Karelian birch. I like the virtual character of this stuff; while simulating reality it always reveals its artificial origins. The supernatural simulation of these plastic textures reminds me of the surfaces in computer games.

What interests you about architectural structures?

Architecture creates spaces and structures movement. It surrounds us and bears historical information. All this is very important for my work.

Do your organic and visceral sculptures reference the human body?

I like the violent contrast that comes from the junction of flexible soft bioforms with rigid architectural structures.

Is narrative important to you?

What's really important to me is the story or impression, which often triggers the creation of a new work; though it is also important to extract from this story some inner logic or system. Frequently the viewer can hardly recognize my story without explanation, but I don't feel uncomfortable about that. It is important for me that the viewer can perceive the structure inside my work and experience emotion.

What attracts you to using something functional in an irrational way?

I like shifting the point of view. I like freedom from irrational acts, as if they have dropped out of the system.

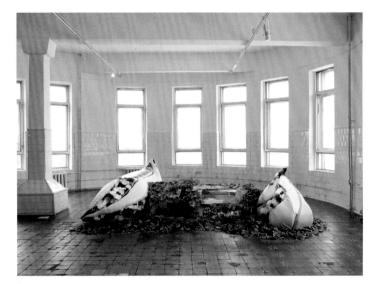

1

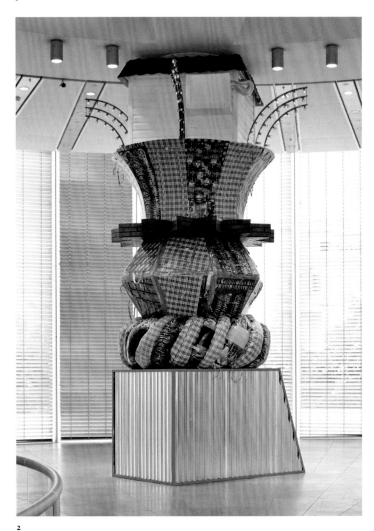

2

1. *Untitled*, 2008. Wood, plastic tablecloth and dry leaves. 300 × 300 × 300 cm (118 × 118 × 118 in).

2. *Column*, 2009. Metal, plastic and lamps. 250 × 170 × 650 cm (98⅜ × 67 × 256 in).

3. *Fontane*, 2009. Wood, metal, lamps and plastic tablecloth. 300 × 400 × 450 cm (118 × 157½ × 177 in).

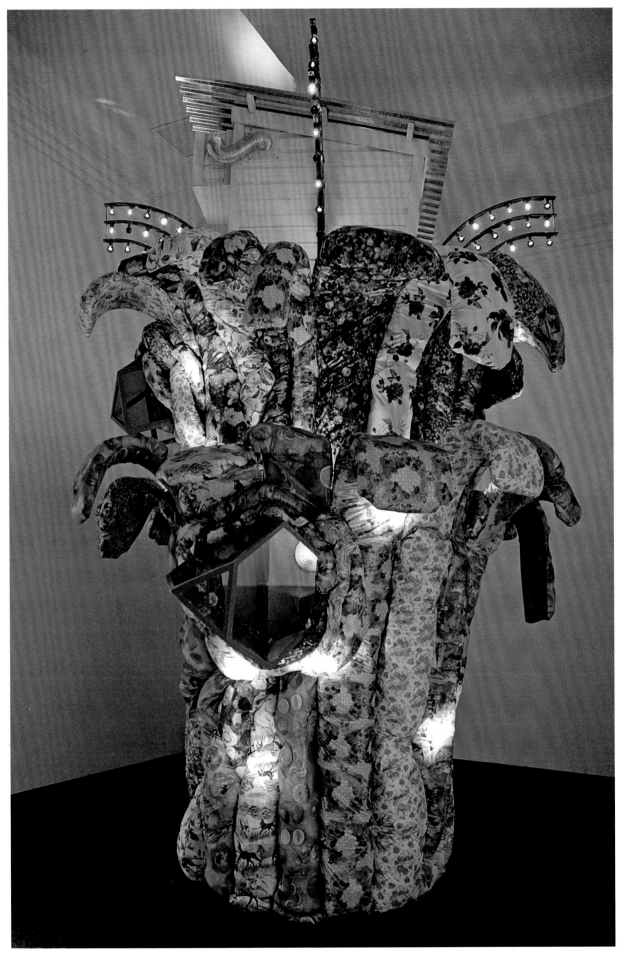

Jompet Kuswidananto 1976, Indonesia, www.thirdrealities.blogspot.com

What attracts you to using electronic media in your sculptures and performances?
In the society I live in, there is an interesting interaction between traditional and modern knowledge. We have a short history of modern technology, but we seem to be very dependent on it. In my society, there is mystery and magic in electronics and modern technology. I'm interested in the tension between modern and traditional. I only learn how to use electronics on the surface. I just understand a few basic ideas and let the rest stay in the dark as a mystery, or even as a divine power.

What kind of comparison are you making between the machine and Javanese society?
I like to describe Javanese culture as a machine: how it works; what the fuel is; who the engineers are; how it is broken, and so on.

Is there a political element to your work? Particularly in pieces that highlight Indonesian colonial history, such as Java's Machine: Phantasmagoria*?*
It's more anthropological. It's more celebratory than critical. That piece doesn't highlight the colonialism, but more the cultural interaction between Java and other cultures; how the negotiation goes, and what is the result.

How and why have you used sound as an element in your sculptures?
I used to be a musician. The sensibility of sound is still with me. In my installations, I use sound to create a dramatic ambience as well as send a verbal message. In my experience, sounds have a strong power of penetration.

What is your approach to performance?
I made performance pieces at the very beginning of my career. Most of them were music and sound performances. At that time I did it as a playful project, with no deep conceptual background. I was just experimenting with different ways of performing music and sounds. I make very few performances now, to strengthen and widen the message of an existing installation.

What do you find interesting about examining history and progress in your work?
The long history of Java shows how they have managed multicultural interactions and how a new culture has been produced. That kind of interaction is still happening across the world. The Javanese history of modernization is interesting to share because of the genuine way Javanese traditional culture has merged with modern culture. The process is still going on even now.

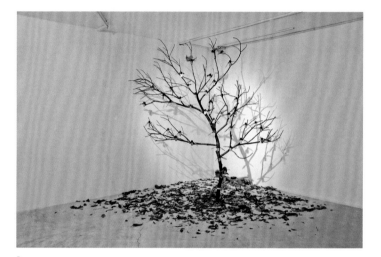

1

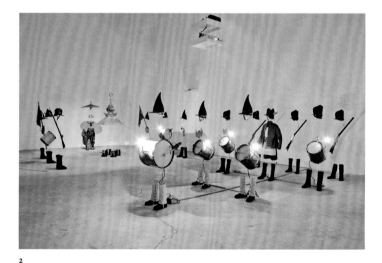

2

1. *New myth for new family*, 2009.
Installation. Dimensions variable.

2. *Java, the war of ghosts*, 2009.
Installation. Dimensions variable.

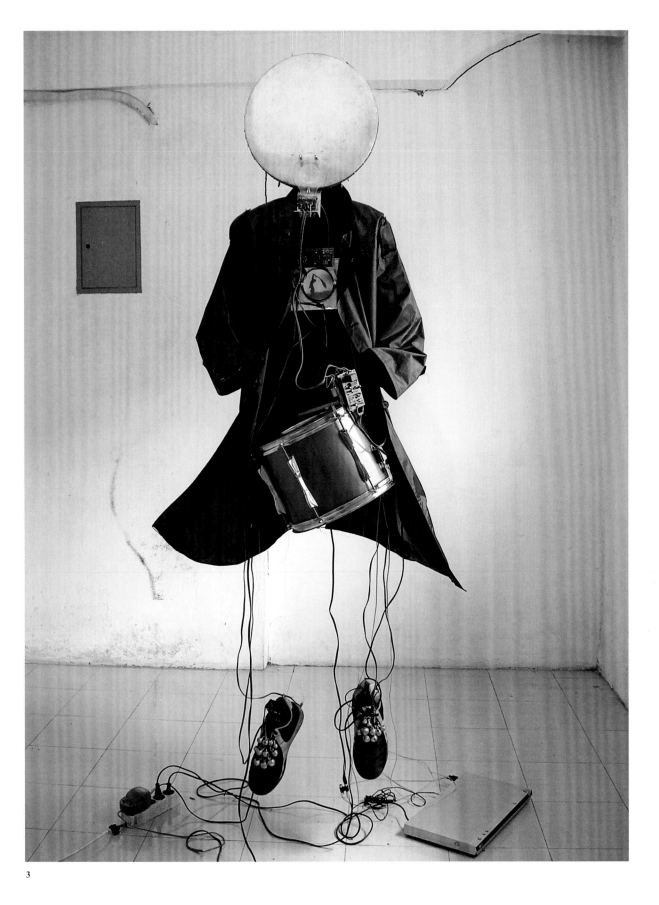

3

3. *Java-Amplified*, 2008.
Installation. Dimensions variable.

Oliver Laric 1981, Armenia, www.oliverlaric.com, www.seventeengallery.com

What interests you about using the Internet as a medium?
I'm interested in using the Internet as a space of primary experiences. My work is as authentic online as it is in a gallery setting.

What music is a source of inspiration for your work?
50 Cent, Bach and R Kelly.

What interests you about using amateur music performances posted online, for example in your 'Stevie Wonder duets' or '50 50' series?
The possibility of endless variations of standardized note combinations, and the shift of the definition of the amateur.

Tell me about the idea behind the Versions of Under The Bridge *installation?*
'Under The Bridge' [by the Red Hot Chili Peppers] is reconstructed note for note, using videos of performances by hundreds of musicians found on YouTube. The videos are freely available and easily accessible. It seems like there is no more need to record material. I am excited to find ways of dealing with the existing material.

What do you find interesting about disseminating your work online, so it is often viewed on-screen?
It is liberating to have a space that does not depend on the approval of gatekeepers. There is little financial investment; it's an off-site space at two euros per month. Work can travel to different sites and audiences without your personal involvement. Other people do the work of spreading your work for you.

What interested you about the manipulation of digital imagery in Versions?
I think there is no more adventure in the identification of manipulated images. I am interested in the levelling of diverging versions.
In some cases, manipulated images become more authentic than their precursors, as with the Iranian missile incident mentioned in *Versions*.

What do you find interesting about doubles and reworkings of a single object or image?
The idea of multiple realities coexisting. If the physicist Hugh Everett is right, every possible outcome within the restrictions of physical law is realized. The remix exists parallel to the bootleg, cover version, variant, reinterpretation, copy, double and duplicate.

1

2

1. *50 50 2008*, 2008.
Video, 2 mins. 6 secs.

2. *50 50*, 2007. Video, 2 mins. 6 secs.

3

3. *Versions*, 2009.
Video, 6 mins. 25 secs.

Bo Christian Larsson 1976, Sweden, www.bochristianlarsson.com, www.steinle-contemporary.de

Why do you play with feelings around fear and anxiety?

I feel that there are so many more sides to the human mind and spirit to be explored. An important element of my work is the humour that hides within these moments of fear. The fear and anxiety in my work is really about darkness and melancholy. I believe they present a more honest and true image of life than a completely happy one. We don't live in a utopia.

Why are you interested in performances without an audience?

The performance aspect of my work is the direct translation of the act of drawing, which is really the root of my practice. The performances are the catalyst that brings the work into reality, much like the moment when Dr. Frankenstein's monster gets hit by lightning and becomes alive. They don't require an audience. The performances are more about the immediate experience for the ones involved. The result of these rituals is what is interesting for an audience to see. Allan Kaprow always said, 'There are no viewers, only participants'. I do, however, always film or photograph the performances. Rituals are a good way for humans to connect the mind to the spirit, the psychological to the emotional. In my work I often try to focus on the rite of passage, a celebration of human development. I believe that it is very important to consciously leave things behind to be able to move on and evolve. Life is a ritual.

What role do black wigs play in your performances?

The black wig is mostly worn by my alter ego, 'Sonuvabitch'. He wears the wig backwards with the hair hanging over his face, so that in a sense he is blinded by it and forced to look towards his internal world. By covering facial expressions, it intensifies the movements of the figure, bringing it closer to a sculptural object.

Why are you drawn towards symbolism and the mysterious?

I use symbols very often as a gesture, to question where or to whom a symbol belongs. An example is my use of the cross, which is such a loaded symbol. If you exaggerate the use of the symbol of the cross, I think it becomes interesting to think of it beyond Christianity, to look at it more as an object or form. Really it is an horizon broken by a figure.

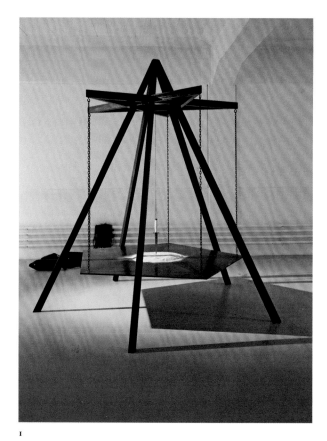

1

1. *The Earthly Whisper*, 2009. Steel, sand, plastic, wig hair and knife. 210 × 210 × 220 cm (82¾ × 82¾ × 86⅗ in).

2. *Violence is Golden*, 2009. Wood and messing bell. 176 × 186 × 270 cm (69⅓ × 73¼ × 106⅓ in).

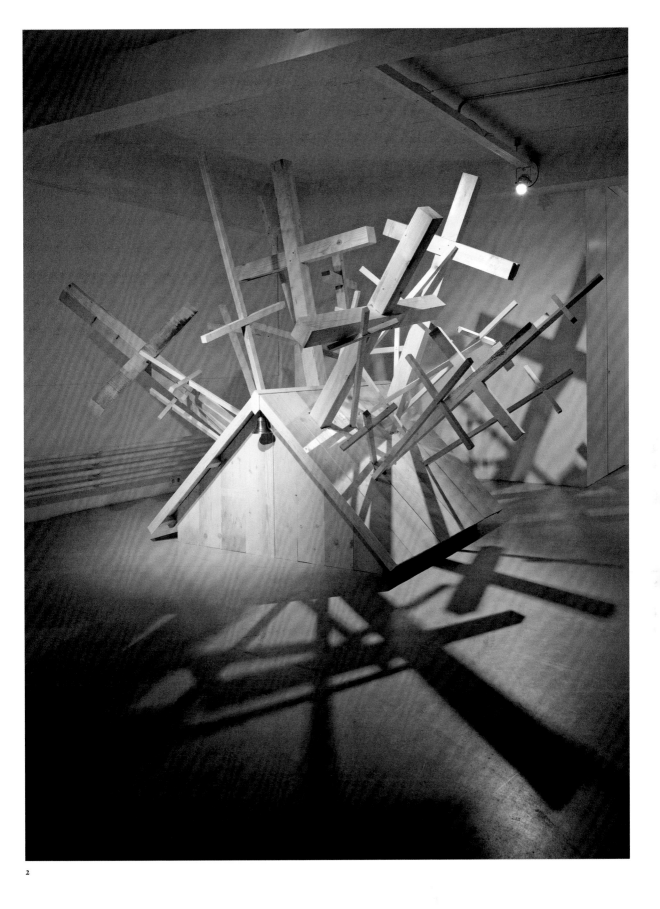

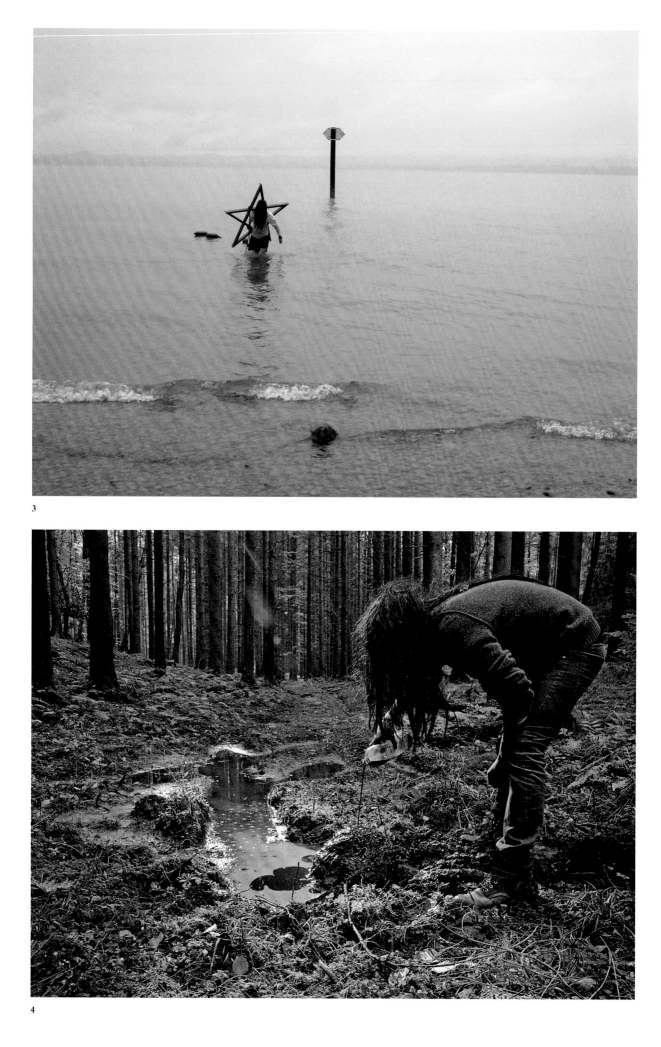

3

4

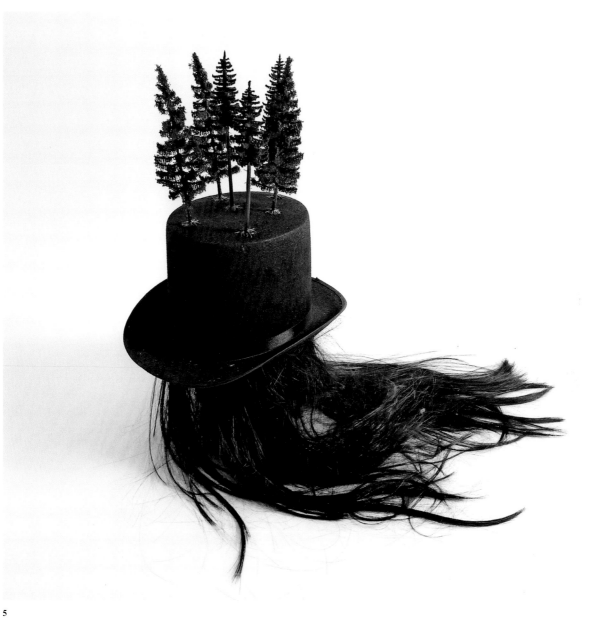

5

3. *Lost And Found*, 2009. Video still of performance. Length: 3.34 mins.

4. *Welcome to The Jungle*, 2008. Still of performance. Length: 6 hours.

5. *Storm Hat*, 2009. Cylinder hat, model trees, spray paint, balsa wood and black wig. 50 × 35 × 55 cm (19¾ × 13¾ × 21¾ in).

José León Cerrillo 1976, Mexico, www.proyectosmonclova.com

How are you influenced by and commenting upon the heritage of modernism?

I am a product of the wreckage of modernism. I am a product of the refusal and the collapse of the Modern Project. It is within the limits of its failure, and the dystopian jumps to progressive understanding, that I can scavenge something to be abolished and produced simultaneously.

What interests you about playing with the aesthetics of graphic design?

My interest in graphic design has to do with the act of communication. I am interested in the organization of information and the way it is set up to be read. There is always a phantasmic underlying structure in everything that supports what is being said. Design is a restrained form of communication that is often built on and being sustained by what is omitted.

What do you find interesting about structures and architecture in relation to your sculpture?

The subject must be negotiated in relation to the object. I think of my sculptures more as architecture and structures to work with, rather than as contemplative things in themselves. It is in the construction of the subject that I situate my structures. Just as architecture, in order to be architecture, needs the passing of a body.

What interests you about abstraction?

It is not abstraction in itself that interests me, but perhaps abstraction in a system of representation. The problem being that, if abstraction is thought of as a means to an end, it could very well change into something rather concrete. That interests me more.

How do Mexican society, culture and politics influence your work?

It is impossible for me to disassociate my work from that cultural legacy. Mexican modernism is an important historical constituent of the current state of things, despite its failures and misgivings – both in an urban sense and within the socio-political fabric. I live in Mexico City, where cultural internationalism pretends to shape the city and its dwellers. The need for 'a modern city for a modern Mexican' was created as a way out of twenty years of civil unrest. Fuelled by modernism, a radical urbanization programme was put into effect under the pretence of national unity. Such 'experiments' paved the way for further political control and decay. The interesting thing for me is the way in which such pretensions are cannibalized and transformed into something else, something contradictory and resistant.

1

1. *Ampersand & Ampersand,*
2007. Silkscreen on wood. Each
panel: 90 × 60 cm (35²⁄₅ × 23³⁄₅ in).

2

2. *Vodka y Valium (almost invisibility, again)*, 2007. Silkscreen on plexi, enamelled wood. Each panel: 185 × 150 × 4 cm (72⅖ × 59 × 1½ in).

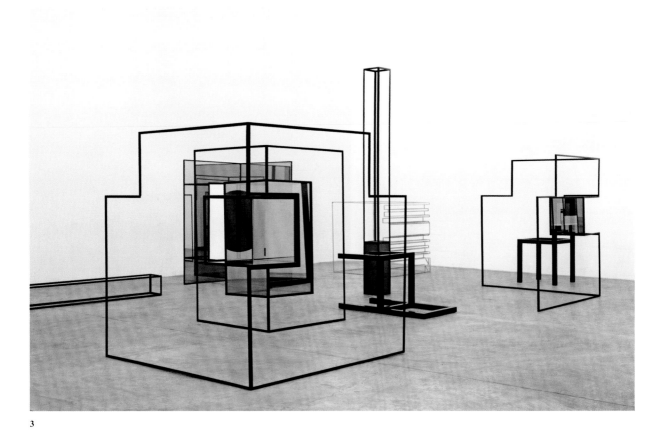

3

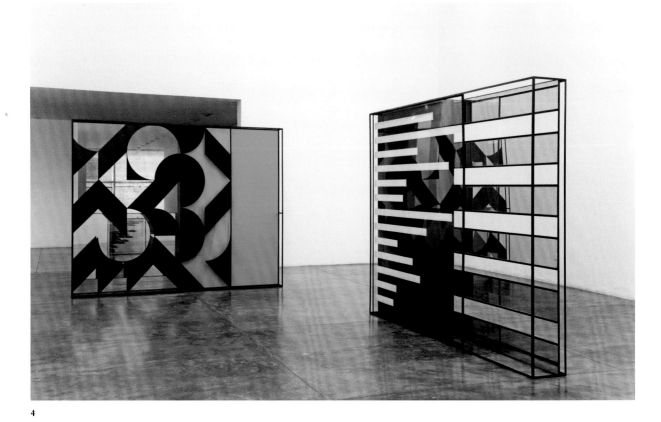

4

3. *Hotel Eden*, 2009.
Metal and double-sided mirrors.
Dimensions variable.

4. *Participante 1, Participante 2*,
2007. Silkscreen on plexi,
enamelled wood and double-sided
mirror. Each: 270 × 193 × 40 cm
(106⅓ × 76 × 15¾ in).

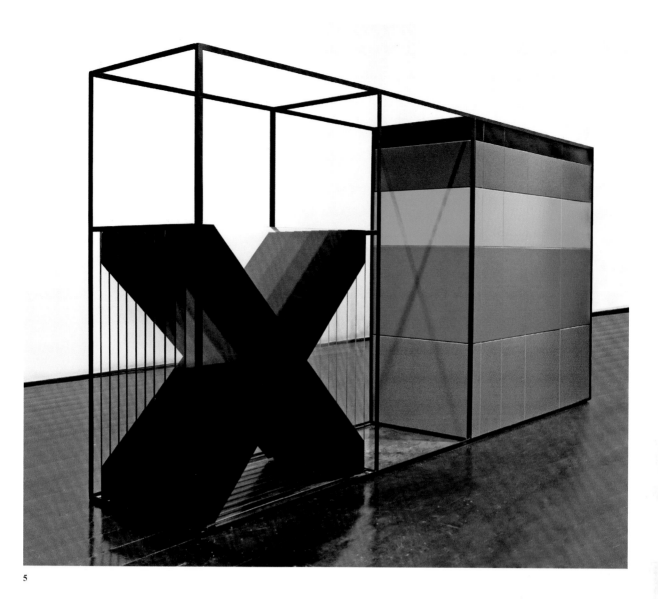

5

5. *Alias, Participante 2*, 2007.
**Silkscreen on plexi, enamelled wood
and metal.** 110 × 237 × 43 cm (43$\frac{1}{3}$ ×
93$\frac{1}{3}$ × 17 in).

Littlewhitehead 1980 and 1985, United Kingdom, www.littlewhitehead.com

Are you interested in ideas about the uncanny or the sinister?

These ideas are always evoked from the use of realistic life-size figures. Our figurative work is no different as we often life-cast to make it. Casting creates an interesting paradox. It embodies presence and absence, reality and fiction. What viewers are presented with looks both familiar and foreign. Consequently, many viewers do feel uneasy in the presence of our sculptures.

Is narrative important to you?

We think work using a very accessible visual language therefore evokes a strong sense of narrative. Viewers often prefer to revert to narrative as a means of negotiating the work. However, we never begin working with a narrative in mind. We prefer to shift the construction of the narrative onto the viewer, where the work stimulates their memory and forces them to construct a story. Viewers step into an enigmatic moment in which they have lost their bearings, and the only way to negotiate it is through a process of deduction, supposition and an attendance to the hierarchical, psychological disposition of the composition. The narrative in the work is always multi-layered, fractional, nebulous and heavily dependent on one's own private history.

Are you interested in the theatrical?

We're not sure if we like the word theatrical. Our work is informed greatly by cinema, with its content, aesthetic and building process. The special effects used in many old B movies are great and relatively attainable with no money. We usually find clips on YouTube, then risk poison and dust inhalation trying to emulate them.

What interests you about the relationship between reality and unreality in your work?

So many of the sources that inform our view of reality are fictitious. It becomes increasingly difficult to differentiate between the fictionalization of the real and the realization of a fiction. Our starting point can easily be either real or fictitious. The origin always becomes fictionalized in our dialogue. Therefore, the final outcome is always a heightened version of itself – a fiction masquerading as the real.

How and why are you incorporating movement into your sculptures?

We're intrigued with animatronics and how they correlate to some absurd repetitious life cycle – something happening again and again and again. Movement adds to the voyeuristic element of the work. No longer are viewers just looking at an inanimate object; they are witnessing an event. There is nothing neutral or impassive about the act of witnessing.

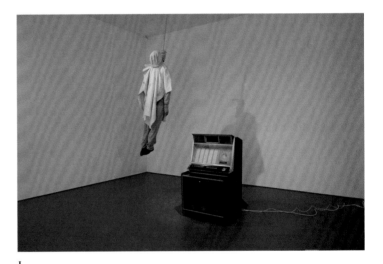

1

2

1. *Nine days, seventeen hours, thirty-two minutes, six seconds*, 2009. Installation at Eleven Howland, London, mixed media with audio. Dimensions variable.

2. *Black Smoke Machine Gun Club*, 2009. Installation at Royal Standard, Liverpool, mixed media with audio and smoke. Dimensions variable.

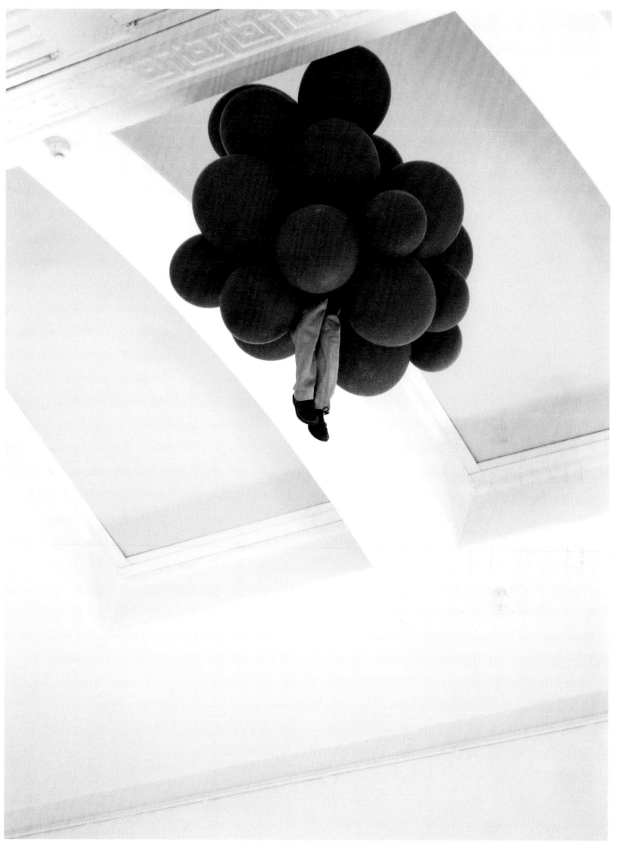

3

3. *Sentient orbs*, 2009. Installation at
Talbot Rice Gallery, Edinburgh,
mixed media installation.
Dimensions variable.

Arnaud Loumeau 1979, France, www.myspace.com/arjulo

Why use such vibrant colour?
Shapes and colour accumulation can make
drawings move. The more the structure is com-
plex, the more the viewer gets lost. Some
shapes start to flash and to stir. I like it when
the eye is excited, not sure of what it sees; when
the brain can no longer register information
and is disconnected.

What do you like about monsters and aliens?
Imagination has an important role when it
comes to interpreting and deforming reality.
I'd like the viewers to project themselves into
the drawing and find shapes they know, their
fears, their own monsters. Drawing monsters,
supernatural animals or aliens allows me to
get away from reality. They're part of collective
memory and act like archetypes. I like Jung's
idea of the totem animal. We may have inside
us some primitive symbols that link us to
nature and bring us closer to our animal or
primitive side.

What do you find interesting about optical art?
It pushes the relationship between the eye and
the brain to its limit. Drugs and intensive use
of video games can have the same effect. I'm
fascinated by the idea of representing the per-
ceptions of an addicted brain. Optical art is
based on optical illusion and on retinal vibra-
tion. Our eyes are not able to look at two
coloured, fiercely contrasted areas. That spa-
tial interference phenomenon perfectly suits
my interests.

*How do pixels, video game culture influence
your work?*
I'm from the generation that has seen the first
games consoles in their living-rooms. I used to
have an Atari 2600 and I spent hours playing.
Some of the games' layouts have certainly in-
fluenced me. I decided to see pixels from a dif-
ferent point of view and represent them
through drawings.

Why do you work on grid paper?
The pixels only wait to be filled in. The grid,
with or without pixels, questions scale, space
and proportions. It exposes ideas around the
(mal)function of human visual systems.
Illusion is an erroneous perception, a wrong
analysis, and that's what I'm interested in.

How does abstraction come into play?
I like the idea of being able to project myself in
the drawing, to be able to project my subcon-
scious and why not my whole self? Mandalas
allow that kind of transfer. Abstract shapes
open the subconscious and show in reality
shapes that are often hidden.

1

2

1. *Moon island*, 2009.
Pen & coloured stickers on paper.
29.7 × 21 cm (11⅗ × 8¼ in).

2. *Orange and blue*, 2009.
Felt pen on graph paper.
29.7 × 21 cm (11⅗ × 8¼ in).

3. *Sekhmet*, 2008.
Felt pen on graph paper.
29.7 × 21 cm (11⅗ × 8¼ in).

4

4. *Head pump*, 2009.
Felt pen on graph paper.
29.7 × 21 cm (11³⁄₅ × 8¼ in).

5. *Golana*, 2008.
Felt pen on graph paper.
29.7 × 21 cm (11⅗ × 8¼ in).

Justin Lowe 1976, USA, www.galleriamanzo.it, www.fredericgiroux.com

Are you influenced by the idea of alchemy?
Alchemy was a central theme for the 'Meth Lab' series. The overarching ideas behind alchemy were used to relate holistic cooking in communities to the clandestine drug labs, the communities that were built around these practices and their accompanying rituals and psychoses.

Tell me about the process of creating your installations.
It begins with a lot of research and writing, in order to create a proposal, budget and time-line. Sourcing, collecting material for the framing, the sheathing for the walls, ceiling, floors, the general electrical equipment, doors and props follow this. During this time all of the smaller, specific, mise-en-scène props are made, things like collages, photos and fake products, such as Sudafed. There is a lot of thrift store shopping, searching Craigslist and eBay, and attending estate sales. Then we go about installing everything and finish with an intense aging process.

Would you agree there is something filmic about your work?
Absolutely. The installation process is on a par with producing a movie set. There is always a specific trajectory planned so that the installa-tion can oscillate between small tight spaces and large open spaces. The viewer is always contained within the installation, except for brief fissures or portals that reveal the artifice. The transitions from one space, or scene, to another are very considered in terms of the duration of time and the amount of informa-tion to process. These transitions act as either jump cuts or slow fades.

What do you like about blurring the boundaries between the interior and exterior?
I like being able to present multiple perspec-tives at the same time. Quite often the installa-tions take on the quality of a dream sequence, where unsuspecting elements continually blend together, and yet there is always some kind of anchor. The reproduction of elements from reality acts as a short cut. It is a form of emotional engineering.

What do you like about narrative emerging from physical spaces?
I like the balance between these large sprawl-ing spaces and some of the restraint that has to be exercised in order to leave things open to interpretation. That is why there is a lot of hybridization with rooms, so they can be more than one thing at a time; which in turn complicates the reading and lends itself towards a manifestation of the fractured and polymorphous nature of altered states of consciousness.

1

1, 2, 3. *Werework Karaoke / Matrix 159*, 2009–2010. Immersive installation at Wadsworth Atheneum Museum of Art. Dimensions variable.

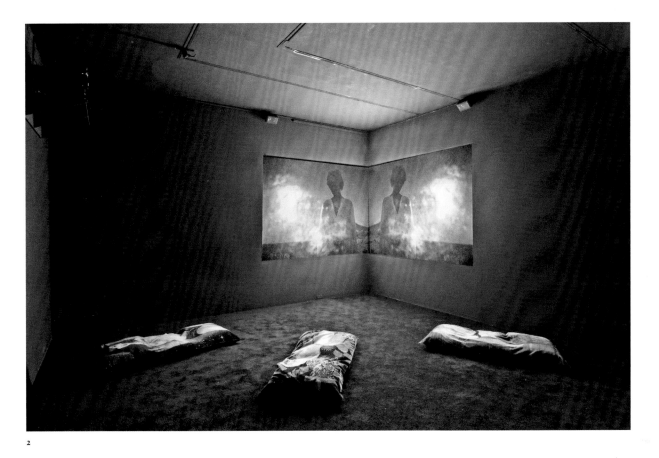

2

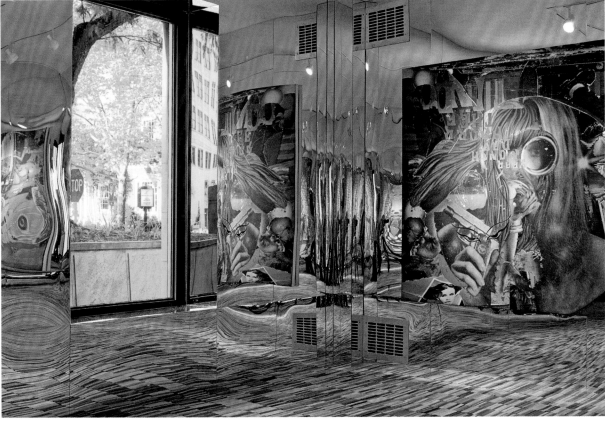

3

4

5

4, 5, 6, 7. *Black Acid Co-op*, 2009.
Collaboration with Jonah
Freeman, immersive installation
at Deitch projects. Dimensions
variable.

6

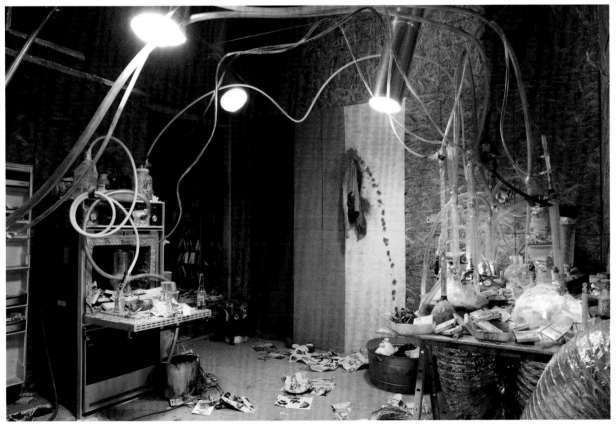

7

Eddie Martinez 1977, USA, www.eddiemartinez.biz

What interests you about bold colours?

I work really fast and just grab whatever colour is near me. The decisions are made in haste.

There is a raw texture to your paintings.

I can't stand to see the duck of the canvas come through in my paintings, so I use a lot of gesso and just start painting. Often a surface will see several ideas and almost complete paintings before it is complete. This facilitates texture. It has now sort of become part of my language and style. I like to exhaust ideas and symbols and then move on.

How is your work informed by your personal life?

That is what it is all about for me, filtering my thoughts and experiences onto paper, canvas or wood – whatever the surface. Sometimes it takes me a while to figure out how to deal with life's circumstances. Making pictures is my best tool.

How do your drawings relate to the paintings?

Drawing is the starting point. I always draw, and then draw more. It's the fastest way to get ideas down. I aim to make paintings that translate as fluidly as drawings. If I make a drawing I really like, I'll hang it on the wall next to what I'm painting and snag bits and pieces from it.

How does your ceramic miniatures collection inform your art?

My mom collected them and put them in old printers drawers when I was a kid; now, when I travel, I collect them. They make me smile. They help me come up with ideas. I really like the idea of using them to make still-life paintings, because obviously the scale is all wrong. It's a great way to start one of my photorealist works.

Is telling stories important to you? Your paintings often depict situations that are unclear and disturbing.

I don't approach things with the idea of telling a story. It's more a stream of consciousness. I find myself wondering more and more what life is about. The idea of death is so abstract. We know it happens, but do we really accept it? I'm not sure I do. Some people, who are more advanced thinkers than myself, say we are a bunch of molecules, 'All but shadows and dust', and are just imagining existence. But I'm still sitting here on my physical couch, you know?

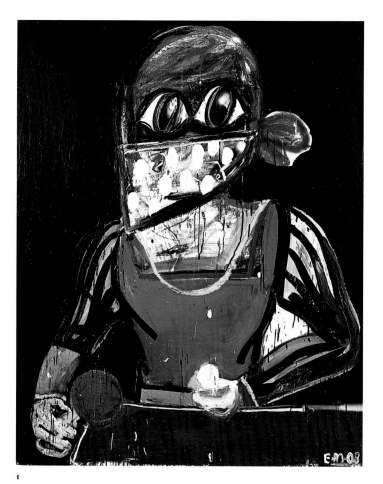

1

2. *Untitled (3063)*, 2007. Mixed media on paper. 22.2 × 27.9 cm (8¾ × 11 in).

1. *Live By The Paddle, Die By The Paddle*, 2008. Mixed media on canvas. 152.4 × 121.9 cm (60 × 48 in).

3. *Untitled (3231)*, 2009. Mixed media on canvas. 91.4 × 121.9 cm (36 × 48 in).

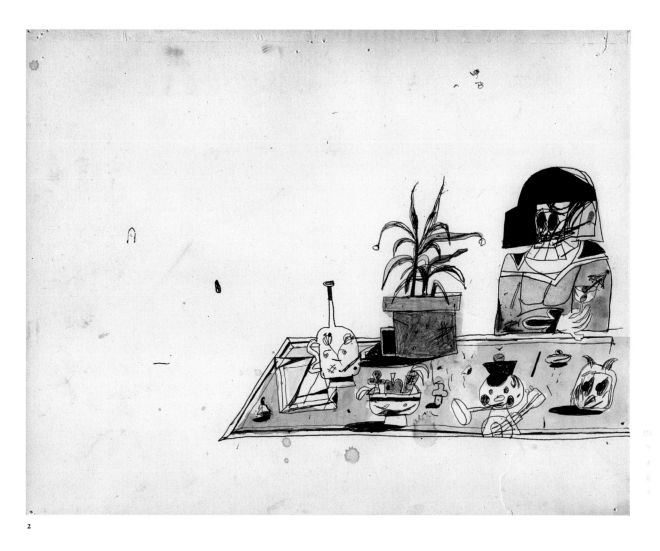

2

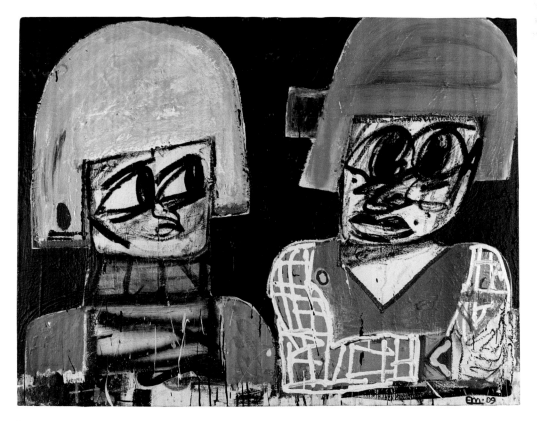

3

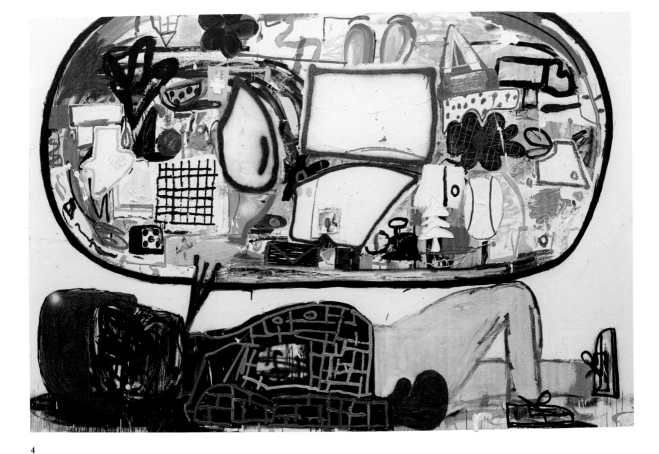

4

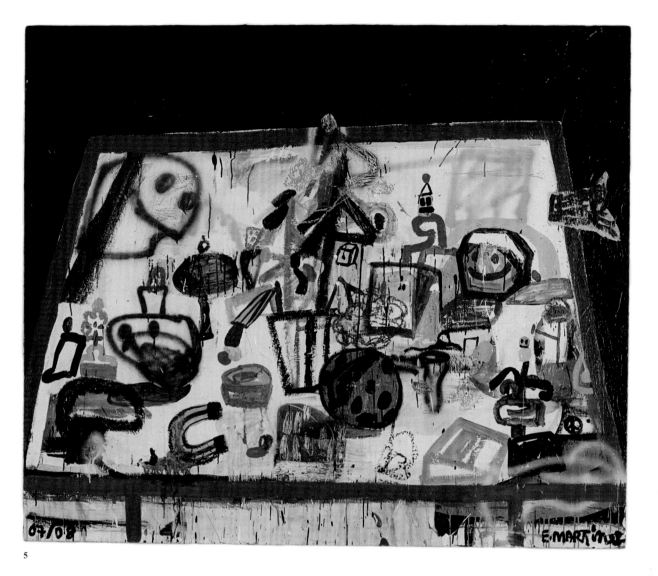

5

4. *They Build You Up To Knock
You Down*, 2009. Mixed media
on canvas. 182.8 × 274.3 cm
(72 × 108 in).

5. *You, Me And Scotty Z.*, 2008.
Mixed media on canvas.
152.4 × 182.8 cm (60 × 72 in).

Keegan McHargue 1982, USA, www.keeganmchargue.com, www.jackhanley.com

How do you use colour in your work?
I have had a long and tumultuous relationship with colour. I am pretty colour-blind, but I have never let it discourage me – perhaps the opposite. I have no real responsibility to commonly held beliefs of what works and what doesn't. I use colours freely and with no consequence. When it comes to colour, I feel open and extremely uninhibited.

What do you find interesting about flatness?
There is no hierarchy in any of my images. No one thing is more important than another. I place them equally on a flat surface. I'm not trying to depict the world as it appears through human eyes; I am trying to break down relationships between things that interest me through some form of collision on the surface of my work.

How do you think being self-taught has influenced your work?
I have followed my own trails of interest, learning and growing as an artist at my own pace. My knowledge and understanding of art have grown around my practice, not the other way around. Anything I ever wanted to achieve as a painter has been reached through experimentation. Perhaps this is why I often think about the surface of my works as pastiche.

What appeals to you about geometry?
I have virtually no understanding of the actual mathematics of geometry. As an artist, I tend to think of the universe as a series of complex and connected geometries. I am deeply concerned with shapes and how they work together.

What is the importance of narrative in your paintings?
I think narratives are often implied, but rarely drive the work forward. I like a more subtle, ambiguous story that reverberates under the surface of the painting. Often my subject matter comes from everyday life, or at least everyday life is the catalyst. I take it and process it, much like a musician takes a found sound, or a sample, and processes it beyond recognition.

What draws you to pattern?
I am both seduced and repelled by pattern. I find myself poring over books of historical patterns in admiration, but I also find myself overwhelmingly disgusted by the excessive nature of decoration. I like to use pattern when it is relevant; I just don't want to use it as a device to make things look pretty.

1

1. *Sterile Environment*, 2005.
Gouache on paper. 96 × 61 cm
(37 × 24 in).

2

2. *Investigation*, 2006. Acrylic on
panel. 88.9 × 101.6 cm (35 × 40 in).

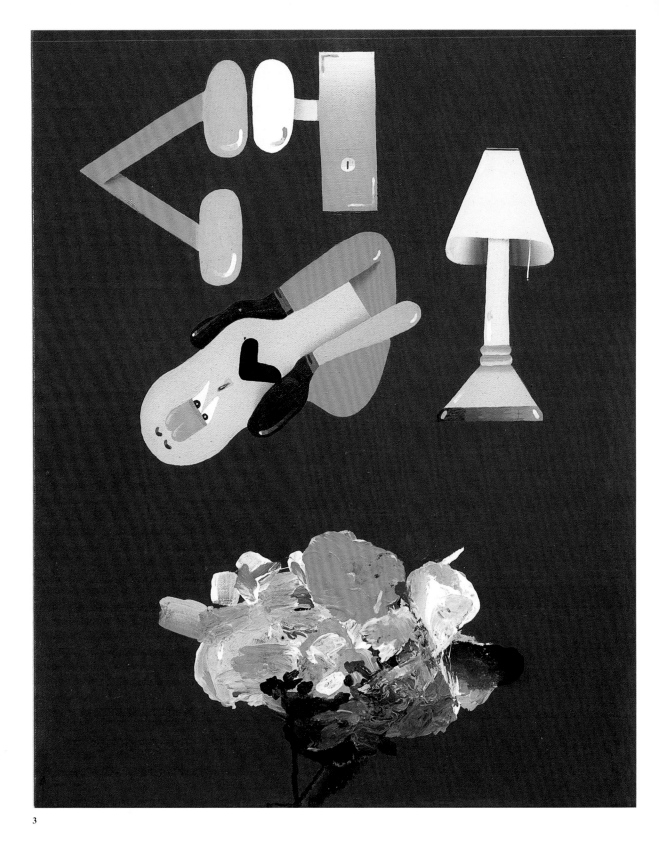

3

3. *Untitled*, 2009. Acrylic on linen.
40.6 × 50.8 cm (16 × 20 in).

4

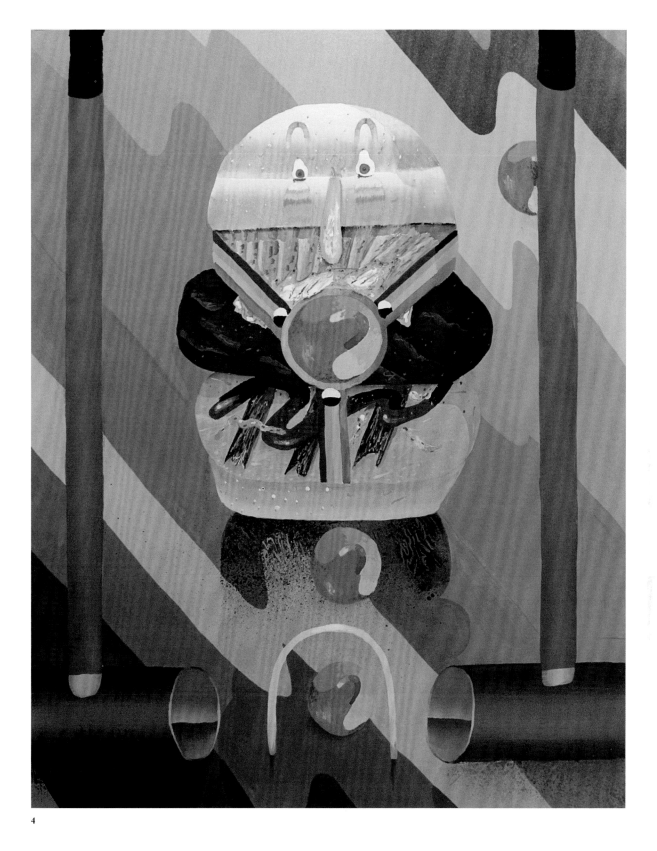

4. *Lawn Games*, 2007.
Gouache on paper. 72.5 × 59 cm
(28½ × 23¼ in).

What interests you about playing with codes of representation?

Photographs speak to us more about photography than about the real world. I start from this point and try to abolish the status of images. I play freely with different image types in a subjective way. The photographic medium carries an historical role of objectivity but it is also a medium for construction, negation and deformation. I like playing with that ambivalence by spreading doubt on content and process.

Your pieces have played with ideas around travel, spaces, perception and image culture. What do you draw from those subjects?

I am a frenetic traveller and architectural tourist as well as an archaeological and geological one. I guess I have a kind of romantic approach to territories and wide spaces. I need the physical experience of space and light. When I return from travelling, I focus on the symbols and the cultural and historical aspects of things and their relationship with aesthetics. The postcard project is a series of five photographs depicting archetypal landscapes. They are studio sets of landscapes made from cheap materials; so actually they are not landscapes but landscape simulacra. The series references archetypes and clichés. It is a synthesis of collective landscape memory.

You use a variety of high and low 'quality' media, from enlarged inkjet printouts from camera-phone images to large format photographs. Why and how do you exploit this approach?

My work questions both contemporary and historical imagery. I use different techniques for every project to get my point across. This ranges from low- to high-res recording devices to any type of available printing surface. Image technology as a means of distribution is evolving fast. I try to follow this evolution by experimenting with new tools and mixing them with historic ones.

You once wrote 'I believe in the constructive and destructive power of images'. Can you explain what you mean and how this influences what you create?

It is a personal thought about the impact some photographs have on appreciation. Even with the high image flux that society creates, and the dissolutive effect of such a flux, I still think that images contribute to creating and destroying mythologies.

Is there a sci-fi element in your work?

I prefer the term 'fantastic', which is wider. I am more interested in the *trait d'union* – the space between science and fiction.

1. *Monument (Japan)*, 2008. From 'The Space Between' series, C-print. 75 × 100 cm (29½ × 39⅖ in).

2. *Levant (Rise)*, 2007. From 'The Space Between' series, C-print. 75 × 100 cm (29½ × 39⅖ in).

1

2

3

4

3. *Cîmes A (Peaks A)*, 2006. From
the 'Postcards' series, C-print.
70 × 100 cm (27½ × 39⅖ in).

4. *Grotte A (Grotto A)*, 2006. From
the 'Postcards' series, C-print.
70 × 100 cm (27½ × 39⅖ in).

178

5

6

5. *Coucher de Soleil A (Sunset A)*,
2006. From the 'Postcards' series,
C-print. 70 × 100 cm (27½ × 39⅖ in).

6. *Forêt A (Forest A)*, 2006. From
the 'Postcards' series, C-print.
70 × 100 cm (27½ × 39⅖ in).

Nandipha Mntambo 1982, Swaziland, www.michaelstevenson.com

What first attracted you to cows and cowhide?
I was drawn to the organic nature of the material, as well as the various interpretations of cows within civilizations and communities throughout the world.

What do you like about the physicality of your work process and how does that influence what you create?
I really enjoy the fact that every hide is different and reacts differently to the chemical process I use, as well as the mould that I stretch it over. No sculpture is ever the same. The material itself is constantly changing as the sculpture is exposed to different situations.

What do think about the representation of femininity?
The female form is one that I see every day and understand on a certain level. As a woman, I have always been interested in how I am perceived and how this translates to different areas of my life.

What do you like about the tension between attraction and repulsion in your work?
I love the fact that the line between what attracts people to the sculptures and what repels them is so fine. People are attracted to the forms but repulsed by the hair and the smell of them.

What interests you about the relationships between cowhide and the female form, between the animal and the human?
What I find interesting is the subversion of boundaries. What is it that makes the animal so different from the human? How clear is the boundary and how is it determined? My interest in cowhide began from my love of forensic science – I wanted to be a pathologist. My interest in chemicals and organic matter has translated itself into my use of this material. My work is about myself, my relationship with my body, my relationship with my mother, her relationship with her body and all that's around me.

What attracts you to using the figure and absence of the figure in your work?
I have always been interested in the 'residue' – what's left behind from a process. My cowhide works are the residue of my artistic process.

Why explore bullfighting?
Bullfighting is a fascinating sport that is associated with patriarchy and colonialism. I am interested in reinterpreting the sport by taking on the characters of the audience, the fighter and the bull.

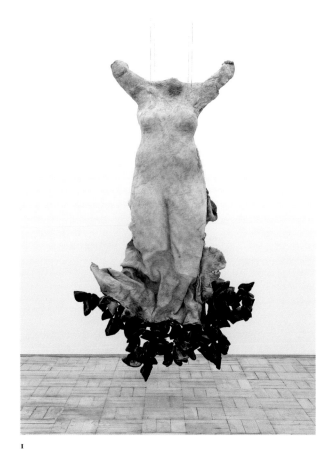

1

2. *Silence and dreams*, 2008.
Installation of 8 figures, cowhide, cows' tails, resin, polyester mesh and waxed cord. 245 × 650 × 300 cm (96⅛ × 256 × 118 in).

1. *Nandikeshvara*, 2009. Cowhide, cows' hooves, resin, polyester mesh and waxed cord. 183 × 110 × 26 cm (72 × 43⅓ × 10¼ in).

3. *Praça de Touros I*, 2008.
Archival pigment ink on cotton rag paper (edition of 5 + 2AP).
112 × 163 cm (44 × 64⅛ in).

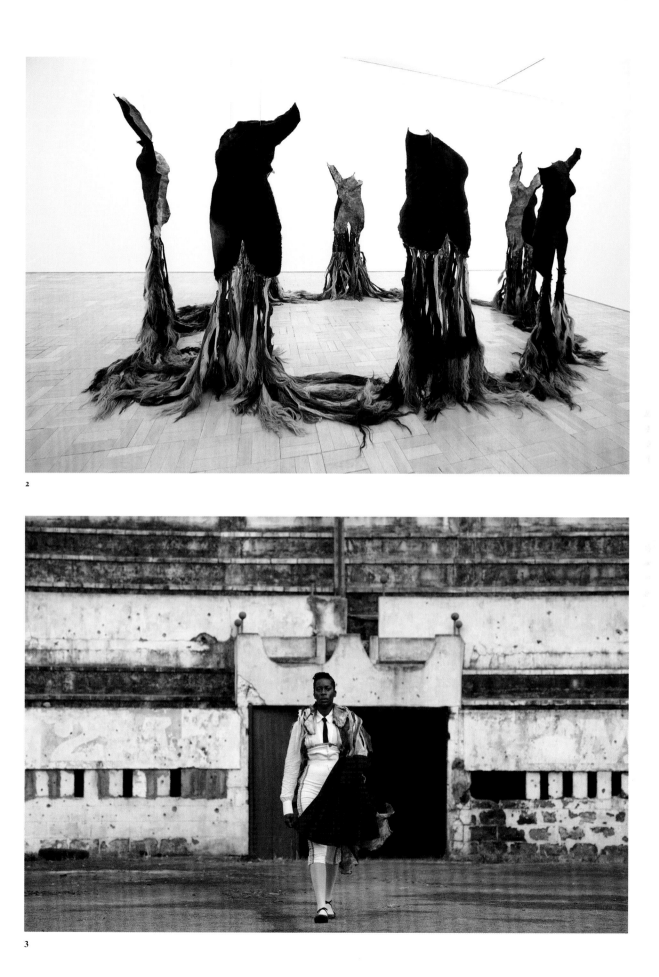

2

3

Richard Mosse 1980, Ireland, www.richardmosse.com, www.jackshainman.com

What attracts you to war and disaster?
Contemporary art's greatest strength is its potential to make visible what cannot be seen – pointing to the limits of experience and representation. Photography is firmly rooted in the world of things, as it carries a trace, an actual physical memory of the world at a specific time and place. Between these poles, I discern photography's unique potential to represent human suffering, which is something that cannot be represented. I'm hoping to find a better way to describe the catastrophe, which I feel is something that defines our era.

Is there a political motivation behind your work?
I'm very careful to keep the work open to people of all leanings, rather than preaching to the choir. The philosopher Theodor W. Adorno delineates between committed and autonomous art. I hope to produce the latter. Art is not propaganda. I feel it's more important to remember what brings us together, rather than what drives us apart. Besides, there's no such thing as a non-political gesture.

Explain the 'Nada Que Declarar' series.
This was a project made on the US–Mexico border. I looked for traces of people crossing the border illegally. I was interested in trying to represent something essentially hidden or invisible, something that you can't actually see. Illegal border crossings are particularly difficult to catch on the type of camera that I was using, which is a very slow and unwieldy 8 × 10 inch field camera. I spent a lot of time scouring the desert or the side of the road hunting for litter left by this invisible traffic in the race across the border. There's also a lot of other rubbish scattered about, and you can't really tell the difference. It wasn't long before the subject transgressed into fiction and became more about my own fantasy – about expectation, desire and projection.

What do you find interesting about the relationship between reality and fiction?
Regarding the catastrophe (I'm referring to a totalizing concept of warfare, disaster and terrorism), we bring a serious amount of baggage to bear. Take Iraq: if you've never been to Iraq before in your life, you still feel you know a good deal about the country, because you're being bombarded with information in newspapers, on television, in movies and in daily conversation. This is essentially fiction; it's a narrative that exists in your imagination. It is the ramification of fear, presumption, projection, hope, confusion and desire.

1

1. *Dormitories in the Birthday Palace, Tikrit, Iraq*, 2009. Digital C-print. 101.6 × 127 cm (40 × 50 in).

2. *Space Wagon Mosul*, 2009. Digital C-print. 182.8 × 243.8 cm (72 × 96 in).

3. *747 Heathrow*, 2007. Digital C-print. 182.8 × 243.8 cm (72 × 96 in).

2

3

4

4. *Pool at Uday's Palace, Jebel*
Makhoul Mountains, Salah-a-Din,
Iraq, 2009. Digital C-print.
182.8 × 243.8 cm (72 × 96 in).

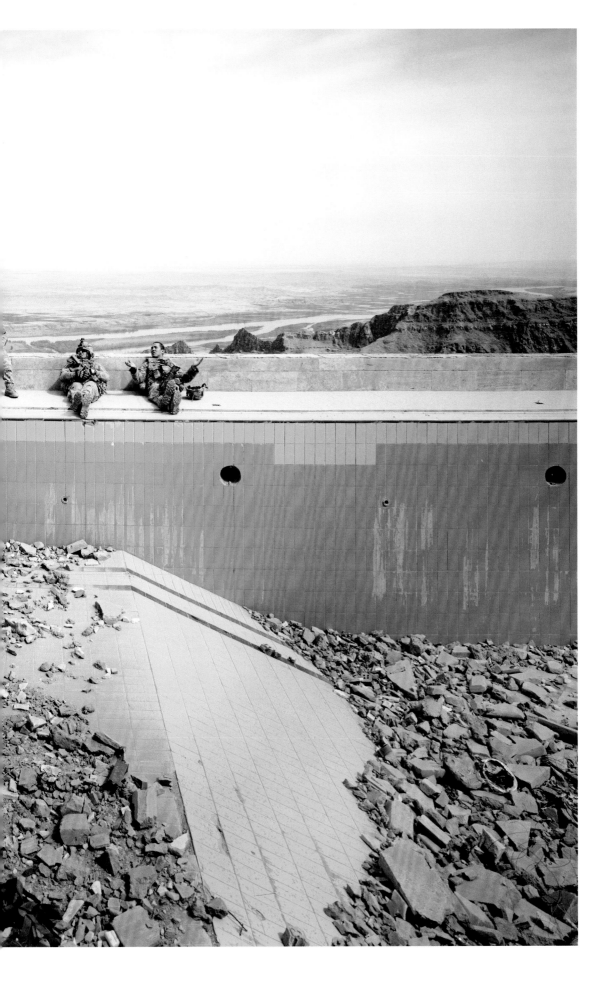

Antía Moure 1981, Spain, www.factoriacompostela.com, www.carloscarvalho-ac.com

What do you find interesting about decay and disintegration?
I'm attracted by the fissures disintegration creates on matter. I want the places I photograph to be seen as fragile organisms, as a body.

Why did you start working with interior spaces?
I needed to find a place closely linked to the private life of the individual; an emotional architecture; a space the individual would consider as a natural container of personal development. There was also a relationship between interior spaces and memory. People tend to link our experiences, our relationships and our memories with a specific place, because we need to recognize ourselves as 'related to' somewhere. A place is needed for something to become memory.

Why do you write in the spaces you photograph and what do the texts mean?
They have a very introspective character with high autobiographical content. Their roots are my deep existential thoughts about the human condition and frailty. It is an intimate speech borne in notebooks, diaries or book margins. Statements such as 'I almost don't love you anymore', 'make yourself cry', or '1977, I remember' are some of these emotional map coordinates. The result is texts that include past and present emotions, perceptions and experience.

Why do you write with chalk?
I like how short-lived the material is. This would not happen if I used spray paint, for instance, because of its resistance, its fixation. I often return to a place after shooting it and am fascinated that many of the sentences have disappeared or that mould has eaten words – changing or deleting their original meanings.

Where do you find the spaces you shoot?
So far they are in Galicia. All the spaces are in my immediate surroundings. Some of the ruins I have shot belonged to my family long ago or people close to me.

What is your process in making your work?
My creative process is very imperfect and I believe this aspect is really important. Even if my projects are born out of deep reflection, reading and writing, there is a moment when intuition, emotion and personal spirit take charge. I'm not interested in getting a polished technique. I want my relationship with the working material (chalk, paper or camera) to be intuitive, sincere. I need to feel free of technical pressures, so the work keeps its immediacy and intuition.

1

1. *Aquí es donde los escondo* (*This is the place where I hide it*), 2006. Digital photography mounted on Dibond, edition of 5. 105 × 70 cm (41⅓ × 27½ in).

2. *Otro diciembre* (*Another December*), 2005. Digital photography mounted on Dibond, edition of 5. 89 × 135 cm (35 × 53 in).

3. *Siempre* (*Always*), 2005. Digital photography mounted on Dibond, edition of 3. 105 × 140 cm (41⅓ × 55 in).

2

3

Ciprian Mureşan 1977, Romania, www.plan-b.ro

How does the political inform what you create?
The political has a strong influence on art, just as it has over life. I am part of a generation that experienced Communism while very young and the change came just in time for us to be able to distance ourselves from it. Our responses to, and comments on, Communism are more objective, more reasonable and less fierce. My generation simply had to adapt quicker.

What do you find interesting about nationalism?
After the 1989 revolution, nationalism (one of the main features of Ceausescu's Communism) had developed so much that the mayor of Cluj-Napoca started painting everything the colours of the national Romanian flag in order to mark territory. The trash bins, the poles on the sidewalks, the benches in the park, everything in a hysteria of the primary colours of the Romanian flag. One of the first reactions was the collaboration with Mircea Cantor and Gabriela Vanga for the *Our Playgrounds* video. We recorded all the places around the city where one could see the colours of the flag, especially playgrounds. Nationalism had to be imposed on people starting at a very early age. In return, when we presented the video, we projected a black and white version as a form of opposition and resistance.

What was the idea behind Communism Never Happened?
The vinyl I used for carving out the letters was from recordings of the Hymn to Romania, a Romanian festival in the 1980s in which Ceausescu's drift towards nationalism was put into practice through culture. There was no argument there. It is also an expression of the desire to forget. Mentally, people deny these things and they wish that they had never happened. It's therapeutic.

Is your work critical about consumerism?
The video entitled *Choose…* was one of the collaborations with my son, who was five at the time. Starting from a conversation we had, we decided to combine the taste of Coca-Cola and Pepsi-Cola, drinks that were so desirable during Ceausescu's regime. Now the freedom to choose between the two was available.

Explain your film piece Dog Luv.
Dog Luv is a video I collaborated on with Saviana Stanescu, a Romanian playwright living in New York. The work is a short history of torture. Other than the obvious message of the play, I wanted to put the puppets and the puppeteers on the same level.

1

2

3

1. *Romanian Blood*, 2004.
Pencil on paper. 21 × 29.7 cm
(8¼ × 11⅔ in).

2. *Choose*, 2005. DVD-PAL, 50 sec.

3. *Untitled (Stanca)*, 2006.
Performance by Stanca Buda, DVD-PAL, 17 sec. loop.

communism

never

happened

4

4. *Communism Never Happened,*
2006. Vinyl records. Dimensions
variable.

Jayson Scott Musson 1977, USA, www.jaysonmusson.com

What was the idea behind the 'Barack Obama' series?
I was in Europe during the summer of 2008 when Barack Obama gave his speech in Berlin. I found it astonishing that Europeans held so much love for Barack Obama – in some cases even more than many Americans. I began contemplating the mythic aspect of Barack Obama's character. It seemed like Obama was restoring an innocence that has been lost in all of us. It seemed to make perfect sense to explore the mythic aspect of Barack Obama as if a child was conducting the investigation. I decided to make these paintings in the style of children's art. Through this simple visual vocabulary I was able to introduce elements of the absurdly fantastic.

What interests you about the fusion of cartoons and porn in the 'Postlollipop' photographic pieces?
The 'Postlollipop' photographs are about things that occupy human beings. As a child we focus on toys, games and cartoons. As adults we are concerned with money, stability and fucking. I wanted these two poles of human interest to exist within the same plane, questioning the nature of human maturity. There is a certain erotic element to cartoons. The first person I ever had a crush on was a cartoon character – Penny, Inspector Gadget's super-intelligent niece. I wanted to rip her from the screen and marry her. I was about six years old.

Do you think your work is confrontational?
My art is definitely confrontational. I think this is mainly due to my love of comedy. Comedy, even in its most banal form, asks its audience to question. It is always pointing out incongruence.

How is your work informed by politics?
I am probably the most unpolitical person I know, but I think there is a heavy political tone to my work. I'm really attempting to grapple with my place in the world. We live in an age in which the vast amounts of information we consume grants us citizens of First World nations the opportunity to adopt ideology and ways of being. The work I produce posits itself upon the shore of this ephemeral ocean of electronic information that is nothing more than digital abstractions relayed through fibre optics – 'The Real World'. I cannot ignore the world – yet I cannot reconcile its madness. Humour is the only way of coping with the absurd incongruence of everything I have come to know via my television and computer screen.

2

1

1. *Untitled (Postlollipop #5)*, 2001.
C-print. 17.7 × 35.5 cm (7 × 14 in).

2. *Untitled (Postlollipop # 2)*, 2001.
C-print. 17.7 × 35.5 cm (7 × 14 in).

3. *Hitler*, 2008. Tempera on canvas.
152 × 91 cm (60 × 36 in).

4

4. *Not on my Watch*, 2008. Tempera
on paper. 70 × 46 cm (24 × 18 in).

5

5. *Cloverfield*, 2008. Tempera
on paper. 70 × 46 cm (24 × 18 in).

Ioana Nemes 1979, Romania, www.ioananemes.ro

What motivates you to create sculpture?
Sculpture, like painting, drawing, sound or
video, is a tool with which I communicate
ideas. Even though I studied photography, my
background is a theoretical and philosophical
one. Irrespective of the visual language I use,
my approach is always a conceptual one.

What do you find interesting about masks?
Rituals always have a functional role. They act
as passage gates placed at the border between
the real and the spiritual. Masks functioned as
a vehicle for people to transcend the material-
ity of the real world and communicate with the
spirits of nature. They were thus able to be
closer to their gods. The aesthetics of ancient
masks were not gratuitous. Colours and
graphic patterns were a codified language
meant to explain both the functional role of
each mask and the geographical and cultural
area of those who produced and used them.
It's totally wrong to perceive masks nowadays
from a decorative perspective. Masks are in-
triguing because of this lost codified language.

*Your sculptures seem to touch on folk-art
motifs. Why?*
In the 'Relics for the Afterfuture' series, I
wanted to discover when and why traditional
rituals lost their functionality, and thus their
magic. One hundred years ago, Romanians
used to sculpt wooden motifs in the porches of
houses in the Maramures region. Brancusi
found inspiration in popular motifs that he
stylishly synthesized in his modernist sculp-
tures. During the Communist era, traditional
crafts were used and abused as propaganda
tools, elevating the peasant to the highest rank
of the social hierarchy. Emptied of their pri-
mary functionality, objects that had been in-
vested with magic in the past are now mere
carcasses, produced only for tourists, featuring
mutilated symbols and exotic aesthetics.

*What do you like about the contrast of human or
animal materials?*
The materials I work with have been chosen
not only for their aesthetic qualities, but also as
a comment on the social and political context
in Romania. I fuse concrete and plastic to-
gether with natural materials (wool, horsehair,
feathers, fur, wood) to underline the social, po-
litical and cultural differences that still exist
between rural and urban life.

Monthly Evaluations *draws a link between the
emotional and the analytical. Why?*
I started this work in progress to understand
what happens with time and energy that
passes through us every day. I've built a com-
plex system of daily analysis and archiving
based on numbers, colours and words.
Monthly Evaluations is a pseudo-scientific
experiment attempting to continuously negoti-
ate the border between the subjective and
the objective.

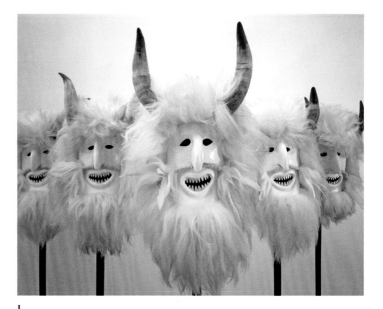

1

1. *Satan Team (White)*, 2008.
Sheep fur, leather, horns, gold, epox-
ide, paint, lacquer and wood. Each:
60 × 35 cm (23⅗ × 13¾ in).

2. *Birdman (Positive & Negative
Ring)*, 2009. Wood, white paint,
wool and chalk on painted wall.
200 × 150 cm (78¾ × 59 in) approx.

3. *Carpathian Mountains*, 2009.
Acrylic and oil on canvas and
wooden frame. 115 × 114 cm
(45¼ × 45 in).

4. *Mask (Alive)*, 2009. Acrylic
and oil on canvas. 30 × 30 × 4 cm
(11⅘ × 11⅘ × 1½ in).

5. *Gate (Stairs)*, 2009.
Black concrete, sheepskin and fur.
110 × 100 × 80 cm (43⅓ × 39⅓ ×
31½ in).

6. *Rosettas (White, Grey & Black)*,
2009. Epoxide, paint, lacquer
and wood. 100 × 58 × 33 cm
(39⅓ × 22⅘ × 13 in).

3

4

5

6

Paulo Nenflidio

1976, Brazil, www.paulonenflidio.vilabol.uol.com.br, www.agentilcarioca.com.br

What is the importance of sound in your sculptures?

I use sound for its plastic qualities. When I create a work I think about everything at once – the form, the materials, the sound, the idea and the technical process. Sound enters as an important poetic material. In some pieces sound enters as a random element; in others, it adds a playful element of surprise or amazement. Sound puts a sculpture into the fourth dimension of time.

Do you aim to connect to the history of sculpture in your work?

I am influenced by the history of sculpture, the history of art and the history of music. At other times, I am more influenced by science and technology, or fiction. Narrative is present in some form in all of my works.

Do your ideas come first, or is your approach more experimental?

I get to create and execute the work from idea to the finished result. Often an idea for a new work comes from experimenting with materials. The idea is to use existing materials for a particular purpose, subverting the original function of these materials. The materials are modified and joined with others, to gain a new function.

Why do some of your pieces resemble animals or insects, such as crabs, spiders and scorpions?

Animals, insects and other living beings have been for me a good source of inspiration. They took millions of years to develop. Their forms are very developed and balanced.

What do you find aesthetically interesting about stripped wood?

Wood has an interesting quality that always refers to craft. I find it interesting to put wood and technological materials together in the same sculpture. The effect of this combination is complementary opposites. Wood also refers to something old. It can be sanded and varnished, or used in a raw state.

What do you find interesting about the intersection between technology and the human in your work?

Electronics, physics and acoustics have elements that we understand, but also a sense of mystery. We know that a light comes on, but we cannot see what happens at the molecular level. We do not have the ability to perceive the infinitely small, or infinitely large. We know that sound exists, but we do not see the sound waves. My interest in these technologies is to approximate the human from something that is simple and fantastic.

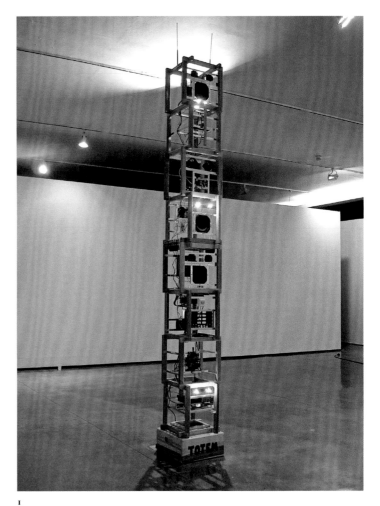

1

2

1. *Totem*, 2007. Automaton built in wood, electronic circuits, motors and amplifiers. 320 × 40 × 40 cm (126 × 15¾ × 15¾ in).

2. *Radionenflidio*, 2005. Wood, electronic circuits, copper plate, lamps, CD player with MP3 player, audio files in MP3 and stereo amplifier. 55 × 35 × 20 cm (21²⁄₃ × 13¾ × 8 in).

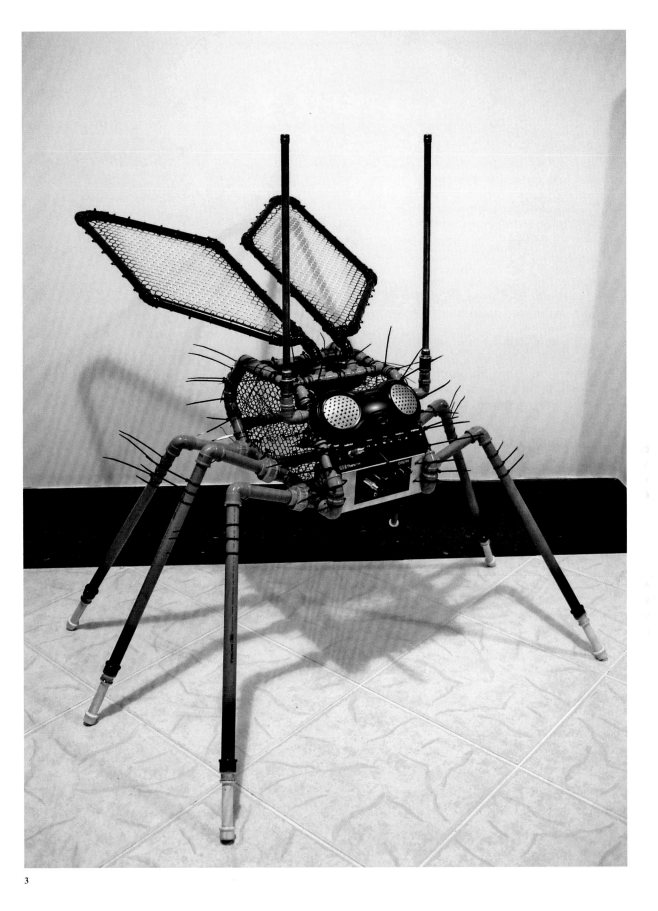

3

3. *Fly*, 2009. PVC pipes and
fittings, amplifier circuit
theremin and plastic screen.
110 × 150 × 150 cm
(43⅓ × 59 × 59 in).

Anne Neukamp 1976, Germany, www.galeriechezvalentin.com

Is there a symbolic element to your imagery?
Certain elements are recurring and are, to an extent, symbolic. These concern shifting meanings and associations, by combining and bringing into conflict different elements from various sources. This is the case in the painting *Schleife* (Loop), in which a fragment of a medieval figure emerges in an area that is structured by discontinuous lines, in a strange comic strip-style frame that was generated by an ordinary sticker.

What interests you about abstraction?
I am interested in both abstract and real forms. Abstract elements are often drawn from the fragmentation or alienation of real motifs. In those cases I am trying to capture the ambivalent space between the abstract and figurative.

How do you use geometry?
Geometry is a clue, a firmament or a mathematical value. The geometry in my work is never perfect, never mathematically correct. It is faulty and handmade.

What attracts you to a subdued palette?
The colours I use are mostly shades that emphasize the generally fleeting or fragile nature of the painting's architecture. I choose colours based on a specific temperature I wish to create in the painting. Their muted nature has to do with the work process. By rinsing and washing away different layers of colour, it attains a sense of having been used. Tempera lends the colours a matt, dusty surface.

Are you interested in the idea of melancholy?
I am interested in the feeling of constant incompleteness or limitation, which leads to melancholy, and in how it is possible to work with that. Most of my paintings remain in this somewhat unfinished, work-in-progress position that speaks of incessant transformation.

Does your work aim to reinvent or comment on the history of modernism?
The varying aesthetics and languages of form developed in modernism relate to its ideology, and in part to religious values. Modernism always claimed to produce truth. For example, thanks to the elapse of time since that 'truth', it is now possible to be inspired by both Magritte and El Lissitzky, even though they used such completely different vocabularies and world-views.

Why depict shapes and forms floating in space?
Cutting out and fragmenting forms and motifs gives you the chance to break free of original context and to create independent elements. The forms remain in an unsolved, open situation.

1

1. *Untitled (kleiner Spiegel)*, 2009.
Oil and egg tempera on canvas.
90 × 70 cm (35⅜ × 27½ in).

2

2. *Maltatal*, 2007. Oil and egg
tempera on canvas. 220 × 180 cm
(86 ⅗ × 70 ⅘ in).

3

3. *Schleife*, 2009. Oil, egg tempera
and marker on canvas.
200 × 160 cm (78 ¾ × 63 in).

4

4. *Untitled*, 2009. Oil and egg
tempera on canvas. 200 × 160 cm
(78 ¾ × 63 in).

Eko Nugroho 1977, Indonesia, www.ekonugroho.or.id, www.arkgalerie.com

Do politics influence your work and imagery?
Living in Indonesia, it is impossible to exclude politics from everyday life. Nearly 90 per cent of art that is made here is a response to, or influenced by, the socio-political conditions surrounding us. This is partly due to what I call 'the commercialization of politics' – thanks to the mass media, which ensures the information is constantly thrown at us, whether we like it or not.

Why did you start using embroidery in your work?
I was interested in embroidery as a fading tradition, slipping away from people's memory as machinery and synthetic materials became more popular. I've always thought of embroidery as a form of drawing, using thread on cloth. The kind of embroidery I work with is more utilitarian, commonly identified with cloth badges and uniform nametags. It was transforming something from the everyday into something extraordinary and unexpected. I like turning things on their heads, breaking preconceptions.

What do hoods and masks mean for you in your work?
It's quite difficult to depict an everyman without a facial description. I don't really want to use someone I know as a model or as the 'face' to represent 'Man'. I believe there is a duality to every human being. Therefore it is easier to depict a human being with a head wearing a hoodie or a mask. This headgear symbolizes the concealment of identity, or the assumption of another identity.

Sometimes your characters resemble aliens or monsters, even if we realize they are just in costume.
Is man that different from monsters? Our potential for violence and cruelty, to do the unthinkable and the inhumane, is pervasive. Even if our skin is smooth, soft and warm. I am only portraying what I see.

What interests you about showing violence?
Violence is a reality and has become a commodity. There is nothing that really surprises us any more. We've literally seen it all. There is very little that shocks mankind these days – in reality or in the movies. Images of war are very much part of our daily visual consumption. Bloodshed has not ceased. I am only portraying what is around, what I have seen. They are not pleasant pictures. That is the reason why I continue to present them – as a reminder of the continuing presence of violence.

1

1. *It's All About Coalition*, 2007. Polyurethane resin. Each: 180 × 70 × 100 cm (71 × 27½ × 39⅗ in) approx.

2. *Under The Pillow Ideology*, 2009. Polyurethane resin, cotton, pillows and wooden pole. 192 × 82 × 110 cm (75⅗ × 32¼ × 43⅓ in).

3. *Be Proud of Your Flag*, 2009. Polyurethane resin, embroidery and stainless steel. Each: 192 × 82 × 110 cm (75⅗ × 32¼ × 43⅓ in).

4. *Kedua adalah Tempat yang Teraman*, 2009. Embroidery. 280 × 160 cm (110¼ × 63 in).

5. *Disekitar Orang Asing 2*, 2009. Acrylic on canvas. 200 × 150 cm (78¾ × 59 in).

6. *In The Name of Pating Tlecek*, 2009. Views of installation, murals, canvas, polyurethane sculpture, paper cutouts and carpet. Dimensions variable.

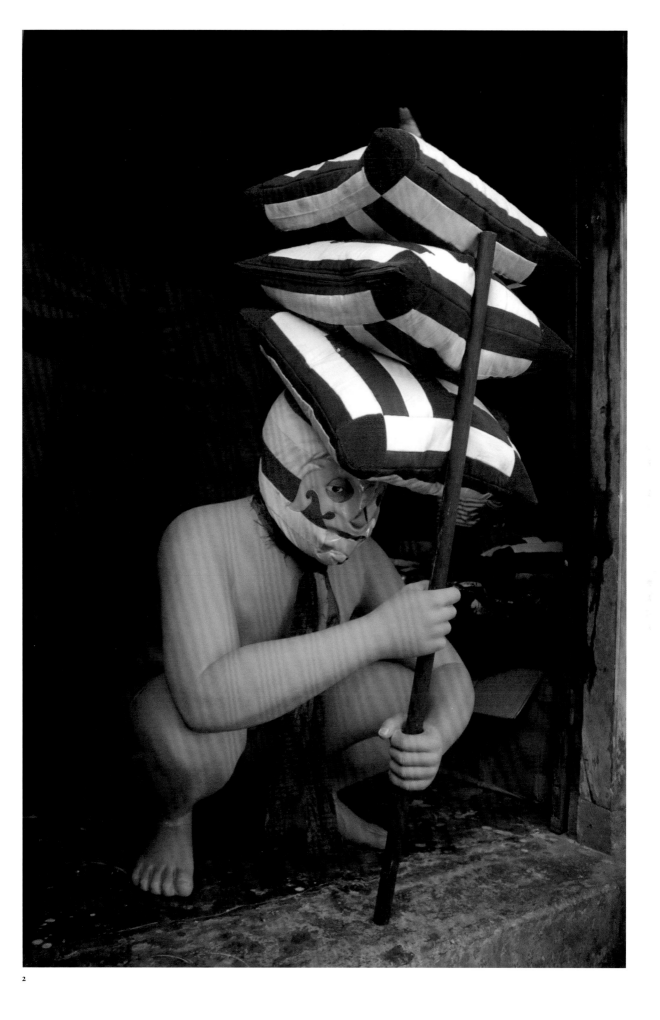

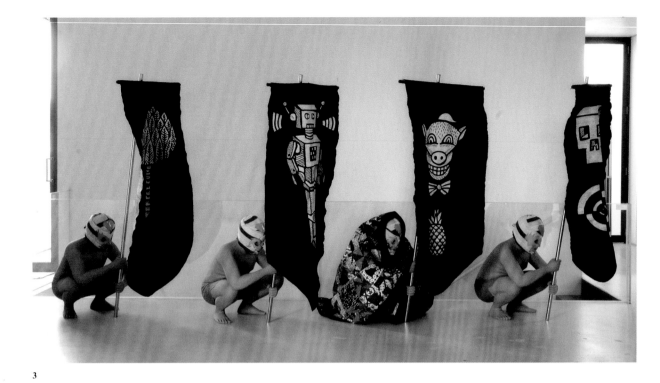

3

4

5

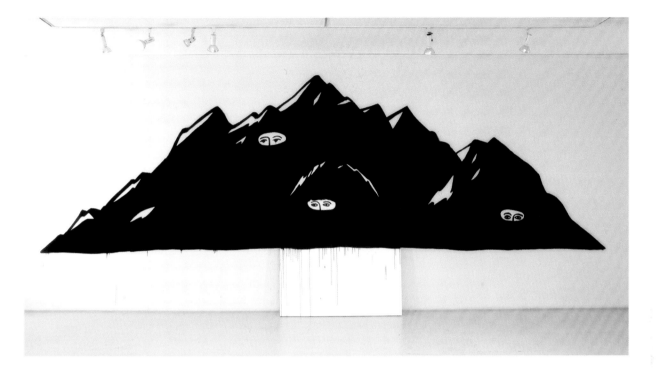

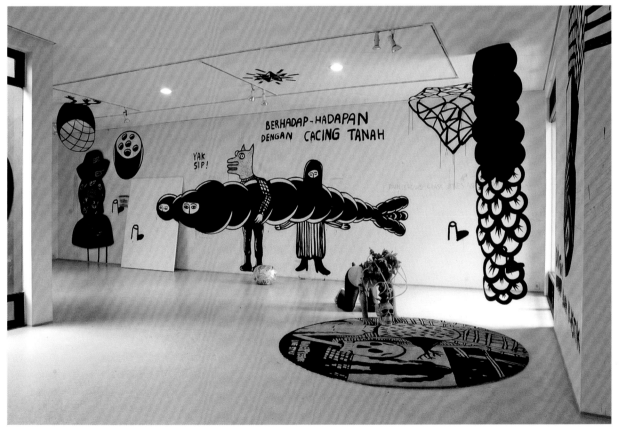

Jorge Pedro Núñez 1976, Venezuela, www.galeriecrevecoeur.com

What was the thinking behind the 'Black Mountain in colour' series?
I became interested in the monochrome advertising pages in *Artforum* because of their visual aspect and seductive power. I used the pages as a colour palette, and to generate a dialogue between the reader of the magazine and its history. Behind the names displayed in the advertisement there are forms, outlines of works of art. A word can replace an image, just as an image can replace a word. They are representations of reproductions of paintings. The title 'Black Mountain in colour' is a direct reference to Black Mountain College, an experimental university founded in the United States in 1933, following the closing down of the Staatliches Bauhaus. This work tries to highlight the relationship between media coverage, history and the economic aspect of art.

What do you find interesting about examining graphic design?
I am interested in geometric abstraction, but the ideas of infiltration and association of elements are also important themes in my work. Graphic design is a simple language that desires to be understood. It is engrained in the collective memory and infuses our daily life. What interests me about geometric abstraction is the space it occupies. In the case of the layouts made from the *Artforum* pages, the generic geometric forms appear on the page like an allegory between fine art culture and the culture of marketing and logos.

Why draw on Op and Abstract Art in particular?
I use abstract forms in a different sense to the artists who first created them. My work is a reduction contaminated by the history of modern art in a contemporary context. I am interested in figures such as Marcel Duchamp or Hélio Oiticica. The work I produce often occupies a place of joyful depression in being unable to get away from classic modernist forms, but at the same time being able to play with these forms by superimposing multiple cultural identities.

How and why did you start working with oversized rubber bands in your sculptures?
I work with rubber bands that imitate the architectural space of an exhibition hall. This spatial imprint converses with the temporal and mental reconstruction of the space. These possibilities fold in and out of space-time. Elastic material creates infinite possibilities for manipulation, yet at the same time the rubber bands are heavy, like a body at rest.

1

1. *The most important artist
(Black Mountain in colour)*, 2008.
Collage on *Artforum* paper.
27.5 × 38 cm (10⅘ × 15 in).

PACE

GEORG BASELITZ LOUISE NEVELSON
ALEXANDER CALDER ISAMU NOGUCHI
JOHN CHAMBERLAIN CLAES OLDENBURG
CHUCK CLOSE PABLO PICASSO
GEORGE CONDO AD REINHARDT
JOSEPH CORNELL MARK ROTHKO
JIM DINE ROBERT RYMAN
JEAN DUBUFFET JULIAN SCHNABEL
TARA DONOVAN JOEL SHAPIRO
DAN FLAVIN RICHARD SERRA
ROBERT IRWIN JOEL SHAPIRO
ALFRED JENSEN KIKI SMITH
DONALD JUDD SAUL STEINBERG
ROBERT MANGOLD ANTONI TÀPIES
AGNES MARTIN COOSJE VAN BRUGGEN
HENRY MOORE ROBERT WHITMAN

32 EAST 57TH STREET NYC / 142 GREENE STREET NYC / 9540 WILSHIRE BOULEVARD LOS ANGELES / 147 NEW BOND STREET LONDON

2

2. *Vasarely's syndrome*
(Black Mountain in colour), 2008.
Collage on *Artforum* paper.
27.5 × 27.5 cm (10⅘ × 10⅘ in).

3

3. *Cruz Diez Violette*
(Black Mountain in colour), 2008.
Collage on *Artforum* paper.
27.5 × 27.5 cm (10⅖ × 10⅖ in).

4. *Josef Albers and other artists
(Black Mountain in colour)*, 2008.
Collage on *Artforum* paper.
27.5 × 27.5 cm (10⅘ × 10⅘ in).

Catalina Obrador 1977, Spain, www.galeriajm.com, www.rphart.net

How important is narrative and telling stories to your work?

In Mallorca there are fables called *rondalles*, that mix fantasy with reality and common instruction. This is what I focus on. I try to say something more than I see. Sometimes the text is necessary to contrast with the image. I use stock phrases to mix with the images and find new points of view. I understand a new situation when I draw it. Drawing and writing are similar to me, both work together. It's the way I get closer to reality. Everything is more than what we see.

What do you find interesting about religious imagery?

Most of the religious images in my work are from the cabala or alchemy – life or death, fire or water, sex or sin, storm or peace. All of them are in constant review. The symbols I use are from past Mediterranean cultures – Jewish, Egyptian, Phoenician. This traditional mix is like a crazy formula. When I start to work I never know how it is going to end. I think this is the reason why sometimes it's possible to see both power and delicacy in my work. All this mixing between contemporary and traditional images, between delicate and strong elements, becomes the focal point of my images.

What is the importance of sex in your imagery?

During 2008 I did a few pieces inspired by porno imagery. I think they come from my deepest female savage. They are fast drawings, like tattoos tearing paper or skin.

Your work often focuses on strong female characters and their experiences. Why?

It's just me. I think all the work that women did at the beginning of the last century is important. I think it's very important to review the situation of women and their emotions.

How important is nature to your work?

Nature reminds us not to forget to understand ourselves. In my childhood I used to hear the old people speaking about life in the country and how we have moved away from our roots. Lost paradise is shown as a romantic idea in my work.

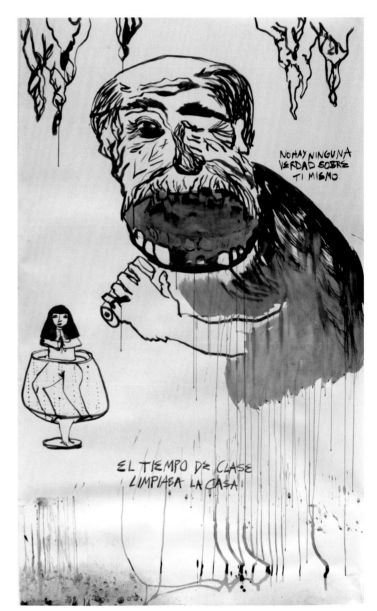

1

2. *Cuando te huelo me siento en casa*, 2007. Acrylic on wall.
600 × 300 cm (236¼ × 118⅛ in).

1. *No hay ninguna verdad sobre ti mismo*, 2007. Chinese ink on paper.
280 × 120 cm (110¼ × 47¼ in).

3. *Peche Lobo*, 2008.
Chinese ink on paper.
145 × 155 cm (57 × 61 in).

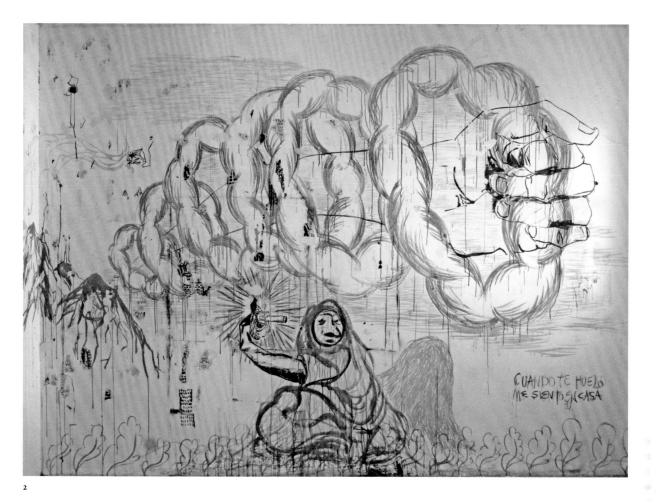

2

CUANDO TE HUELO
ME SIENTO EN CASA

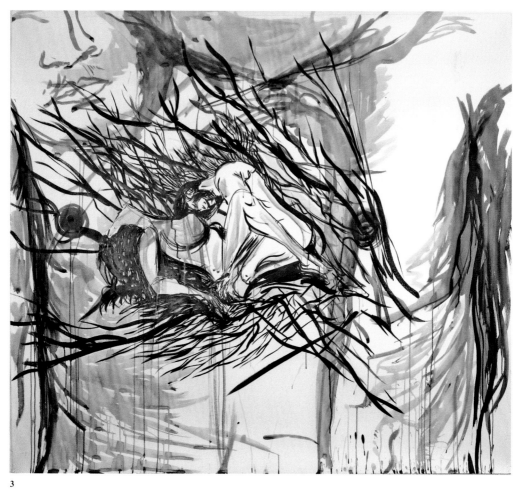

3

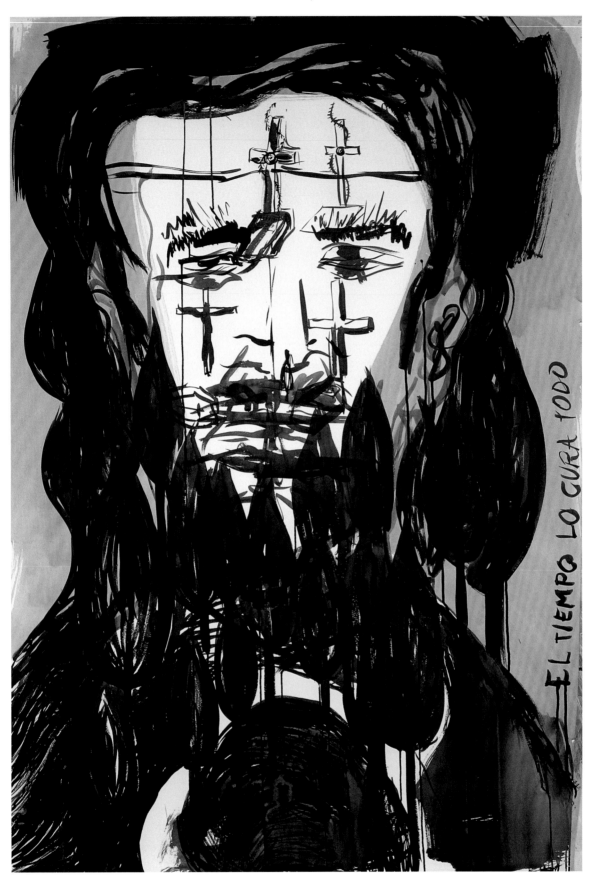

4. *El tiempo lo cura todo*, 2008.
Ink on paper. 150 × 105 cm
(59 × 41⅓ in).

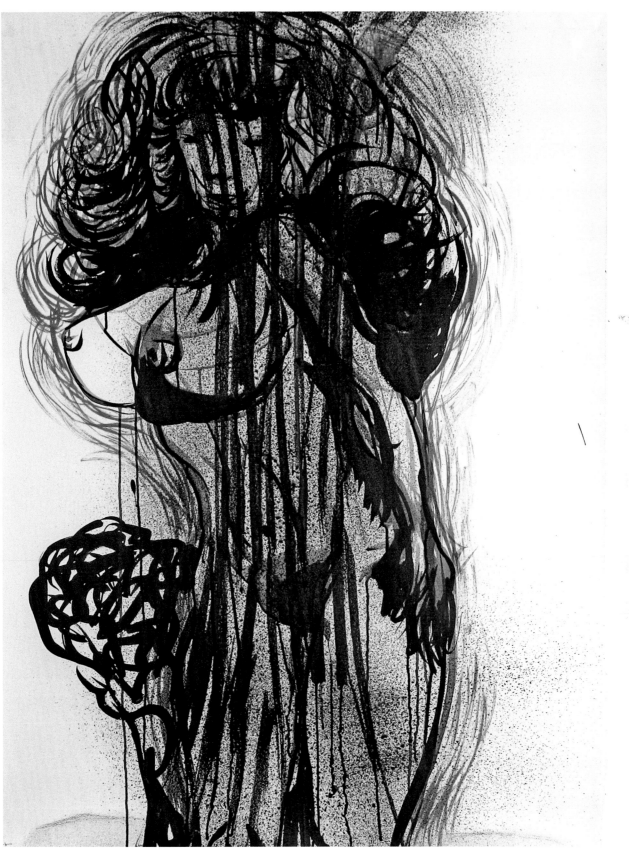

5

5. *Porno Star*, 2008. Mixed
media on paper. 77 × 103 cm
(30⅓ × 40½ in).

Taiyo Onorato and Nico Krebs 1979, Switzerland, www.tonk.ch

How does your collaborative process work?
It follows no defined system. The work is not divided between us. Ideas are passed between us, and they transform in the process of development. It is a constant dialogue.

What is the relationship between your installations and photographs?
We started to make installations and objects for the sole purpose of photographing them – to integrate them into a picture or build a picture around an object. Slowly they sometimes transform into something more self-contained and are able to survive in the three-dimensional world too.

What interests you about staged or simulated reality?
When something is photographed, the depiction is already entering staged or simulated reality, since it is mechanically reproduced and transformed from its original form.
We want to push the boundaries further and blur the distinctions. For us, intervention always happens in a purely haptic form.
Digital manipulation never interested us.

Why examine American pop culture and myths in particular?
No other place in the world defines itself so extensively by its media output. It is like a gigantic multi-layered semiotic playground.

What do you find interesting about the relationship between objects and the photographic lens?
With a handful of very simple photographic tricks you are able to fill an object with significance, or you can empty it, erasing all its meaning. Every angle and light triggers a different association.

What do you find interesting about using found objects in your work?
Working with found objects is different from working from scratch. Every object brings in a background, a story or a memory.

Explain your road trip series 'The Great Unreal'.
We moved to New York in 2005 with a residency grant and decided to explore the land beyond the city. It turned out to be a great adventure. We spent many months on the road, working in woods and deserts, on shopping mall car lots and in motel rooms. As with every journey, it wasn't only about fun and having the opportunity to meet good people. Exploring America also means being confronted with extreme despair, ignorance and mistrust. These feelings all go into the work.

1

1. *Map*, 2006. C-print.
94 × 120 cm (37 × 47¼ in).

2. *Red Glow*, 2006. C-print.
94 × 120 cm (37 × 47¼ in).

3. *Dawn*, 2006. C-print.
94 × 125 cm (37 × 49⅕ in).

4. *Leadville 1*, 2008. C-print.
50 × 65 cm (19⅔ × 25⅗ in).

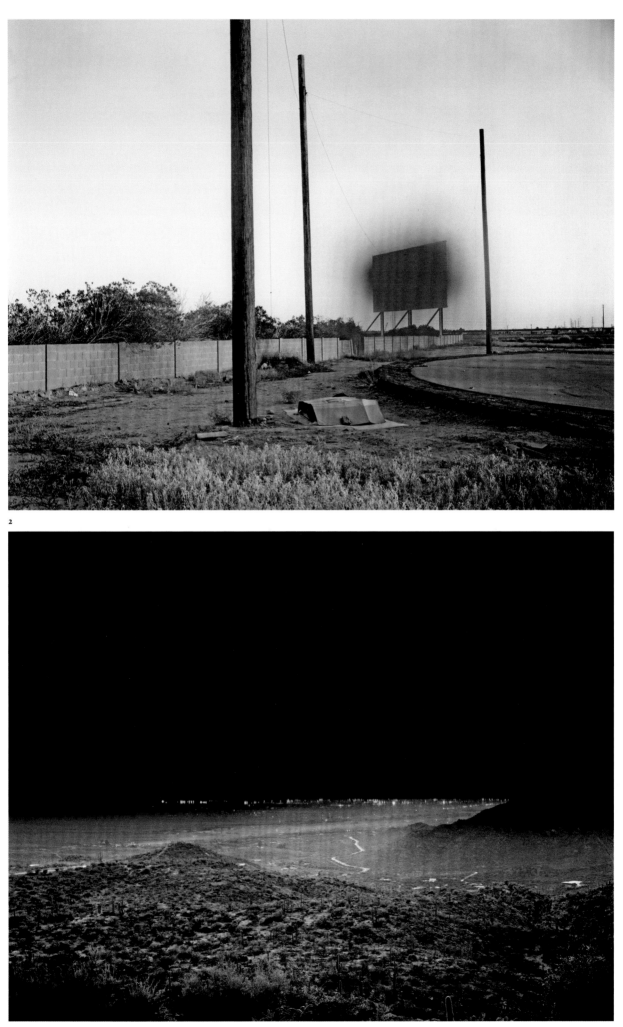

2

3

4

Pim Palsgraaf 1979, The Netherlands, www.pimpalsgraaf.nl, www.mkgalerie.nl

Is the intention behind your work to criticize issues around urban space?

I have a hate-love relationship when it comes to cities. On the one hand, my ideal city is an organism, an organic mechanism in which people can move, build, construct and dream freely. On the other hand, there is a reality in cities with their man-made, institutional structures and order. People are forced to live in a structured world they cannot influence. I get the feeling of cities becoming very big maquettes or fabrications without real people.

What do you find interesting about the relationship between man and nature?

What I'm really curious about is the vague borderline between these two worlds. This border region is a place where both worlds meet and attack each other.

What attracts you to cities as structures?

Cities attract me because they are accumulations of structures, systems, institutions and mechanisms, both natural and man-made. These combined layers make me think of cities as beautiful growing organisms, but there are moments when I hate all these layers and complications. I prefer the lifeless material structures of a city; the forgotten, messy, old, raw corners. These are places where small and big structures are colliding, from street patterns to the texture on a brick wall. In these twilight zones natural and unplanned elements creep into the existing urban structure.

How did you start working with taxidermy?

I am fascinated by the remains of animals. When I was ten years old I started collecting bones, skulls and fossils. It all started with a duck skull I found in my grandpa's vegetable garden. That was the moment I became aware of worlds that were not regulated by humans, but have their own logic. The first time I used taxidermy in my work was when a housemate gave me a big stuffed fox. I had been looking for something that could symbolize nature. As soon as I started working on the fox, I knew I had found my symbol of nature.

Your paintings also explore architecture, often in disintegration or covered in drips. What do you find interesting about collapsing spaces?

The atmosphere of former times that is preserved in these places. In these buildings miniature landscapes arise during the process of decay, like wallpaper coming down, rotting wood, layers of dust and cracked paint. Events that happened in the past are visible or can still be felt when you enter these buildings.

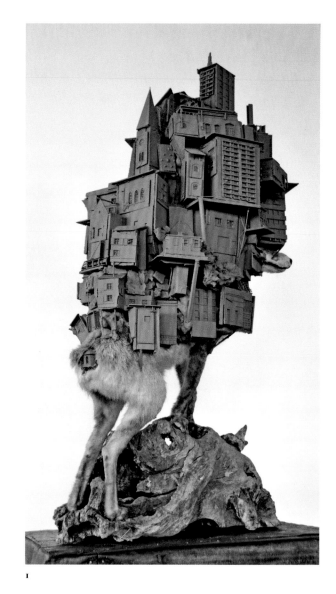

1

1. *Multiscape 01*, 2006. Taxidermied fox, wood, foam, styrofoam and model houses. 100 × 60 × 40 cm (39⅖ × 23⅗ × 15¾ in).

2. *Multi structure 01*, 2009. Taxidermied monkey, wood, bark, foam, plastic and model houses. 200 × 50 × 80 cm (78¾ × 19¾ × 31½ in).

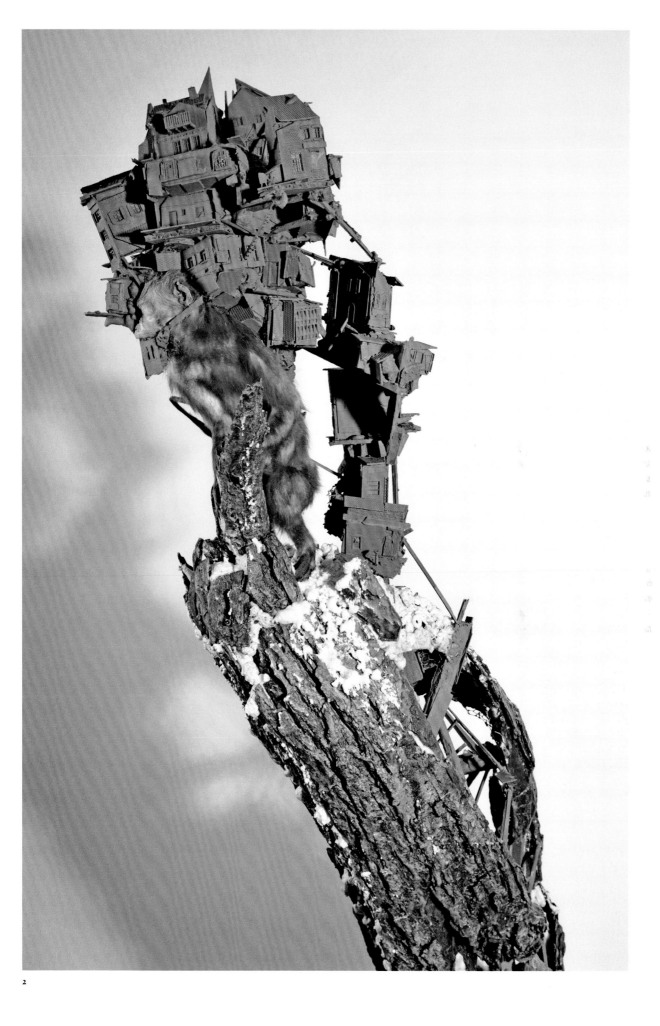

2

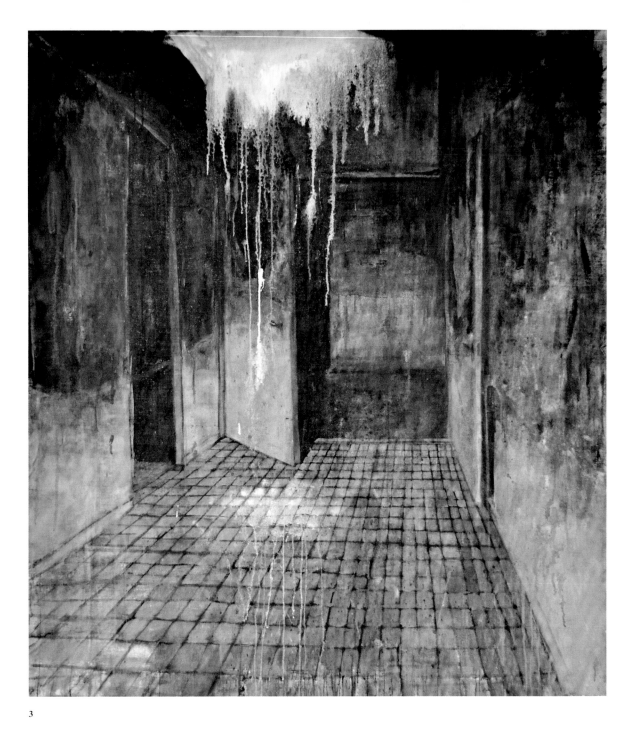

3

3. *Bucaresti 06*, 2008.
Acrylic on canvas.
130 × 130 cm (51⅛ × 51⅛ in).

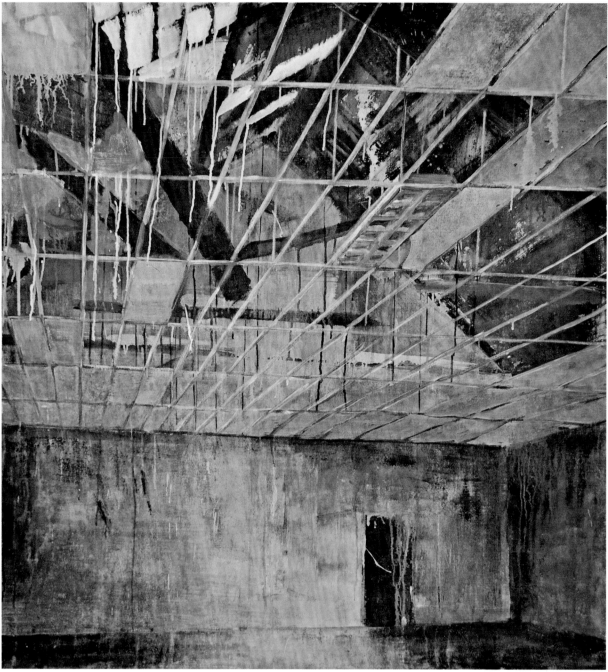

4

4. *Bucaresti 02*, 2007.
Acrylic on canvas.
130 × 130 cm (51⅕ × 51⅕ in).

Pedro Paricio 1982, Spain, www.pedroparicio.com

What interests you about abstraction?
The capacity for hyper-reality to attack us.
We are bombarded by thousands and
thousands of images every day; there isn't
space for our own mental images. Super-real-
ity destroys the capacity for a person to create
his own images. You have to be careful with
pure abstraction because it easily falls into
the decorative and design.

Is there a symbolic element to your abstraction?
Maybe unconsciously. My personality, my
fears, my vision, my unconscious are included
in my paintings. I don't tell stories in my work.

Tell me about the colour palette you use?
I use a lot of pure colours, directly from the
bottle. I mix gold and silver and fluorescents
– all strong colours that are seen on a screen
or in a video game. These colours are always
strongly saturated. It is possibly a result of my
pop art years and the digital era. We are a re-
sult of our times. We cannot escape.

*There is a strong sense of movement in your
work. What interests you about that dynamic?*
The world is not static. It is in continuous
movement. Look at a plant, for example.
It is constantly moving, growing and working.
It may move at a different speed but it is
moving! The world, the land, flowers, our
minds, the circle of life and death never stop.

*Why contrast textured areas in your work with
flat blocks of colour?*
Texture, any kind of texture, is one of the
central principals of contemporary painting.
Design and digital prints own planes like
property. Graphic blocks of colour don't
make sense these days. Why make something
by hand that you can do with technological
media? I think that the new target for art
in the twenty-first century is to find its own
essence, the properties that make it different
from fashion, cooking, music and cinema.
Painting planes of colour is a reflection of the
visual world we are living in now – a world of
new plasma TVs, mobile phones and PCs. All
their planes are beautiful and saturated with
colour. At the same time plane painting is part
of the recent history of painting (pop art),
which developed before our digital era. My
painting is like a meeting between the digital
media era and human nature. The essence is
far away from chips, bits and pixels.

1

2

1. *Yubarta in an amusement park*,
2009. Acrylic on canvas. 70 × 50 cm
(27½ × 19⅔ in).

2. Study of a studio, 2009.
Acrylic on canvas. 100 × 100 cm
(39⅓ × 39⅓ in).

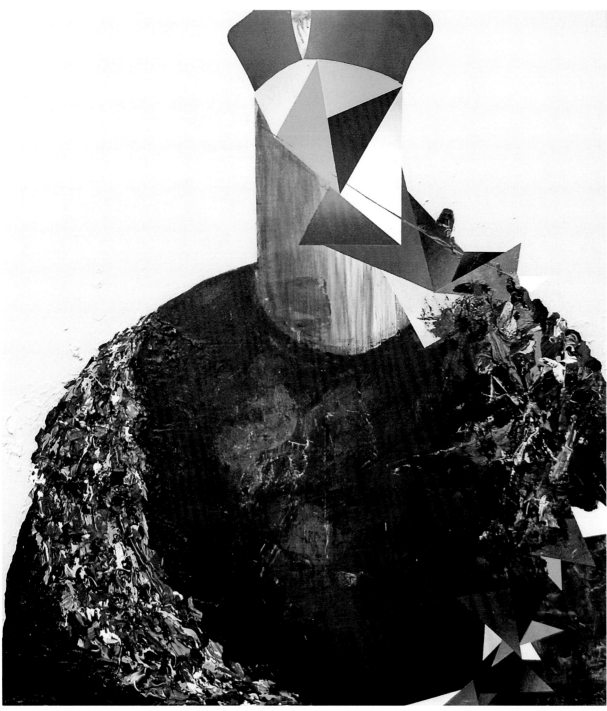

3

3. *Cardinal after Raphael*, 2009.
Acrylic on canvas. 100 × 90 cm
(39⅓ × 35⅔ in).

João Pedro Vale
1976, Portugal, www.joaopedrovale.com, www.galerialeme.com

What does the recurring symbol of the boat mean to you?

The boat appears in my work as a way to talk about Portuguese culture, its association with the sea and how this is reflected in popular culture. It works as a metaphor to talk about travel, drifting or sinking. The title of *Black Boat*, for example, is a fragment of a fado song by Amália Rodrigues, whose lyrics are a reflection of what Portuguese culture is. A young woman facing the sea says goodbye to her lover hoping he will return, while old widows tell her that he will never come back. The sculpture is a shipwreck that was rebuilt with objects related to miracles. The boat and the sea talk about the unknown and the unexpected, ideas important to the idea of conquest, which led to many Portuguese voyages. There is a certain nostalgia that characterizes the image that is promoted by Portugal abroad.

Are your urn pieces about the history of sculpture or a comment on death?

Both. They are a reference not only to the tradition of funerary sculpture, but also to sculpture as archaeological data. I did a set of works, some using ashes, which may reflect more directly on this funereal tradition. I also made a set of vessels out of spices. They talk about the Portuguese colonial past, when the trade of these goods had a crucial role.

What do you like about using Styrofoam in your sculptural pieces?

It is the easiest and fastest way to realize and materialize my ideas, but the use of this material is not accidental. There is something scenic and theatrical in its use that refers to the festive decorations of the carnival parades that is also important.

Why are you interested in references to childhood stories, like Jack and the Beanstalk?

One reason is to question how children's stories work as a way of promoting values in childhood, which largely remain for the rest of our lives without being questioned. The other reason is the feeling that the viewer has of knowing the story behind the work of art; they are already caught by this false feeling of belonging. That's when they start questioning the project.

What is the importance of history in your work?

Over time the same historical data may have different types of interpretation. That I always have in mind, how historical facts are used politically.

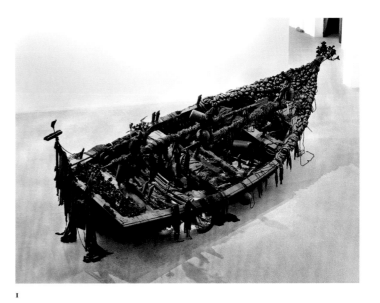

1

1. *Barco Negro* (*Black Boat*), 2004. Wooden boat, iron, plastic objects, wax, satin ribbons, ropes, rubber, coins, net, tires, clothes and shoes. 200 × 200 × 600 cm (78¾ × 78¾ × 236¼ in).

2. *Beanstalk*, 2004. Leg stockings, fabric, iron, wire and styrofoam. Dimensions variable.

3. *Bonfim* (*Good End*), 2004. Iron, taffeta ribbons and wooden boat. 120 × 150 × 400 cm (47¼ × 59 × 157½ in).

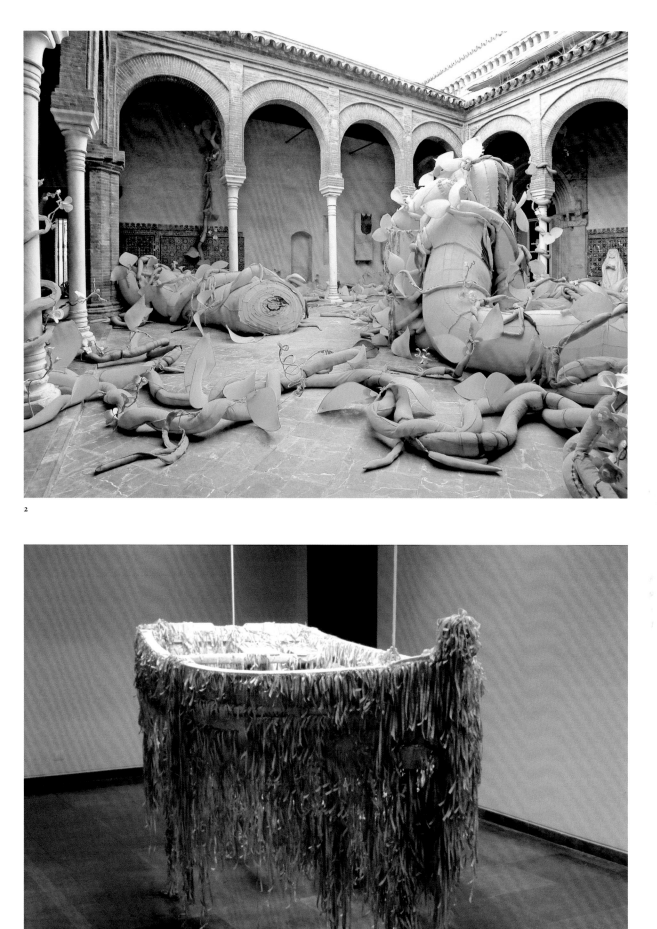

2

3

Amalia Pica 1978, Argentina, www.dianastigter.nl

How do you approach public interventions?
When I first started doing interventions in
the public space I created a persona that was
a kind of Don Quixote: a character who goes
around transforming the world into their
fantasies; a schoolteacher who would attempt
to live out the fantasy written in schoolbooks,
correcting reality instead of rewriting history.
I hoped to highlight the gap between what is
taught and how things really are.

What interests you about hot and cold climates?
In some of my works I refer to the difference
in weather (or vegetation) just to play with the
idea of a place that is distant or far away. These
works deal with the nostalgia that has to do
with distance, not just with time. In a sense,
I was interested in exploring the idea of utopia.

Explain Sorry for the Metaphor.
It is a wallpaper piece made out of photo-
copies. It is a picture blown up to wallpaper
size of me looking into a German landscape
(one of the locations of a Caspar David
Friedrich painting), holding a megaphone.
The aim of the piece was to somehow overlap
political and art historical romanticism. The
format then points to cheesy landscape wallpa-
pers as well as home-made political protest
signs. The reason why I am interested in
posters and wall pieces has more to do with a
reference to free expression and how walls and
posters are used to find a political voice in a
hectic public space. I am interested in them
as a metaphor for free expression.

How have you worked with nostalgia?
To Everyone That Waves was the first piece in
which I tried to work with the idea of displace-
ment. I arrived at this universal goodbye
gesture – waving with white handkerchiefs.
In one movement, it reminds us of something
in the past, rescuing it from what is forgotten.
At the same time it stands in the way of proper
understanding of that past. I am aware of the
manipulation and rhetoric that makes images
nostalgic. The film itself is the result of an
event that I organized in Amsterdam. I handed
out white handkerchiefs to people boarding a
boat and to people on the shore, without giving
them any instructions. I was curious whether
they would wave without being told to.

1

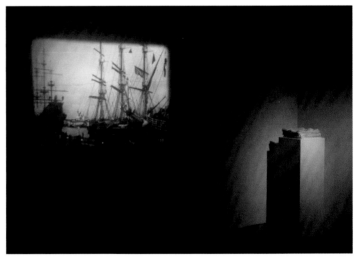

2

1. *Sorry for the metaphor*,
2005. A3 photocopies.
Dimensions variable.

2. *To everyone that waves*, 2005.
16 mm. Installation of black-and-
white film and stack of white hand-
kerchiefs on plinth. Dimensions
variable.

3. *Islands*, 2006. 35 mm slide
sequence on loop.

3

4

4. *Some of that colour*, 2009.
Installation of paper flags, drained
dye on watercolour paper and chair.
Dimensions variable.

Emilie Pitoiset 1980, France, www.lucilecorty.com

What do you like about monochrome?
I often associate monochrome with vertigo.
I am not sure if it is the emptiness or the over-
fullness which makes me feel uncomfortable
and therefore attracts me.

*What do you find interesting about images of
guns and firearms?*
Firearms are objects that symbolize a threat.
What I am interested in is the tension they
convey. *Just Because* consists of anonymous
hobby photographs from the 1950s. The
tracker faces us in deep concentration. His gun
is pointed at us, while the crowd around him
seems to have fun. The idea was to immortalize
the heroic moment that introduced the term
'shot' to instant picture-taking. The shooters
are incarnated as the figures of the potential
killer. We are aimed at directly. Formally, the
gun is an in-between object, which separates
on one side life and on the other side death.
What is interesting about this kind of image
is the fictional aspect; we do not know over
what, nor over whom, the weapon has author-
ity, not even why. Nonetheless, we know that
everything can shift. Its suspense can be felt.

How do you explore history in your work?
The time period between the 1920s up to the
1950s and 1960s captivates me enormously.
Those years were marked by disruption.
From an ideological point of view, it draws a
line under one's past. The principle of erasing
and deleting is inherent in reconstruction.
It turns perspectives upside down.

How did you start using appropriated images?
The re-appropriation started through
questioning the status of archives and their
authors. I began to question the legitimacy
of using archives and the status of works
within them.

*Does your work engage with ideas around
modernism and modernist compositions?*
I pay special attention to the composition
of images, the visual grid in general and the
line in particular. When I first began, I started
to work on the notions of the accident, the
mistake and unstable situations, which have
slowly led me to introduce movement, direc-
tion, imbalance, lines that hesitate between
the vertical and the horizontal and finally to
consider the fall. I always come back to these
ideas. The sloping line is recurrent in my work.
It is the one which hesitates, the one which
threatens, the one which is nervous.

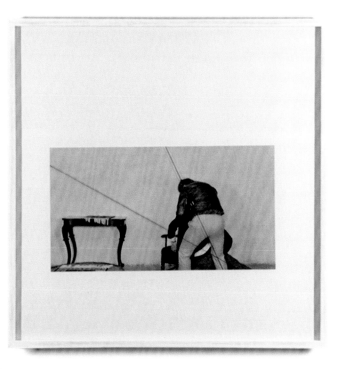

1

1. *Liebe ist kälter als der Tod #1*,
2009. Print on silver paper, marker.
41.5 × 41.5 cm (16¹⁄₃ × 16¹⁄₃ in).

2. *Ordinary Experience*, 2008.
'Beau Window #3' exhibition in
Le Confort Moderne, Poitiers,
stuffed horse. Dimensions variable.

3. *Liebe ist kälter als der Tod*, 2009.
Still from black-and-white video,
1:11 mins. (edition of 5).

4, 5, 6, 7. *Just Because #2, #3, #4, #5*,
2008. Prints on silver paper.
Each: 32 × 32 cm (12½ × 12½ in).

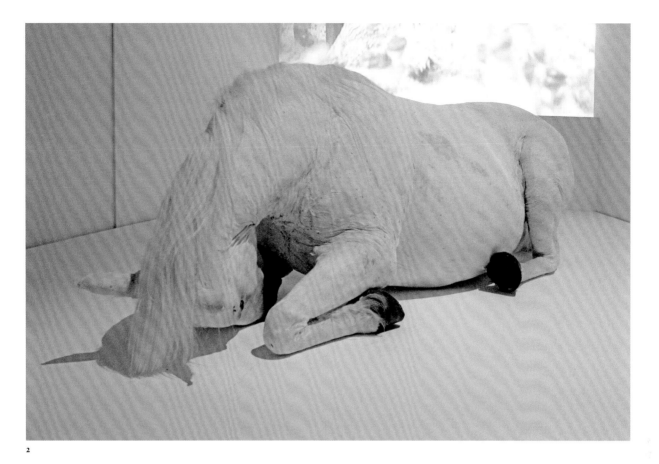

2

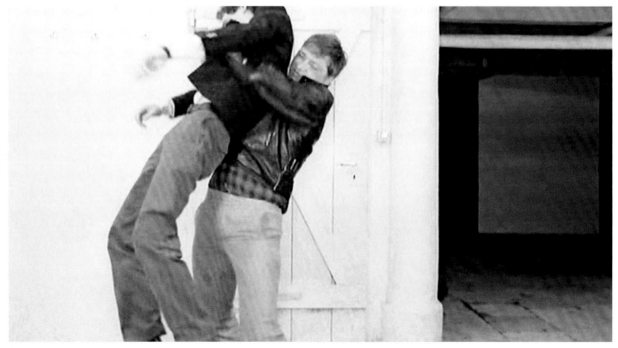

3

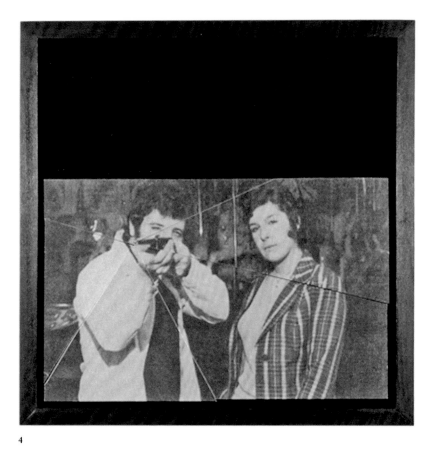

4

5

6

7

Aleix Plademunt 1980, Spain, www.aleixplademunt.com

What do you find interesting about the relation-
ship between man and nature?
Nature speaks about us: about our attitudes,
desires and concerns. We project ourselves
onto it. I'm interested in analyzing landscape
from this moment of history – how we use it,
how we move about in it. In some projects
I make interventions within the landscape,
in order to influence or manipulate the final
reading and thus introduce my own concerns.
People are not present in most of my land-
scapes, but the images reflect on people.
Tell me about the Nada *project.*
Nada (nothing) is a rumination on the use
of public space, the way our space is used to
attack us with thousands of messages. The
project is based on the saturation of advertis-
ing messages and the vacuum this generates.
Over the course of six months, I visited a series
of countries on five continents. The action
consisted of obscuring the adverts with a white
covering, upon which the word 'nothing' was
written. This action generates a very interest-
ing dialectic with the viewer, who faces a
billboard that is both devoid of meaning and
yet loaded with a very direct message. The
project is an immersion into the emptiness of
the word, into the globalization of nothingness.
What do you find important about placing work
in public spaces?
It is different to the conscious action of visiting
an exhibition space, where we adopt a more
receptive attitude before entering the room.
In the case of public intervention we find the
work, whether we want to or not, and this cre-
ates a more spontaneous and sincere response.
Why work with architectural structures such
as billboards?
They have become a political form of manipu-
lation and control. I find the proposal ap-
proved by Gilberto Kassab, Mayor of São
Paulo, Brazil, very interesting. He has made
São Paulo the first city in the world not to
have advertising on its streets. It really is
a radical action.
What do you find interesting about playing
with the idea of viewing in your 'Espectadores'
series?
The reader of the image should identify with
it. Some chairs are facing a nuclear power
plant because I want to draw attention to that
plant and I want the reader of the image to
realize this. The chair is merely a tool with
which to engage the viewer, to push the viewer
into the picture.

3, 4. *Nada*, 2007. Two C-prints from
4 × 5 negatives. Each: 125 × 150 cm
(49⅕ × 59 in).

1, 2. *Espectadores*, 2006. Two
C-prints from 4 × 5 negatives.
Each: 120 × 150 cm (47¼ × 59 in).

5, 6. *DubaiLand*, 2008. Two C-prints
from 4 × 5 negatives. Each: 90 ×
110 cm (35⅖ × 43⅓ in).

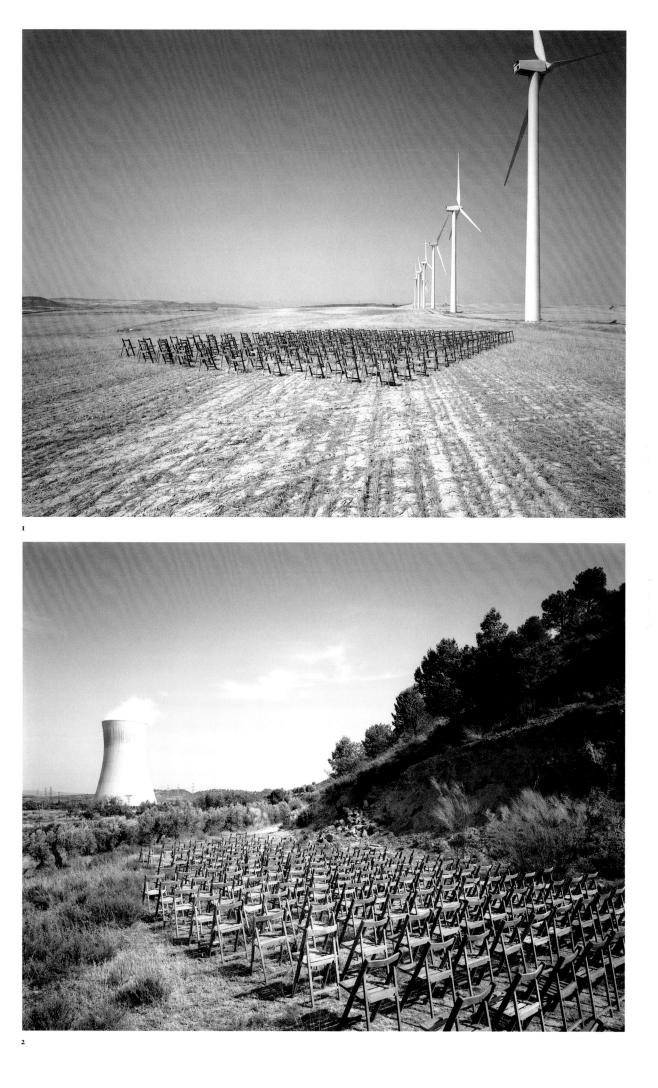

1

2

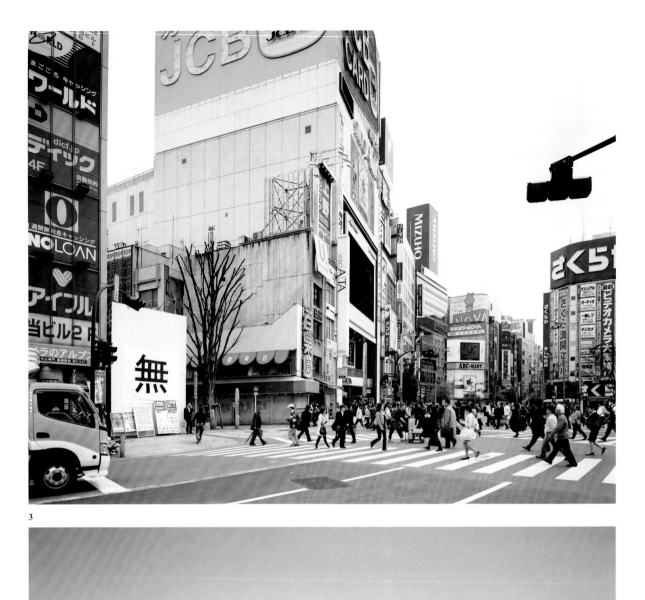

3

4

5

6

Sara Rahbar

1976, Iran, www.sararahbar.com, www.hilger.at, www.carbon12dubai.com

What attracts you about exploring ideas about national identity?

I was born in Iran. My family and I emigrated to America when I was five years old. People emigrate for many reasons, but mainly because their country has somehow become unliveable for reasons such as war, poverty, political situation, government, economy and so on. My family and I emigrated to the very country that, as far as I was concerned, was one of the major causes of the chaos that was occurring in my country. Entering, adjusting and attempting to conform myself to the American way was not easy, as I never truly felt that I could call America my home. I am trying to sort out who I am, where I belong and what the purpose of all of this chaos is. In this process of authentically exploring myself and my life, and communicating my findings through my work, my work becomes borderless and universal. In the end we are all immigrants. We are all in exile. We are all just visiting.

Is Iran's violent history something that you are trying to highlight in your work?

What country does not have a violent history? It's not always so much about violence, but rather turbulence, challenges and a transformation that is at times painful. In order for growth to occur there is always a bit of pain that comes along with it. I might add that America also has quite a colourful history as well, as all countries do. I have had the wonderful fortune of falling somewhere right in between these two countries. What I am highlighting in my work is my falling, my standing, my attempt to survive and my present locations.

What first drew you to working with flags?

I feel that we give symbols more value and more weight than human life. This obsession we have with nationalism, and being patriotic, well it is all quite strange to me, as all I see are shapes and colours. I guess that you can say that in my work I am responding to all of this chaos and backwardness that I see taking place before me. I began as a painter, and I still feel as if I am painting, only now it's with textiles rather than paint.

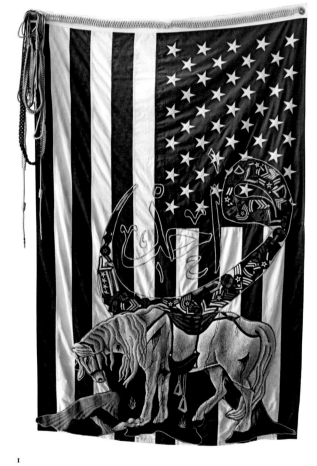

1

1. *Flag #35, Vahed (the one)*, 2008. Mixed media on textile. 180.3 × 119.3 cm (71 × 47 in).

2, 3. *Love Arrived and How Red*, 2008. Two C-prints from a series of 11. Each: 152.4 × 114.3 cm (60 × 45 in).

4. *Flag #10*, 2008. Mixed media on textile. 165.1 × 88.9 cm (65 × 35 in).

5. *Flag #5 kurdistan*, 2007. Mixed media on textile. 165.1 × 88.9 cm (65 × 35 in).

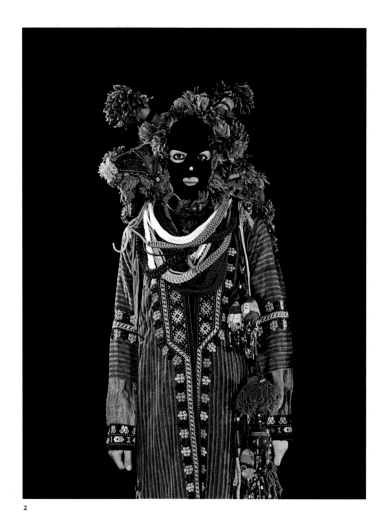

2

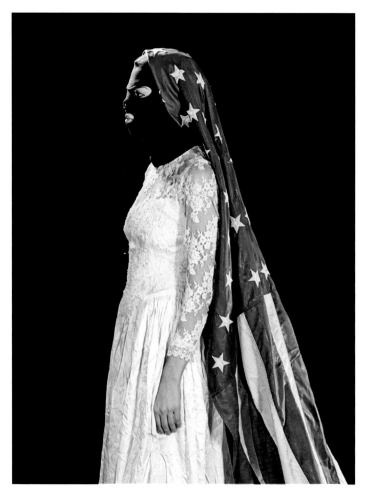

3

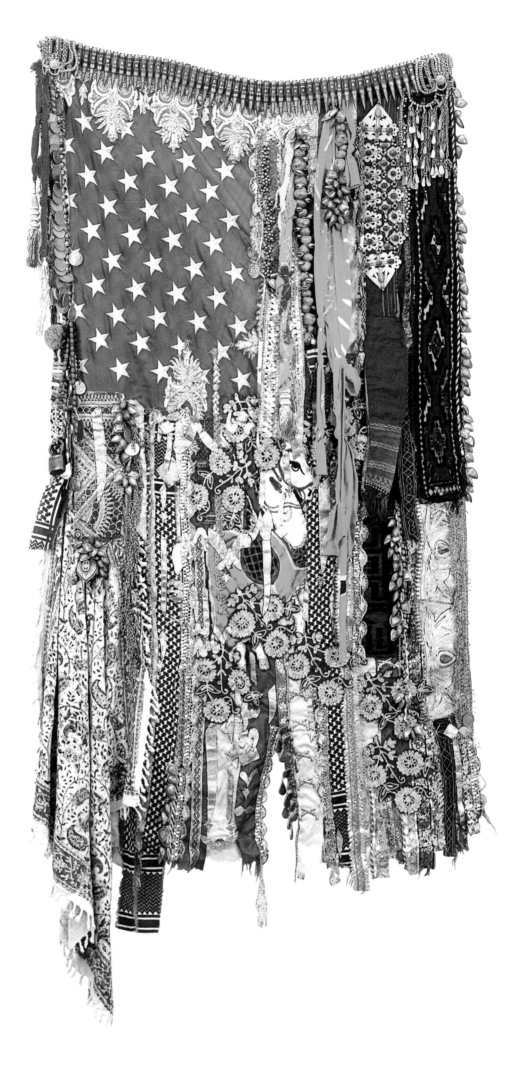

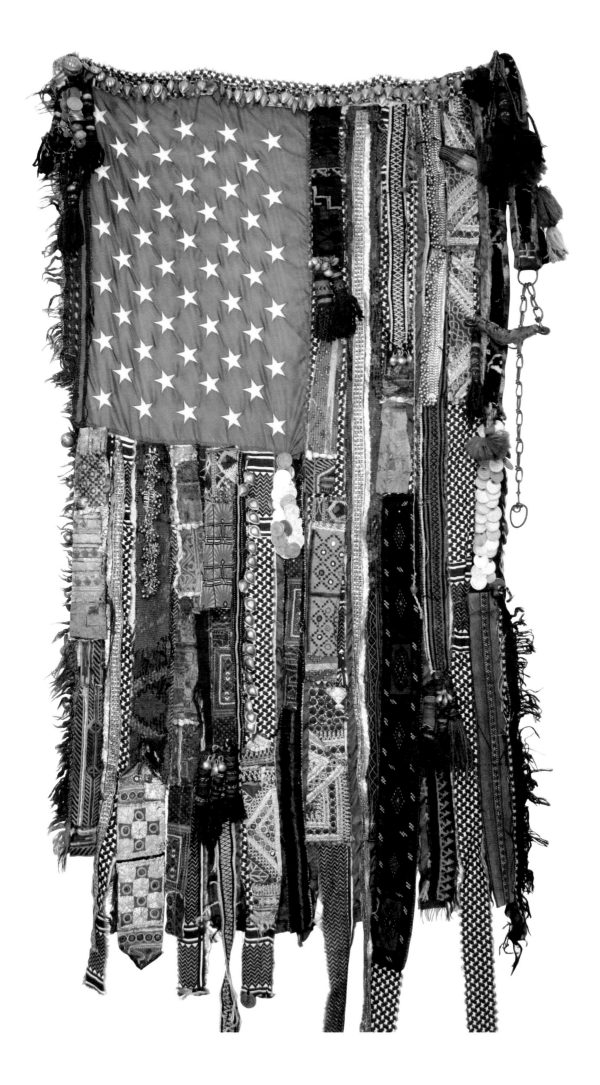

5

Jimmy Joe Roche 1981, USA, www.jimmyjoeroche.com, www.rare-gallery.com

What do you like about using found footage?
I started working with video by shooting
horror films on VHS and editing them with
old VCRs. There is a lot that we can learn
about ourselves by using material that has
been generated by others. Sometimes in art
it is good to have clear limitations that force
you to be innovative. I find that working with
found footage can become a comment on
visual language. The right juxtaposition can
make us aware of the subconscious processes
we bring to the media we consume.
There is a sense of chaos in your films, over-
whelming the viewer with imagery, movement
and colour.
I've been more and more interested in intro-
ducing a kind of raw chaos into my work,
a sense of loss of control of the medium.
For me these manifestations are represented
as psychedelic visual and auditory overload.
I am fascinated by films and events from
1965 to 1975. I think my work wants to have
a relationship to a certain lineage not only
of avant-garde cinema, and early video art,
but also 'drugged out, bad trip occultism'.
Is your work critical of American society?
My videos reflect the fantasies and reality
of my experience and inner life and how the
two become confused, fractured and woven
together. I worry that we're losing touch with
what some would call our soul, and our rela-
tionship to nature. I think technology uses
us as a tool as much as we use it.
What do you find interesting about disseminat-
ing your work on YouTube?
YouTube is like a video version of a Wakulla
County fleamarket – a mix between Walmart
and Death Metal, McDonald's and David
Koresh. It's totally awesome, free or cheap,
extremely powerful, stupid and potentially
evil – all at the same time. It's like a microcosm
of America. It gives a voice and outlet to inter-
esting and bizarre people. I like that people
are able to have conversations about my
work, that there is a forum built in. It is nice
to throw your work in the digital abyss and
see what happens.
Why have you started working with sound?
I have become more and more fascinated
with sound over the last few years. It is invisi-
ble. Making sound can be very meditative and
really pleasurable. I pride myself on making
the soundscapes of my videos quite complex.

1. *Vortex Accumulator*, 2008.
NTSC video, 1 min. 8 secs.

2. *Basement Bleeds*, 2009.
NTSC video, 1 min. 16 secs.

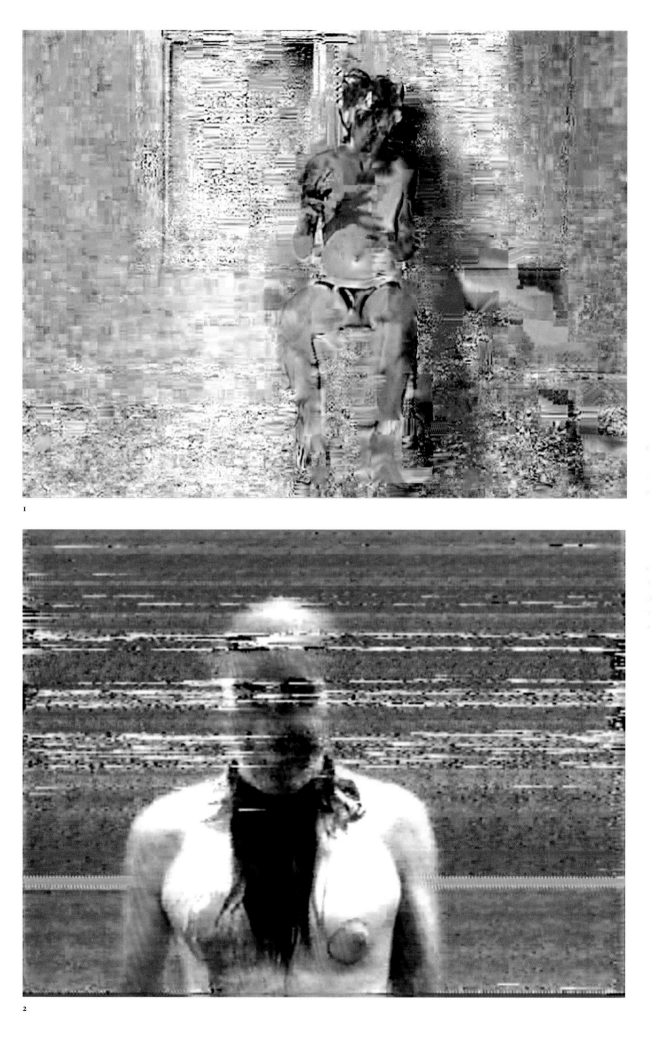

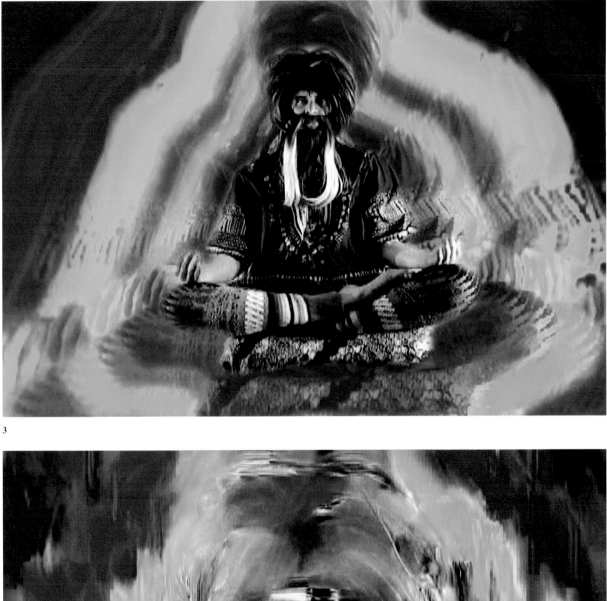

3

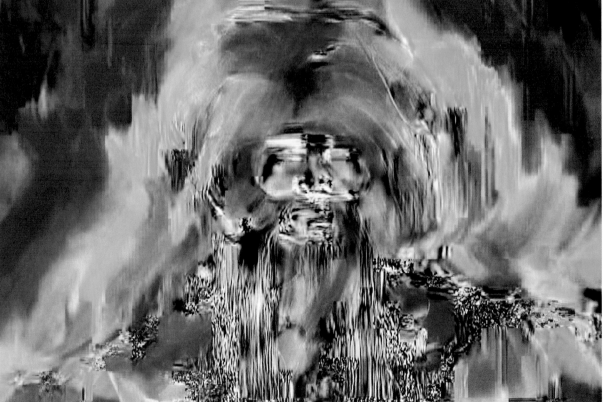

4

3, 4. *Power Wagons*, 2009.
NTSC video, 9 mins. 38 secs.

5

5. *New Power*, 2008.
Acrylic on cotton rag paper.
292.1 × 198.1 × 5 cm
(115 × 78 × 2 in).

Noel Rodo-Vankeulen 1982, Canada, www.nrodo-vankeulen.com

What interests you about space and skies?

I originally came to photography as a dissatis-fied painter and because of this I'm drawn to the cliché subjects within the medium. Astrophotography, sunset and cloud pictures are all by-products of a cultural longing for that which is beyond human creation – the sublime.

Describe the 'Aura' series.

'Aura' is a body of work – exactly 100 photo-graphs – that explores the transitory being of light. While there are obvious attachments of sentimentality and explicit beauty within the series, I'm more interested in how something ephemeral or transitory can be mediated through photography. The still image trans-forms something ethereal into a very concrete object. At its core 'Aura' is a manifestation of how a post-object (the projected light from a crystal) becomes at once an object (photograph) in between the light and the experience.

What do you like about refracted colour and light?

In many of my photographs there are light bursts, stars and haloes. I like the fact that these formalities of picture-making are at once central to any photograph, but are also indicative of God, spiritualism, death, night and space. Refraction is very ingrained in how we see through our own lenses and the lens of photography. It's a basic example of how our experience of looking is very different from the autogenic nature of the camera.

Is there a relationship in your work between the geological and the human mind?

Yes. The most explicit reference here is in my artist book entitled *Karst*. The term, which describes an erosion process of limestone by water, becomes a proxy for memory, place and the subconscious. I wanted the publication to act as a fragmented and highly open narra-tive; one where the pages could become shuf-fled over time from repeat viewings – shifting a specific reading of the whole. How does an image transform its subject generally? I try to force the viewer to rely on an organic way of thinking. These actions are similar to the wearing away of stone; by forming paths you draw the viewer through and, ultimately, to where a consensus of tone can be executed.

What attracts you about photography?

Making a photograph is an attempt at some sort of duel subjectivity. It's all about building a code of experience and a representation of a document or record, which is a complex thing. I'm very much attracted to the reincar-nate quality inherent in photography, and its intuitive process and open character of signification.

I

1. *The Vampyre*, 2008. From 'Nocturne' series, crystallized salt on C-print (unique). 25.4 × 20.3 cm (10 × 8 in).

2

2. *Cataclysm*, 2008. Archival
pigment print (edition of 5).
60.9 × 60.9 cm (24 × 24 in).

3

3. *Aura#32*, 2009. Archival
pigment print (edition of 5).
60.9 × 50.8 cm (24 × 20 in).

4

4. *Untitled* (*Orange*), 2009. Archival
pigment print (edition of 5).
35.5 × 27.9 cm (14 × 11 in).

Boo Saville 1980, United Kingdom, www.bonesanddust.blogspot.com/

What interests you about monochrome or subdued palettes?

I like the strength and simplicity of shapes and symbols. I work from a lot of black-and-white photographs and have adopted the palette as a direct reference to that, but I am starting to introduce colour now. I am interested in stripping down images to find their essence.

Why did you start working with archaeological images?

I found a book on Lindow Man in a charity shop by chance and felt compelled to make an image of it. The bogmen had retained such an amazing level of detail, even after 2,000 years, that my ability to be faithful to them became very important. I am absolutely fascinated by the past and archaeological artefacts. The bogmen have been lying in the earth for such a long time and their natural preservation became symbolic to me. There is something about the tracing of time as if it is a window into the past. Archaeology reveals the evidence of our existence. The further back in time you go, the more reduced and sublime are the objects. You literally get down to the bones of what art is for.

What attracts you to decomposition and decay?

There is beauty and creativity in the process of destruction. I am interested in decay not as a negative reduction, but as a unifying symbol of matter, of our bodies. There is clarity for me when something is stripped down to the bare bones and studied or just observed.

How does the research process inform your work?

When making my work it can be intense and very chaotic so my research usually comes out of that environment. I collect hundreds of images from the Internet, books and journals, which I may use or come back to at a later date. The more images I collect the more seem to penetrate my practice in an abstract way and this is how I figure out painting.

Is there something violent underlying your images?

Violence plays an important role. It provides something abrasive with which to prop something beautiful. I am interested in things that contain duality. I don't believe there is anything beautiful about violence but as an artist you want to find a contradiction and investigate it. The power of Christ on the cross is a perfect example. Here is a man who has been violently tortured, bloody and nailed to a cross, yet he looks peaceful.

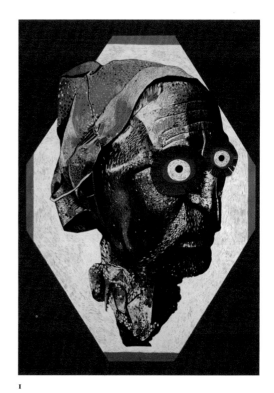

1

1. *Emblem*, 2008. Collage and pen on paper. 51 × 38 cm (20 × 15 in).

2. *Ghost – OC7203*, 2009. Etching with mixed media, each unique within edition of 31. 76.2 × 56.2 cm (30 × 22 in).

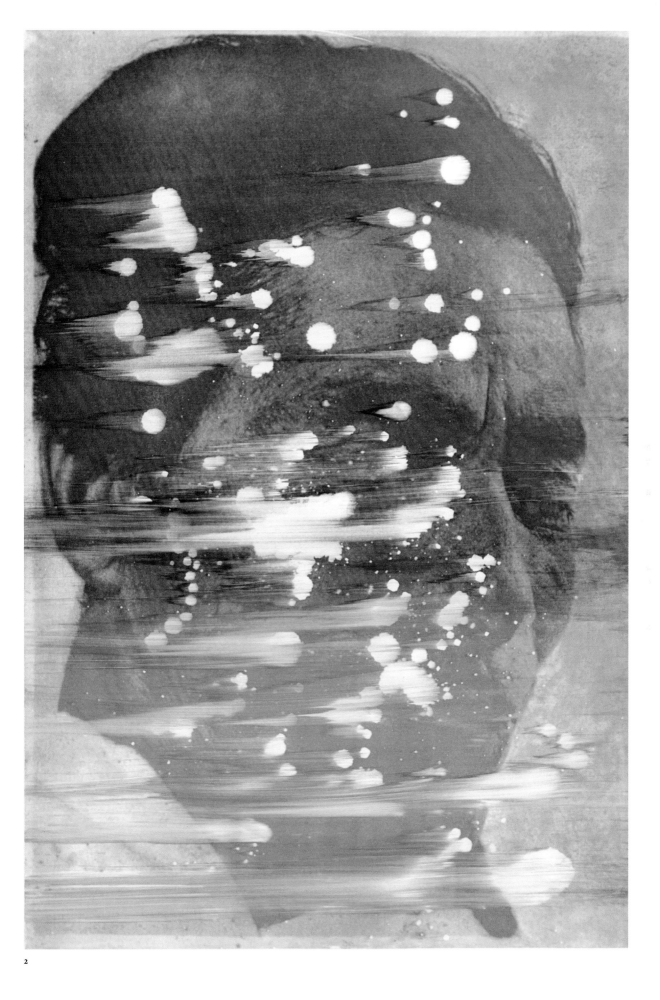

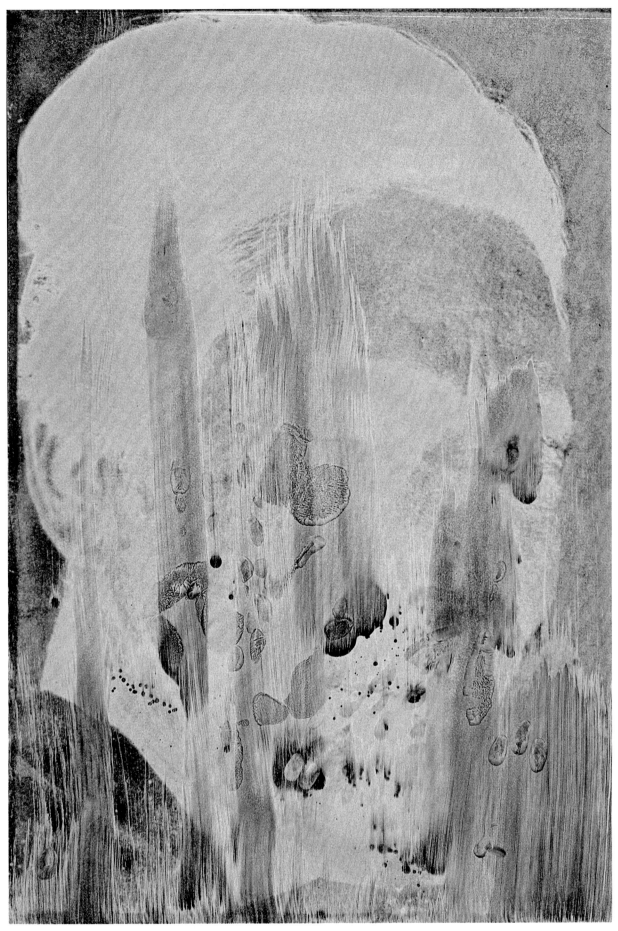

3

3. *Ghost – OC7216*, 2009.
Etching with mixed media, each
unique within edition of 31.
76.2 × 56.2 cm (30 × 22 in).

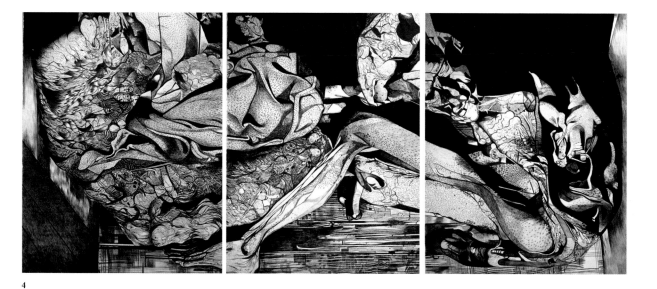

4

5

4. *Buttersunk*, 2008.
Ballpoint pen on paper.
85 × 181 cm (33½ × 71¼ in).

5. *Circle*, 2008. Ink on paper.
71 × 56 cm (28 × 22 in).

Ariel Schlesinger 1980, Israel, www.graffitiprinter.com, www.dvirgallery.com

Why do you use consumer products, particularly very everyday ones?

I use them because they are always around us. If I tamper with them, they lose their functional value. We are still able to recognize them but we just look at them differently.

What do you find interesting about doubling and pairs?

That's a hard question. I have that in mind constantly. I even went as far as trying to buy the domain Tvvo.com, which is a take on the word Two, just spelled with a couple of Vs instead of a W – but the owner of the domain didn't accept my offer.

How does the Graffiti Printer *project work and what was the idea behind it?*

Five colour spray cans are attached to hand apparatus. When it is pushed against and slowly unrolled upon any wall surface, it transmits desired information. The *Graffiti Printer* was an open source project distributed as a DIY kit. I was mainly interested in developing a tool that others could take and use as they wish. It gives you the ability to cover big spaces faster, while moving. Now there is a smaller version that you make in an hour. The instructions are on www.graffitiprinter.com.

Is your work influenced by the uncanny in some way?

It would be more accurate to say that the idea of influence is in some way uncanny. If I knew exactly what turned me on, I wouldn't travel around the world as much as I do, looking for adventures.

What is it about objects in particular that you find interesting?

Finding a way to use them in a different manner to the way they were originally meant to be used. At the moment I especially enjoy opening wine bottles with shoes.

What do you like about using flames in your work?

The fact that I have no control over them; the chance to damage things in a perfect and unique way.

What interests you about objects that have been bent and curved?

Taking something and twisting it to turn it into something different without any grand gestures.

What do you like about breaking up and playing with street 'architecture' in the 'Minor Urban Disasters' series?

I like unexpected encounters with the city. My intention in this photo series was to portray what happens when reality goes wrong for an instant.

1

2

1. *Untitled (paper stand)* 2003. Paper and cardboard. 16 × 26 × 18 cm (6⅓ × 10¼ × 7 in). A cardboard pedestal constructed for the purpose of supporting a resting stack of paper.

2. *Minor Urban Disasters*, 2007–2010. Series of 34 slides. Dimensions variable. A collection of photographs documenting 'minor urban disasters'. Each image was taken in different cities, and they all portray what happens when reality goes wrong for an instant.

3. *Untitled (Bicycle piece)*, 2008 (detail). Bicycle and cooking gas. 180 × 92 × 33 cm (70⅘ × 36¼ × 13 in). Cooking gas was pumped into the tyres of this bicycle. A special device enables the gas to slowly burn as a small flame.

4. *Graffiti Printer*, 2006. Wood, cardboard, spray paint, punch cards, sensors and batteries. 80 × 42 × 44 cm (31½ × 16½ × 17⅓ in).

5. Detail of *Graffiti Printer*, 2006.

6. *Untitled (Socks Holder)*, 2009. Silk screenprint and used socks. 23 × 46 cm (9 × 18⅛ in).

3

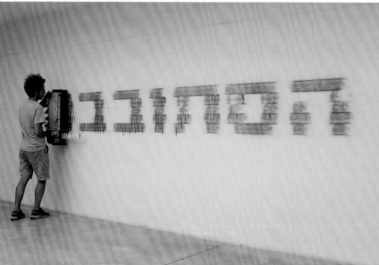

4

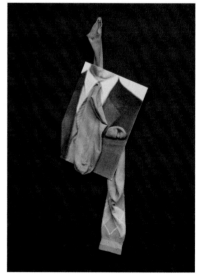

6

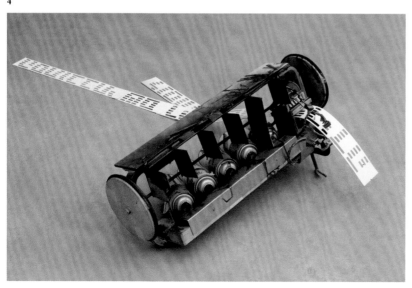

5

Christian Schoeler 1978, Germany, www.dontprojects.com

Why focus on a translucence and lack of solidity in your approach to skin?

When I think of skin, certain images directly come into my mind: the stigmata on the hands of Francisco de Zurbarán's *Saint Francis in Meditation*; the complexion of the dead Jesus in Matthias Grünewald's *Isenheim Altarpiece*; the *incarnato* of Titian's delicate faces and hands. Pictorially, I am always trying to move painting from the dark towards the light; maybe in the same way that the eyes of Caravaggio's saints illuminate a scene for a brief moment. When it comes to watercolour, which is my form of drawing, it is something very different. Watercolour functions like a breath, nimble and uncontrollable.

What fascinates you about adolescence?

The boys who interest me are aware of the glances they get and openly join in the game. The way they move, the way they seek close-ness to their own bodies is, in my mind, more of a sign of their longing for physical integrity and a sound soul than an expression of seduc-tion. In my work, adolescence should be understood as an auto-regressive moment and rarely as an expression of the artist's desire. I understand Larry Clark's *Tulsa* as being an autobiographical story rather than a pornographic one.

How do you approach making a painting?

I still believe in the age-old tradition of paint-ing – in the extravagant, the sensual, in its glamour, in the enchanting and the obsessive. Often today there is a rejection of artistically formal means of production. Discursiveness takes place instead of obsession. Painting is luminous and enigmatic. I am interested in the glamour of the magical, particularly in the abstraction and colour tones found in the painting of the late nineteenth century.

Why work on such an intimate scale?

I like to observe my surroundings. Quickly painting a small watercolour is my way of reflecting what I see and what I feel. If my art seems very intimate, it is mainly because I need to find a motive for a painting. For me this need is best met from within, and inspired by the people in my life.

You have spoken of your work as a form of self-portraiture.

I try to connect my personal experiences with the reality of my paintings, with my longings and my quest for self-assertion. Through my own experience, I have developed an acute awareness of my own vulnerability and the transience of my body and its connection to my past.

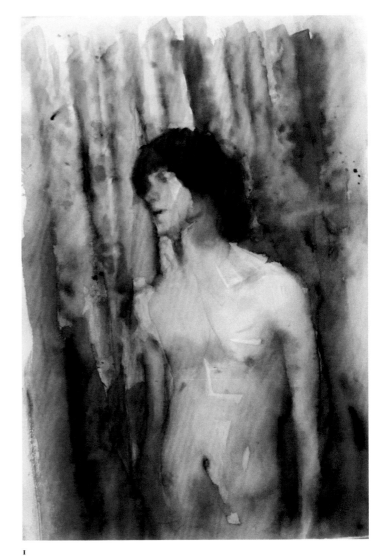

1

2. *Untitled*, 2009. Watercolour and pencil on paper. 16 × 21 cm (6⅓ × 8¼ in).

1. *Untitled*, 2008. Watercolour and crayon on paper. 50 × 35 cm (19¾ × 13¾ in).

3. *Untitled*, 2009. Watercolour and pencil on paper. 32 × 24 cm (12⅖ × 9½ in).

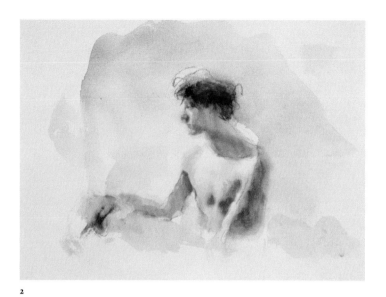

2

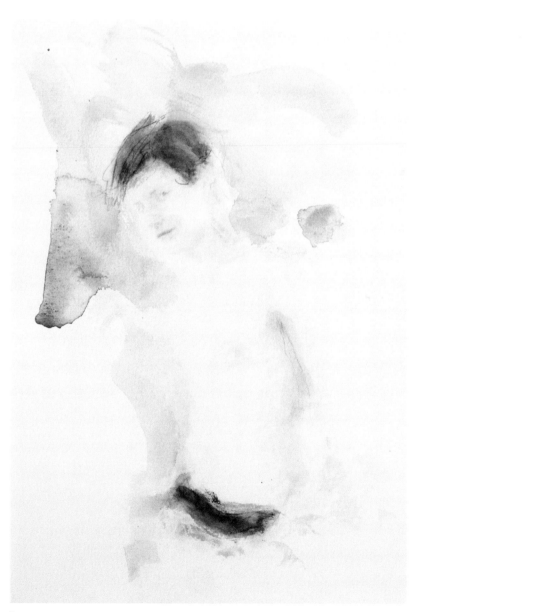

3

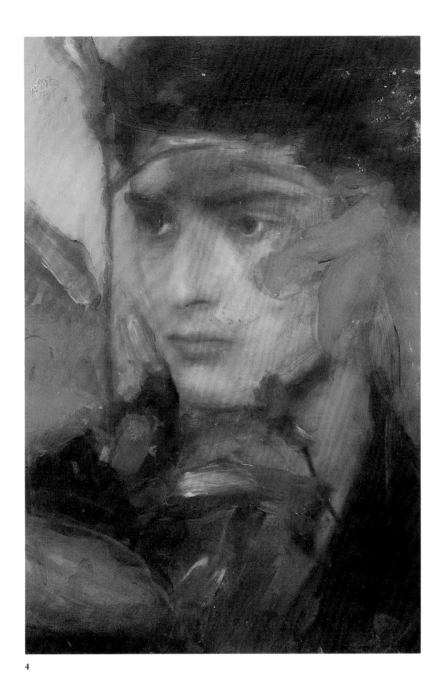

4

5. *Michael und Benedikt #4*, 2009.
Oil on canvas mounted on panel.
60 × 90 cm (23⅗ × 35⅖ in).

4. *Untitled*, 2009. Oil on canvas
mounted on panel. 45 × 30 cm (17¾
× 11⅘ in).

6. *Michael und Benedikt*, 2009.
Oil on canvas mounted on panel.
180 × 100 cm (70⅘ × 39⅓ in).

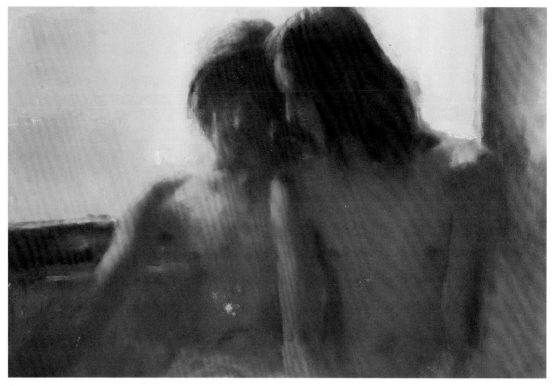

5

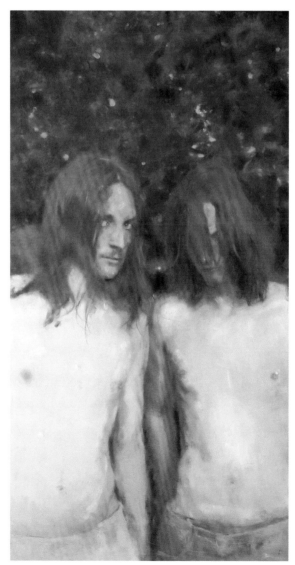

6

Vahid Sharifian 1982, Iran, www.khastoo.com

Why did you start working with found images?
I started with the series 'Bush distance family'. I gathered some family photos from websites around the world and selected eight images to use. I gave them imaginary titles that would suggest George W. Bush's distant relatives. The work doesn't have any political agenda. I admit that I often insert typically Eastern imagery into a Western context to subvert translation, but in these photos it was so weird and interesting to explore second- and third-degree family members of a famous person. At that time, Bush was the most famous person in the world. In Iran and the Eastern hemisphere, family is extremely important. Despite my efforts I could not find a single image of Bush's actual distant family. In my curiosity I was forced to lie, use images of anonymous people and make an imagined narrative for them.

What interests you about imagery of domesticity?
Maybe it's because I spend so much time at home, which is also my studio. My home is for me the most interesting place in Iran. Inside is safer. The series straddles a fine line between the art of appropriation and a more traditional idea of our fathers' art and their subsequent appropriation of a woman's soul.

Explain the term Papa'ism you use to describe your work.
It is POP + dada. My work mixes pop culture and Dada anarchy and absurdity. Maybe it comes from being born in the 1980s and growing up with Mickey Mouse and Pink Panther on TV. My generation was watching and absorbing the pop culture of a pre-revolutionary time, while living among bombs and war with Iraq and the smell of petrol. Cartoons were more fun than images of war but it all affected our minds and imagination. Everything was absurd and still is today. Dada describes this exactly.

What do you think about fictions?
When you live and work in your home, and spend most of your time on the Internet or watching boring TV programmes, you have no choice but to imagine some spaces. I can't go outside of Iran because I have refused to complete my military service. My artwork travels around the world for exhibitions yet I can't be there. Instead, I make my own fictions reality through my art. Art becomes like a dream. I convert those dreams into real images. I don't have wishes, rather memories or fantasies that bring a smile to people's faces.

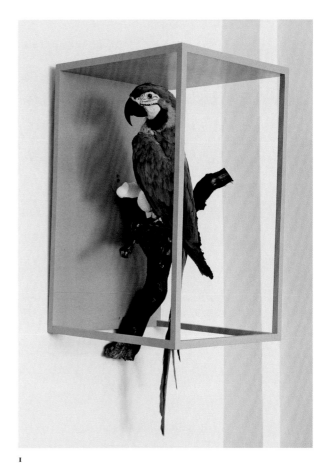

1

1. *Talk to me (Last Part)*, 2008–2009. From 'Last part' series, gatch plasterwork, taxidermied parrot and wooden box. 35 × 37 × 90 cm (13¾ × 14½ × 35⅖ in).

2. *Bush Distance Family (The brother of the driver and his wife)*, 2007. Photograph. 40 × 60 cm (15¾ × 23⅗ in).

3. *Untitled, No. 6*, 2008. From 'My father is a democrat and through his chimney there are always hearts flying to the sky' series, D-print on holographic paper. 50 × 70 cm (19⅔ × 27½ in).

4. *Untitled, No. 17*, 2007–2008. From 'Queen of the jungle (if I had a gun)' series, D-print on metallic paper. 60 × 79 cm (23⅗ × 31 in).

5. *Caressing Dog in Iran*, 2005. Centre panel of a triptych, acrylic on canvas. 80 × 120 cm (31 ½ × 47 ¼ in).

6. *Waiting for Jeff Koons*, 2006. From 'Waiting for Jeff Koons' series, photograph. 30 × 40 cm (11⅘ × 15¾ in).

2

3

4

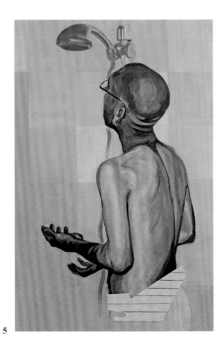

5

6

Liang Shuo 1976, China, www.c5art.com

What is the idea behind What Thing*?*
I did a lot of experimentation to create *What Thing* and most of it failed. It was a huge technical challenge. None of the original sculptures could be reproduced. Usually when people see something unknown or unfamiliar, they start to think and search for information to find out its origin and socio-cultural background to help them understand and confirm the details with their own thoughts. People want to learn the original meaning of that thing. Yet the original meaning may limit human imagination. I wanted to create an artwork that doesn't have an 'original meaning' by leaving an imprint of a figurative sculpture which leaves no clue as to its original shape.

How do consumerism and the shopping culture influence what you create?
I'm more interested in mass consumption than art. What concerns me is an object's 'value' and meaning. Consumption is aimed at people's needs. Most consumer products contain people's thoughts and their understanding of life. That is more direct and clear than so-called 'art'. It helps me to have a more comprehensive understanding of the world.

How does your use of found pop objects relate to ideas about modern China?
I think that China is full of contradictions – mainly the impact of Western values coupled with our own problems left by history. Things are happening in a mixed and confused way and are hard to understand. It somehow contains vigorous strength and surprise effects. This is very appealing to me – the state of collision and exploration in the absence of established rules.

What was the process of creating Temple Fair*?*
I spent a whole month's salary and bought a lot of things that are generally representative of a Temple Fair to most Chinese people. I recorded the shopping process with videotape, and exhibited all the items that I had bought and the video in a very formal manner. It really has nothing to do with art. It implicated my interest in Chinese society and my concern at that moment; it triggered other ideas in my artwork afterwards. The world around me is even more absurd than my work.

What do you find interesting about real and false nature?
Real nature does not matter at all; what matters is how people understand it. Communication between different understandings gives meaning to life.

1

1. Objects purchased during the making of the video *Shopping at the Temple Fair*, 2007.

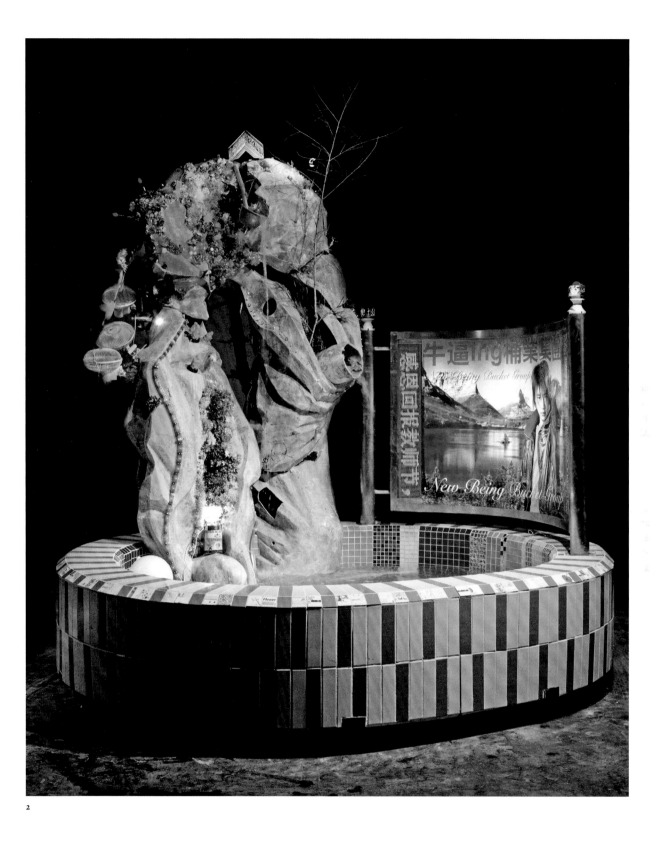

2. *I am Fucking Beautiful No. 3*,
2008. Mixed media. 360 × 350 ×
350 cm (141¾ × 137⅕ × 137⅕ in).

3

3. *Shopping at the Temple Fair*, 2007.
Stills from the video, 3 hrs. 19 mins.

4. *Study of substance – Chinese Ink
& Plaster Powder*, 2005. Chinese ink,
water and plaster powder.
Dimensions variable.

5. *What-thing #4*, 2008. Aluminium.
68 × 28 × 21 cm (26¾ × 11 × 8¼ in).

4

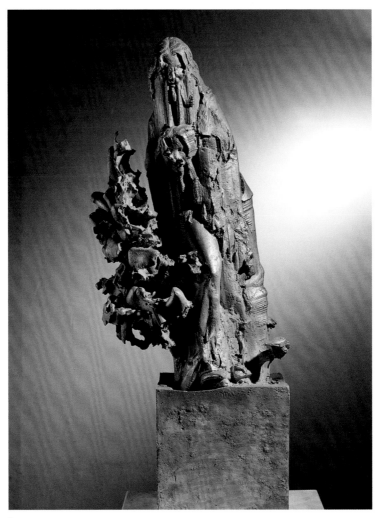

5

Sirra Sigrún Sigurdardóttir 1977, Iceland, www.this.is/klingogbang/

What do you find interesting about using light in your work?
I find it interesting to work with light, to see how it changes spaces and circumstances, to contain it, let it free again, to change its directions and effects with various elements and objects. There is the light that comes from the projector, which I often use, and light that bounces back off things like mirrors and glass and light that goes through materials like crystals, plastic, films, glass and Plexiglass. I have also done work with sunlight and used the projector as a tool for drawing with light beams.

What do you like about installation?
I like the installation form because the viewer physically enters the space it occupies. If it's successful, it can be regarded as a singular totality. The viewer's body, the sense of space, the place of exhibition – all these factors define an installation just as much as the objects it contains.

What interests you about physics, mathematics and science?
At first it was the visual imagery around information that fascinated me. Both science and art use models and metaphors: both are a means of investigation; both involve ideas, theories and hypotheses. You can think of science as an ideology, like religion, magic or mythology. But these are also the subjects of study for both fields. Artists, like scientists, study – materials, people, culture, history, religion, mythology – and transform information into something else.

What do you find interesting about rainbows or the spectrum?
It represents a small part of a bigger reality. I find it interesting as a tool and symbol with endless possibilities of references. It is fascinating because it makes something visible in a way that it usually is not and breaks it down to fundamental elements. It is both a scientific tool used to expand our horizon and our understanding of the world and symbolic in mythology and culture (for example, in old Nordic religion the rainbow is the bridge Bifröst that you have to pass over to get to Valhöll, where you spend your afterlife). For me it is a symbol of the search of knowledge.

What do you find interesting about using art to explore ideas around systems of understanding?
For me art is one system of understanding. Comparing how other fields of study evolve, and what pushes new discoveries onward, is really interesting to me.

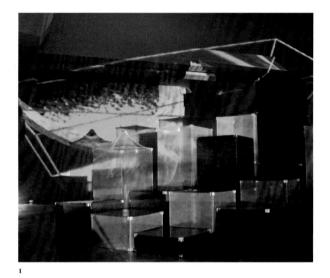

1

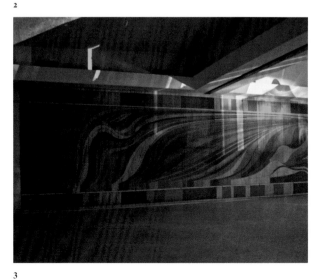

2

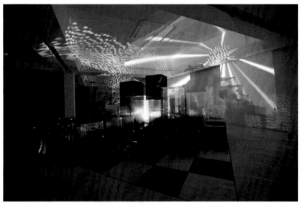

3

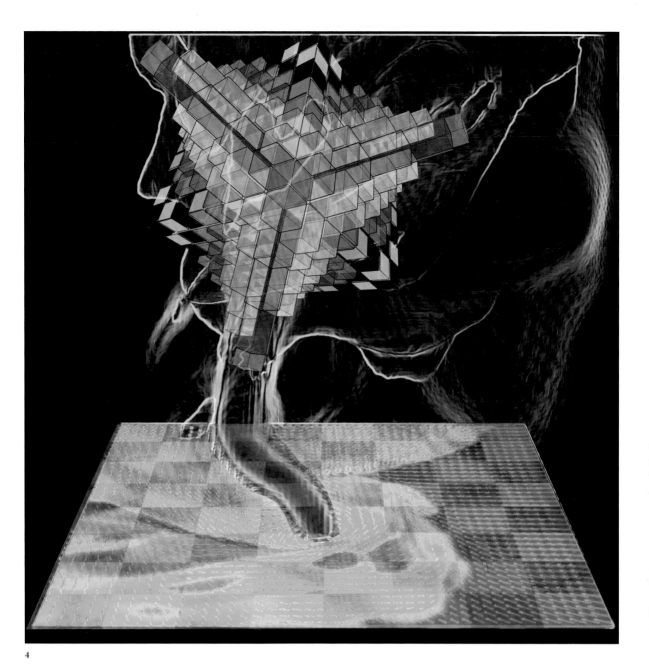

4

1, 2, 3. *Uncertainty Principle*, 2008.
Installation at Kling & Bang
Gallery, Reykjavík, 52 Plexiglas
pedestals with coloured film
standing on a painted chessboard,
prints on canvas and video
projections. Dimensions variable.

4. Poster for *Uncertainty Principle*,
2008.

Alexandre Singh 1980, France, www.preromanbritain.com

What interests you about magic and alchemy?
I feel that sculptors are the metaphorical alchemists of our times. They strive to transmute base materials, wood, plaster, stone, plywood and so on, into objects of a higher value, objects transcending intellectual and spiritual nature. The contemplation of a work of art is still couched in a mystical framework. Art, like alchemy, is an all-consuming task that is never completed. In a modern world, where religion is on the back foot, there is a renewed onus on all works of culture to dredge through our society looking for answers, for a greater meaning to our existence.

What do you find interesting about charting the logic or illogic of thought processes?
The way that we usually connect ideas together is through a very linear chain: A to B to C. The simplest form of 'illogical thought' is to skip along this line of association. In this short-circuiting of thought, the poetic can be picked apart and understood just as readily as the mechanisms by which arousal can be analyzed in hardcore pornography, and fear in a horror film. By deconstructing and understanding the illogic of madness, narcotics, superstition, religion, myth and all the other genres rich in tangential associations, we can better understand the materials of our own storytelling and strive perhaps for 'meaning'.

What do you like about playing with modes of display, like vitrines and cabinets?
Even an empty vitrine is already an interesting sculpture. Any object placed within the vitrine is immediately activated. It's an interesting convention to work with. Much like the pedestal or plinth, the vitrine locates the work in a dialogue with classicism, be it in emulation of an ancient artefact or in a deliberate friction with history. The audience is invited to ask, 'Is this thing a trophy, an artefact, an object of veneration or just someone's shoe?'

Why is your approach to collage lo-fi and loose?
Restriction is important. I can source one image from an old encyclopaedia and the other can be a screenshot from Google Street View. But flattened together on the glass of the Xerox machine, there is little difference between them. It's analogous to the narratives that I am creating. Ideas lifted from popular culture, classical mythology, consumer culture, academia, all collapse in on each other. When a piece has 120 collages, it's ridiculous to labour over each one; they need to be fast, loose and simple.

1

1. *Assembly Instructions (Manzoni, Klein, Colour Theory and Statuary)*, 2008. Seventy-nine framed Xerox collages and dotted pencil lines. Dimensions variable.

2. *Assembly Instructions (Tangential Logick)*, 2008 (detail). Seventy-nine Ikea-framed Xerox collages and dotted pencil lines. Dimensions variable.

3

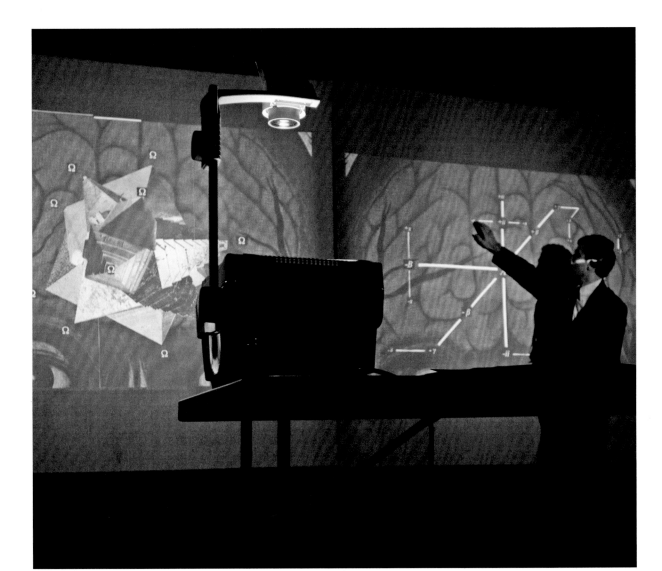

4

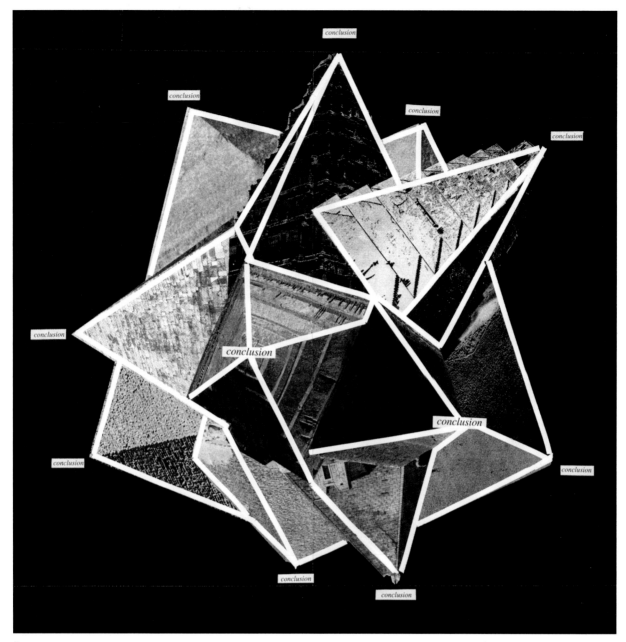

5

3. *The Economist (EsThetic moon)*, 2006. Collage of *The Economist* magazine on pressure-treated plywood. 91.4 × 63.5 cm (36 × 25 in).

4. *Assembly Instructions Lecture (Tangential Logick, Tangential Magick)*, 2009. Performance at Renwick Gallery, New York.

5. *Assembly Instructions (Tangential Logick)*, 2008 (detail). Seventy-nine Ikea-framed Xerox collages and dotted pencil lines. Dimensions variable.

Agathe Snow 1976, France, www.peresprojects.com

Did you always want to be an artist?
Never. It was all about surviving. You don't
really want to be anything – just alive. Looking
at everything as I do, people would say 'that's
art'. Don't call me anything; I just want to be
me. I've recently started calling myself an
artist and it's a big step.

How did you first start showing in galleries?
I started in New York. I was mostly doing
anonymous stuff at Reena Spaulings, then
they started representing me. My things were
bought and I really panicked. I hated it be-
cause I didn't really know what I was saying.
I was doing performance or cooking on the
streets. I went all over the world doing these
dinner installations. It was all about commu-
nity. I was doing processions, dance
marathons; lots of endurance-based things,
like peeling onions for twenty-four hours or
dancing every day for hours. It was all about
pushing your body to exhaustion, to the point
when you just can't think anymore; you are
beyond the machine. I think, when you're in a
safe environment, that that is an amazingly
liberating feeling.

*Do you always create work directly within
a space?*
Generally there's a narrative. I love inviting
people into the narrative. Most of the 'stuff'
I use is found, for financial reasons. At Peres
Projects, I came with all my own garbage and
rolls of fabric. I invited people who had never
made art to contribute. It was the revenge of
nature, but not destruction. It was a question-
ing of things. Nature doesn't have any form of
communication. I love human beings for their
ability to communicate – it's a way of living
together. Nature takes so long to communi-
cate; it's such a rebel, a renegade.

*You've created sculptures using prams and
stuffed materials. Are you referencing mother-
hood in some way?*
I am very motherly. I create this world around
me. I'm very much like the mother. I don't
know if I'll ever have kids. I collect all these
kids everywhere I go (including the boys in
New York). Together, Dash [Snow] and I were
a force to be reckoned with, super-creative.
It lasted a long time.

What influences your approach?
Movement; any kind of movement. I used to
dance. I'm not trained at all as a sculptor, but
I have made some really classical sculptures.
It's just about understanding movement. I love
people in action.

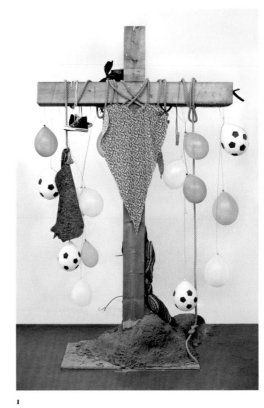

1

2

1. *Three (Cross with Balloons)*, 2007.
Balloons, found objects, cloth, wood,
concrete and wire mesh. 300 × 180 ×
80 cm (118 × 70 × 30 in) approx.

2. *Five (Cross on the Left with
Spider Web)*, 2007 (detail).
Balloons, found objects, cloth, rope,
wood, concrete and wire mesh.
300 × 180 × 80 cm (118 × 70 × 30 in)
approx.

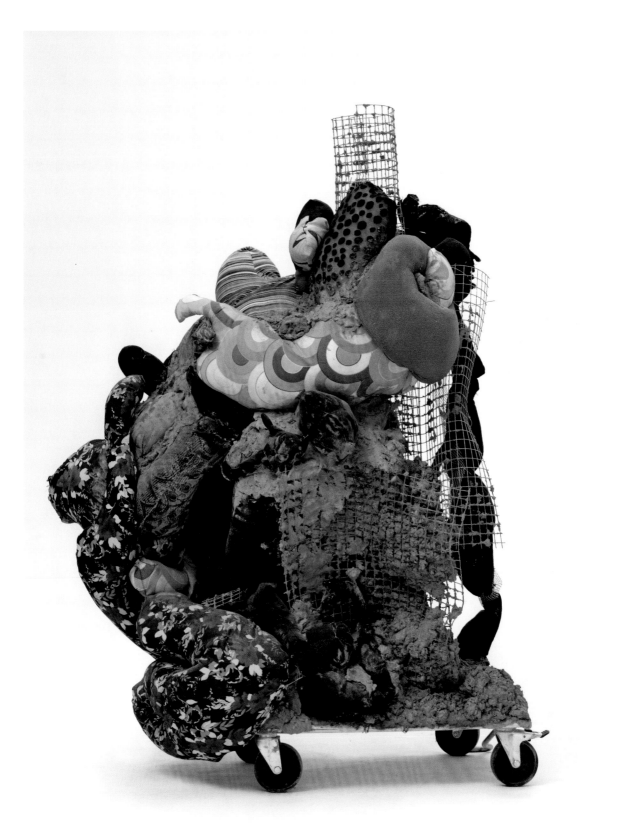

3

3. *Twelve (Nike Swoosh, McDonalds)*, 2007. Cloth, concrete and pigment, wire mesh and moveable dolly. 122 × 113 × 131 cm (48 × 45 × 52 in).

4

5

4. *Sixteen (Four Red Strollers)*,
2007. Concrete and strollers.
Dimensions variable.

5. *Two (Balance of Power)*, 2007.
Concrete, wire mesh wood and
latex paint. 140 × 400 × 115 cm
(55 × 157 × 45 in) approx.

6

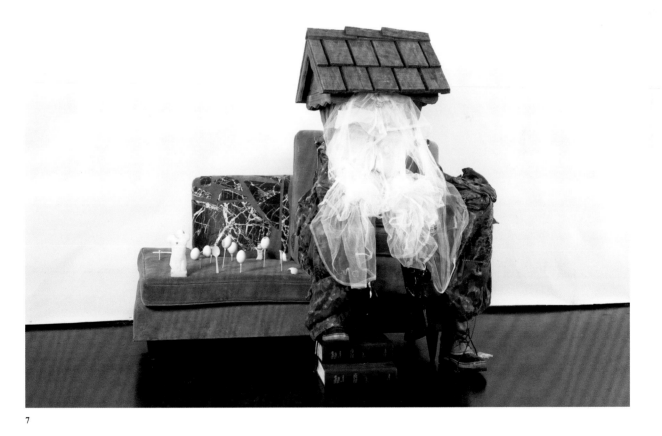

7

6. *Do You Think I'm Better off Alone*,
2008. Sofa, cushion, bubble wrap,
light fixture, football shoulder pads,
wooden frame, cardboard cutout
and rope. 166.3 × 129.5 × 152.4 cm
(65½ × 51 × 60 in).

7. *In My House, My House*, 2008.
Sofa, chair, wood cottage, boots,
clothing, eggshells, golf tees,
patterned vinyl adhesive,
various found objects.
143.5 × 114.3 × 142.2 cm
(56½ × 45 × 56 in).

Soda_Jerk 1977 and 1979, Australia, www.sodajerk.com.au

What are your ideas around remixing imagery?
We see a correspondence between the histori-
cal politics of George Orwell's *1984* and the
current hysteria around copyright. There is
this great slogan: 'Whoever controls the past
controls the future. Whoever controls the pres-
ent controls the past.' For us, remixing is very
much a form of cultural warfare. Part of what
is at stake is whether cultural history is some-
thing everyone should be able to participate
in, or whether it should be controlled, shaped
and owned by a minority. All illicit sampling
practices implicitly affirm a dynamic of shared
culture and historical multiplicity.

*Your lo-fi way of juxtaposing images is often
intentionally jarring. Why?*
We are bored with the way that mainstream
digital films strive for invisible effects, always
wanting the image to look as seamless and
realistic as possible. We are much more inter-
ested in exposing the seams where the different
fragments of the digital image are grafted
together, the point at which the different con-
texts and timeframes of samples are brought
into collision. We try to retain a certain awk-
wardness or off-kilter quality. We also have a
soft spot for the aesthetic of aged or damaged
footage – decaying celluloid, grainy video and
unruly digital glitches.

*What do you find interesting about archive
imagery?*
We see the DVD player as a kind of Tardis
that enables fragments of the past to be time-
shifted into the present. It extends the inherent
time-shifting capacity of recorded media by
multiplying, warping and confounding the
conventional timelines of cultural material.

What interests you about child stars?
The passage of real time is inscribed on their
bodies as they age in front of the camera.
Their physical presence acts as a sort of shared
cultural clock recording the passage of time.
These dynamics underpin 'The Dark Matter
Cycle', an ongoing series of work that we
started in 2005 with the video *The Phoenix
Portal*. In this work a young River Phoenix,
from the film *The Explorers,* builds a super-
computer to summon his future self from the
later film *My Own Private Idaho*. In our 2009
work *After the Rainbow*, the twister from Oz
transports a young Judy Garland into the
future, where she encounters the tragically dis-
illusioned figure of her adult self. The melan-
choly that emerges from these two meetings of
older and younger selves has to do with the
way that recorded media makes visible the
process of aging and death.

1

2

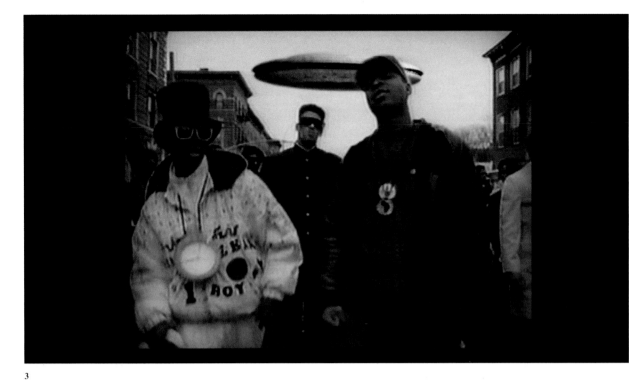

3

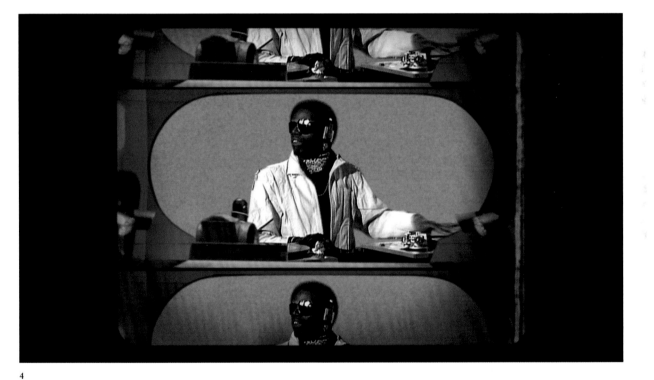

4

1. *Pixel Pirate II: Attack of the Astro Elvis Video Clone*, 2002–20 06. Video stills from single-channel video, digital video, 60 mins.

2. *After the Rainbow*, 2009. Video still from 2-channel video installation, digital video, 7 mins.

3. *Astro Black: A History of Hip-Hop (Episode 2)*, 2008. Video still from 5-channel video installation, digital video, 31 mins. 45 secs.

4. *Astro Black: A History of Hip-Hop (Episode 1)*, 2007. Video still from 5-channel video installation, digital video, 31 mins. 45 secs.

Anton Stoianov

1978, Bulgaria, www.artnews.org/antonstoianov

What drew you to icons?
In my native Bulgaria, icons are the first and the last pictures people are confronted with in their lives. I grew up with them. They really play a crucial role in everyday life. After the downturn of the Communist regime, these images became a symbol for the resurrection of the conservative values of the Orthodox Church. In the academy in Sofia where I studied, painting icons was part of our schedule. I refused to paint them, in a way protesting against the traditions we were confronted with. I only started to paint icons when I came to Berlin, where these traditions didn't belong to the academic canon. It felt subversive to use these ancient, strictly academic, techniques. I think icons can often be seen as autobiographical documents.

What do you find interesting about playing with ideas around history and modern life?
I think it is interesting how the same image can be either subversive or affirmative in different social, political or historical frameworks. The persistence of pictorial traditions fascinates me. During the Communist regime, as well as during the Ottoman Empire, icons became forbidden images, symbols of a suppressed community, of a secret knowledge. I see parallels to the codes of certain subcultures. I've always felt drawn to and part of subcultures – social, sexual and artistic – as a resistance to mainstream standards. I show subcultures not from a voyeuristic point of view, but rather from my own experience.

Why do you work with inkjet prints?
Like icons, they have a physical materiality. The rubber gives a special quality to the flatness of the copied and drawn-over prints. I like the in-between state of these drawings – half object, half drawing, partly photography, partly painting.

What interests you about painting landscapes?
The landscapes are about the absence of the body. These landscapes are drawn from a religious background and only function with the people that they display. The original images are filled with depictions of saints and martyrs.

Is there something volatile in your approach to image making?
Quick gestures are the basis of my way of working. In the icons and the photocopies I often add something like a drawing or a rivet. I tend to subtract parts of the image, scratching other parts, destroying it with fire or water. You could call these gestures volatile and spontaneous.

1

2

1. *The Ascension of Elia*,
2007. Gouache on wood.
30 × 40 cm (11⅘ × 15¾ in).

2. *Me and Scenes from My Life*,
2007. Gouache on wood and gold.
80 × 99.5 cm (31½ × 39⅕ in).

3. *The Miracle*, 2007.
Gouache on wood and gold.
20 × 30 cm (7⅘ × 11⅘ in).

3

Matthew Stone 1982, United Kingdom, www.matthewstone.co.uk, www.union-gallery.com

Why did you first start working with the naked body?

Increasingly, clothes got in the way of the images I was making. I don't consider or intend nudity to be confrontational. In a physical sense, it's easy to see where one person begins and ends. The body demonstrates our individuality. Creating images that blur this physical divide, bodies in union, has become a way for me to consider interactions between individuals on other levels. Action, exchanging ideas, energy and emotions extend parts of ourselves into others. By increasing our sensitivity in certain ways we can begin to become each other and understand more.

Why are you pushing your photographic work into sculpture?

I began installing my photography sculpturally, using wooden billboard structures. I cut them so that they seem to pass through the walls and then down into the earth. I want them to appear to have come simultaneously from the future and the past. I extended this process into sculptures that are composed of intersecting wooden cubes. The separate cubes, much like the individuals on them, share complex space hidden beneath their surfaces. By trying to understand the space we share with another, I think we can begin to navigate the conflict we encounter in the world.

Tell me a bit about your idea of optimism as cultural rebellion.

I have long defined optimism as the vital force that entangles itself with and then shapes the future. The idea of it being rebellious is a timely one. Postmodernism destroyed the idea of a singular truth. The enormity and complexity of this gesture created a type of nihilistic paralysis that seemed to eclipse the possibility of the future and optimism. By replacing meaninglessness with endless possibility, it now seems possible to reclaim new futures. Ultimately I believe that all art is optimistic and aspirational.

How do the spiritual and shamanistic inform your work?

I use what I understand to be the role of a shaman as a way to determine my role as a contemporary artist. I am working on an opera with a young composer and we are using archaic shamanic techniques within the musical structure. We want to induce trance-like states in the audience. These types of immersive states plunge you directly into your mind and remove you from the material world. Artists translate and externalize what is inside. It is a shamanic process.

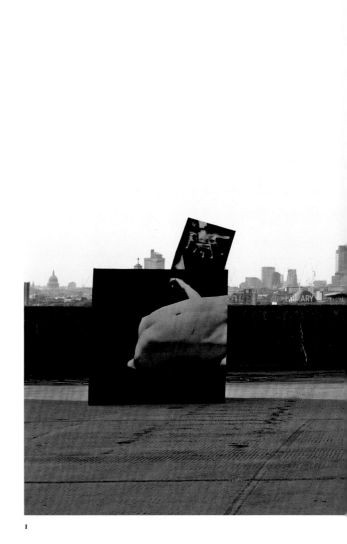

1

1. *And as they reached for God with their fingertips, their toes wrote Stories in the sand*, 2008.
Digital inkjet on wood.
Dimensions variable.

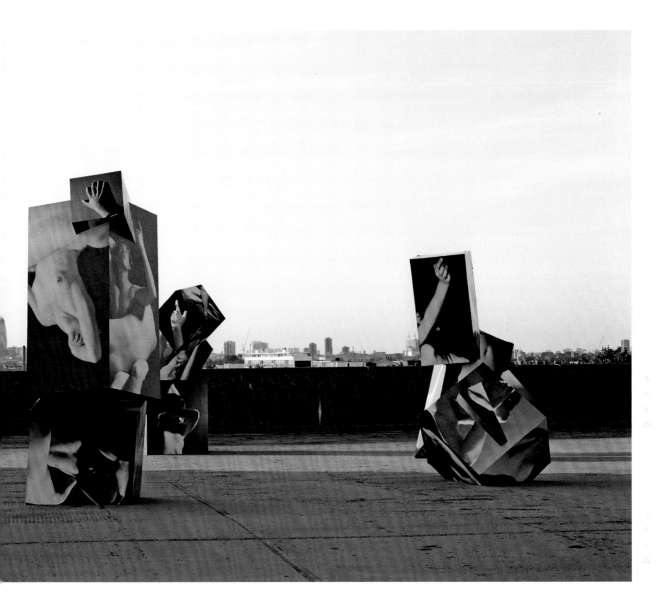

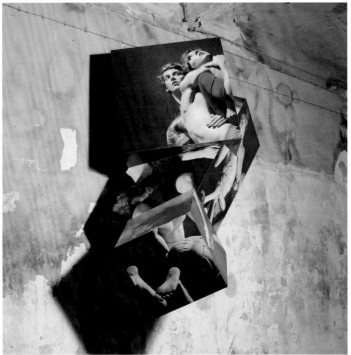

2. *Everything is Possible*, 2008.
Wood and digital inkjet on vinyl.
245 × 190 × 140 cm (96½ × 74⅘ ×
55 in).

2

Jack Strange 1984, United Kingdom, www.tanyabonakdargallery.com

What interests you about the concept of repetition and loops?

Repeating feels like it has no edges, it creates space. It feels like a very sculptural tool. It feels intrinsic to my sense and logic of understanding. That's what makes it such a good tool to question things; it's expansive.

How and why have you used laptops in past installations?

I'm definitely interested in how the laptop has now become such a common everyday tool in the production and existence of life and art. I'm also interested in many other things that are there within the space as well as the material qualities that the computer has created and the emotions it effects.

What interests you about the idea of heroes and superheroes?

I think it's very funny. It feels like it's quite a macho alpha male thing. I can feel myself identifying with it in some way, which terrifies me. I think it's a very strong symbol for the desire for some sort of power. That feeds into all sorts of things to do with one's character, self-expectation and beliefs, ideals and morals, rights and wrongs. It feels very authoritative. You only have to look at the Hollywood machine and see how sedating movies have become. They don't make you think, they are trapped by these ideas.

Why particularly use clips from Hollywood blockbuster films?

Hollywood affects our sense of reality so strongly. It's like a mirror feeding back to us a reflection of ourselves. But it's a very superficial reflection. It's like a closed feedback loop constantly reaffirming and conditioning us with what we believe to be the ideas we want. There is no space to question, think or feel other things. Generally it's just like advertising.

Why use humour in your work?

It's one of the things that will get closest to articulating some sort of internal logic. There is definitely something boyish in the humour of my work. Maybe it has something to do with being in a world outside of my making and finding that both delightful and disgusting.

What aesthetically and conceptually do you like about cut and paste?

It feels like a very natural technique we use to edit and communicate our sense of the world. It's a language that can often have quite transformative effects. It can create ways for things to behave that one might not have seen coming. By cutting into or out of something, then reapplying it somewhere else, you can disrupt and really change the original source.

1

1. *Boneless (Coral)*, 2008. From series of archival inkjet prints with two hole punch outs. 10 × 25 cm (4 × 9⅘ in).

2. *g*, 2008. Lead ball. 3.8 × 4.4 × 4.4 cm (1½ × 1¾ × 1¾ in).

3. *Study Group*, 2008. Cardboard and inkjet prints. 10 × 54 × 42 cm (4 × 21¼ × 16½).

4. *Tom*, 2007. Four video stills, DVD, 22 mins.

2

3

Esther Teichmann 1980, Germany, www.estherteichmann.com

Why do you depict subjects that turn away from the camera?

The subjects in my images are not returning the gaze of the camera; their eyes are closed, fragmented or turned away, as though they are withdrawn inside themselves in a state of imagining or dreaming. This withdrawal refers to a sense of loss and grief. In its hard smooth surface, the image affirms my distance – an auto-erotic touch from which I am excluded. This sense of mourning is perhaps intrinsic to the photographic medium and is bound up in my relationship to picture making: that it is in place of something missing. Perhaps it reflects an anxiety about not being able to hold on to people and being in constant fear of losing them.

What interests you about fiction?

Throughout the work the personal rubs up against a world of mythical symbols, melding fiction with autobiography. Fragmented narratives move towards grand narratives divorced from time or place. These repeated narratives, which cross histories and cultures, draw upon shared desires and fears.

Do you connect your photographic work to a painterly tradition?

The relationship with other media is very important to my practice, particularly examining and playing with the relationship between photography and painting, the monumental and sculptural in relationship to the bodily, and the still and the moving image.

What do you like about photographing flesh?

Skin acts as a mirror, reflecting difference and separation and countering the uterine fantasy of reassimilation. Skin is a barrier, a marker of refusal that defines our relationship with the maternal body and that of the lover. The one disallows a re-entry into her body; the other's skin is an awakening that any fantasy of oneness is only that. The skin resists being localized and fragmented by vision, both internal and external.

How do your landscape pieces fit with your more figurative work?

That sense of a desire to return to something that eludes us pervades the work. It is beyond or before language, a sense of homesickness, without orientation or geographical location – a sense of loss and grief without a fixed subject. By constructing a space in which the subjects become protagonists of a fantastical narrative of loss and desire, the space becomes a non-existent, impossible one – loosened from its photographic relationship with reality.

1

2. *Untitled*, 2009.
Diptych from 'Mythologies' series, slide projection onto a wooden gessoed cylinder and photocopy. Cylinder: 40.6 × 10.1 cm (16 × 4 in); Photocopy 30.4 × 40.6 cm (12 × 16 in).

1. *Untitled*, 2009.
From 'Mythologies' series, A4 photocopy. 30.4 × 25.4 cm (12 × 10 in).

3. *Untitled*, 2009.
From 'Mythologies' series, hand-tinted C-type. 101.6 × 127 cm (40 × 50 in).

2

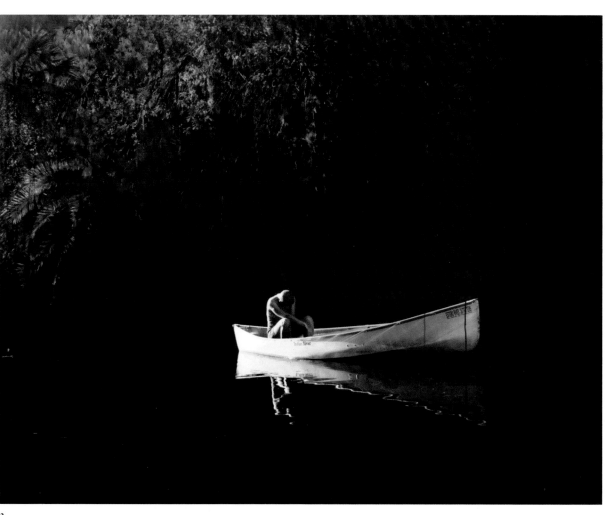

3

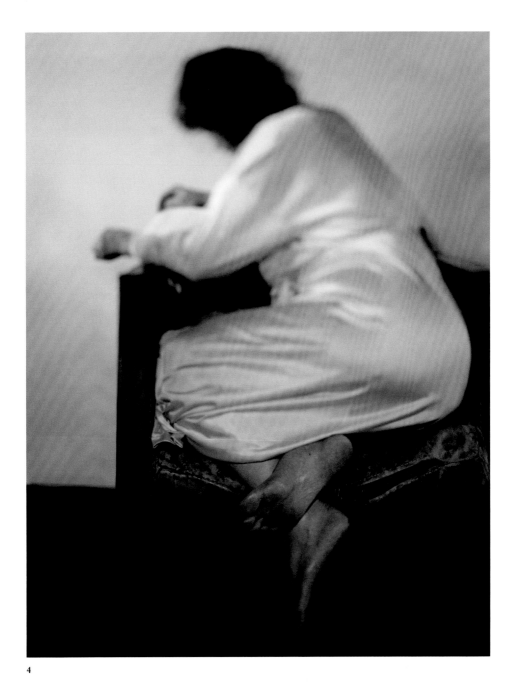

4

4. *Untitled*, 2004. From 'Stillend
Gespiegelt' series, C-type.
127 × 101.6 cm (50 × 40 in).

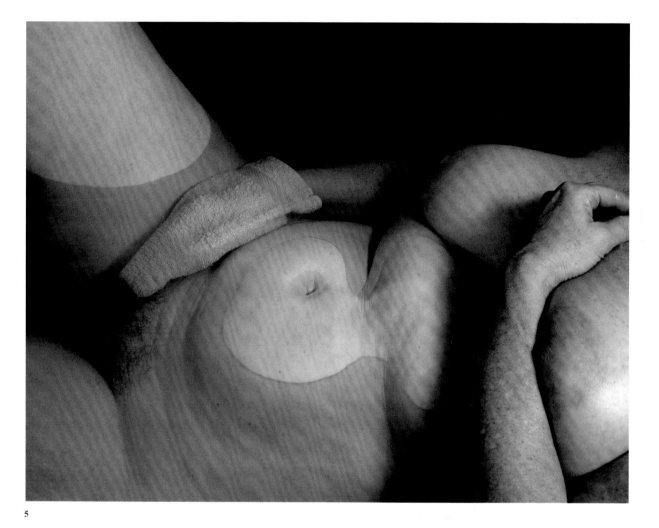

5

5. *Untitled*, 2005. From 'Stillend
Gespiegelt' series, C-type.
76.2 × 101.6 cm (30 × 40 in).

Ilya Trushevsky 1981, Russia, www.oi1.su

Your canvases can be very visceral. What do you like about that sense of texture?

Surfaces are just the background to an action. The most common background surfaces that anybody sees every day are like a canvas. In an urban space they are asphalt, bitumen and glass. I am trying to look for beauty in everyday things. Nothing is more important than the details.

What do you like about blackness?

I use black, especially black liquid, as a universal material to play with ideas like social phobias, personal fears or abstract negatives. This material can hide and be smooth. It can show you the atmosphere of something from your past. It is the best background for brilliant shining lights.

Many of your installations and paintings are covered in spills and drips. What does that mean for you?

I am trying to recreate chaos or a random process. I use the unpredictability of gravitational surfaces and liquid. There is beauty in chaos. Dripping is the simplest way to create that.

Tell me about the relationship between the sculpture and the canvas in your piece Komovaljanie.

I am not a painter. In that project, I laid two sheets of cloth on the ground to document the process of creating objects on their surface. Canvas is just another form of documentation.

What do you find interesting about maps, aesthetically and conceptually?

A map is the model of a surface. It is one way to describe the universe in a system of colours, text and numbers. For me it has great beauty and power. You can feel something behind these lines and dots – millions of kilometres of space.

Describe your piece Map of the World.

This was my first work. I found a map in St Petersburg's Museum of Artillery, Engineers and Signals. It was a hand-drawn map of American navy bases. I made a small shift to its reality using a hidden video projection of flies. I wrote a simulation programme that multiplies and moves flies like they are real. At first they look like normal museum flies, but after few minutes of looking you can see more and more, an unreal, huge number of insects.

What is the importance of performance in the creation of your objects?

I think that when you create an art piece everything can be interesting and important. Production organized in the right way is performance.

1

2

1. *KOM*, 2009. Part of 'KOMO-VOLYANIE: KOM, SHAR, CLOT' project. Video, found objects and canvas. Dimensions variable.

2. *Fort Srein Puppies*, 2009. Photo from unfinished project.

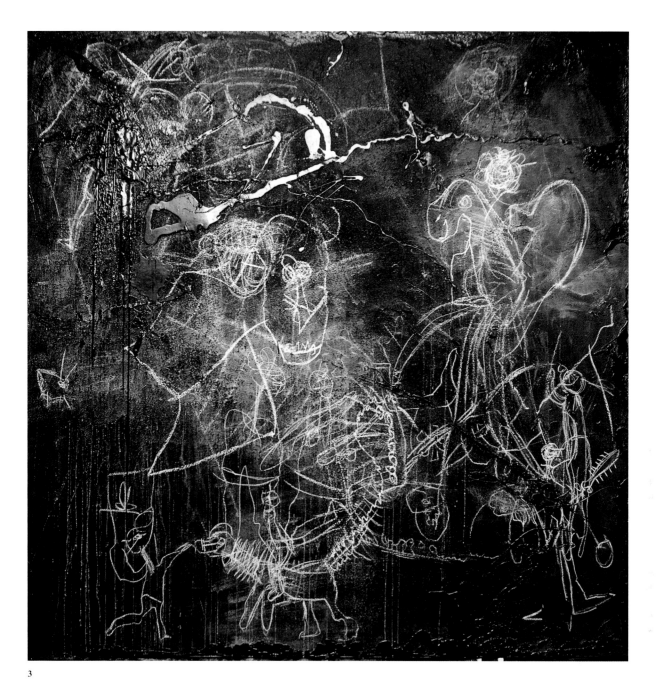

3

3. *Asphalt*, 2009. Black bitumen,
white chalk children's drawings,
asphalt and canvas. 200 × 200 cm
(78¾ × 78¾ in).

Ian Tweedy 1982, Germany, www.studiodabbeni.ch, www.monitoronline.org

Where do you source the found imagery you use?

The images are mostly cut out from books and magazines, most dating up to the 1980s. I used to keep them all categorized in marked folders, but I gave that up since I have nearly all my images memorized. I can work with them better if they are scattered all over the floor, like a large jigsaw puzzle with its pieces spread all over the place like shrapnel.

What do you find interesting about the process of collecting and categorizing?

Living among the debris can be both empowering and discouraging at the same time; picking up the pieces and reassembling them, forcing them back together again, to make some kind of sense from it all.

How is your work informed by ideas about memory, history and social history?

It's hard not to be influenced by all the writing and material you can find on archives and memory these days, but that's not to say I don't want archive images to influence me. They can become integrated into my own memory by reinterpretation or intervention.

Why did you decide to create works on book covers?

'Arrangements of Forgotten Stories' is a series of small, very condensed oil paintings on book covers that have then been ripped off from the seam of the book, leaving only the cover – as if the image has completely consumed the written word. It is an ongoing series, referring to my interests in history and the practice of archiving. The cover, when dislocated, is a sort of portal. I see no difference between a book cover and public wall. It's simply a container.

What attracts you to images of war or aggression?

War and aggression don't interest me as much as our history's relationship with power, exploitation and violence – both past and present.

Does your work explore ideas around the representation of masculinity?

I can't escape from it. I recently finished a large work called *70 Zeppelins*, consisting of seventy different zeppelins drawn meticulously onto separate scraps of paper. They were leftovers and cutout images left from my entire archive after moving it from Milan to New York. Phallic it may be. I was exploring ideas of power, geography, architecture and occupation. I see the fall of the Hindenburg zeppelin as a symbol of the impotence of our culture and the failure of western civilization.

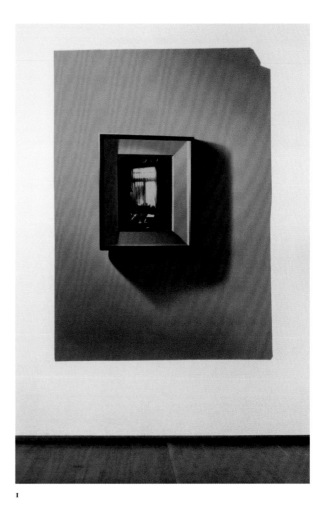

1

1. *A Portrait of a Picture*, 2010.
Wall drawing, latex paint on wall.
228 × 165 cm (89¾ × 65 in).

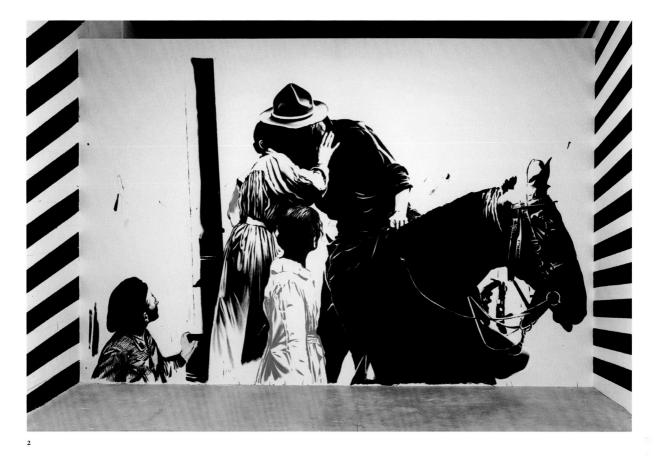

2

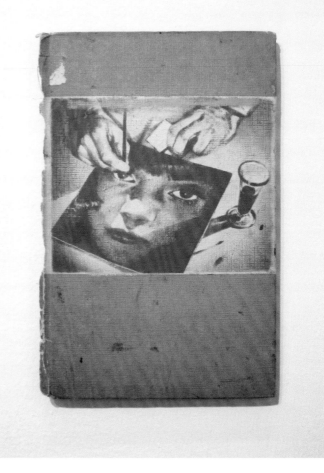

3

2. *The Departed in Dazzle*, 2009.
Detail of installation at EX3,
Florence, latex paint on wall.
326 × 500 cm (128⅓ × 197 in).

3. *Arrangements of Forgotten
Stories #79*, 2010. Oil on book
cover. 25 × 17 cm (10 × 6⅔ in).

Joris van de Moortel 1983, Belgium, www.jorisvandemoortel.eu

What do you find interesting about containment?

That it can explode. I don't want to conserve something like beans in a tin can. The work is an assimilation of all kinds of different materials, all relatively innocent, but together they become a beautiful violent cocktail. By using a method, like framing and capturing, I try to get the work in a 'scream' position, in a silent shock. The work has to deal with itself and its environment.

Why do you work with compressing materials?

The floor and *Vlaamse stenen* are explicitly based on the idea of compressing materials that come from one thing, are shredded into pieces and are remoulded again into a new shape. It's a process related to doing things by 'undoing' them.

You often build installations that grow out of existing architecture. Why?

I always think I ignore or deny the architecture that surrounds the work, although I am very much aware of its influences in every moment of the process of developing or displaying the work. The domination of a certain site has always had an enormous 'natural' influence on my work. It's there. You cannot erase it and make a 'marriage parfait' or try to get its attention. I think I operate as a 'harmonized parasite'.

Are you aesthetically interested in the rawness of the building materials?

For sure. Something triggers you because of its beauty, qualities, and eventually its aesthetics. It changes very rapidly. Materials come and go, like the colours from one canvas to the other. The material shouldn't make the work.

What do you like about the tension around your sculptures?

They sometimes seem as if they could fall apart and spill at any moment. The so-called 'accident', or rather the predictable incident, is a potential catastrophe. The tension of a collapse or breakdown vibrates all along the work, even if the accident has already taken place or still has to happen. The sudden way in which an accident can flatten something, without any sense of discrimination, is a revealing moment.

Is there a performative aspect to your work?

Performative, in the sense that nothing is static? Yes I believe so. It's all an endless loop isn't it? Rhythm, motion, sequence, and static – in a constant flux. Everything has the ability to disappear or multiply itself.

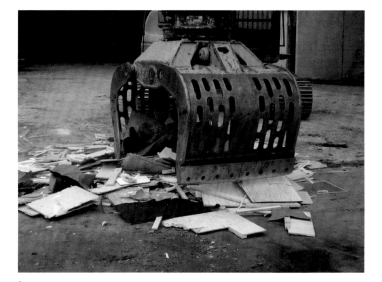

1

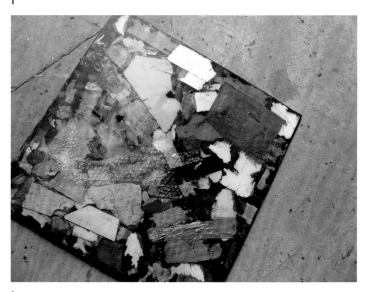

2

1. *Shredding the Studio of 2008–2009*, 2009. Video still.

2. *The Floor*, 2009. One of 90 floor tiles remaining from the studio, polyester resin. 70 × 70 cm (27½ × 27½ in).

3. *Hit the snare, don't you dare*, 2009. Drum kit, wood and Plexiglass showcase and wheels. 200 × 120 × 50 cm (78¾ × 47¼ × 19⅔ in).

4. *La Grande Verre, Zelfs*, 2009. Installation at Volta Basel. Dimensions variable.

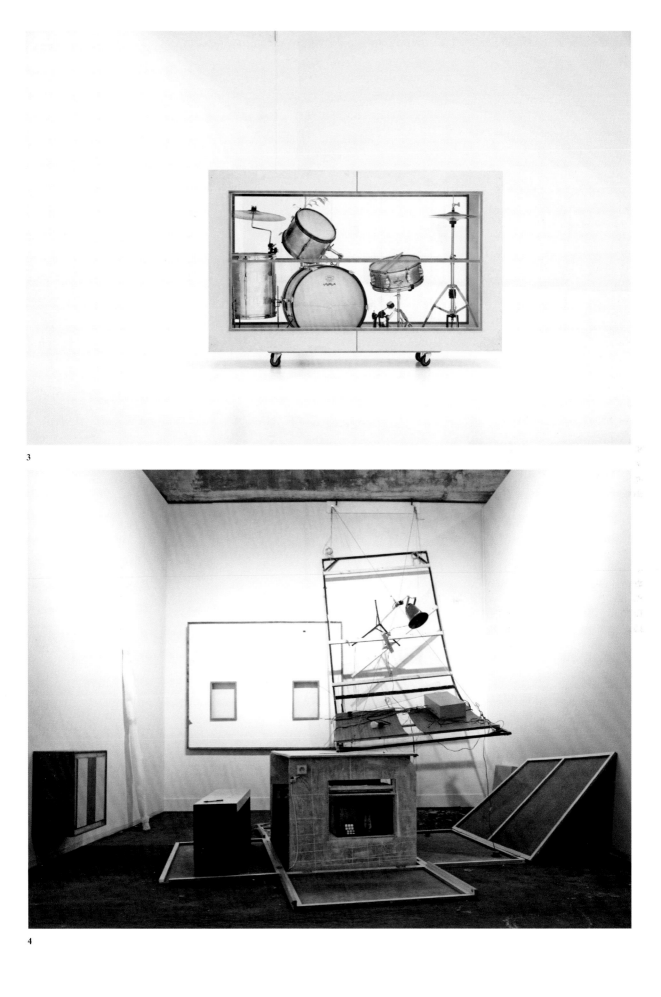

3

4

Jannis Varelas 1977, Greece, www.thebreedersystem.com

What interests you about blackness and monochrome?

Black for me always begins with Kasimir Malevich's void or Georges Bataille's narrative structures. Monochrome is like a confrontation with the abyss or mortality. It absorbs all light, so you are left in your body to contemplate the post-corporeal life. Blackness also creates a bridge between what might be termed 'total space', in the space–time continuum, and the notion of an atmospheric sensation of inability.

How do masks influence the work you create?

Masks give certain attributes to a person as much as hide their weaknesses. The face is paramount in my work, not as a representation of a character, but as a basis for an escape to nature. The mask is an abuse of the rationality of existence – a cultural perversion. It is somehow a unique artificiality that implies a traumatic cultural incident. The mask is a container of memory.

What do you find interesting about geometric forms?

The geometric element in my work is a direct reference to 1920s Russian avant-garde movements and Dada, as well as the Euclidean approach to logic. The use of geometric forms in my drawings and sculptures is also connected to the plot structure of low-brow horror movies and soft porn from the late 1970s and 1980s produced in California. It's a genre that truly interests me in the way it builds up a simple plot by using a very specific rectangular structure. I use this simplistic way of storytelling to formally create a narrative plot within a drawing.

What role do the graphite 'auras' play in your mixed-media pieces?

The auras are a play on caricatures made by the French artist Odilon Redon, who published drawings in newspapers that showed dark auras around the heads of those executed at the guillotine! I found this symbolism quite interesting. It's also a framing device used to create tension around the nodes that comprise the complete drawing.

Why do you like exploring imagery around sexual forms and gender?

Sexuality is an integral part of the structural overview of our society. The forms we use to imprint sexuality are very sophisticated but often clichéd. I try to overcome these clichés via the symbolic nature of the erotic. Through sexuality we can create a discourse on the hegemonic power structures of our time, and take a stand for or against them.

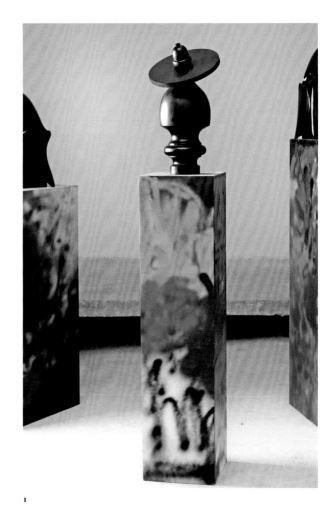

1

1. *Marquise de Merteuil*, 2009. Cardwood and spray paint. 100 × 50 × 50 cm (39²⁄₃ × 19²⁄₃ × 19²⁄₃ in).

2. *Proletkult-x opera costume*, 2008. Mixed media, collage, graffiti and ink on paper. 265 × 168 cm (104¹⁄₃ × 66 in).

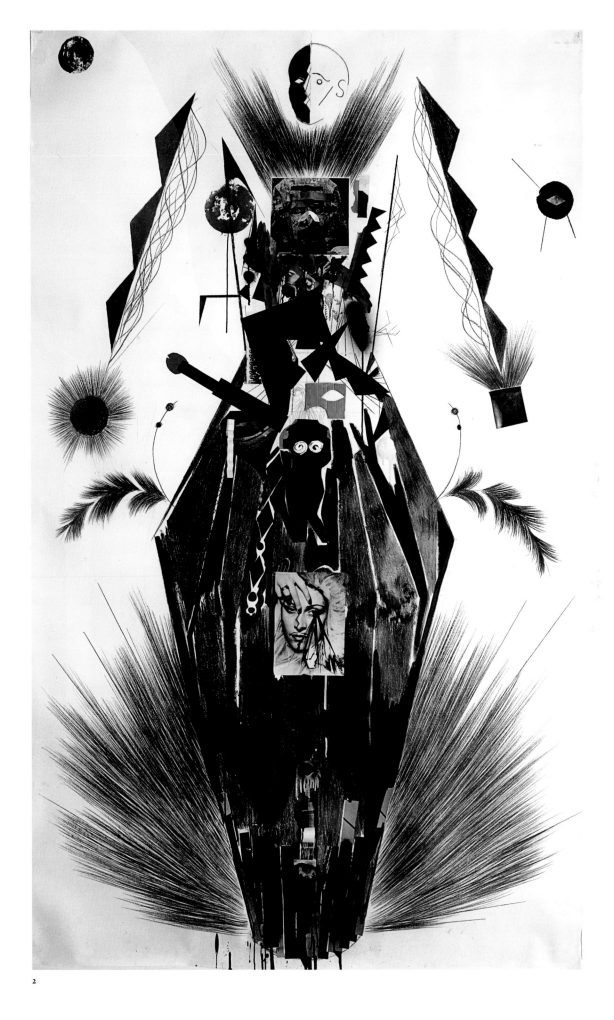

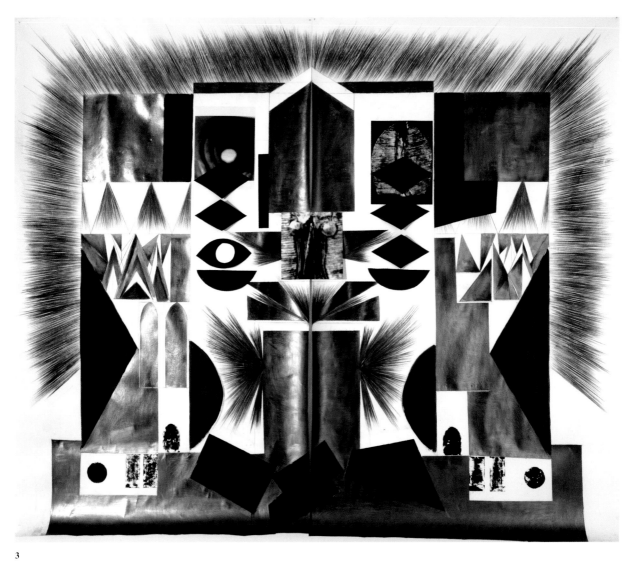

3

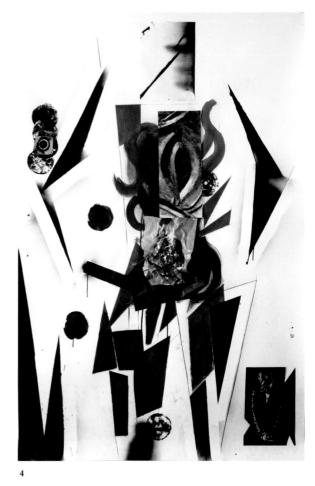

3. *Façade*, 2009. Mixed media,
collage, graphite, ink and spray
paint on paper. 253 × 300 cm
(99⅗ × 118 in).

4. *The soldier*, 2009. Mixed media,
collage, graphite, ink and spray
paint on paper. 170 × 120 cm
(67 × 47¼ in).

4

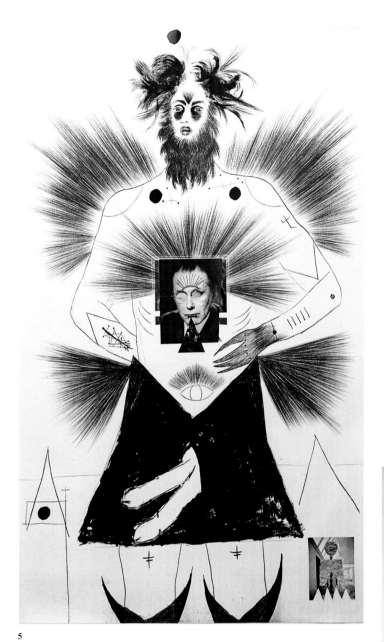

5

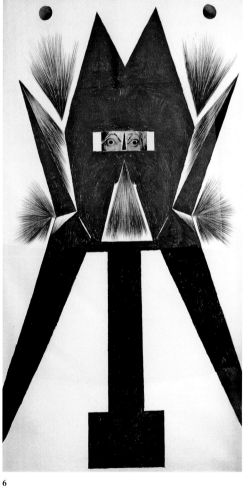

6

5. *Man on the moon*, 2007. Mixed
media, collage, graphite, ink and
spraypaint on paper. 170 × 120 cm
(67 × 47¼ in).

6. *Moon tower*, 2007. Mixed media,
graphite, collage on paper. 290 ×
160 cm (114 × 63 in).

Nico Vascellari 1976, Italy, www.crisplondonlosangeles.com, www.monitoronline.org

You were in punk-noise bands before moving into performance art. How did that influence your approach to making art?

My approach is deeply influenced by my experience in music. I left school to dedicate myself to it – playing concerts, doing flyers, arranging tours for other bands, making and distributing records and fanzines. I am still in different music projects. I was always interested in art, but while I was touring with my band, With Love, I started to think of myself as an artist. We toured small clubs, smelly squats, youth centres, people's houses. During the day I was visiting museums. All of a sudden it seemed clear that I was looking in the smelly clubs for what I had seen during the day in the museums. I would search for smelly clubs in museums – without any luck.

What role do visceral sound, rhythm and noise play in your art?

Visceral is a word I really like. Primitive is certainly another one. I prefer to talk about sound in general, rather than music, even though my work is probably about both. I'm very interested in creating ambience and atmosphere.

What attracts you to the concept of ritual?

The energy of being alive and not being alive.

How do you think collaboration has influenced your pieces?

I don't think the pieces have ever changed because of the collaborations, but they were surely influenced by them. I give very simple rules and direction when I start talking about what I'm looking for in a piece. In my performances, the people that are involved are normally my friends. They are really not acting in any way. On the other hand in *HYMN*, the atmosphere was determined by the sound provided by the musicians I invited (Black Dice, Prurient, Dead Raven Choir, KII, Ottaven, Kam Hassah, Stefano Pilia, Stephen O'Malley, Lizzi Bougatsos, Sylvester Anfang, Burial Hex and Coro S.ilario).

The sculptures, photographs and objects that come out of your performances often have a dark, gothic aesthetic. How did that evolve?

I'm the performer of my actions, so the answer could possibly be through me. One of the reasons I have decided to create objects during some of my performances is because I'd like to avoid the idea of looking for a specific aesthetic and be in total control of what I'm making.

I

1. *Revenge*, 2007. Partial view of installation at the 52nd Venice Biennale, burned wood, 64 speakers borrowed from European underground bands, neon light, lightbulb and performance with John Wiese. Dimensions variable.

2. *I Hear a Shadow*, 2009. Bronze, iron, acids and performance with Aaron Dilloway and C. Spencer Yeh. 430 × 210 × 117 cm (169⅓ × 82⅔ × 46 in).

3. *Dripping At The Feet Of The Mountain*), 2009. Partial view of installation at Galleria Monitor, Rome, pottery, perspex on wood, video projection and audio track. Dimensions variable.

4. *Cuckoo*, 2006. Burned tree trunks, wood, sawdust, wool, plaster, neon, lamps and audio of performance with Stephen O'Malley and John Wiese. Dimensions variable.

5. *Hymn*, 2008. Partial view of installation at Manifesta 7, perspex on wood, video projection, 12 amplifiers and 36 audio tracks. Dimensions variable.

2

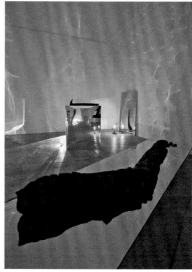

3

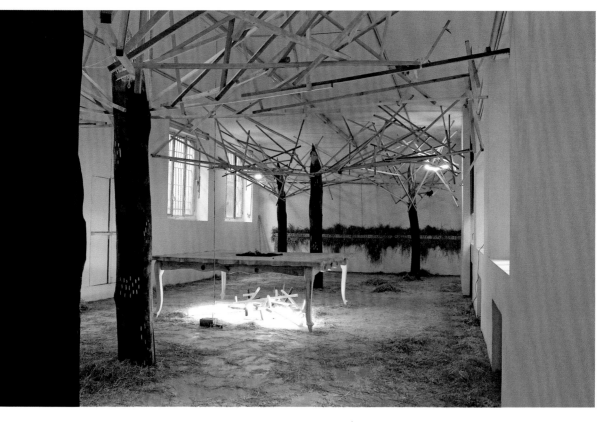

4

5

Steve Viezens 1981, Germany, www.galeriekleindienst.de

*Why do you focus on the image of the clown
or mime?*
A clown is a cultural image, a persona, a mask,
not human in a direct sense. Clowns can make
you laugh but can be evil. They do not have
manners and aim to break social taboos with
their pranks. The moment you think you un-
derstand them, you have to admit they fooled
you. They are elusive and have the fascination
of a riddle that never can be solved completely.
The clown mimes things we are afraid of.
He confronts us with our fears and sorrows,
so we can laugh them away. He works as a
valve and a distorted mirror for emotions and
situations we are usually not able to deal with.
*What interests you about the depiction of
animals?*
Using animals to portray human moods and
feelings is just easier. They make it possible
to keep a certain distance. If I used human
figures the message would be too obvious,
and that does not appeal to me.
How does collage influence your methods?
The coincidental collision of bits and pieces
often creates the best moments and results.
Lots of my works would not have been created
without this method. It is similar to a treasure
hunt that allows you to make exciting discover-
ies. It stops you from getting too comfortable
with your own style. I collect impressions from
everyday objects and experiences on the street,
in the supermarket, on the Internet or in the
theatre shows that I pick up and process.
*What are your feelings about the role of history
and art history?*
Art history is the best teacher I can imagine:
the technique, the dramaturgy, the way the
stories are told, the historical references. You
can especially learn a lot from so-called 'bad'
or unknown painters, more than from the
established ones. Their mistakes and failures
are instructive, amusing and encouraging.
*Are the seventeenth and eighteenth centuries
a particular influence on what you do?*
I love this period. Watteau, Boucher, Goya,
Hogarth – they are simply amazing. Their
pictures remind me of little stages where plays
are put on; little escapes from reality. I specifi-
cally like scenes in pictures from that time that
resemble little theatre scenes, showcases of
old memories with lots of costumes, uniquely
designed rooms, handcrafted artificial worlds.
This orchestration attracts me.

1

1. *Fantasie*, 2009. Oil on wood.
90 × 175 cm (35½ × 69 in).

2. *At home in the golden age*,
2009. Oil on wood. 54 × 53 cm
(21¼ × 20⅗ in) approx.

3

3. *Prinz im Scherbenwald*, 2006.
Oil on wood. 40 × 50 cm
(15¼ × 19⅗ in).

4

4. *Der liebesunterricht*, 2008.
Oil on wood. 53 × 55 cm
(20⅞ × 21⅝ in).

Samsudin Wahab 1984, Malaysia, www.taksu.com

What do you find interesting about using satire and humour?
It makes it easier to convey the message and create a storyline in my artworks. For me, satire and humour turn my ideas into something serious and complicated.

How do pop imagery and comics influence what you do?
Since I was a kid, I loved to draw cartoons and comics. That affects the way I think and create my work today. I am really interested in old propaganda posters and editorial commentary cartoons. I am more into responding to the situation with simple methods. Pop imagery is easy to understand and connects with people's lives today.

What attracts you to the earthy colour palette you use?
I like an image that evokes memories and a sense of history because it creates a strong and deep mood. It also differentiates my artworks from comic art seen in other magazines or comic books.

What materials do you use in your paintings?
Anything. I use printmaking, collage, acrylic, oil, bitumen and sometimes found objects. I am fond of using more than one medium in my artwork. I like experimentation. I like to observe the special and astonishing effects that might emerge through mixing various materials.

What interests you about circus imagery?
The circus is a place where people go and watch fantastic acrobatic performances – just for the sake of entertainment! I use the circus to visualize the political situation, so that it is not transparent. Stereotypes and iconic characters help the audience to think and create their own insights.

What do you find interesting about using metaphor to look at history and politics?
It helps me not to work too literally. My use of metaphor relates to my background as Malay. Malays use metaphors in art and literature, such as *Gurindam* (Malaysian traditional poems that consist of two lines with the same rhythm at the end), *syair* (a traditional Malaysian poetic form that expresses the mystical side of Islam), as well as other poetry.

What draws you towards aggressive imagery?
I am trying to express my thoughts and feelings, which sometimes makes me rebel against certain ideas. Perhaps it is also because of my present surroundings, which are full of cruelty, aggression and violence. I am not critical. I just want to document the situation around me – the politics, the people, the government, the culture and the events that happen around me.

1. *Jackass*, 2008, Mixed media on canvas. 152.4 × 182.8 cm (60 × 72 in).

2. *The Dalang*, 2008, Mixed media on canvas. 121.9 × 152.4 cm (48 × 60 in).

3. *Novus Ordo Seclorum*, 2009. Mixed media on canvas. 182.8 × 274.3 cm (72 × 108 in).

1

2

3

Mathew Weir 1977, United Kingdom, www.alisonjacquesgallery.com

How did you start to paint ceramic objects and figurines?

Ceramics are inert models. They can be open to the abuses and manipulations of the artist. Ideas can be projected onto them because of their inanimate nature. In painting ceramics you are painting reality at one remove. It is another form of representing a person. It can draw attention to and question the artificial nature of painting and forms of representation. The figurines themselves are hand-painted, static objects. They attempt to create or depict a scene. All these features suggest a parallel with painting, which interests me on a visual level.

What are your aims in highlighting the more disturbing side of cultural history?

My intention is not to add to the excessive imagery depicting racial stereotypes, but to appropriate such imagery in order to raise questions and provoke discourse. Where does such imagery come from? To whom does it belong? How do interpretation and meaning shift and change through time? The difference between the imagery I present and the imagery I use is one of intention. The distance between racism as subject and racism as motive is made through my own aims, then through history – with the knowledge that what is being shown comes from another time. Painting can be a way to ask questions, without set agendas and definite answers.

What interests you about violence and death?

I am attracted to imagery that tries to assist some kind of understanding or explanation of subjects that are so abstract, distant and fearful. The use of images of the living dead in a painting, an object that will outlive me, is also a metaphor for what painting is or can be.

Are you intentionally creating a sense of discomfort in the viewer?

I don't intentionally select imagery to achieve this, but I am aware that it is a factor. My selection is often driven by what I myself find uncomfortable. Discomfort can often come from the inability to apply language to certain images.

What do you like about flatness and surface?

The use of flatness and the attention to surface in my paintings has a lot to do with ideas of seduction. This display of craft, as well as sometimes frustrating people, can be a way to draw them in. An initial seduction may shift through an understanding of what is depicted. The surface is part of the psychology of the image.

1

1. *Early Bird*, 2008. Oil on canvas, mounted on board. 39 × 28 cm (15⅓ × 11 in).

2. *Afterlands*, 2009. Oil on canvas, mounted on board. 55 × 39 cm (21⅔ × 15⅓ in)

3. *Serenade Melancolique*, 2007. Oil on canvas, mounted on board. 60 × 36 cm (23⅔ × 14⅕ in)

4. *The Empty House*, 2007–2008. Oil on canvas, mounted on board. 52 × 38 cm (20½ × 15 in)

3

4

Andro Wekua 1977, Georgia, www.gladstonegallery.com

Why did you first start using mannequins?
I wanted to make a figure which was like an
actor playing a part, rather than a cast of a
specific person. Mannequins seemed to be
the most direct and easy things to use because
that's what mannequins do. Even in shop
windows, where they wear wigs and clothes
and make-up, they express someone else's
ideas, they don't express themselves. I cus-
tomize my mannequins and then cast them
in different materials.

What interests you about collage?
The principle of collage is important in all
my work. Working on collage allows me to take
things that I know from a distance, cut them
out of their contexts and create my own con-
text from them. It's like a game. At some point
I lose control and they autonomously show
me their real face, without me having much
to do with it.

What do you like about layering imagery?
Layering images creates depth, by creating
narratives and relationships between the
layers. On the other hand, layering images
is like building a façade. The effect is like
looking at a superficial surface. I like this
double standard.

*What do you find interesting about fragmentary
narratives in your work?*
There is always a conflict within narrative
for me. My narratives are not fragmentary.
I always push my narratives as far as I can.
I tell as much as I can.

*The eyes of your figures are often blocked out
or defaced. What does this image mean to you?*
It was always hard for me to paint the eyes.
Eyes would create a more specific, defined
figure, but if I leave the eyes out in the collages,
or leave figures without eyes, it becomes easier
to project onto them and to interpret them
as mannequins.

*What do you like about using tactile materials
such as wax and rubber?*
Wax is interesting because it has a sensitivity
and warmth. It is a material that I often use
for figures. It is dynamic, even if it is poured
and frozen. I have only used rubber for one
installation so far, but I always look for new
materials that will help me express an idea
in the best possible way.

How do your different media fit together?
Each medium has its benefits and shortcom-
ings. How do they relate to each other? I think
well, since none of them have complained to
me yet.

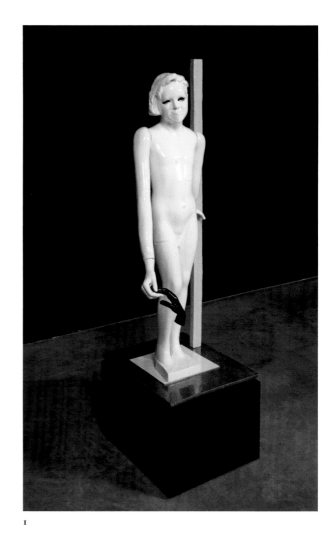

1

1. *Holding*, 2007. Ceramic.
168 × 57.2 × 50.8 cm
(66 × 22½ × 20 in).

2. *Circle Smile*, 2007.
Collage, felt pen, coloured pen,
lacquer spray, pencil and ballpoint
pen on paper and photo.
23 × 18 cm (9 × 7 in).

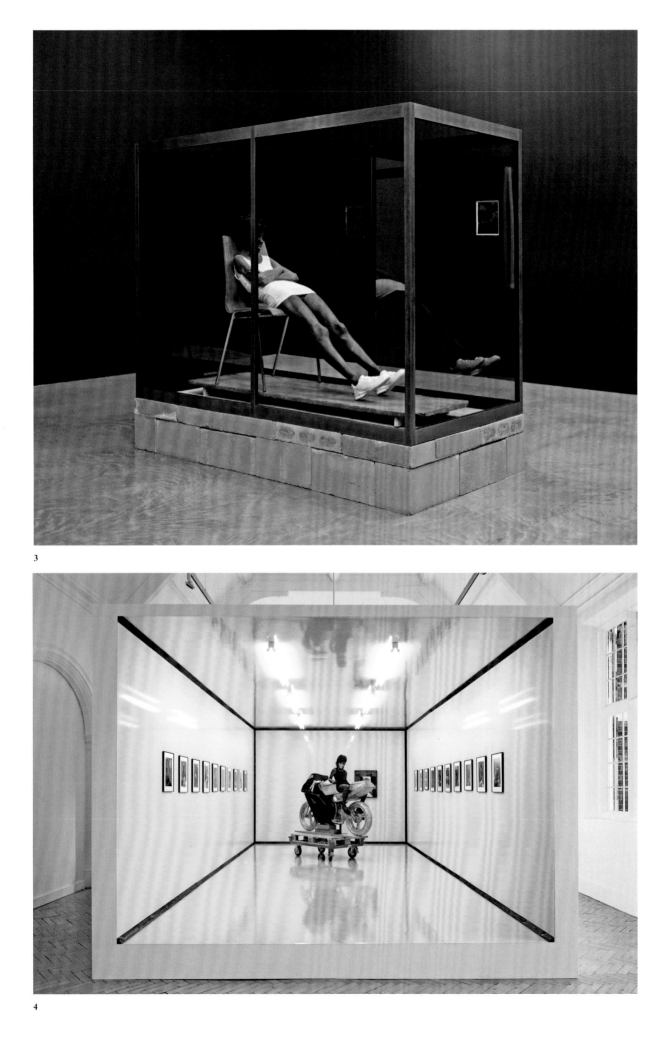

3

4

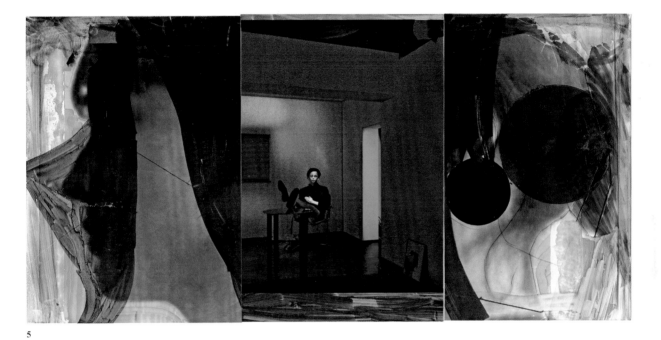

5

3. *Gott ist tot aber das Mädchen nicht*, 2008. Installation of wax, hair, aluminium, coloured plexiglass, brass and bricks.

4. *My Bike and your Swamp (6 p.m.)*, 2008. Installation with black polyurethane rubber, wax, aluminium, wood, cloth and artificial hair. 202 × 86 × 186.5 cm (79 ½ × 33 ⅞ × 73 ⅜ in).

5. *Calling Over*, 2007. Collage, felt pen and ballpoint pen on photo print. 15 × 36 cm (6 × 14 in).

Charlie Woolley 1981, United Kingdom, www.davidrisleygallery.com

Why did you start using flags?
I had this idea that flags could be two very different things at the same time. On the one hand, they are these very live objects used for protest, and on the other they are dead, elegiac monuments used to commemorate the dead. I wanted to find a place in between. *Black Flags for Dead Revolutionaries*, for example, is two flags memorializing two Black Panthers who were murdered by police. These are com-memorations of death and protest banners at the same time. A lot of faith is put into flags. In America the flag does the same job that the royal family does in the UK. It can be a symbol that eloquently explains many complex abstract notions. I am particularly interested in objects that are vessels for meaning.

Why did you start working with film stills?
I made a piece called *The Flicker Effect*, which is a series of sixteen images taken from the opening credits to Robert Bresson's film *Pickpocket*. Each image is a photograph of the TV screen at the moment when one credit fades into the next. The images become con-fused, transposing words over more words, rendering them unreadable. I became inter-ested in some of Bresson's ideas about lan-guage and the way he would make his actors, whom he called 'models', repeat actions over and over, until they became robotic.

Are you aesthetically interested in the grain of screen imagery?
It really began with *The Flicker Effect*. I found that if I blew up digital photos that had been taken from black-and-white movies shown on TV screens, the colour begins to leak out. This is what started me off making collages from jpegs, screen grabs, photos from TV and com-puter screens and from language. Collage is central to the last hundred or so years of art. Sometimes I think the whole history of art can be understood as collage, taking two things that didn't previously belong together and forcing something new.

How do film credits and subtitles influence you?
It is interesting to see how language affects images. This is also a stalwart of modern and conceptual art history. René Magritte or John Baldessari are obvious examples. Language is just as useful a tool for collage as images are. William Burroughs said, while cutting up newspaper headlines, that if you cut into the present, the future leaks out. I always keep this in mind.

1. *Soldier Palimpsest 1*, 2009.
Giclée print. 150 × 100 cm
(59 × 39⅖ in).

2. *Now, 'I' is someone else*, 2008.
One-cut collage Giclée print.
150 × 100 cm (59 × 39⅖ in).

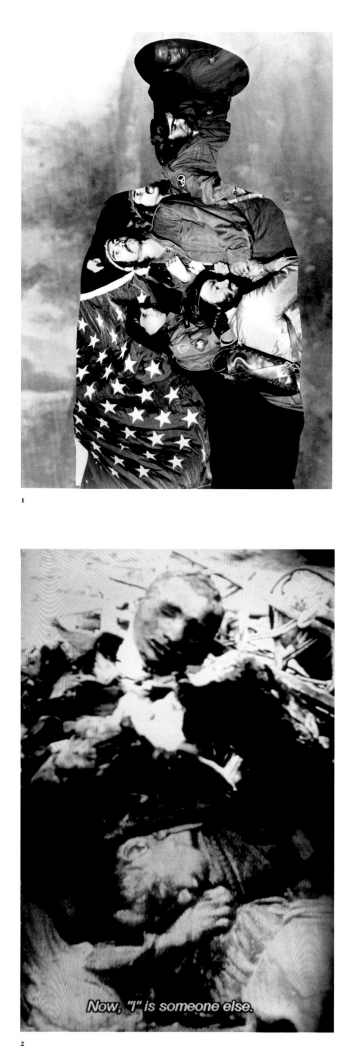

1

2

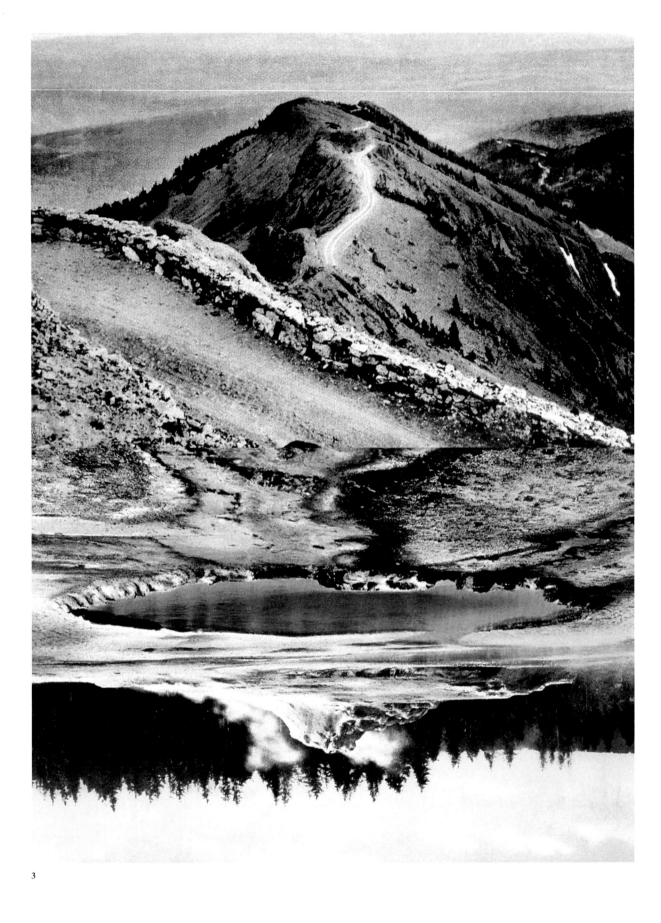

3

3. *Mountain Pool*, 2009. One-cut
collage Giclée print. 150 × 100 cm
(59 × 39⅖ in).

4. *Rock Rock*, 2009. One-cut
collage Giclée print. 150 × 100 cm
(59 × 39⅖ in).

4

Yarisal and Kublitz 1981 and 1978, Switzerland and Denmark, www.yarisalkublitz.com

How and why did you first start experimenting with movement in your sculptures?
A lot of the works we did were research into finding out about art's potential for communicating and rousing instinctive reactions from viewers. Movement seemed a natural tool, because it gives the viewer a feeling of being part of an unfolding narrative. Besides being preoccupied with the narrative and 'happening' elements in movement, we also work with movement as a source of transformation.

Why use humour and irony?
Our art draws on banal slapstick humour, as an exploration of comedy's effects through repetition and displacement. It is a central element in our work because the comic briefly annuls the order of things and allows us to experience a momentarily liberating blow. Irony is a way of dealing with the presentation of reality, creating a space where we can defamiliarize the familiar and work with feelings of uselessness and displacement in a light, humorous way.

How do you exploit sound and rhythm?
We have a preoccupation with time repetition and the idea of waiting for a known outcome. In the duration when the viewer is waiting for an expected outcome, we use sound to create an inner mental scenario, which plays upon the viewer's preconceptions, constantly making them question whether the work will correspond to their expectations.

What do you like about the idea of the machine?
We see the machine as both a symbol of functionality and practicality and as an interesting way to work with movement, because of its often repetitive nature. Our interest is in using these qualities in relation to the audience's existential need for order and function. The need probably stems from having grown up in Switzerland and Denmark respectively. In both countries there is a great emphasis on functionality and control, even in situations that are clearly not controllable. We like to point to the absurdity of the need for order.

Why add a destructive element to your work?
There is a satisfaction in chaos and destruction. The destruction in our work allows an opportunity to realize that an accepted pattern of thought has no necessity. Our work can be seen as a celebration of momentum, but also as a reminder of the unbearable fragility of the moment. It probably also comes back to this need to mess with the perfect, since the perfect is always so bone dull.

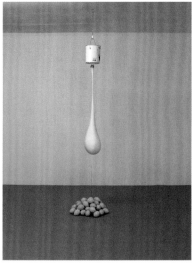

1

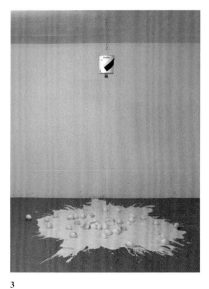

2

3

1, 2, 3. *Lemon Incest*, 2009. Time-based sculpture of paint can, yellow paint, balloon, concrete lemons and needle. Dimensions variable.

4. *Corny*, 2009. Mechanical sculpture of coconut, motor, spray paint, wood, metal and various devices. 50 × 45 × 110 cm (19¾ × 17¾ × 43⅓ in).

5, 6. *Ketchup*, 2006/2008. Mechanical sculpture of ketchup bottle, ketchup, ball, wire, wood, electric devices, motors, MP3 player and speakers. 190 × 60 × 80 cm (74⅘ × 23⅗ × 31½ in).

7. *Anger Release Machine*, 2006/2008. Interactive sculpture of vending machine, porcelain plates, glasses, statuettes and various items. 70 × 77 × 181 cm (27½ × 30⅓ × 71¼ in).

4

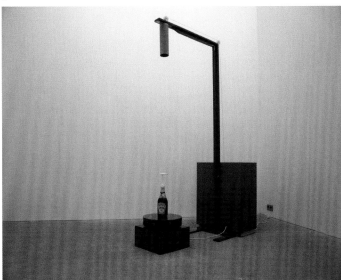

5

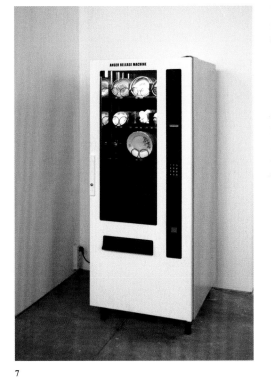

7

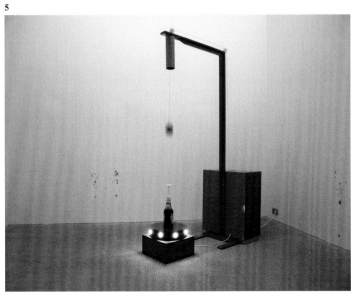

6

Liang Yue 1979, China, www.shanghartgallery.com

What attracts you to creating work about urban space?

I was born in a city. I always absorbed a lot of information from the world around me. That background makes me feel and think like a citizen.

What do you find interesting about dusk and twilight?

Actually it is not that interesting to me. The work was more about reflecting a pessimistic mood. Having a lot of questions and problems, I realized I have no power to create change. Sometimes I photograph a few pure seconds just in my mind and try to capture them in reality – as if the truth and perfect time are hidden in the crowded world.

Why and how have you incorporated the element of performance into your photographs?

The idea was to produce an atmosphere with a performance. Performance acts as if it is reality and can even be more than reality.

Explain the idea behind the 'Morse Code' series.

It is a series of photographs taken in 2002 and 2003. The air in Beijing was full of dust all day during that time. Everywhere the air you breathed was full of sand. People could only see the brown sky with blurred sunlight. It was quite a mysterious moment. The whole day looked like twilight and dusk. I put a boy with a torch in the photos because the torchlight gives the feeling of puncturing an exit in a constrained and suffocating space.

How do ideas around landscape and the environment inform what you create?

Sometimes the idea comes before I see the landscape and the environment. Sometimes the landscape and the environment give me an idea.

What interests you about the medium of photography?

The photographic camera is a direct and fast way to catch an idea in my mind.

What are you working on now?

I am taking photos of city life around me – of people and their emotions when they pass by.

Is there something critical underlying your images of modern China?

Everything in my work is about people's peaceful and personal moments inside their own minds.

1

1. *Morse code, beside the railway rail*, 2003. Photograph. 120 × 80 cm (47 ¼ × 31 ½ in).

Raphaël Zarka 1977, France, www.michelrein.com

How is your work influenced by ideas of mobility?

Nomad is not a word I use a lot. I feel more concerned with the more general idea of mobility. Mobility does not necessarily imply motion. One can travel a lot in a room, especially if that room happens to be some kind of library. What I like about nomads is, for instance, their capacity to see tracks in a desert where anyone else would not see anything but sand. That's how I think we can learn from nomadism. Apart from that and despite the travels I feel quite sedentary.

How does skateboarding inspire your work?

It did not start as an influence. But I noticed, over the years, that skateboarding was such an important part of my experience as a young person that it kept coming back in one way or another. The second important influence of my teen years was archaeology. I think there is something archaeological in the process of looking for skate spots and foreseeing what kind of movement they imply. Skateboarding has shaped the eye of many contemporary artists, but I was always more interested in skateboarders' methodologies than folklore.

How do you use found objects to explore ideas around history?

My work springs from the basic idea that although there is a very large number of shapes, they and the world are nevertheless limited and repetitions occur. One of my pleasures, as an artist and a viewer, is to spot recurrences. When it is only formal, that's not bad, but when a formal similarity helps you understand something differently, that's fantastic. That's what happened when I discovered Galileo's apparatuses for the study of mechanics. The forms of his wooden half-pipes, launch ramps and inclined plans were extremely close to what skateboarders build or appropriate in the city. The action is also similar. Today's skateboarders are Galileo's followers. They unwillingly study the same thing – the law of falling bodies. When I see skaters riding a public art sculpture, it's not the idea of vandalism that interests me, but the fact that the sculptures turn into giant mechanical apparatuses. In that case sculptures are assessed on mechanical values rather than on aesthetic values. Also skaters reveal what modern sculptors often try to embody in their works – dynamics.

3. View of the exhibition 'Ratiocination', galerie Michel Rein, Paris, 2008.

4. *Padova (replica n° 4)*, 2008. View of the exhibition 'Padova', La Vitrine, École des beaux-arts de Cergy gallery, plywood and carrara marble. 550 × 36 × 130 cm (216½ × 14⅕ × 51⅕ in).

5. View of the exhibition 'Ratiocination', galerie Michel Rein, Paris, 2008.

1. *The Forms of Rest n°8*, 2006. Lambda print. 70 × 100 cm (27½ × 39⅖ in).

2. *The Forms of Rest n°6*, 2002. Lambda print. 70 × 100 cm (27½ × 39⅖ in).

6. *Riding Modern Art*, 2007 (detail). Installation of a photographic collection around *Katarzyna Kobro Spatial Composition 3* (1928).

1

2

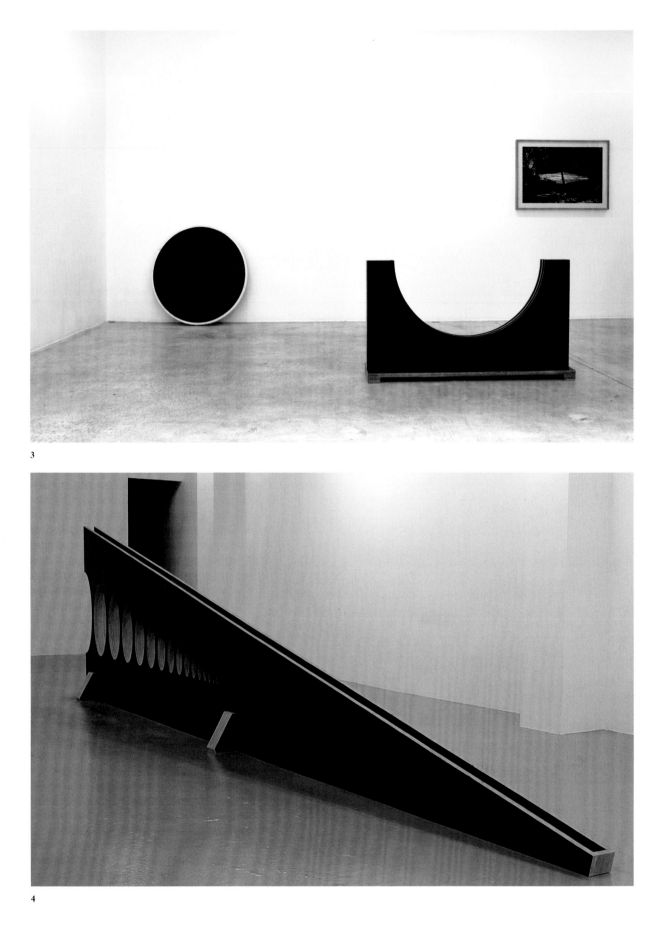

3

4

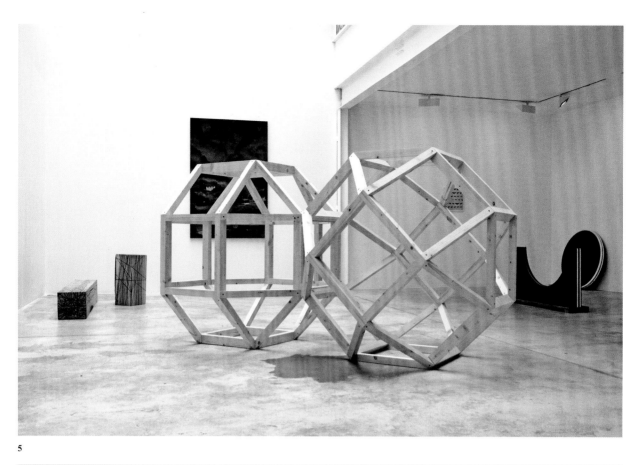

5

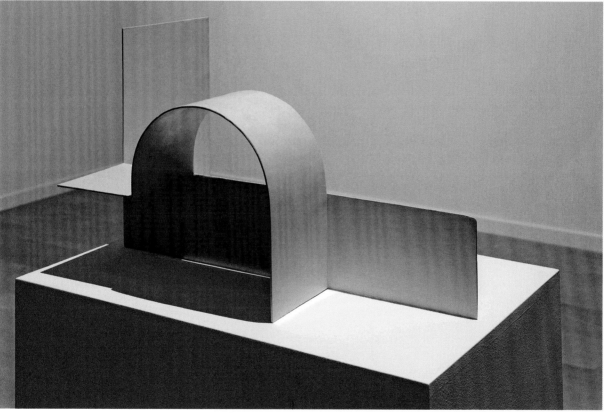

6

Acknowledgements

I would like to thank all the artists and
their galleries for their generosity and help
in making this book happen. Thanks to
Tom Giddins, Kris Latocha, Freire Barnes,
Jen Lewandowski, Gabriel Coxhead,
Paul Pieroni, Atalanta Weller, Seana Gavin,
Bianca Gavin, Tom Cecil, Annika von Taube,
Ana Finel Honigman, Fabio Rossi, Andrea
Thompson and Sonja Patel for their company
and input. Thanks to Donald Donwiddie,
Sophie Page, Helen Rochester and Laurence
King for their continued support. Thanks to
physiotherapist slash genius Suzanne Mauer
(tatamihealth.co.uk) without whom I would
not have physically been able to get on a
computer. Thanks also to Paola Gavin, the
second brain, coffee companion and world's
greatest sub. And to Tim Berners Lee for
creating the internet without which research
would be a lot harder.

Dedicated to the memory of
Ioana Nemes (1979–2011).